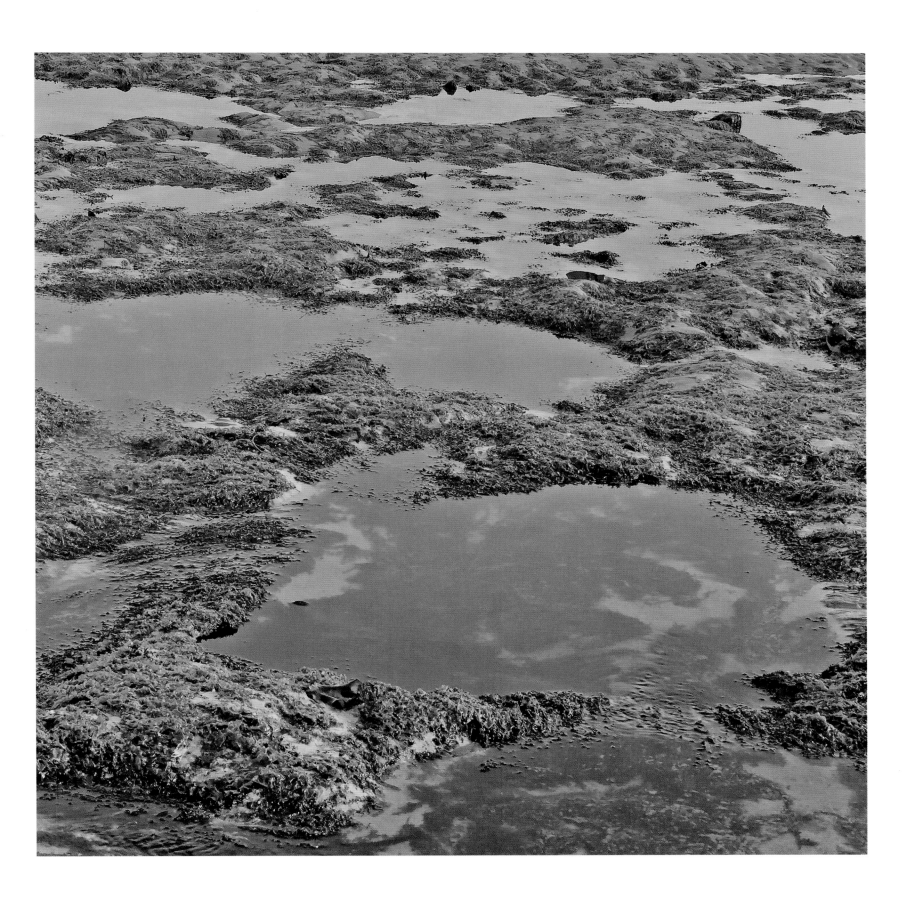

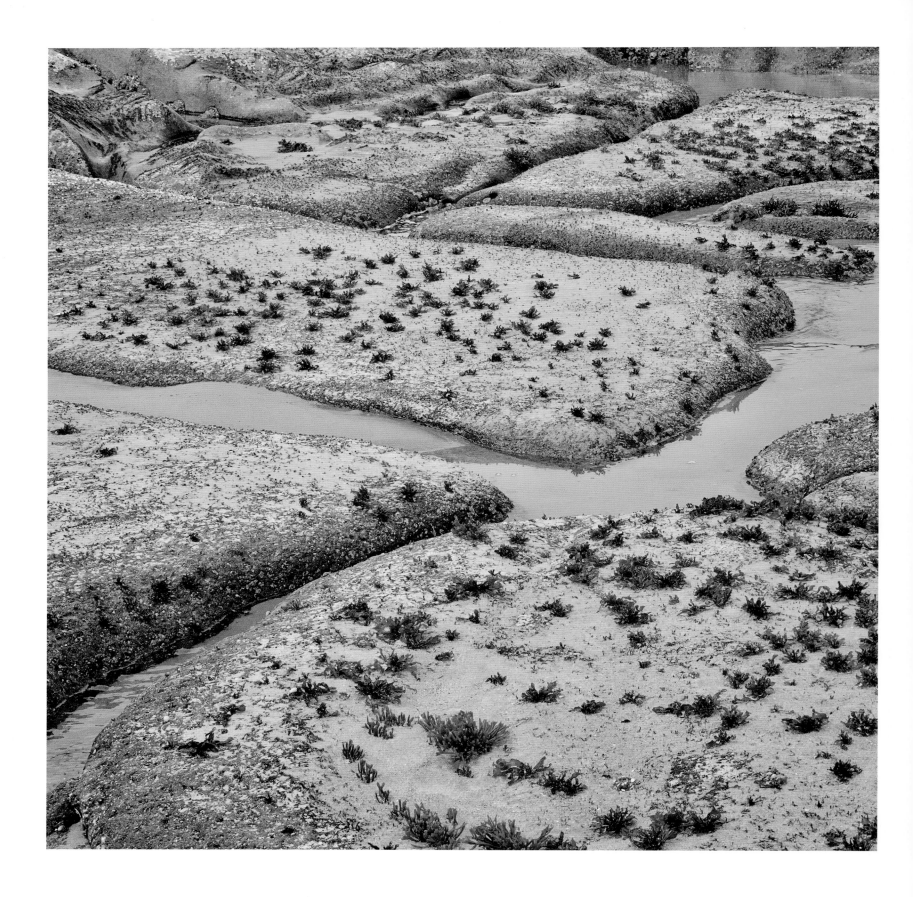

Tidal Rhythms

Change and Resilience at the Edge of the Sea

Photographs by Stephen E. Strom
with an introduction and essays by Barbara Hurd

George F. Thompson Publishing
in association with the
William and Salomé Scanlan Foundation
and American Land Publishing Project

St. Augustine asked where time came from. He said
it came out of the future which didn't exist yet, into
the present that had no duration, and went into the past
which had ceased to exist.

—Graham Greene, *The End of the Affair* (1951)

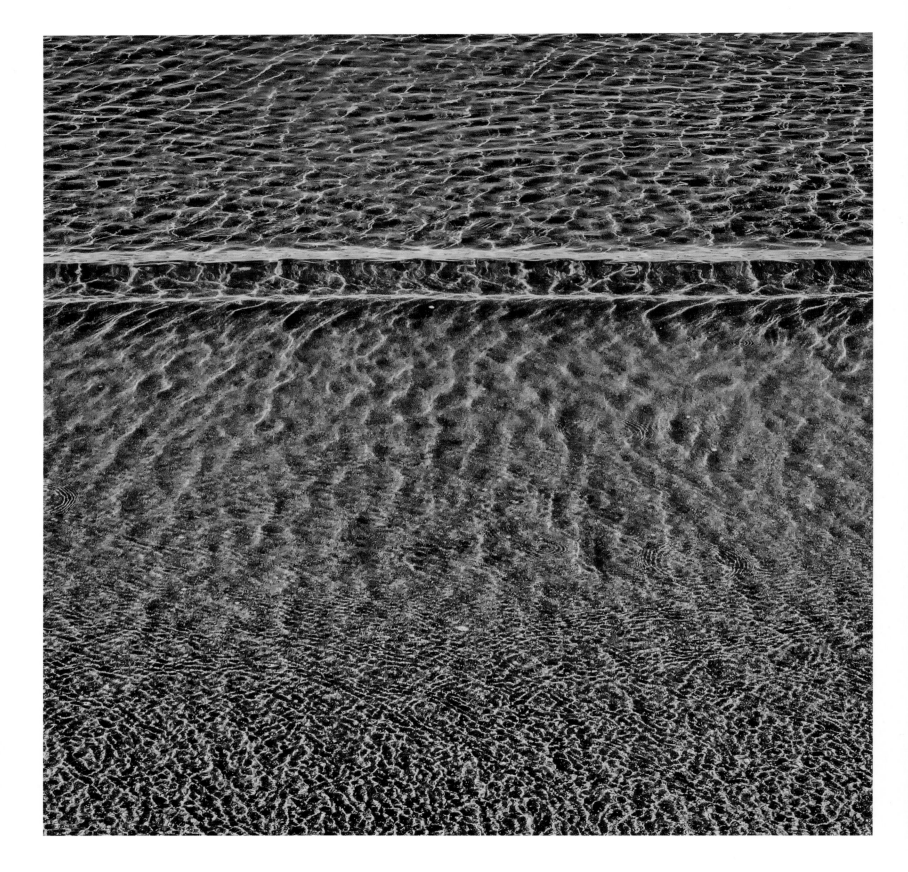

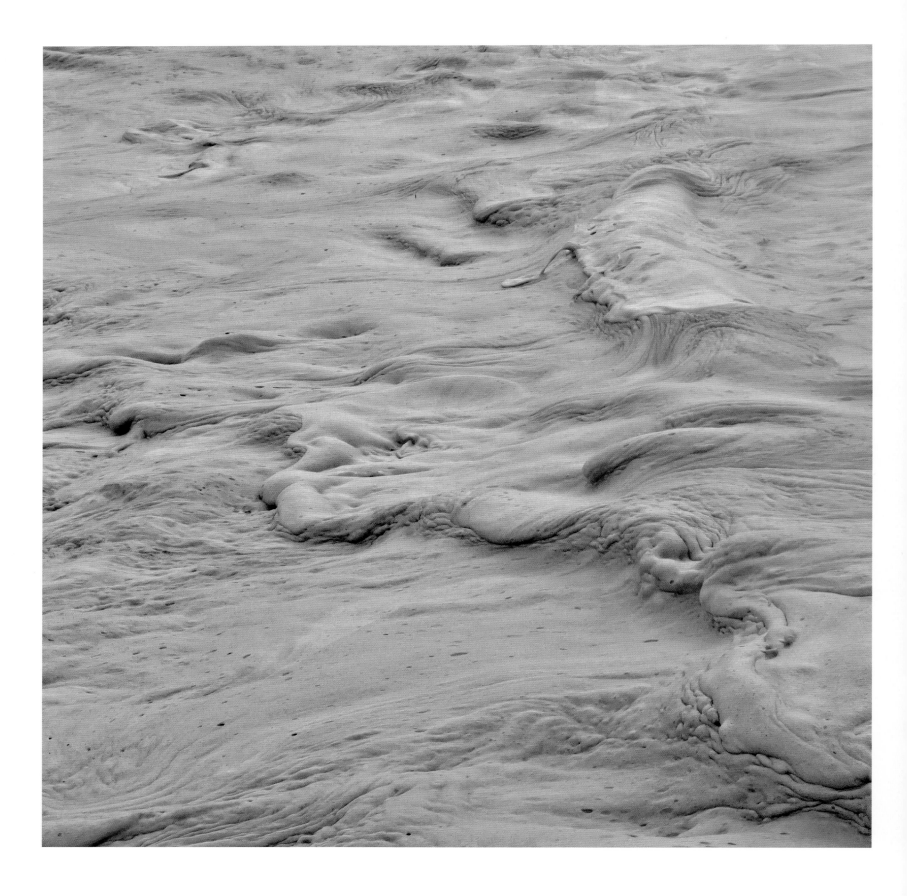

Introduction
Tidal Rhythms

Earth was formed from chaos, from collisions, explosions, expansions, accretions. Dust and gasses became the primeval planet, which eventually developed a primitive crust. On and on it went for some billions of years, while land masses cooled and hardened and oceans sloshed into different shapes and lapped against continents that continued to meander. And then, in a geologic flash, we humans appeared on the shores.

We've been drawn to the overlap between land and sea ever since; we built our villages on the edges and then our cities. All the while, many of us have wandered down—and still do—to wade in the shallow waters and tide pools, to consider the planet as part of a solar system with moon-pulls and ocean bulges, which means that our feet are sometimes soaked by salt water and sometimes slimed by mud. We've learned, too, of the strange beauty that exists here in the subtle, slipping shadows, in the cross hatchings of ripple and stone.

Although the photographs in this book were made along the Gulf of California and the Pacific Coast, from Big Sur and Point Lobos in northern California to the Olympic Peninsula in Washington, they reveal a universal rhythm enacted twice a day, every day, all over the globe: as the ocean waters recede, for a few hours an otherwise hidden world is exposed, teeming with ancient life forms, clinging to rocks, finding a different kind of nourishment before the waters return.

Many life-forms that live between tides rely on that twice-daily rinse of seawater. The incoming tide dampens, then drenches; the pound of surf moves up-beach, then overhead, bringing an influx of food, a swirling smorgasbord of plankton and fish.

Many creatures that live here also need the opposite: the slow drying out of sun-warmth, the chance to crawl up a rock and breathe a little air. They've lived this life of opposites for millions of years, established their niches here in the turbulent zones squeezed between ocean and land.

This is the zone Stephen Strom and I have tried to capture with images and words—a place of shadings and rhythms and the dynamism of opposites: dark/light, wet/dry, covered/revealed. A place of now you see it, now you don't. Are those sea stars there or not? And what happened to that patch of lichen? Is it submerged now

and become invisible? In reality and in image, it's hard even to pin down exactly where the tidal zone begins and ends. Its transience, its ephemerality, haunts. How can we not think about the illusions of immortality, the inescapable truth of endless flux? Entwined, primitive flora and fauna together create changing landscapes whose complex rhythms somehow resonate with what we humans perceive as beauty.

The images and prose stories allow the reader to travel between intimate portraits and expansive vistas. They also complicate those rhythms as they explore not just resonance, but also disturbance. Though the abstract qualities of the images may prevent the telling of a single story, below their surface elegance lurks a heightened plot.

Another way to say it: the tidal zones are multi-storied, full of short lives and yet of enduring persistence. Strom's photographs reveal and conceal. Though attentive to line, color, and shape, the eye is never sure whether the subject is close by or far away. Are we looking at sea stars, bioluminescence, sky, or galaxy? Are we hovering at three feet or 3,000? Things glow and decay underfoot and overhead. Space and time are fluid here, meaning the imagination has to stretch to accommodate uncertainties. We are tempted to conclude that the past predicts the present, which foreshadows the future.

Only it doesn't. In fact, as we move from high tide to low tide, from the panoramic to the miniscule and back again, we're confronted with the larger issues: What happens as seas rise, warm, and acidify?

Tidal zones, it turns out, are one of the first landscapes to be threatened—almost invisibly—by the intricately braided, slippery, and sometimes unknown effects of global climate change. Mussels, barnacles, even the wet sand itself and tidal pools are flung and ruffled or warmed and acidified in ways that stress the lives of those who live there. Shells begin to thin; species migrate north; habitats disappear.

Anything that lives in a tidal zone has usually found a way to adapt—to move a little to the north or inland or higher up, to grow sturdier shells, longer stalks, or more efficient holdfasts. They could do so, because they had decades, millennia, to adjust.

It isn't like that any more. Today, the sea, covering and uncovering these tidal zones twice a day, is being altered at a rate far faster than anyone predicted. In geologic terms, the pace of change now is frenetic, and the effect on tidal zones is no longer languorous. For the creatures who live here, there are fewer options. They're not coming back, those old rhythms.

It is that order and that fading which we attempt to explore in Tidal Rhythms, even as we're confronted with a new and urgent question: Can these balanced sys-

tems evolve rapidly enough to enable continued sustenance and maybe even a new kind of beauty?

Maybe, maybe not.

We begin, in the first two sections of this book, by moving from the expanse of ocean-at-the-edge to grains of sculpted sand and tracks of tiny prints. Water in the act of creating and destroying leaves traces of patterns caused, we know, by the physics of wave action and wind. But as we investigate these repeated patterns, what emerges is our complicated response to order and the solace of predictability. And so larger questions remain: What might happen as that order and solace grow less stable? Jostled by new forces, how will these patterns change? What will they look like as the ocean itself changes?

In the third and fourth sections, Strom moves the camera up close, examining the myriad patterns of tidal life, its siphoning critters, the twice-daily ebb and flow. Here, too, the questions multiply—about attachment and habits of attention, the evidence of large forces at work on tiny lives, and the mesmerizing sway of underwater forests.

In the final two sections, we move back from transient habitats and miniscule worlds to the bigger, seemingly more stable scene: remnants of old mountains, tectonic plates, reminders of durability, though even these remnants might some day be submerged. As our gaze is lifted, we acknowledge a different view.

We hope this collage of images and words invites a sustained consideration of ancient rhythms and the myriad forms of life that long ago achieved some balance at the edge of the sea. We hope, too, that it compels the act that only humans are capable of—extending our imaginations into the lives of others and into the history and future of our planet.

There will be a new order some day. We'll adjust, and beauty, we have to believe, will likely persist in the subtle hues and graceful movements of tidal pool creatures and, perhaps perversely, in the inexorable drive—of all life—to carry on. We'll do our clumsy best and pay the consequences. In the meantime, tidal zones beckon, as we hope these words and images do with their mysterious arrangements of color and line, of textured and layered perspectives.

The scale of inquiry might disorient us, compel us to ask: Where do we think we are? If a kind of despair follows, maybe that will galvanize us. Yes, the sea levels and tides are changing—which moves us in this book to try to sing, as Wallace Stegner already suggests, the "unbroken doublesong of love and lamentation."

Oceans: Refrains

To ancient peoples daunted by the size of the sea yet fed by its riches, the idea of oceans with limits might have seemed absurd. To them, the vast water was a primordial universe, boundless and deep.

No wonder it haunted. No wonder, in the face of what is simply too big and formless to understand, they did what we humans have done with mystery for millennia: fashioned stories and characters—Kanaloa, Neptune, and the Nereides, those dolphin-riding water nymphs who, blessed with the gift of prophecy, would warn sailors away from hazards.

Meanwhile, the sea provided enough to feed millions for thousands of years. It supplied, inexhaustibly, other riches too—seaweed for fuel, passage to exotic lands, the impetus for some of the world's greatest literature: *The Odyssey and Moby-Dick.* When it comes to the sea, it seemed for a while that the poet Lord Byron got it right: *dark-heaving, boundless, endless, and sublime,* a world so capacious it's hard to imagine—let alone see—its limits.

In endless cycles, its waters move around the poles, under ice, up—vaporously—into the atmosphere and down again, a constant replenishing. It's been circulating like this for billions of years, dissolving mountains, drowning coastlines, washing everything, eventually, down to the sea. In those lightless depths lies not the source of Neptune's power but the dim beginnings of life. Even now, in those unreachable canyons and deep sea vents, whole new creatures are brewing.

An ancient cadence, though, persists. We hear it at the tidal edge—come in, go out—and in the refrains of seafaring stories—*Come hither. Beware.* We assume it will repeat forever.

The balance, until recently, always tipped in our favor. The bounty was extravagant, and for thousands of years the price we paid for it was relatively small—capsized boats, the occasional shark attack, illness on a ship too far from shore, a tsunami and hurricane now and then—events we might once have called necessary sacrifices to the oceanic gods.

Nothing in the history of countable disasters has interrupted this sense of abundance. Nothing has made us question Byron's further claim that "Man marks the earth with ruin; his control / Stops with the shore." Nothing has diminished our sense that the sea—great repository—couldn't absorb whatever we put in it.

The refrain: The sea giveth; the sea taketh away.

But the sea is a world that conceals more than it reveals. There've been no obvious signals of saturation, no warning bells to tell us we've asked too much. For decade and decades, almost forty percent of the carbon dioxide we pumped into the atmosphere returned to the seas, which accommodated it without major effect. Whatever subtle changes in the ocean's chemistry began to take place remained hidden for decades. The sea taketh.

But it turns out Milton was wrong when he described chaos as "Dark illimitable ocean, without bound." Chaos will likely be the result if we don't recognize that the sea can no longer provide without limits or absorb without consequence. Acidification will likely impact every thimbleful of ocean water—from North Pole to South Pole, along the equator and from continent to continent, from deep sea to watery edge.

And so, today, the sea giveth something else: When it comes to us, as it does twice daily up and down coasts all over the world, it brings with it the evidence that an invisible line has already been crossed. Herman Melville's "ungraspable phantom of life" is approaching land with graspable signs of damage: thinned mollusk shells, stunted sea stars, urchins with shortened spines, to name a few.

How to adjust to such lessening? We'll need new stories of limits, songs about boundaries, perhaps a reminder that refrain is not just a literary device—a noun connected to verse—but also a verb meaning to hold back or abstain.

Sometimes it seems as if what we see has been designed, or a good eye has framed it in such a manner as to give us the illusion of design. The smallest details take on an importance that, if seen singularly, would be ordinary—a drop of water, say, that is merely what it is. Bring a more intense focus to it or surround it with undulations or what appear to be ridges, and we have a portrait of ocean.

So we must, as best we can, see the world as such a throng-inside-swarm-within-sweeping expanse that there's a place in it for the odd, the lost, until it is found and made part of something larger.

Here on the edge, we're reminded of the problem. Look at the images Strom provides: in the sand, in the sea; in the flora, in the fauna. In our assumption that we can see it all, the barely visible disappears.

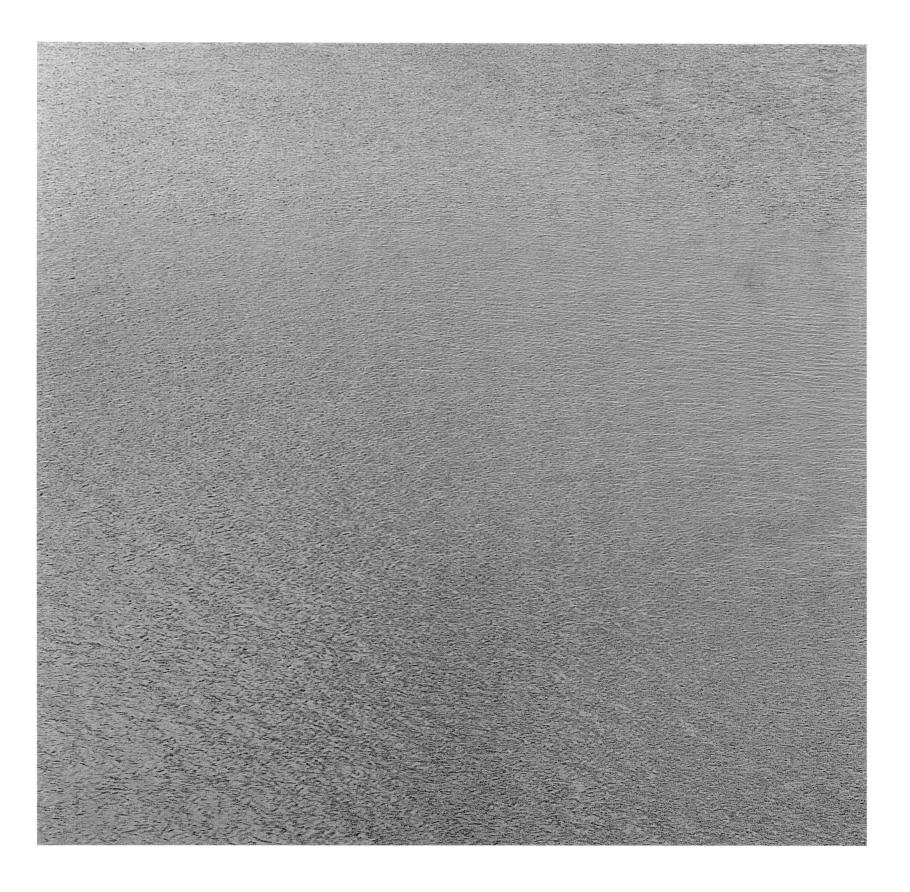

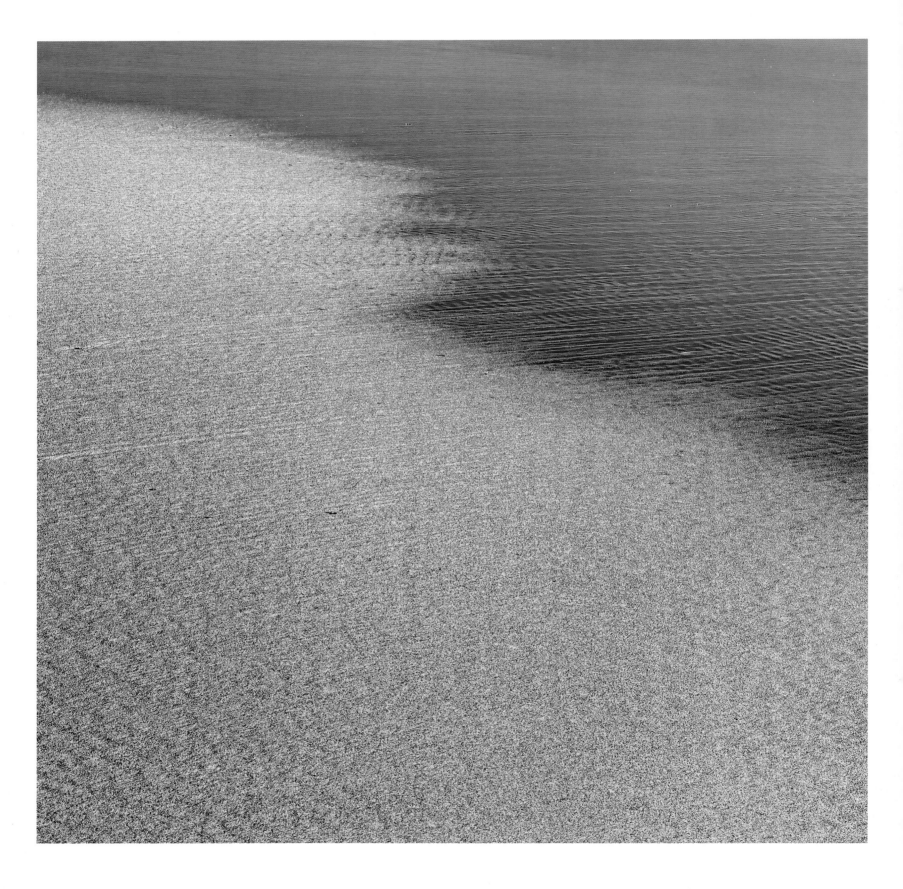

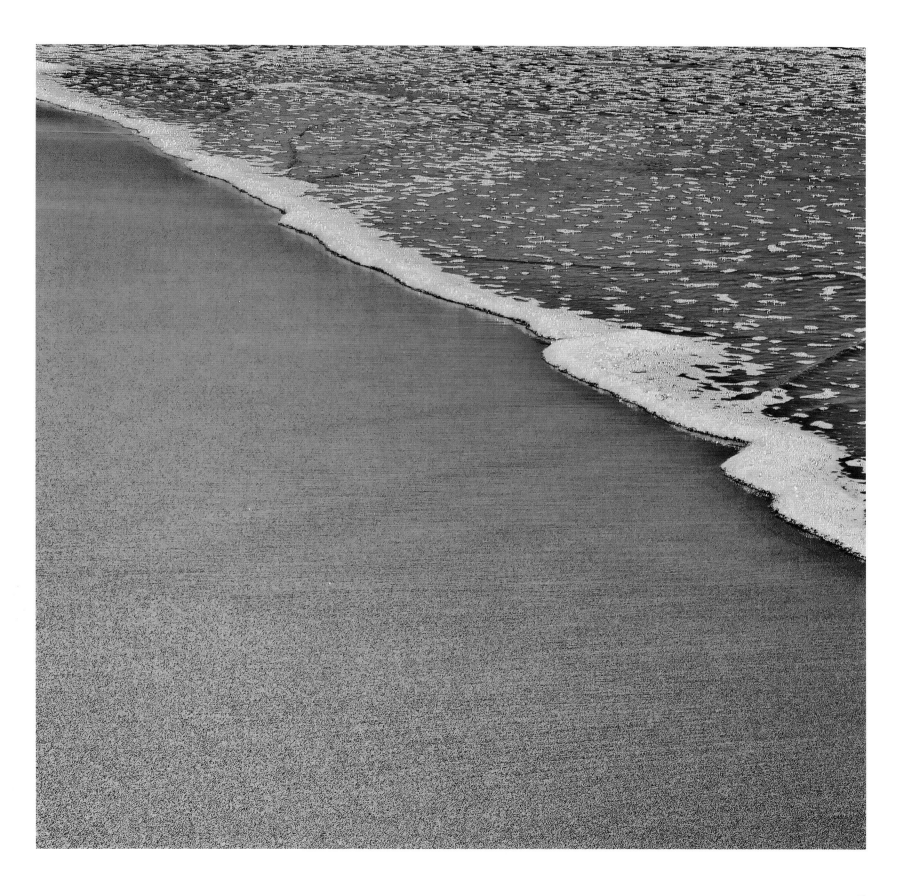

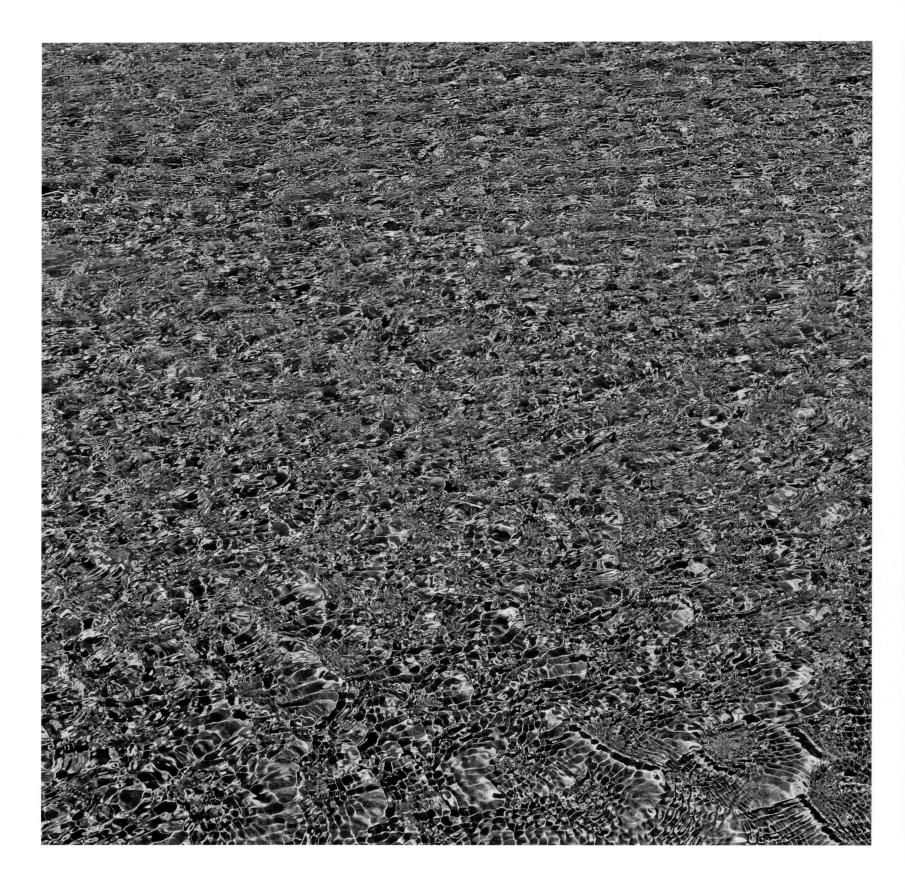

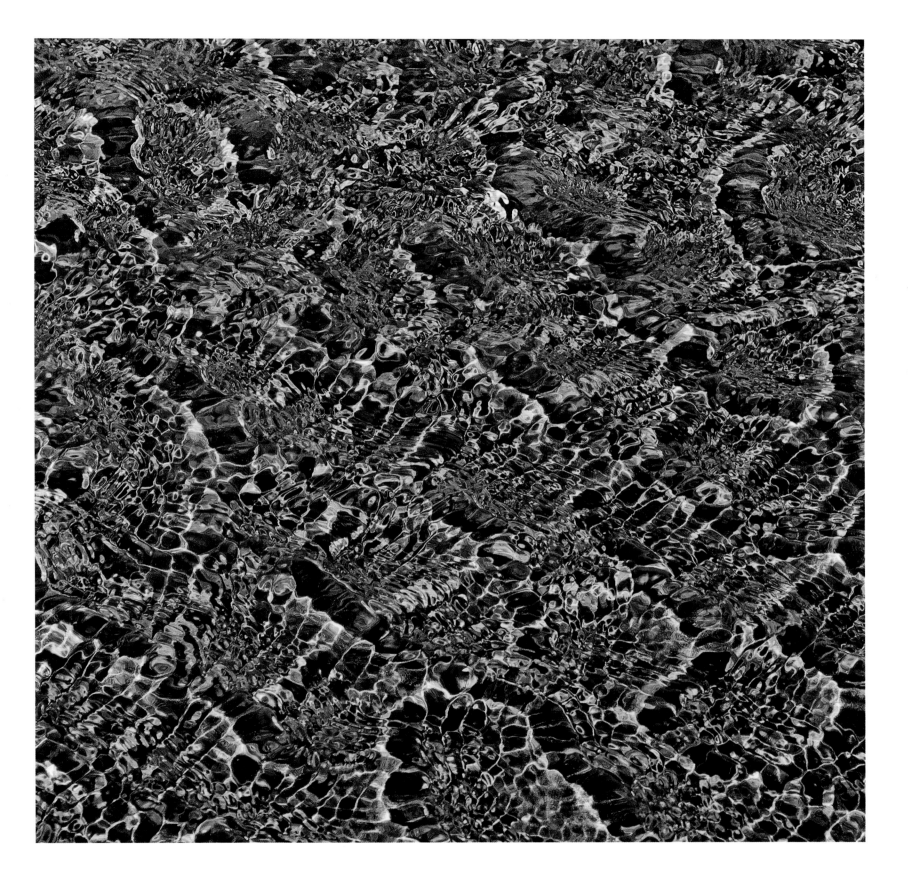

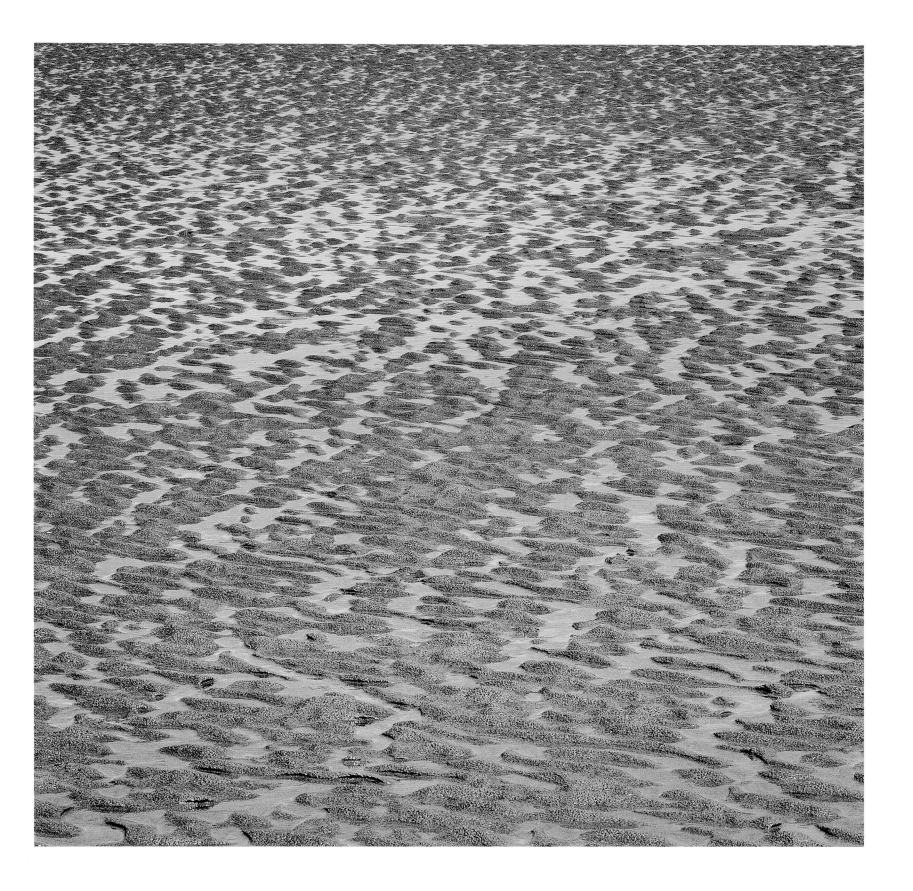

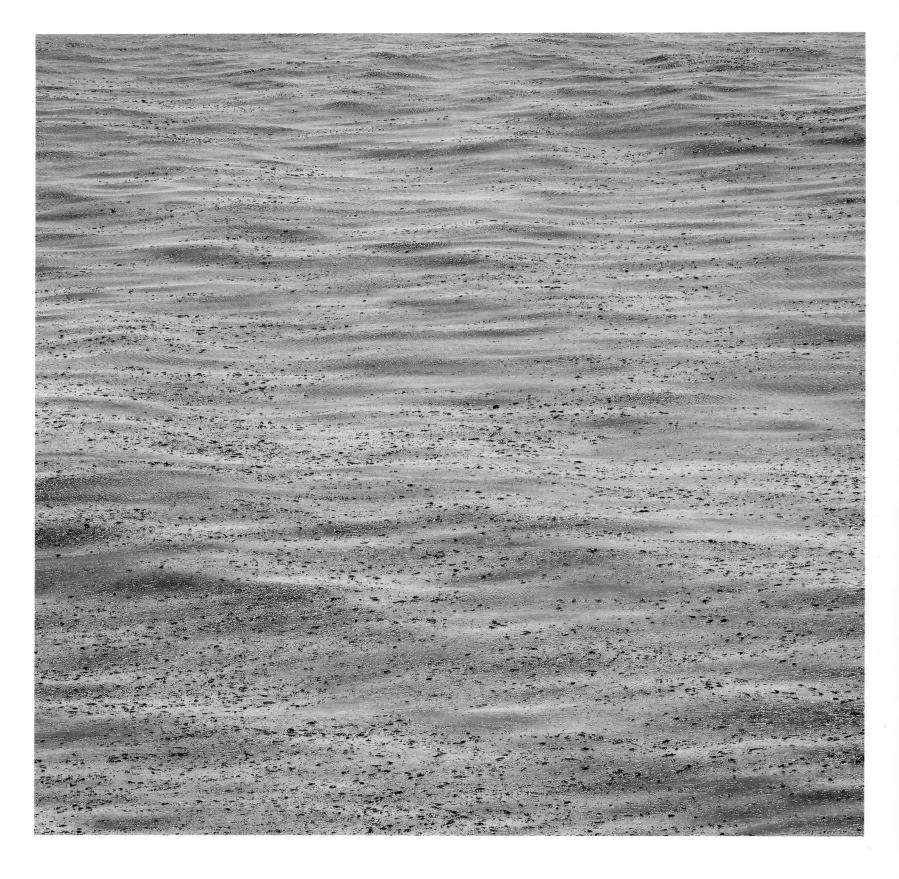

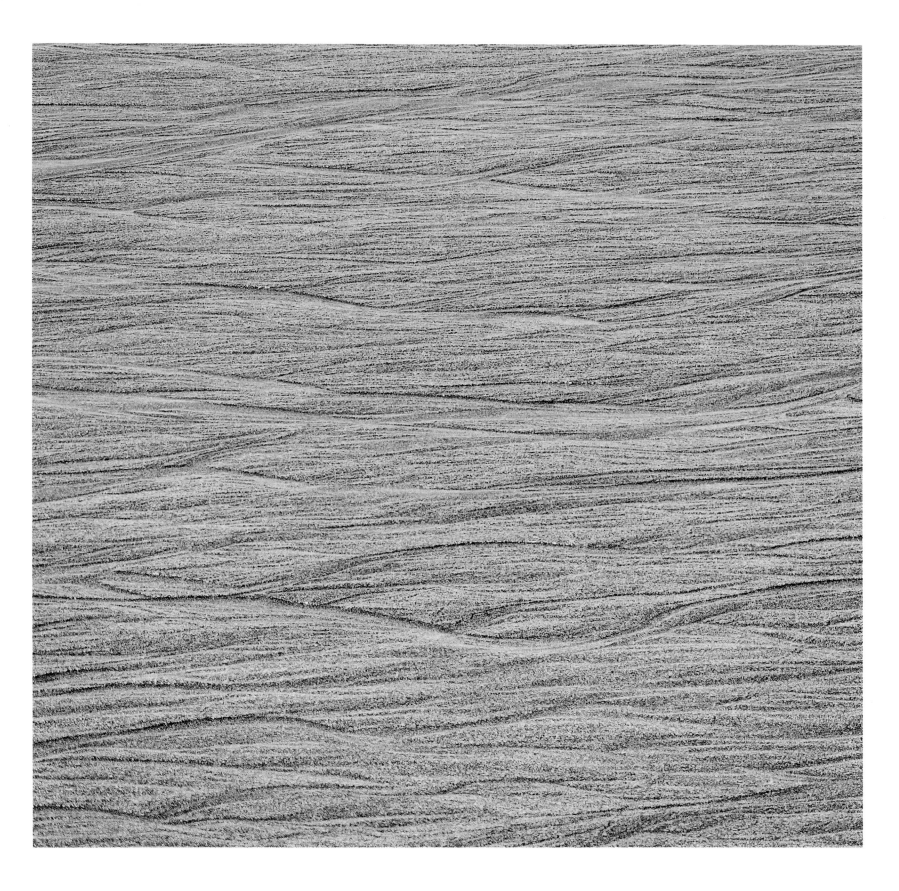

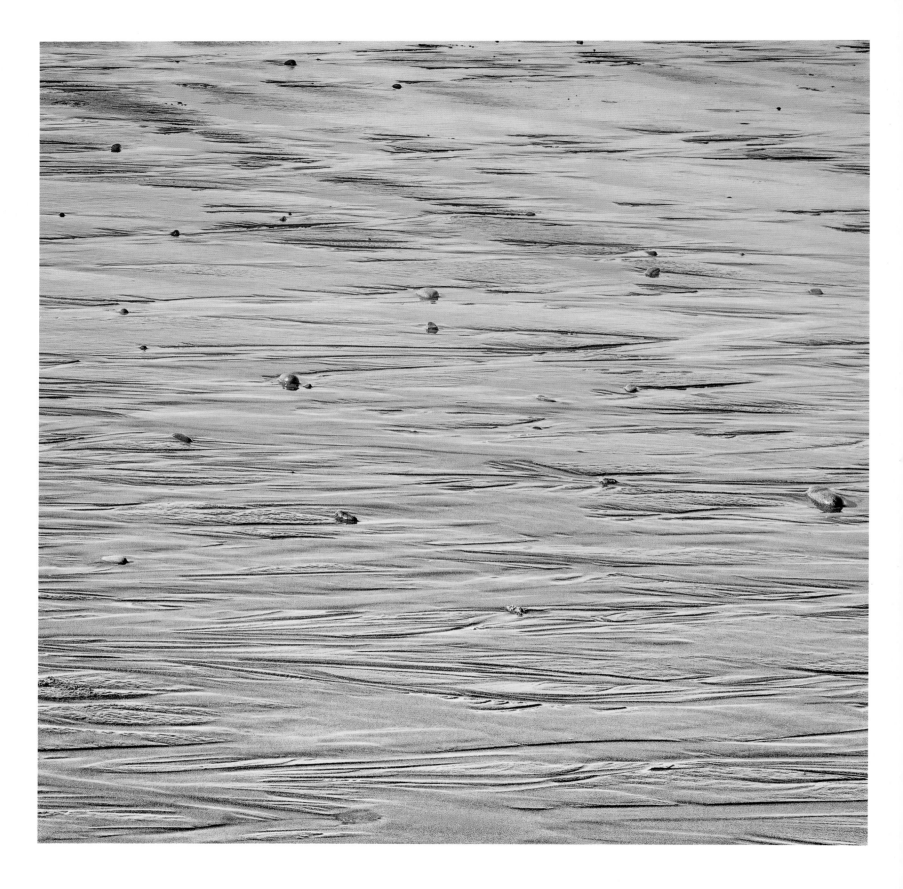

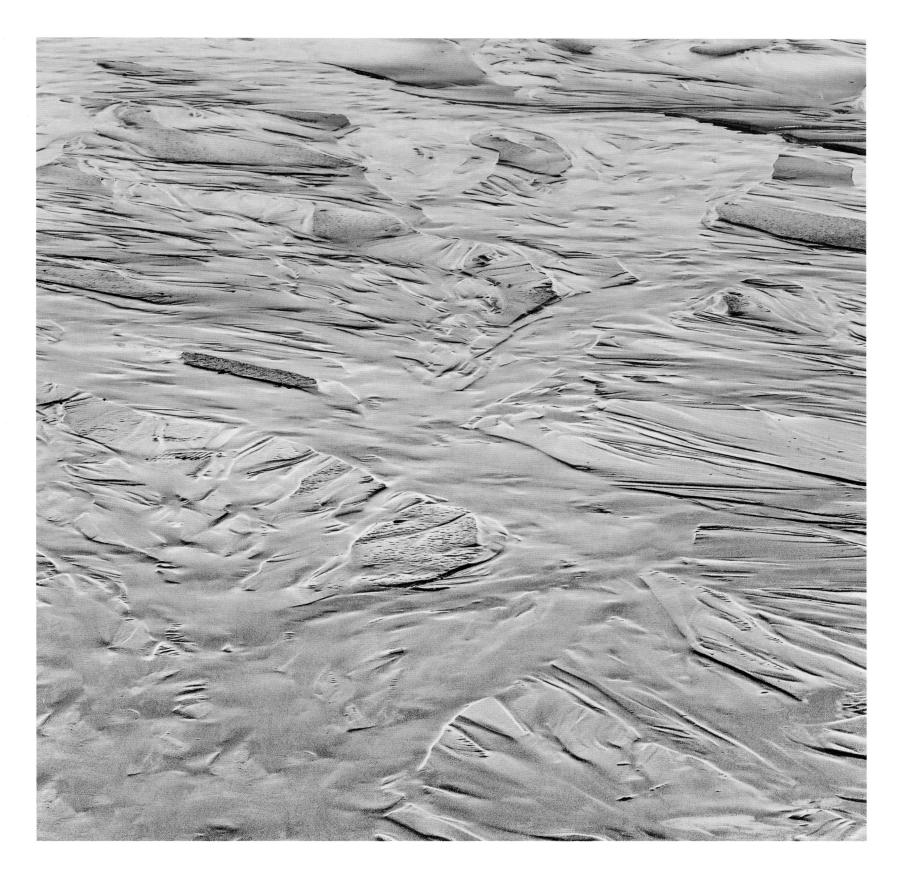

Sand: Pattern and Mutability

From miles away, sand looks still, un-urgent, the essence of a Zen dry garden, the monk withdrawn. Whatever rake he'd used to comb patterns in the sand is gone, too. What we look at is what remains: In this book, the aftermath of the photographer's contemplation, images help us see what's been composed.

"Composed," as in arranged. Or, as the monk might say, tempered, serene, meaning no attachments—let the thought go, let it go.

In a Zen dry garden, sand can symbolize white space in a poem or painting, emptiness. But, as Strom shows, in spite of the barren sweeps and apparent stillness, sand is anything but empty or motionless.

Like a grainy behemoth, it even "breathes." Incoming tides force air out of sand, replacing it with water; outgoing tides suck water out, allowing air to flow back in. The rhythmic exchange leaves evidence in the sand: pits and nail holes, tiny volcanic cones, blisters we can pop with a finger.

Can we, like William Blake, really see the world in a grain of sand? As the oneness of all creation and the absolute presence of the present is spiritually uplifting for some, for others Blake can be heard more literally: to see a grain of sand is to begin by asking, What, actually, is this? A grain of silica, limestone, sandstone? Derived from basalt, obsidian? And how did it get here? From what outcropping was it eroded? By wind or water? How long ago? And what will become of it? Will it be used for sandcastles or the manufacture of glass? Bricks or habitat for sand fleas and piss clams?

Such an inquiry into that grain of sand yields details about sandstone or wind erosion, which spin into whole histories of beach biology, geology, industry, and recreation. All those worlds yield thoughts about origins, deterioration, bonding and heat, and so all those ideas, too, are embedded in a single grain of sand.

There's nothing still about that kind of contemplative mind, either.

Or about sand as an incubator, a massive swaddle of larvae and eggs, a whole squirming cradle of the newly hatched.

Or about what goes on below.

To a mole crab, sand must seem like a three-dimensional maze, some passageways leading up toward sunlight and food, others aiming down toward deeper, cooler sand-below-sand. Hungry and clamorous, searching for sustenance and mates, the

mole crab scuttles through underground slivers of passageways opening and closing between and among the grains even as wind and water and the footsteps of people and gulls press from above.

It isn't alone. Within those ever-shifting passageways, millions of other tiny creatures scramble to get out of the way of tiny avalanches, to form new corridors, to keep the tunnels open to food sources and mates. They scale tiny granules, swing themselves along strings of grains, glide and undulate, sink hooked mouth-parts into bits of grit.

They flourish down there in their now-wet-now-dry world—those mole crabs and stumpy tardigrades, beach fleas, flapping rotifers, suction-toed creatures and the ones with moveable snouts—because sand does not cohere. Grains don't fuse; there's always a particle to catch, an in-between cranny through which to slip. Young sand—angular, unpolished—means more room in jagged corridors and low-ceilinged niches; but even older sand, nestling more closely, has plenty of interstitial space for the millions that flourish, invisible to human eye, below the surface.

Above, increasingly strong storms from a changing climate begin to ruffle the sand. Below, it's unlikely that any can foresee their tunnels becoming water-filled sluices that never dry out; more likely, they can sense something big is about to change their well-being, their home place.

Of course, changes of this nature have been happening for millennia. One force overcomes its opposite. Things adjust, find a new balance, settle down. If that monk were to return to the now-altered garden, swirl sand away from the stone, he might sit for hours in the all-too-accommodating silence.

But speed up the camera, see that same monk sprinting, the rake jittering in his blurred, moving-too-fast-to-see hands. The sand sprays, furrows empty; tiny ridges erupt, sand critters race up beach and down, try to grow bigger gills, smaller claws, stronger byssal threads. It's all frantic dash and lickety-split and happening in a second—geologically speaking—because the water's rising faster than anyone first predicted, hastening coastal erosion, squeezing beaches between higher sea levels and humans' approach from inland. Storms, too, ravage not just by wave action, but by increased sediment washed into rivers, which dump their load as they enter the ocean, fouling the sandy edges.

The sand itself has also begun to warm. For embryonic creatures whose genders are affected by incubator temperatures, this is not good news. Within those sand-nestled clutches of leatherback turtle eggs, females may soon wildly outnumber males.

Seventy percent of Earth's sandy beaches are now in retreat. Whatever design might have been in place for eons is being obliterated by literal stampede, the present anthropocene rushing headlong into the future, ready or not.

There might be no time to adapt. No time to re-balance. No time to cohere.

Let it be seems increasingly obscene

How disorienting, this wild repetition of particles piled into patterns. It's like a sculpting of opposites, their shadows blowing over and over toward no known place anywhere.

What did the poet Valery once claim? "It is the nature of intelligence to do away with the infinite and to abolish repetition." To which Strom's images suggest it is the nature of the artist to do the opposite: to keep expanding the perspective until repetitions are made so visible they can't be denied.

Still, the sand looks calm, brushed with quiet swirls of yellow and taupe.

Maybe someone—that imagined monk, perhaps—practicing detachment might embrace Ivan Klima's definition of tedium as "time filled with encounters that leave no mark on us."

Or maybe what we're talking about here is vacuity: a state filled without heed for what marks we humans are leaving.

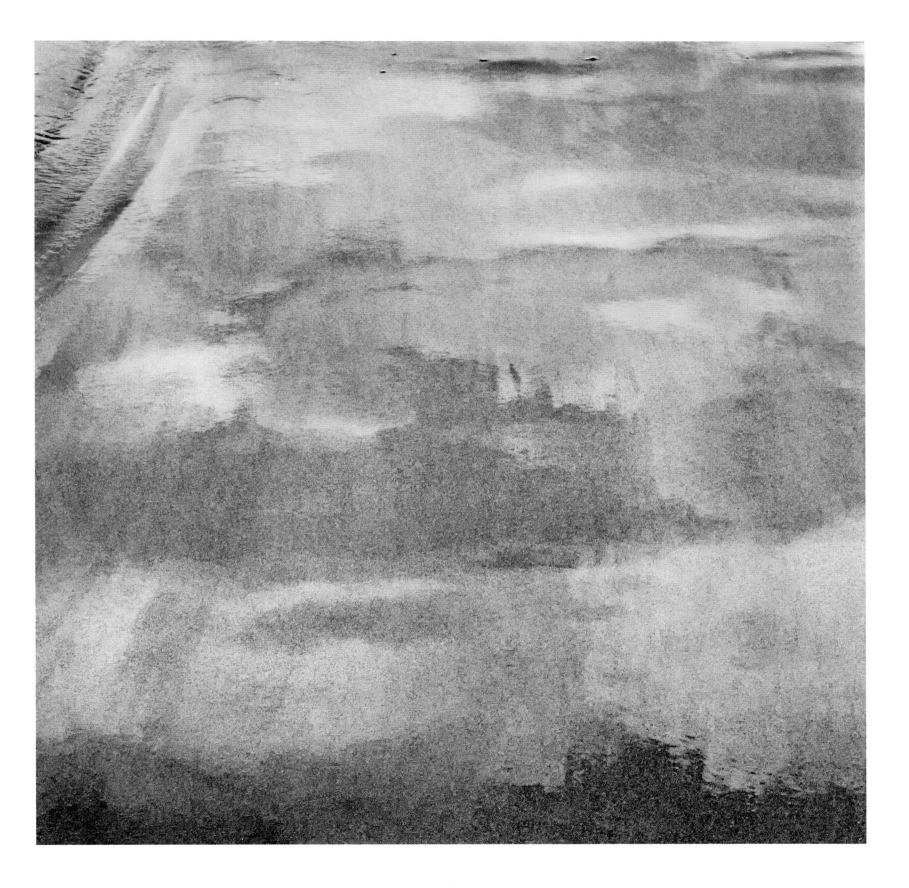

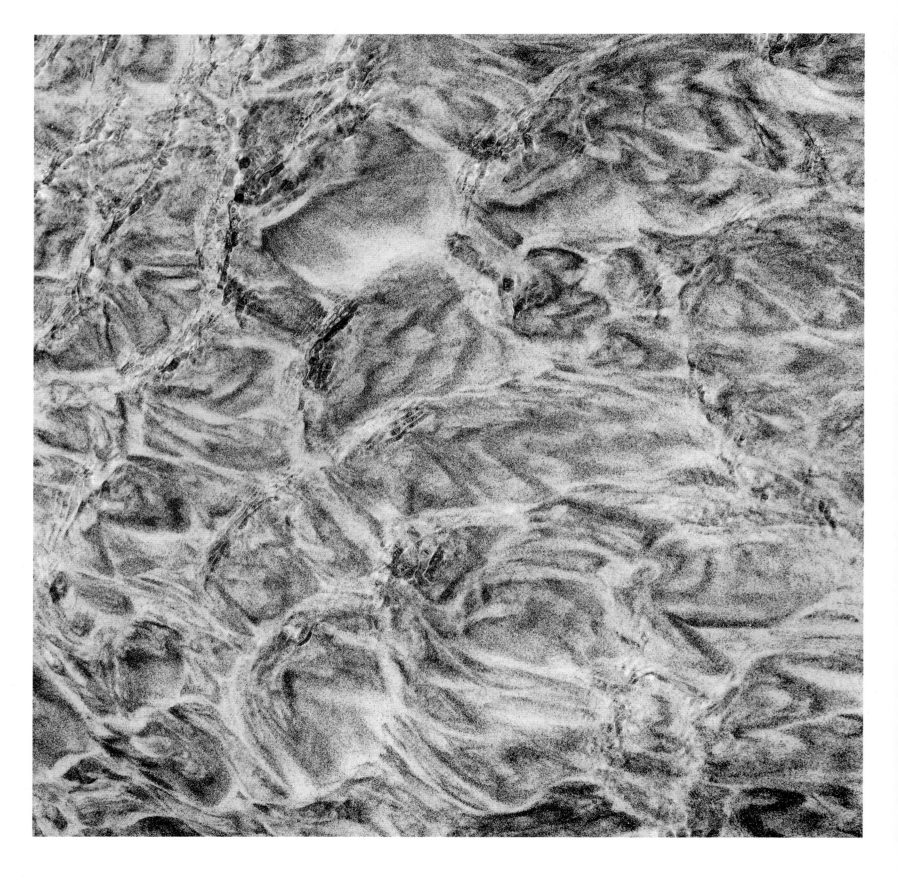

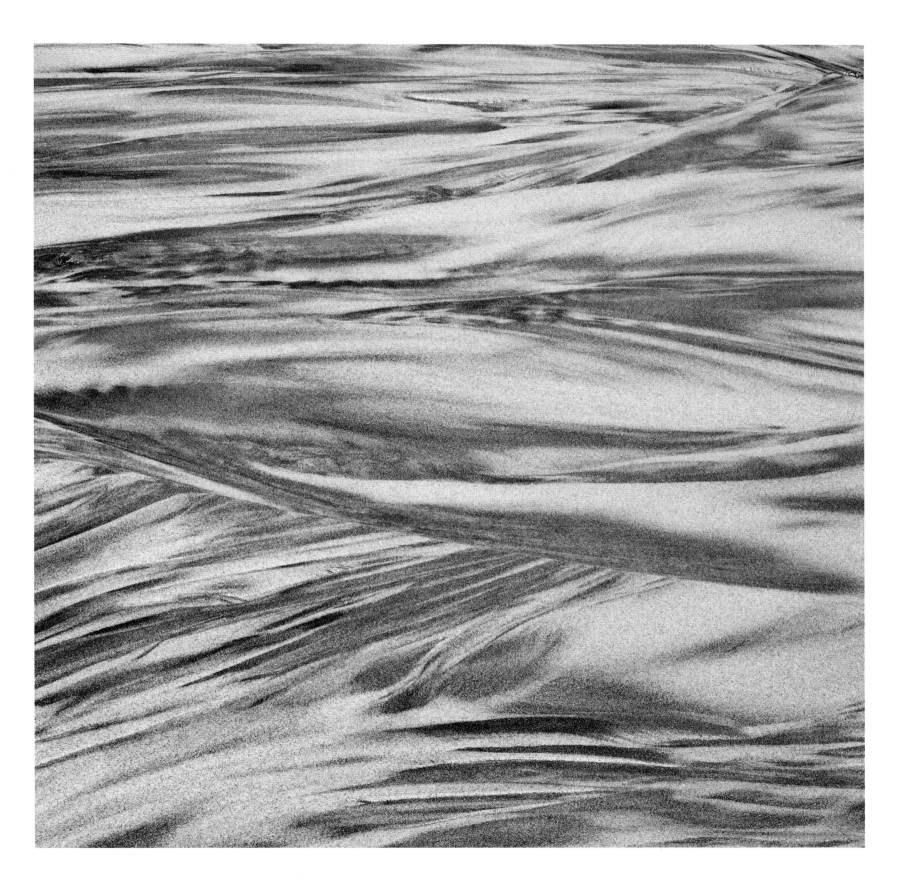

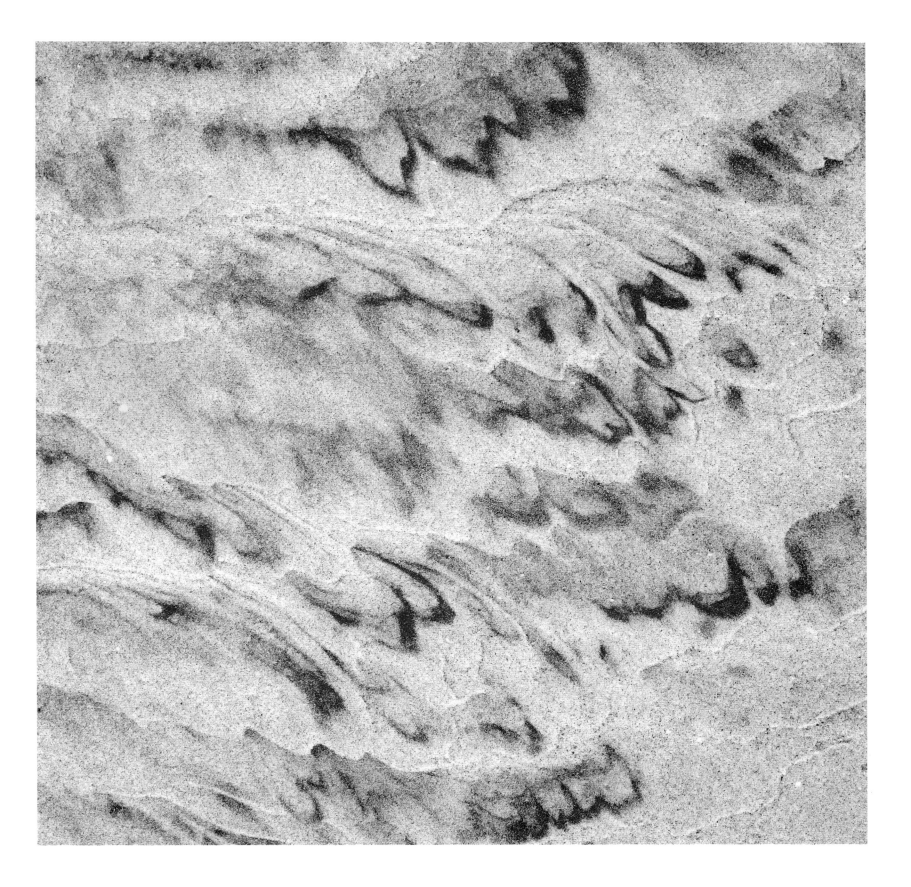

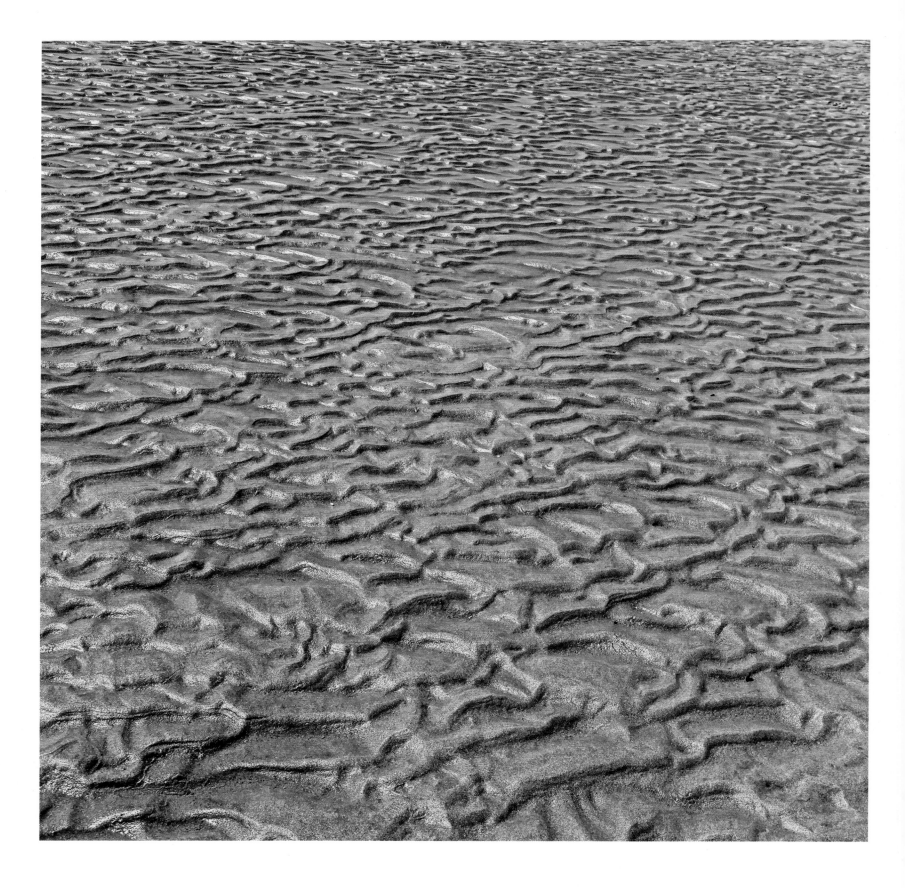

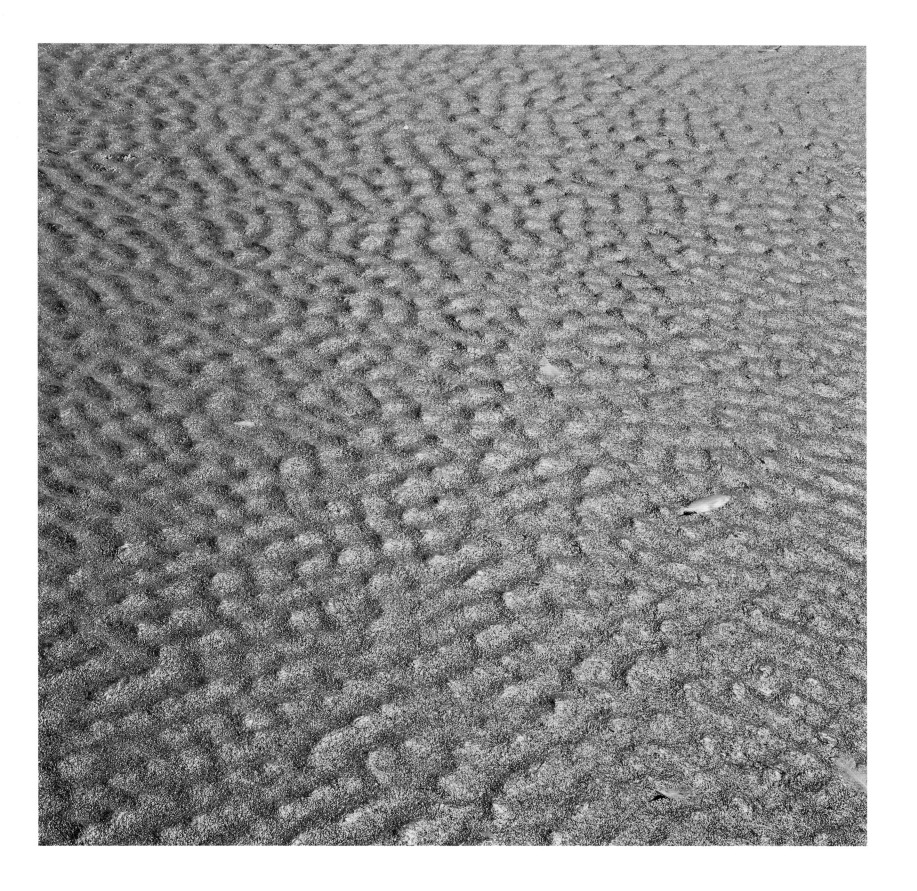

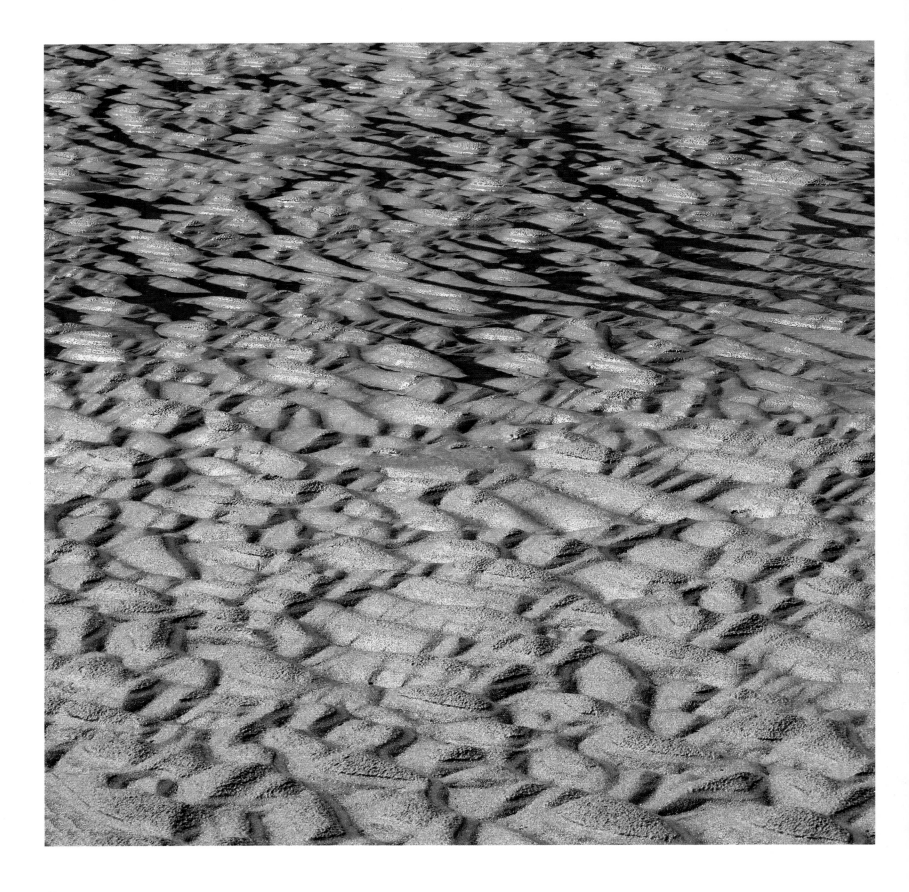

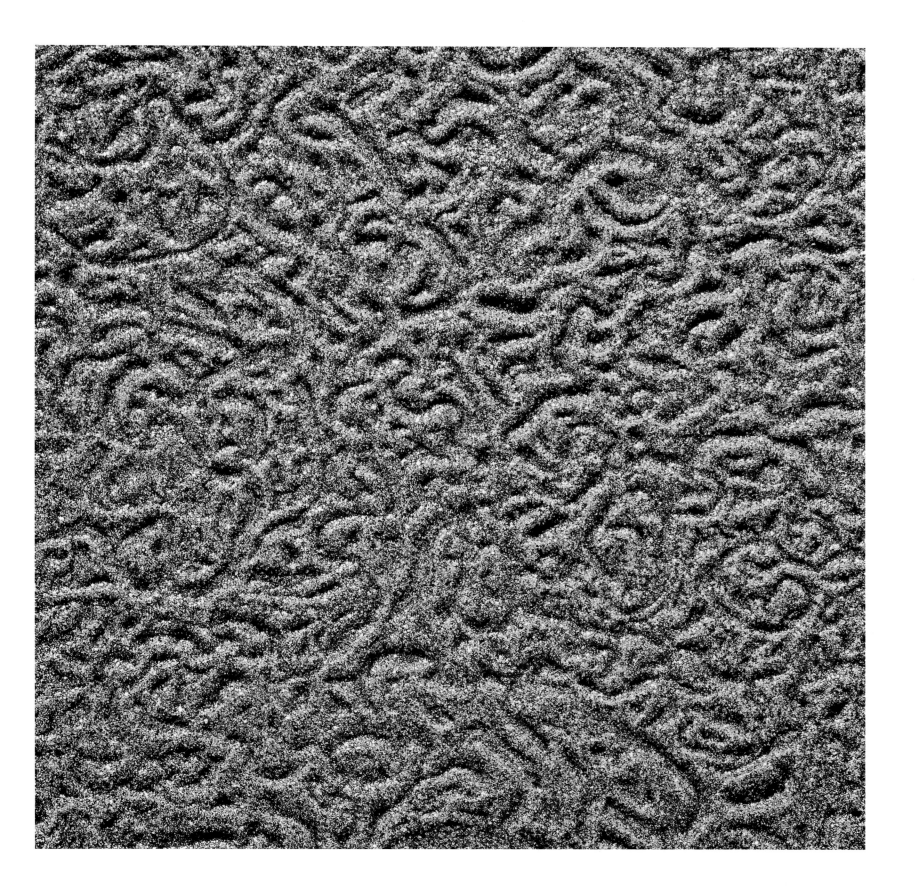

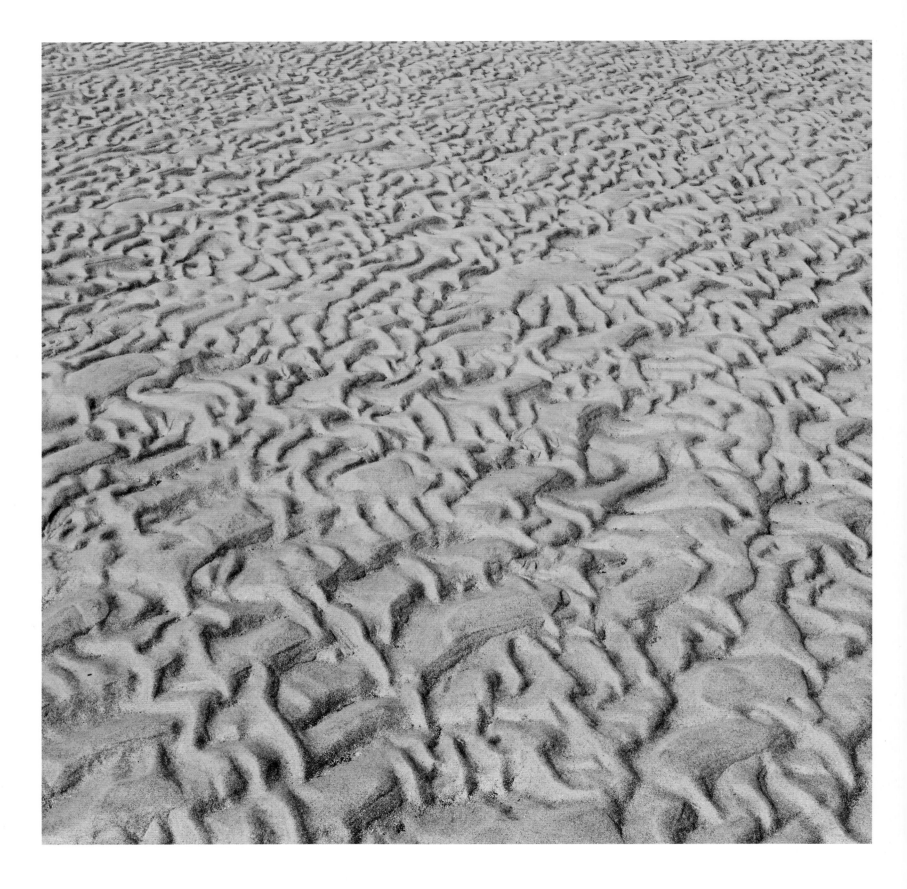

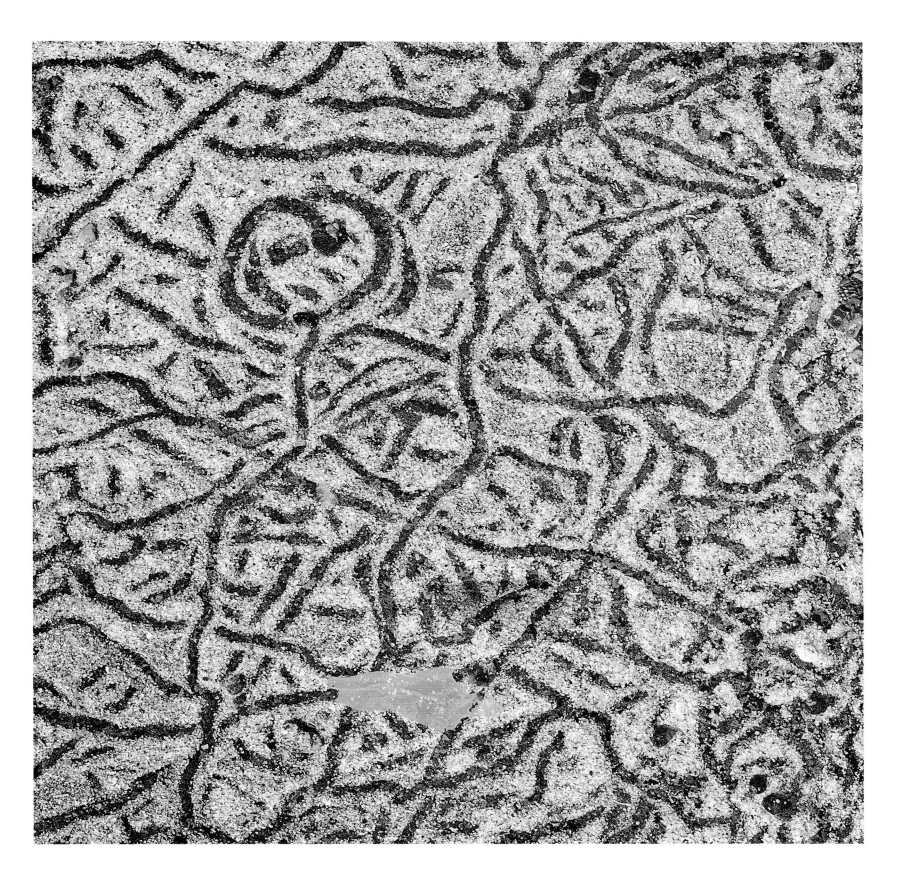

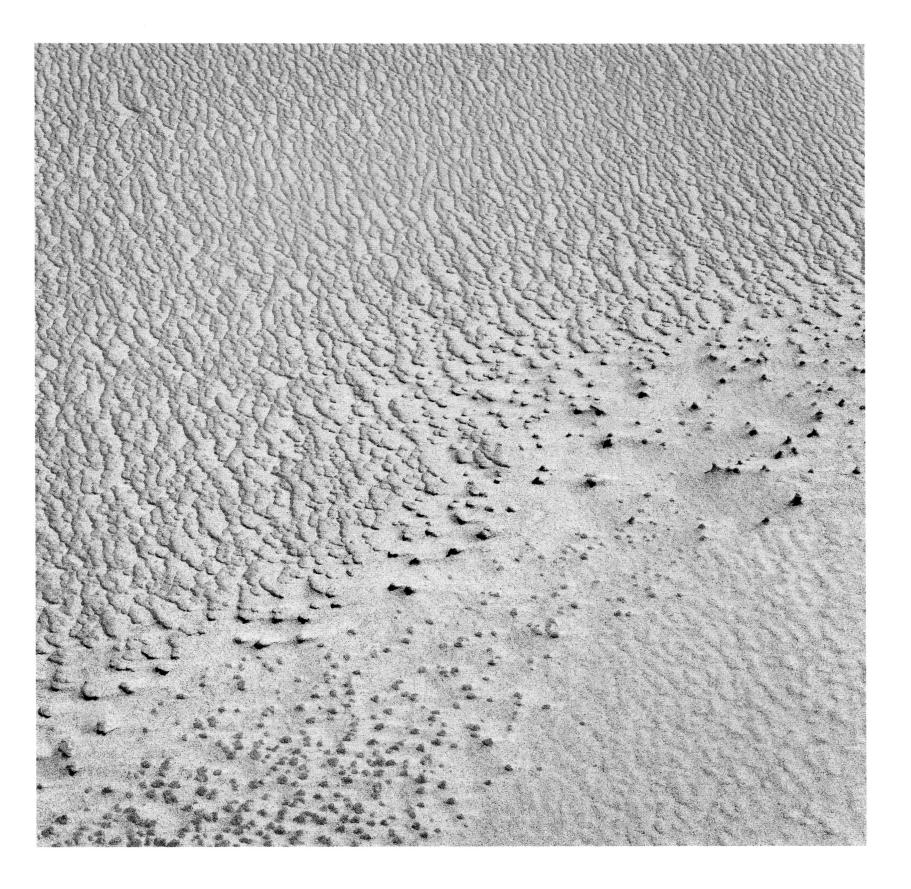

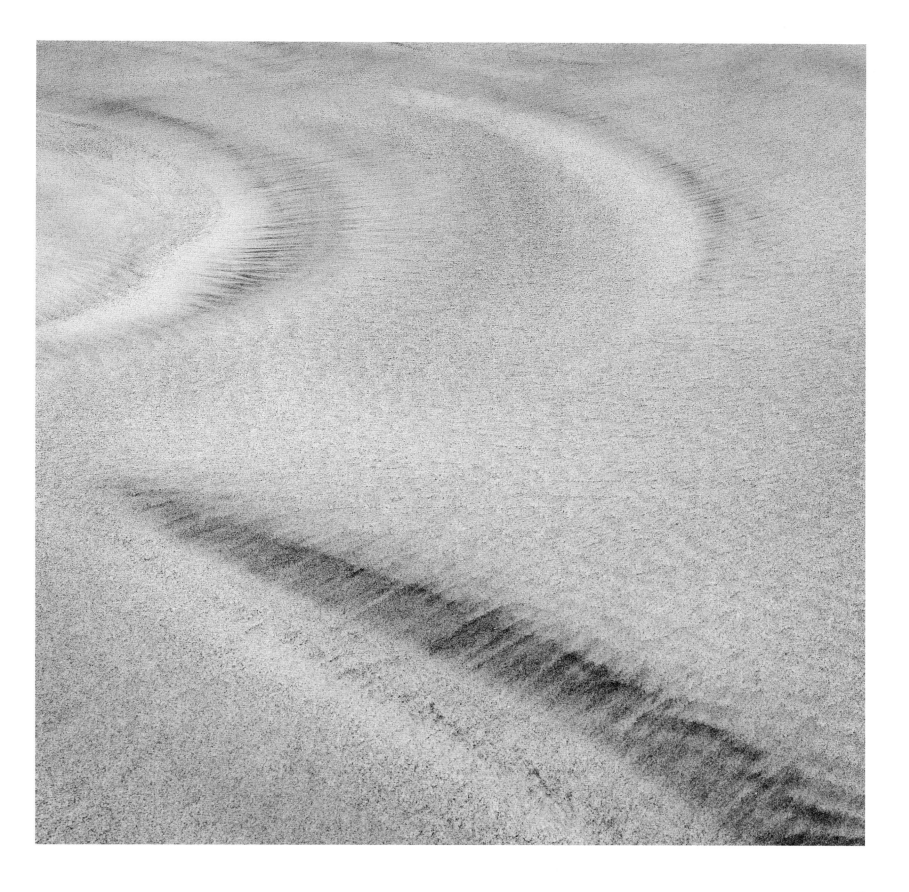

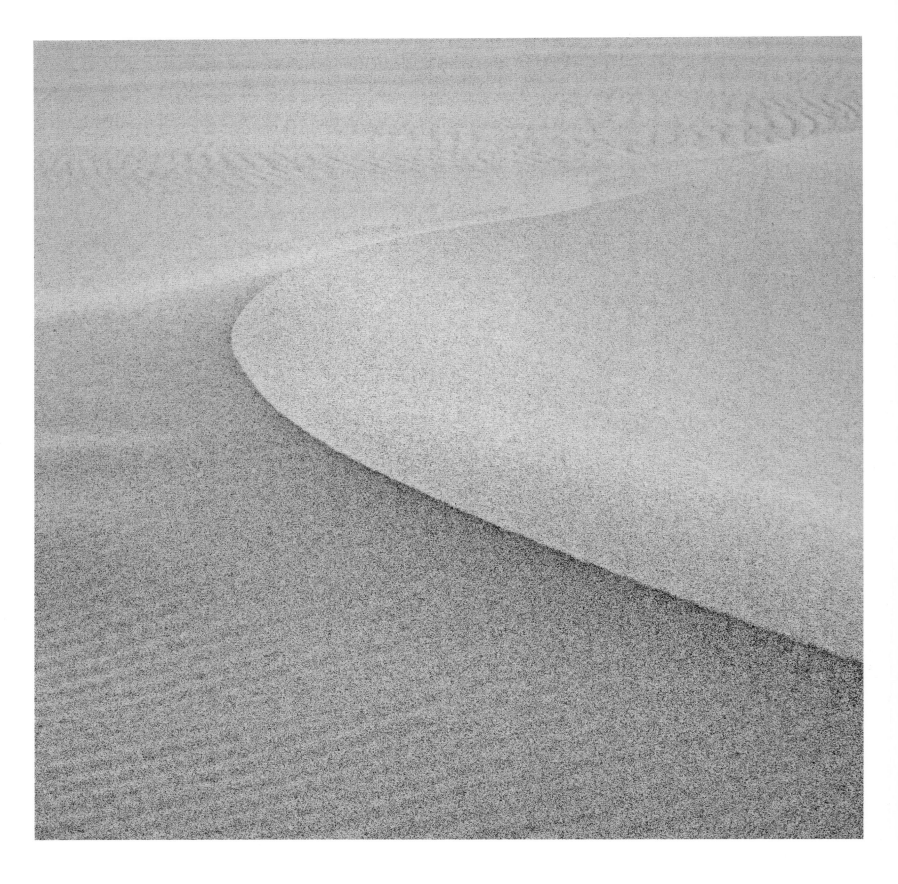

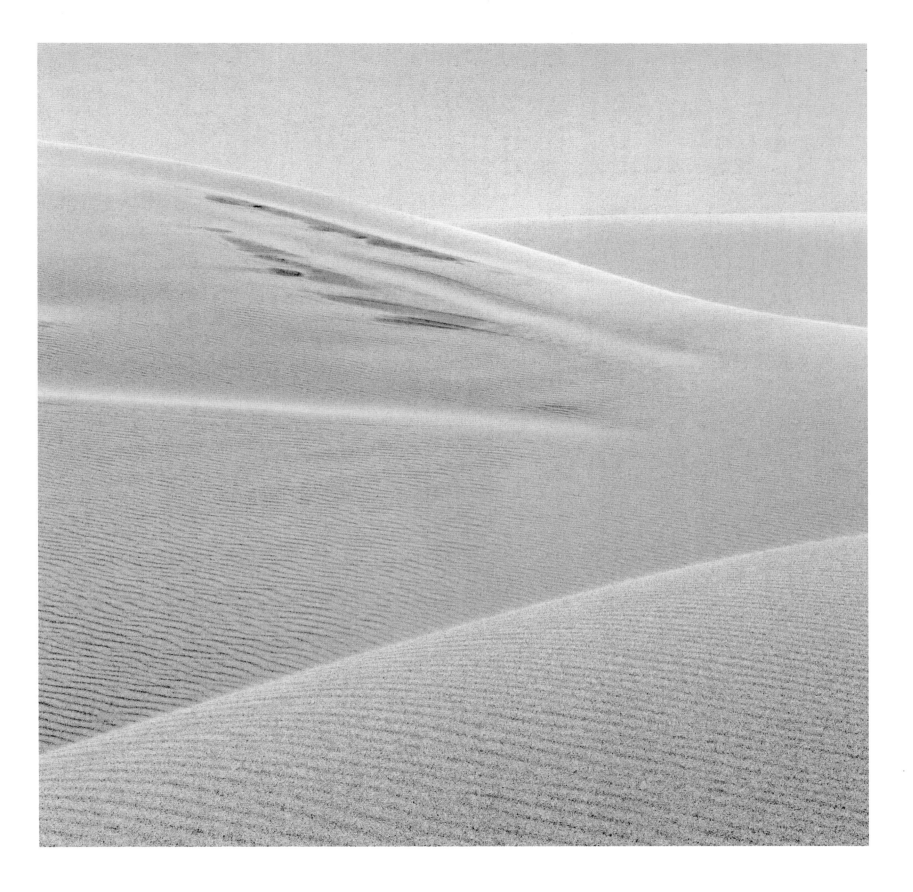

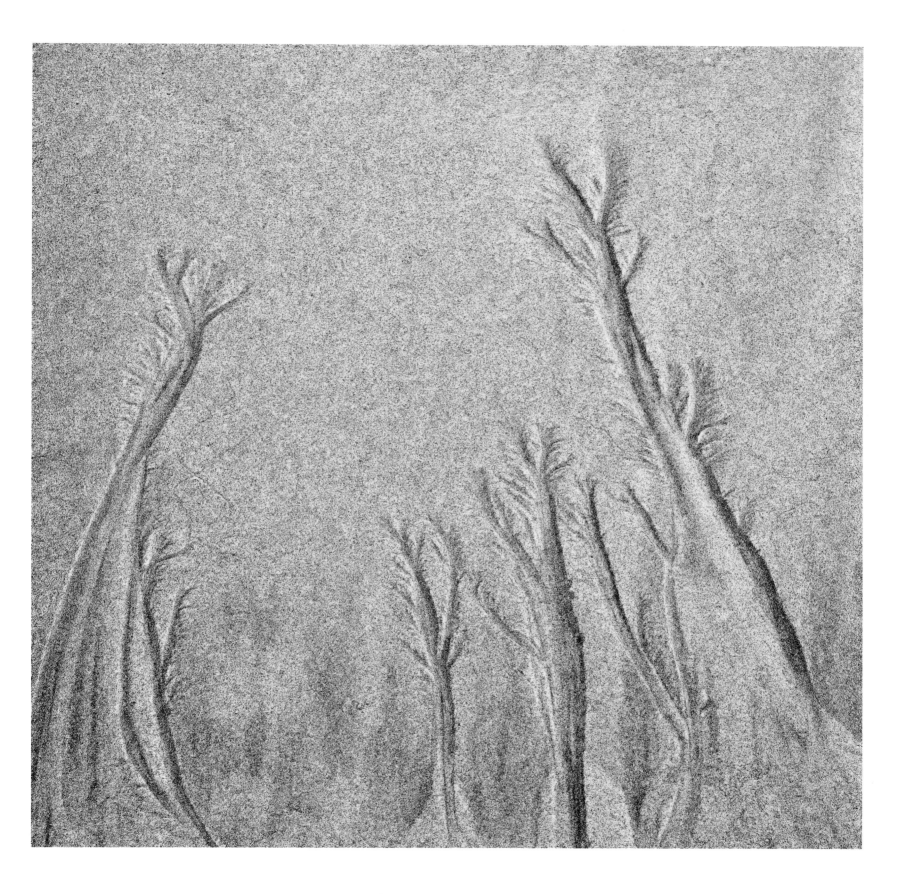

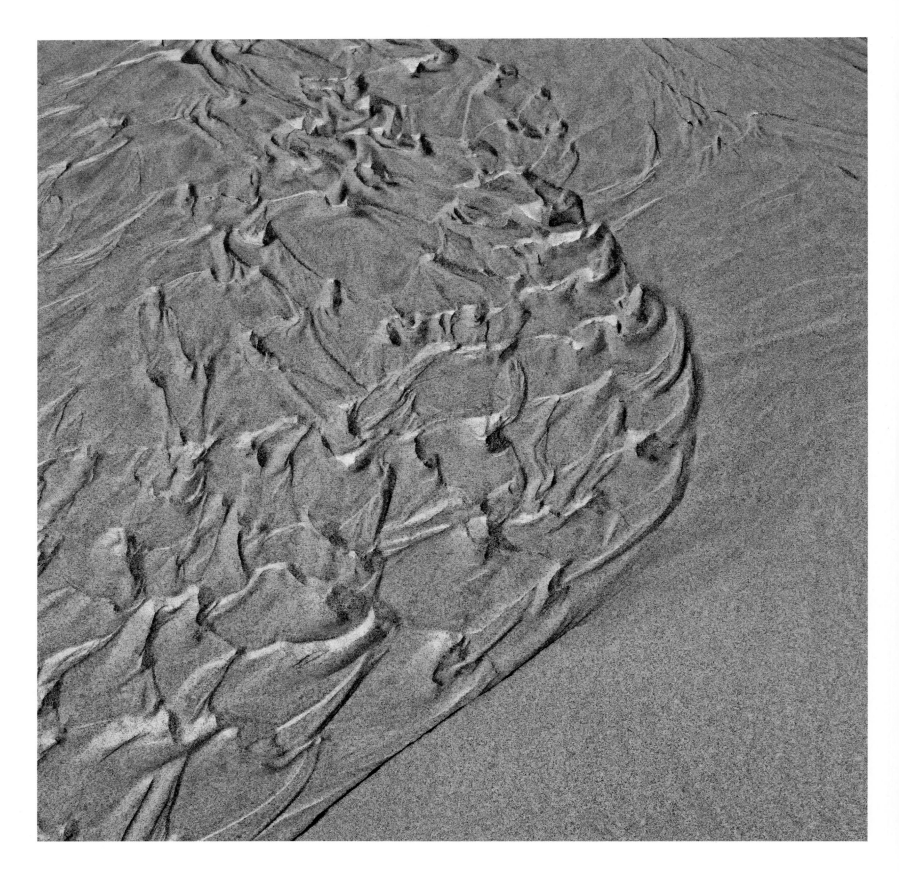

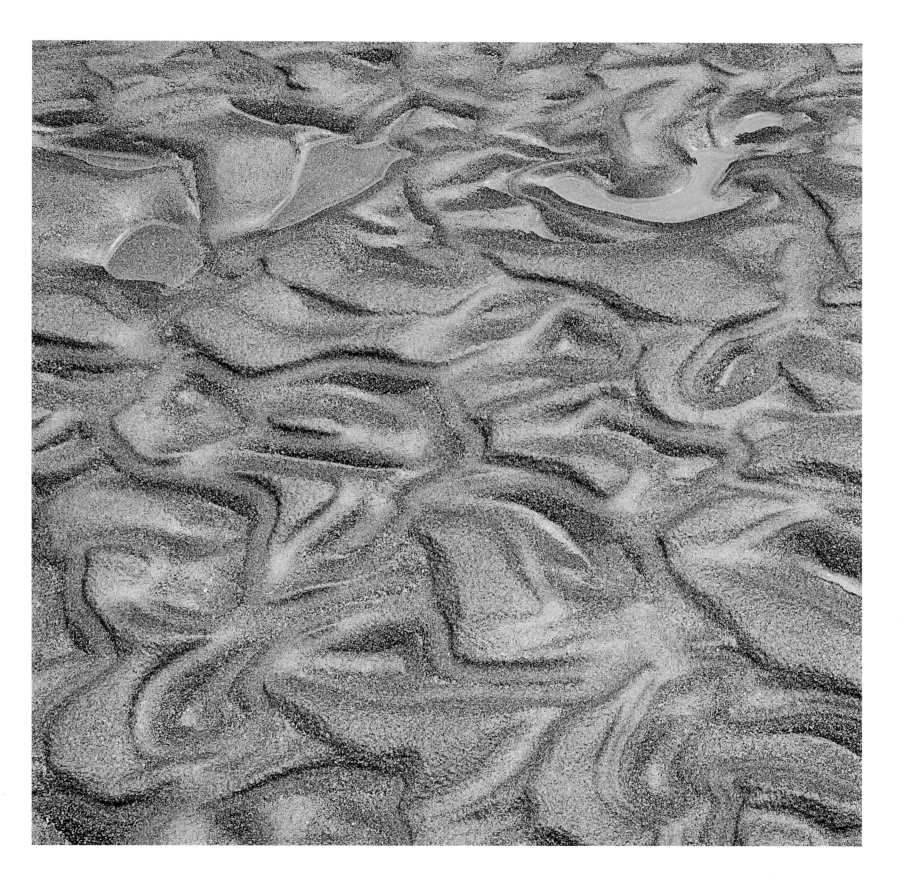

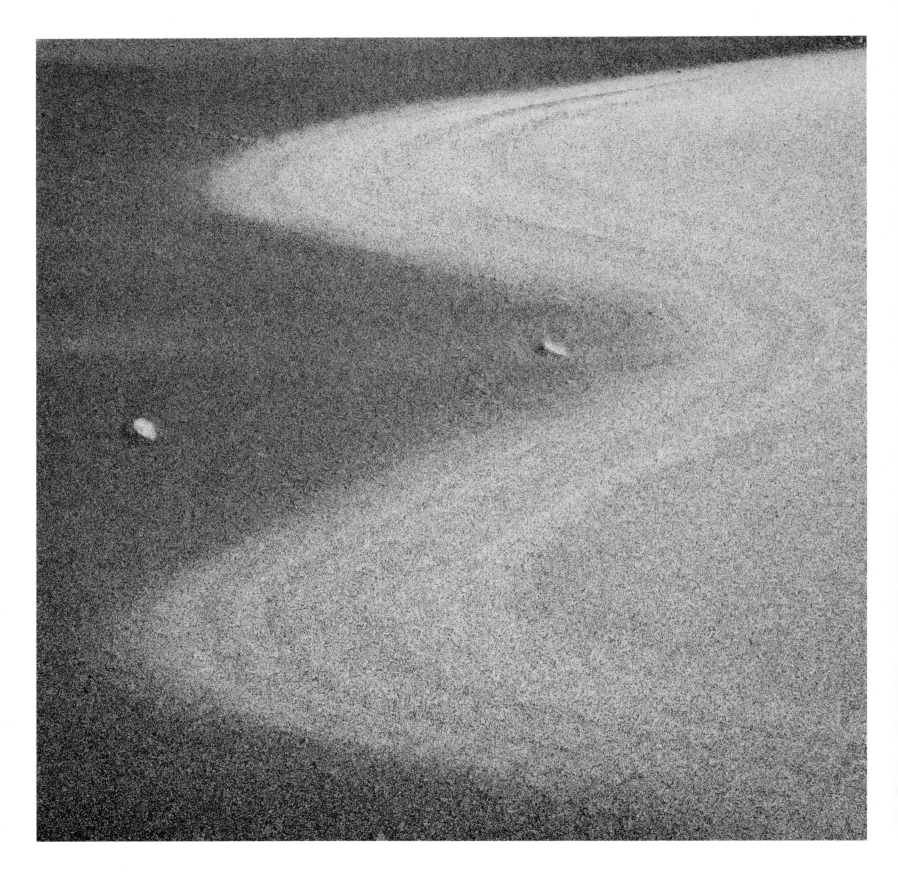

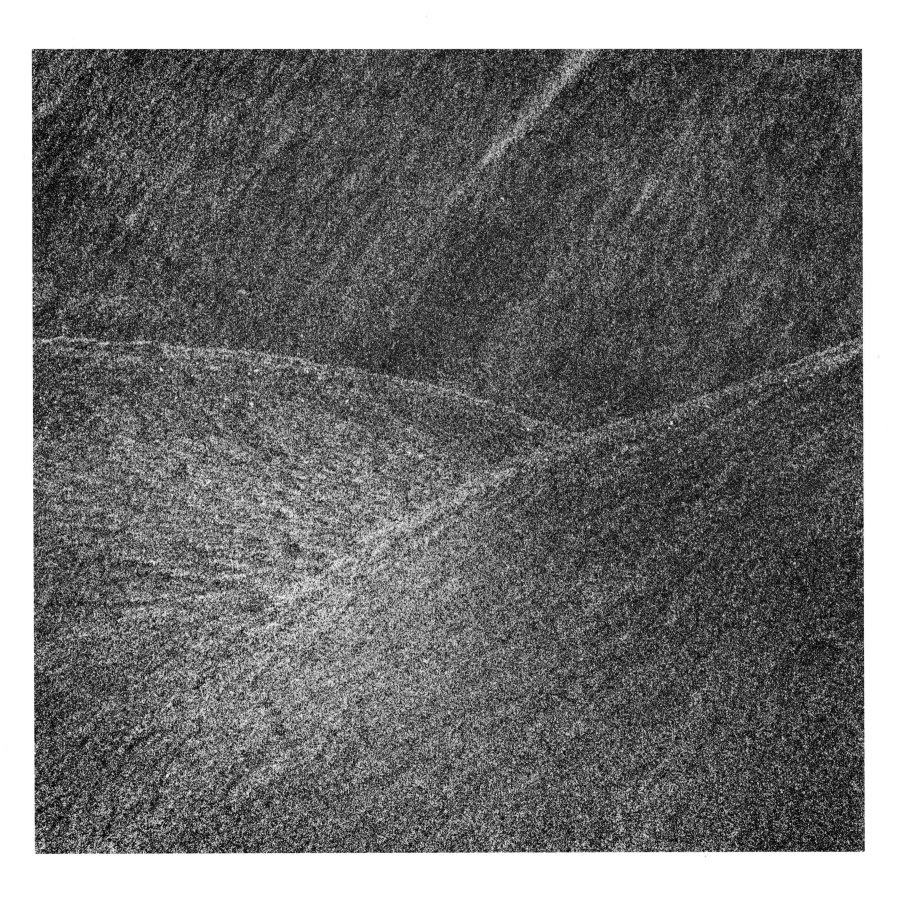

Flora: Underwater Forests

This is the twilight world of seaweed forests. Of waving fronds and canopies of kelp, draperies of bladderwrack, carpets of encrusting algae, all soaked or set to swaying by tide, wave, and ocean current.

Some float on the surface, their long strands dangling like untied ribbons into the watery forest below. Others rise from the ocean floor like cobras out of baskets.

Imagine a village in a jungle every bit as dense and green as those of tropical zones. And wetter, subject not to downpours but to tides whose rhythmic advance and withdrawal keep the canopies swaying, the food moving, the underwater forests teeming with birth and decay while who knows what more is brewing in that veiled, half-hidden world.

In description, there's delight in sound: spiny sour weed, sea potatoes and sausage, colander and horsetail kelp. And in metaphor: knotted wrack-forming beds of wet noodles.

For millions of years, seaweeds have formed these tangled habitats. Their watery-green, dim-lit havens just under the surface form the foundation of near-shore and tidal homes. Their proliferation helps filter light from above, prevents the kind of brightness that can damage tissue, subdues the rush of incoming tides, hosts the daily drama of hide and seek as thousands of invertebrates slink among stalks, slither under a wet mat of algae. In other words: Description helps to clarify function.

In the quieter slosh of outgoing tides, some beached seaweeds remain stranded in the wrack line. This, too, is part of their function. Losing more than eighty percent of their moisture, they lie there, parched, while sand fleas emerge from their burrows to infest and feast on debris.

And then the tide returns, reclaims the banquet, swirling around and under the weeds until they're drawn back into the sea where every clump becomes a harbor again for drifting larvae, a haven for fish, shelter for a scuttling crab.

Let's say such description—delightful as it can be—can also help substantiate a feeling, to make a free-floating wonder settle down, be tested by a focused attention to what's in front of us. Let's say, too, when it comes to that feeling and a focus on seaweed, that test must lead to something beyond marvel in underwater worlds. It must compel us to think about why any of this matters.

Imagine now slipping through the cracks in under-the-surface veils of flattened blades that divide and divide again. Here, where we can pretend to be knee-high to a

clump of towering rockweed, olive-green tinges to watery gold overhead. Trace the raised midribs, finger the pairs of bladders, each filled with a mixture of gasses that work like small floats, keeping the fronds upright in the water, the better to soak up sunlight. Competition for semi-lit sun space is fierce. The higher their reach, the more likely they'll flourish.

If we were to keep going, slide our fingers down the stipes, we'd find the hold-fasts, small disc-like apparatuses fastened to pebbles and small stones. No stately pleasure-domes, they're tiny, inverted cups of tangled root and rock, and the stony substrate is studded with them. They keep the seaweed attached and serve as hide-outs for millions of invertebrates scurrying out of a predator's reach.

Perhaps the payoff of description has nothing to do with substantiating any feeling, and perhaps test—with all its implications of assessment, even right and wrong—is not the best word for getting at what matters. Here, where the mind is en-livened by multiplying images and layers of analogies, maybe challenge is the better word for what we need to rise to: How to evoke an underwater world? More crucially: How to simultaneously observe and inhabit flux?

As oceans warm, some seaweeds thrive, others don't. Some kelp like it hot, some don't. There is no clear good or bad to these shifts in populations; things change; they'll go on changing.

Already some seaweed forests have begun to drift poleward, taking with them the fish, mollusks, countless invertebrates that hide and dwell among them. But for species unable to release their holdfasts and, therefore, doomed to stay in one place, it's a different story.

Imagine the approach of an underwater heat-wave carried by currents begin-ning to slosh among the beds of seaweed. Imagine the new warmth bathing delicate stalks. This is no luxurious, spa-like treatment. Rising temperatures can stress a plant and cause cellular damage, triggering a reallocation of its resources.

Forced to "choose," some plants will try to repair their damaged cells before they grow bigger or reproduce. If the damage is severe enough, seaweeds will grow listless, be less able to resist the onslaught of pathogens that act like underwater flames thinning out the forests. Diseased—bleached—the seaweeds will grow thin and sparse, allowing more sunlight to penetrate Earth's shallow waters, illuminating the underwater jungles and their myriad shelled, gelatinous, clawed, and tendrilled creatures, many of which need shadow and murk to grow.

More warmth stimulates more bacteria. And on and on it goes, the increased brightness and warmth undoing what has swayed mostly out of sight, quiescent and rich for millions of years.

Among all the experiments and slow adaptations, what remains is the ruthless drive to survive. Acclimating takes energy. So do adapting and moving. The effects of ensuing re-arrangements will cascade throughout the webs of communities both off-shore and inland. In the mind, too. And that reality, perhaps, will trigger real and game-changing challenges: Among the shifting images and changing communities, can we see ourselves as creatures in flux, too? That is, can we imagine less destructive ways of living?

Meanwhile, at some point, those heat-fleeing seaweeds, like those in Australia, will find themselves stranded at the southern edge of the continent, beyond which there's no place to go. No final frontier in which to adapt and survive.

Draped over rocks like some plumy adornment, feather boa kelp is studded with limpets that can live only on it and nowhere else. They use their teeth-like radula to excavate depressions in the plant's main stalk, where they snuggle in, protected, and graze on the kelp's delicate tissue.

If this were a parable, the message would be something obvious about not destroying the host that feeds you. But it's not. The limpets do, in fact, often weaken the plant until its fronds break in the increasingly harsh storms, and the mollusk, now homeless, is in deep trouble.

The feather boa's scientific name is Egregia. At one point, it meant "remarkable."

The strands of surfgrass, pushed every which way by the tides as they come and go, seem beyond any sense of order. But wild as they look, surfgrasses—like all else in the natural world—have limits. They like their water cool. As water heats up, they die down and with them go the nurseries they harbor, the prey hide-outs and havens. Temperate turns tropical. For those that remain, heat stress ensues; then algae crusts develop bleached edges. Tide pools are altered.

Yet what appears untenable at the moment might be seeking new and subtle balances, especially if every act of creation, as Picasso claims, is first an act of destruction. Or what appears untenable just might be untenable.

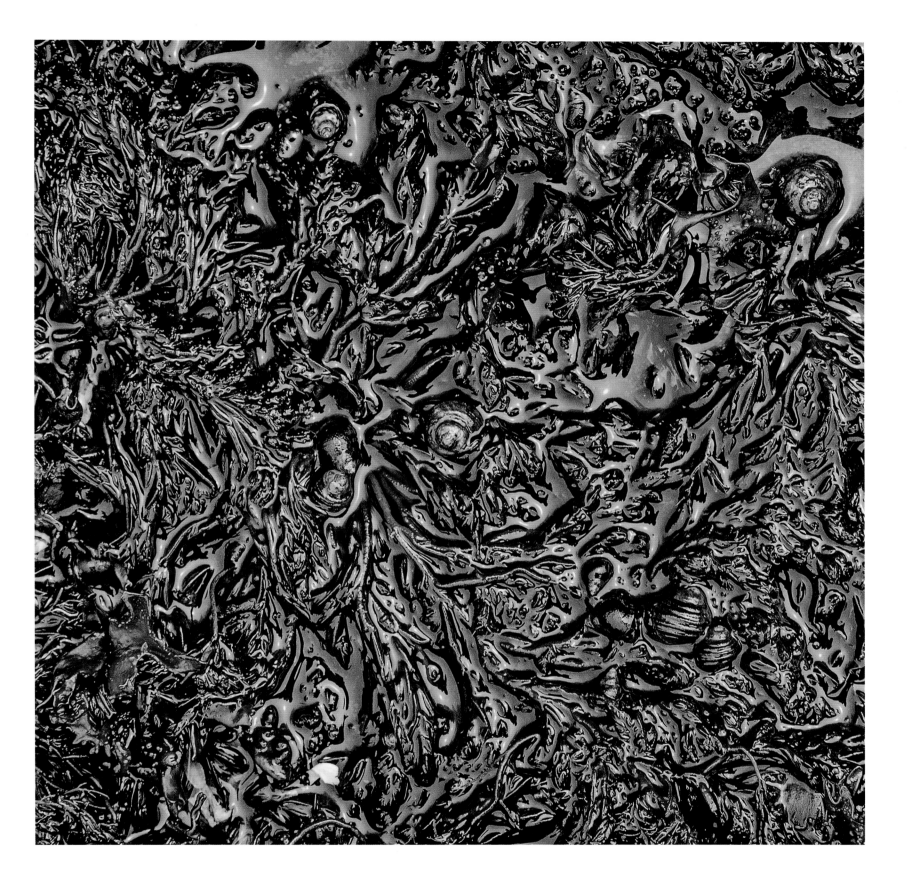

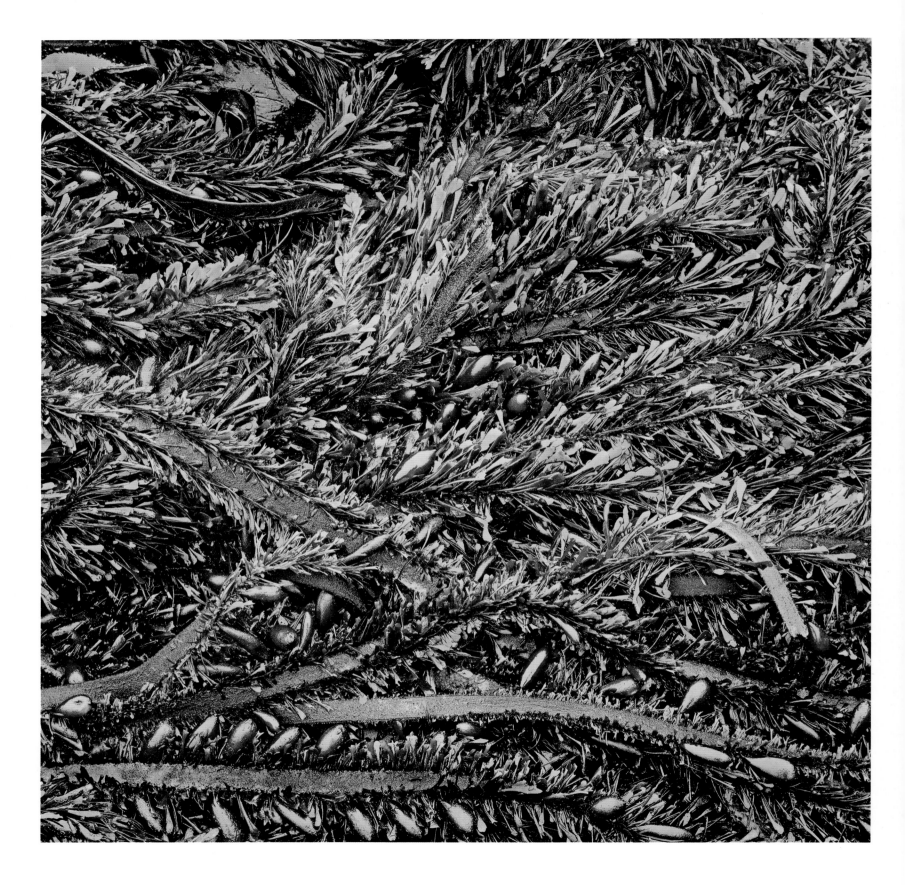

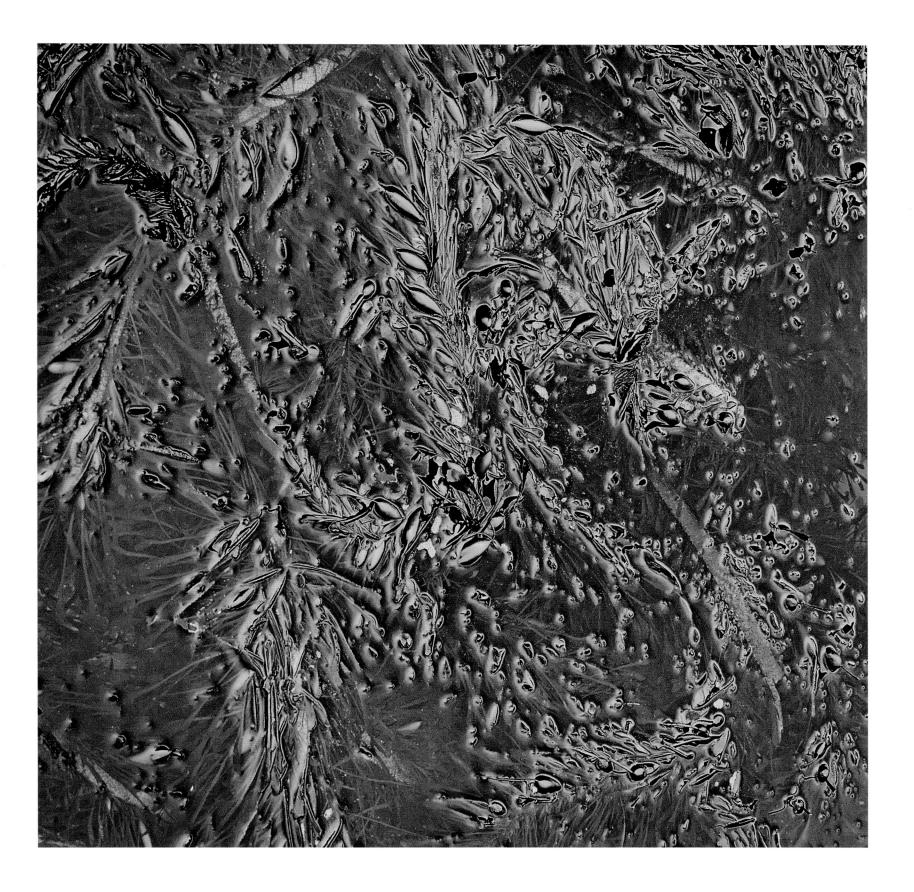

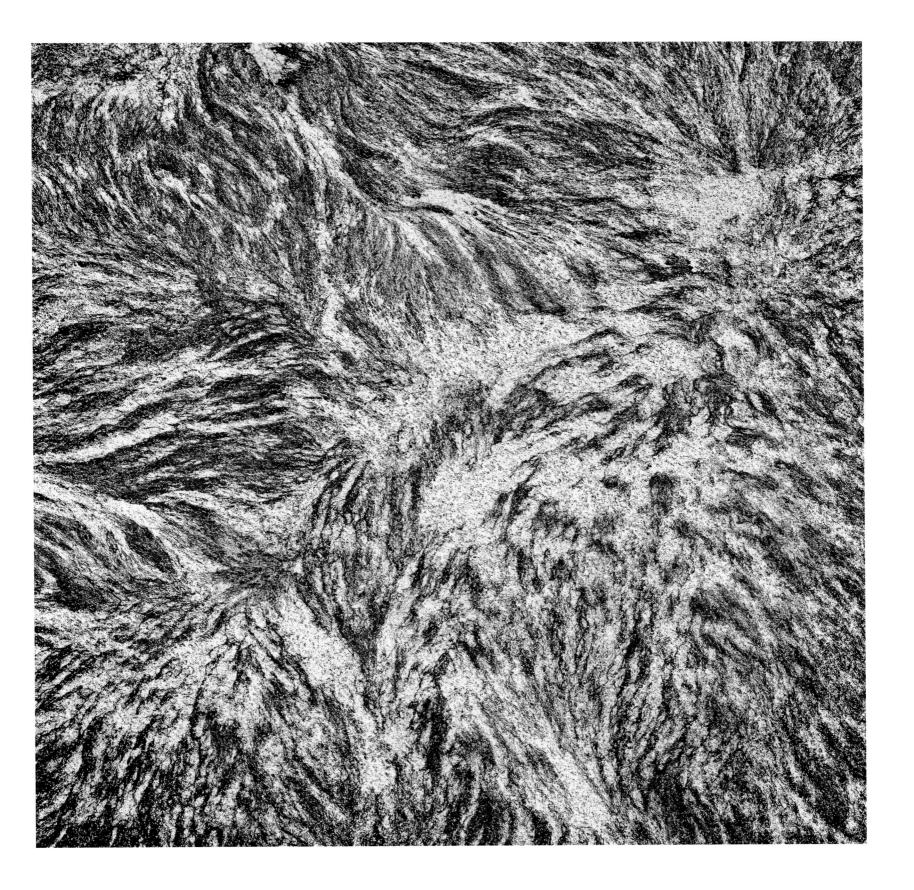

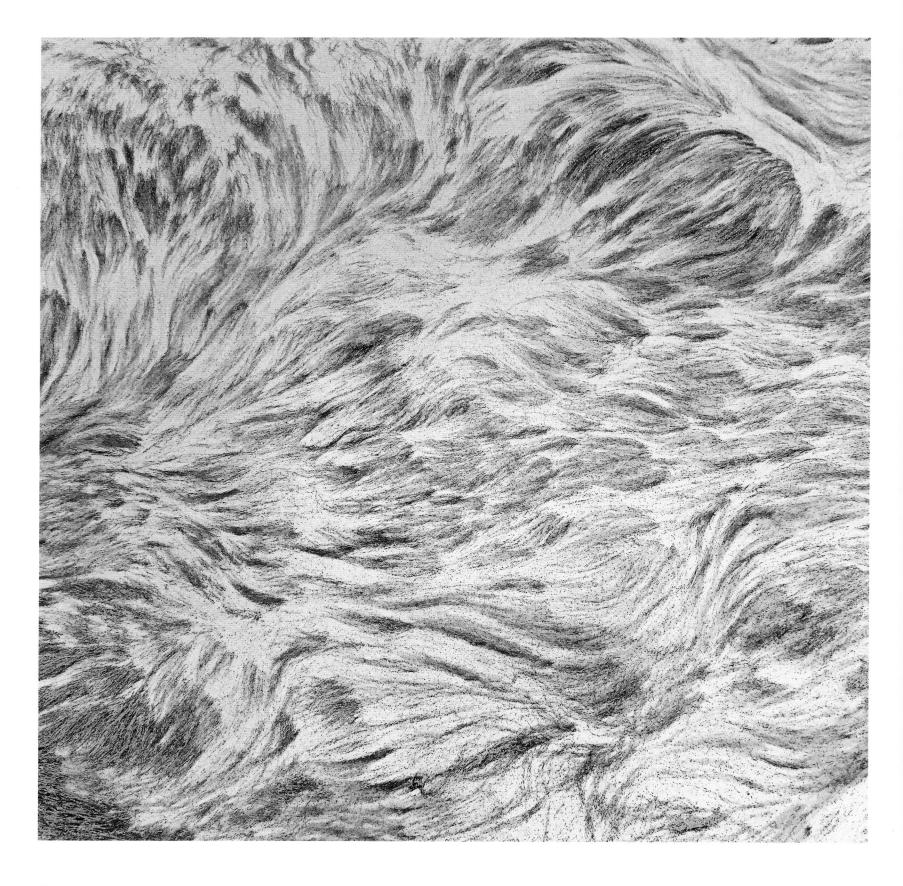

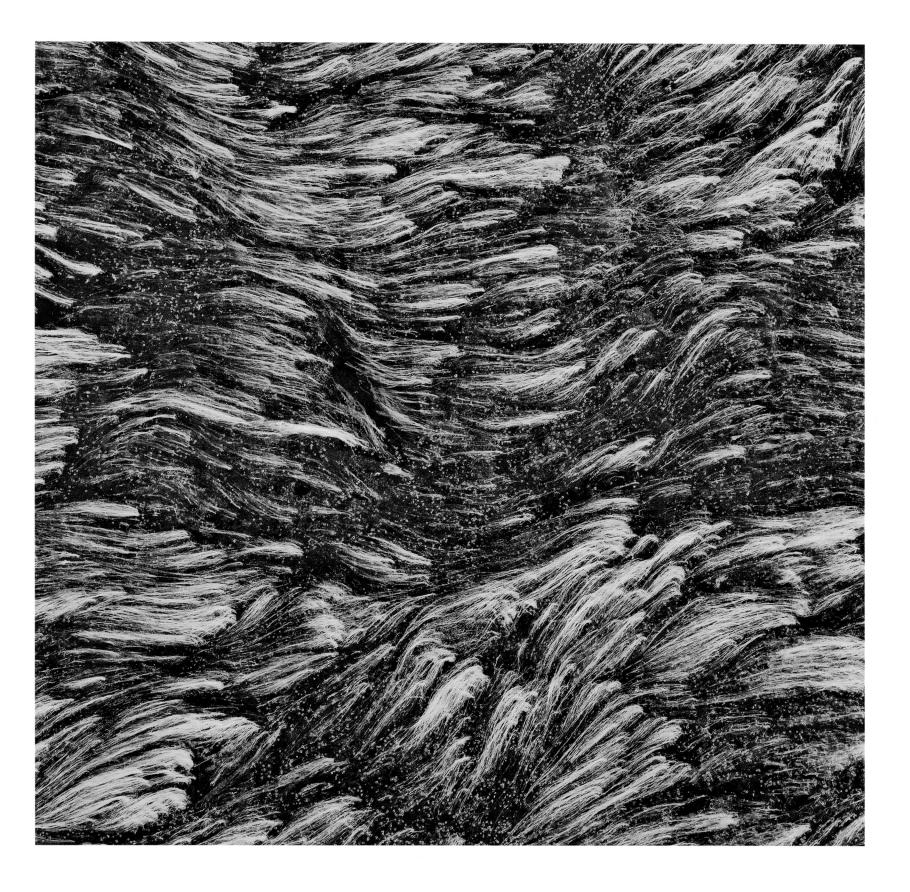

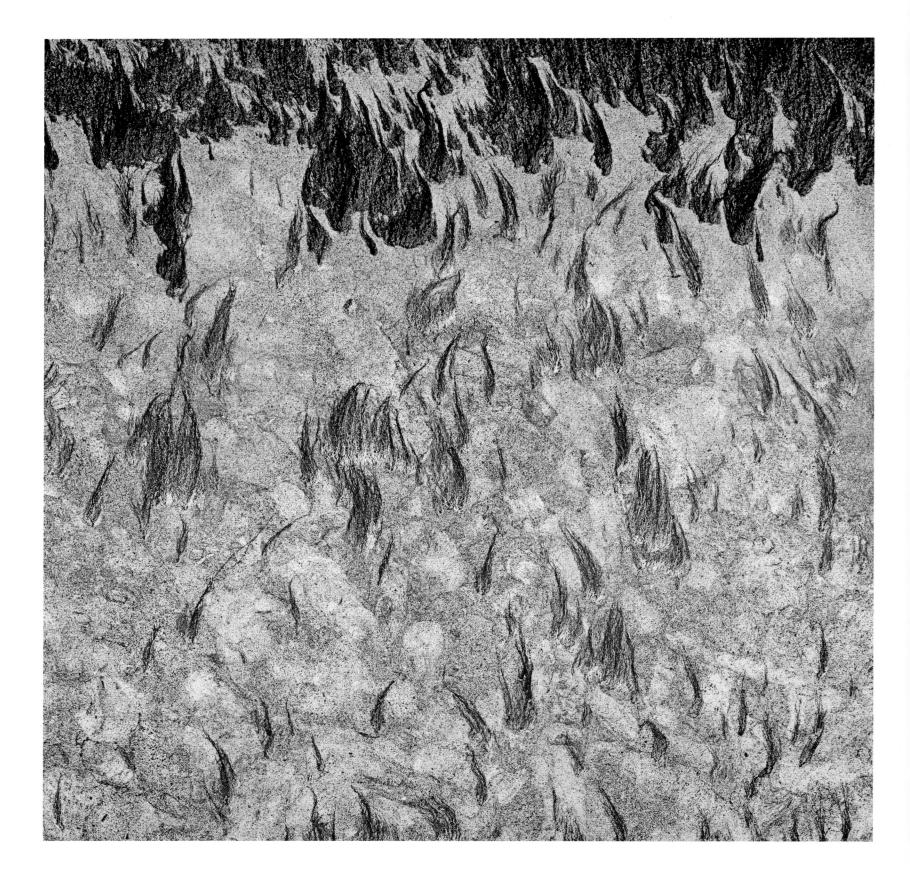

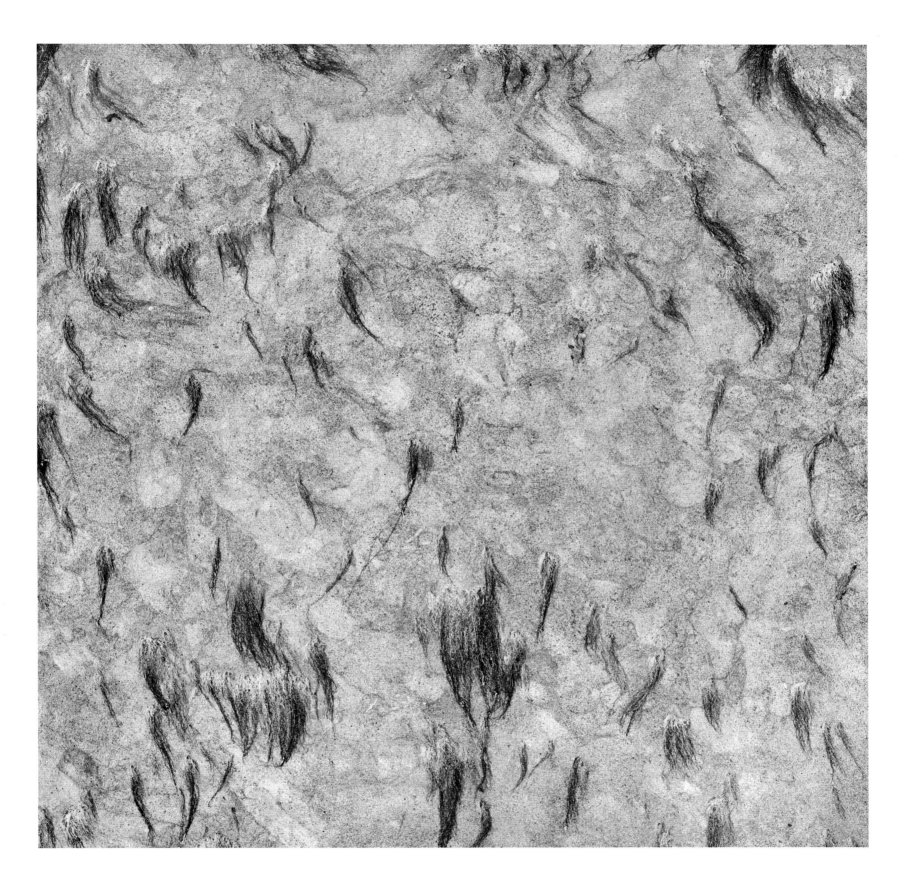

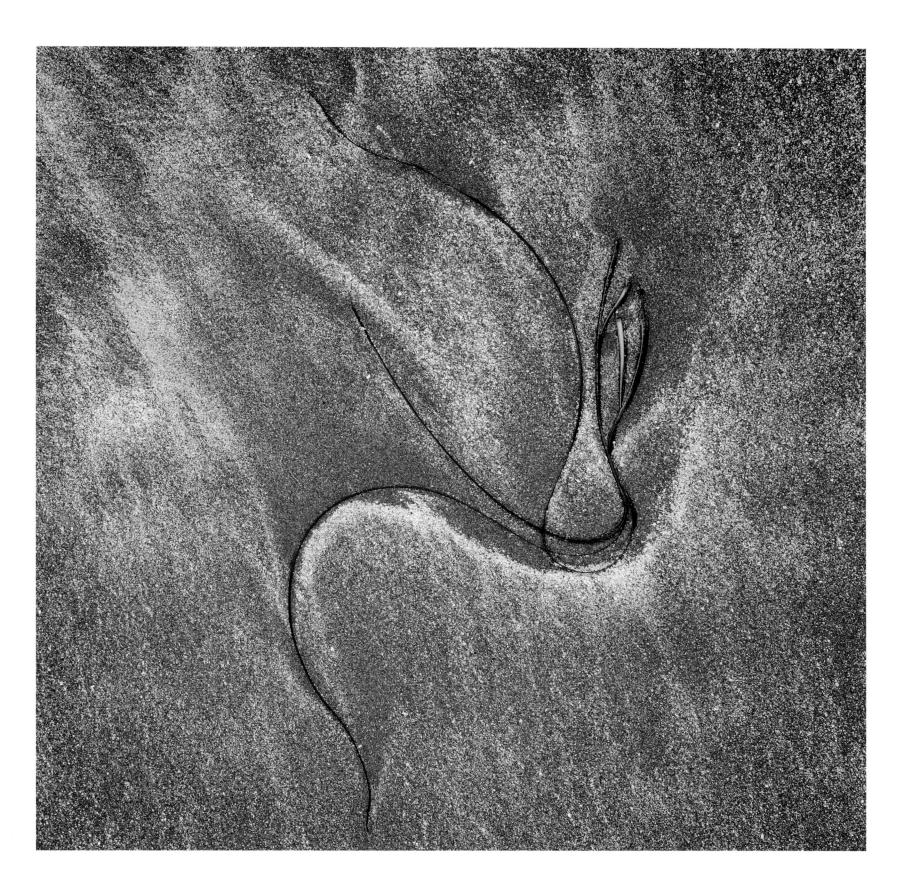

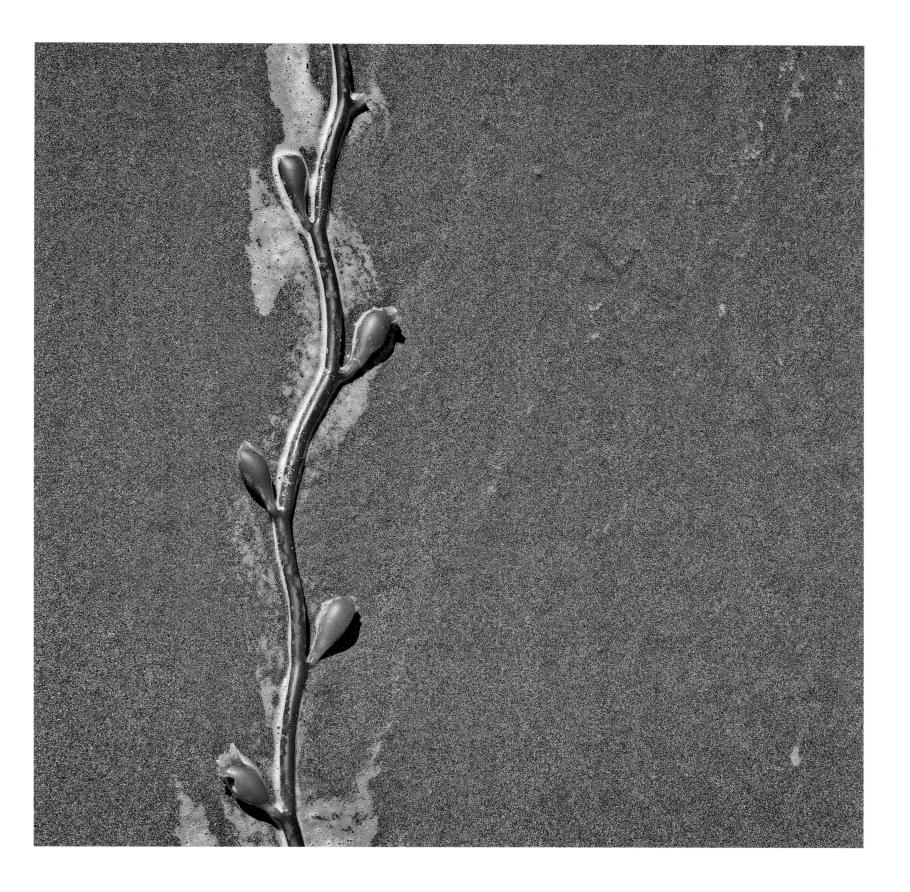

Fauna: Attachments

Mussels might appear to be still, but they are restless with hunger and an urge to stay alive. Gathered in tidal zones, they form what Rachel Carson called a "living blanket."

Underwater, they open their bivalves, filter seawater for plankton and zoospores, close them against the intrusion of a hungry whelk's proboscis. Over and under and among the beds, thousands of mussel larvae swarm, divide, flatten, beat their invisible velum, grow and discard early shells, until they start, finally, to fashion the foot that used to help assure their safety.

For a mussel, staying alive means staying attached—sometimes for humans, too. That foot will eventually secrete a kind of glue that twines into byssal threads—a bit thicker than human hair—which grip the surface. Picture a home anchored cliffside by short ropes. More mussels then congregate, sidle up to one another, attach themselves in protective beds to the rocks and one another.

That is the ancient story. And this is the new one: World-wide, increasingly acidified ocean waves slosh around and under the mussel beds and eat away at those threads, changing the proteins in the silky glue, weakening the mussels' attachments.

Meanwhile, seawater is slowly rising, and more violent storms hammer the coasts, pound the mussels whose threads, stretched by the force, sometimes snap. The mussel is flung who-knows-where, increasing the force on those remaining, which are now more exposed. The living blanket is ripped, and on and on it goes until not just the mussels are at heightened risk but so, too, are the communities of crabs, snails, and worms that live within the blanket and the birds that feed here, and on and on that threat, too, goes.

And here's the next chapter: Across the planet, CO2 (carbon dioxide), pumped into the atmosphere for decades, centuries, by the burning of fossil fuels, sinks into the oceans and reduces the carbonate ions available for shell-building. When those mussel larvae are ready to settle down and grow a shell—as they must—they may find ingredients in short supply. Protection, then, may be thinner, more fragile. Porcelain walls instead of concrete.

Easier to peck, if you're a gull. If you're a whelk, easier to bore a hole into.

If you're a thin-shelled mussel on the verge of being yanked from the safety of your bed, then what has saved you in the past might now be undermining your chances of survival. If only mussels could do what some other threatened species can: detach, migrate to better habitats.

There's no escaping the acid, though, and mussels, once attached, can't move anyway. Staying put is in their DNA. Thus, they remain at the mercy of us, a species capable of mercy but often too preoccupied with ourselves to be inclined.

So when a storm moves in, mussels cope by inching themselves around in their crowded beds, shifting on those ropy attachments growing brittle and stiff. Like moored boats swinging on old anchor lines, they aim their narrow ends into the storm and stay together, as if trying to hang on until the fury has passed. For, as we know, attached mussels cannot go elsewhere.

Neither, finally, can we, who should be burdened by knowing this. To ignore such a truth is—as Pope Francis exclaims in Laudato Si—to commit the sin of indifference.

To watch a sea star in disease-triggered death throes is grisly business. It begins with white lesions on the body. An arm or two, maybe three, shrivels; the suction power in its remaining feet starts to wane; the body bulges in odd places. Internal organs rupture, and the star itself finally explodes. Gooey remnants wash ashore.

Beach-combing kids poke at them with the toes of their sneakers. A few adults might remember orange ones glistening in tidepools.

Because healthy sea stars are voracious predators, they keep other species from taking over tidal zones. Sick stars mean too many mussels, less room on the rocks for others, decimated seaweed beds, diminished opportunities for the systems to thrive.

Marine biologists with microscopes scrutinize the gooey residue for clues to the infection, perhaps by a pathogen gone haywire in warming ocean waters. The disease is called "wasting syndrome."

If barnacle larvae want to grow up, they need to cling to something. Adrift in currents and tides, they wait to bump into firm objects, at which point they swivel and squirm until they can press what passes for their heads into a plank, a piece of driftwood, a tiny fissure in a rock. There, they exude a bit of glue to keep themselves upside down and stuck for the rest of their lives.

For them, it works.

Waiting for the tide, sea anemones hang limply on a vertical wall. When a crab wanders close by, the anemone suddenly contracts and hurls hundreds of tiny harpoons. Toxins in the tips paralyze; tentacles sweep the crab into the anemone's mouth where, helpless, it's eaten whole. Some time later, the mouth becomes an anus, out of which the crab's indigestible parts are expelled. The anemone, still waiting for the tide, droops again against the stone.

Inside, however, the anemone is all mutuality and symbiosis. Its guts have been infiltrated by algae whose photosynthesis provides key nutrients to its host, which returns the favor by providing easy exposure to sunlight.

During the last few decades, increasingly acidic waters from air pollution provide the algae with the equivalent of a power drink. Carbon dioxide greens them up and spurs their growth. Their host, feasting on what's inside, gets bigger, more prolific, more threatening to those who live nearby.

When the tide turns and the anemones bloom, looking altogether like the flower for which they are named, the tidal shelf becomes an underwater melange of purples and greens. Abundance aside, though, Strom's images depict no gardens of earthly delight. The beauty they capture neither warns about temptations nor laments any paradise lost. They invite, instead, something more than a single vision.

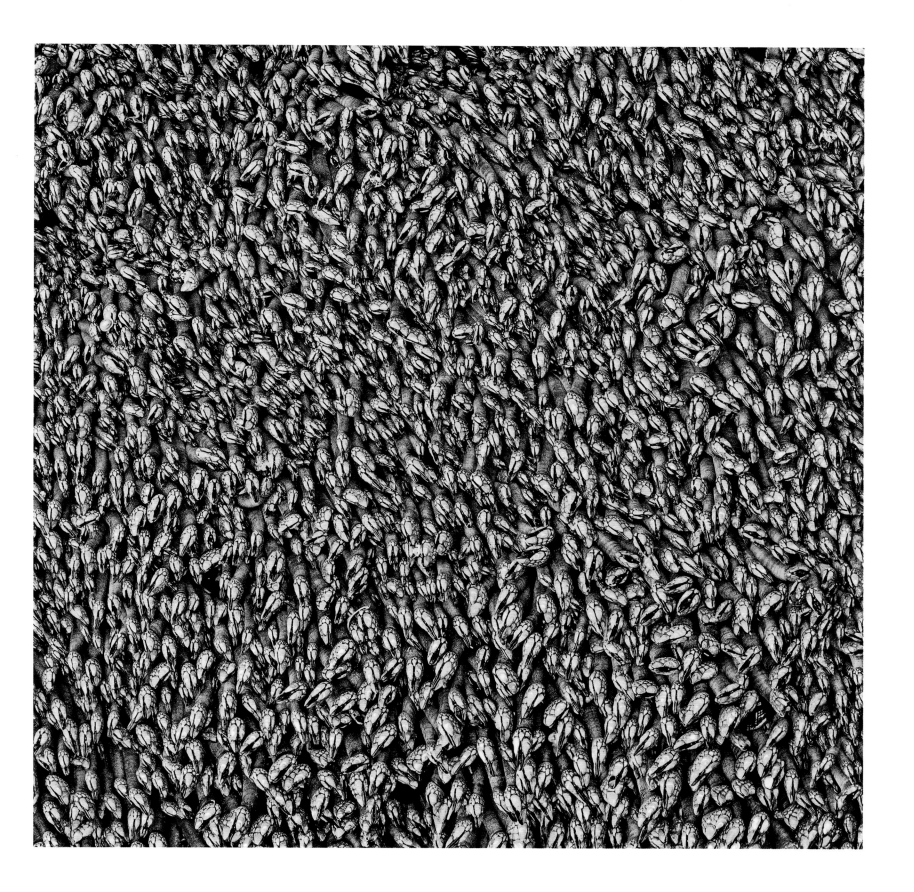

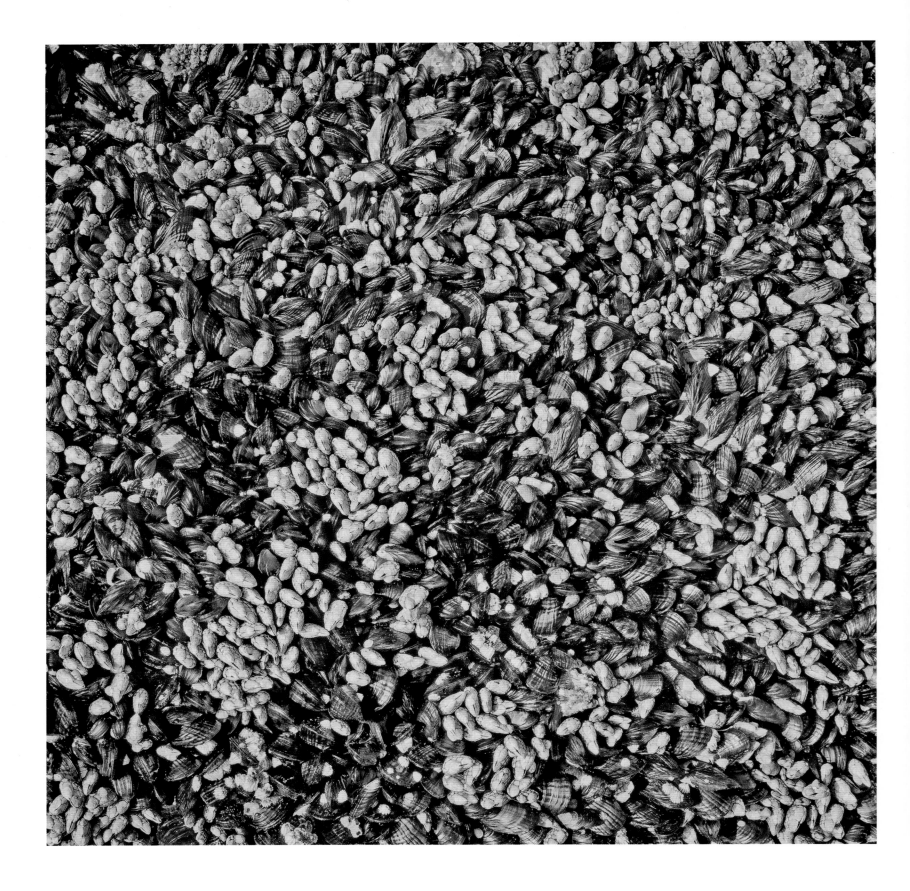

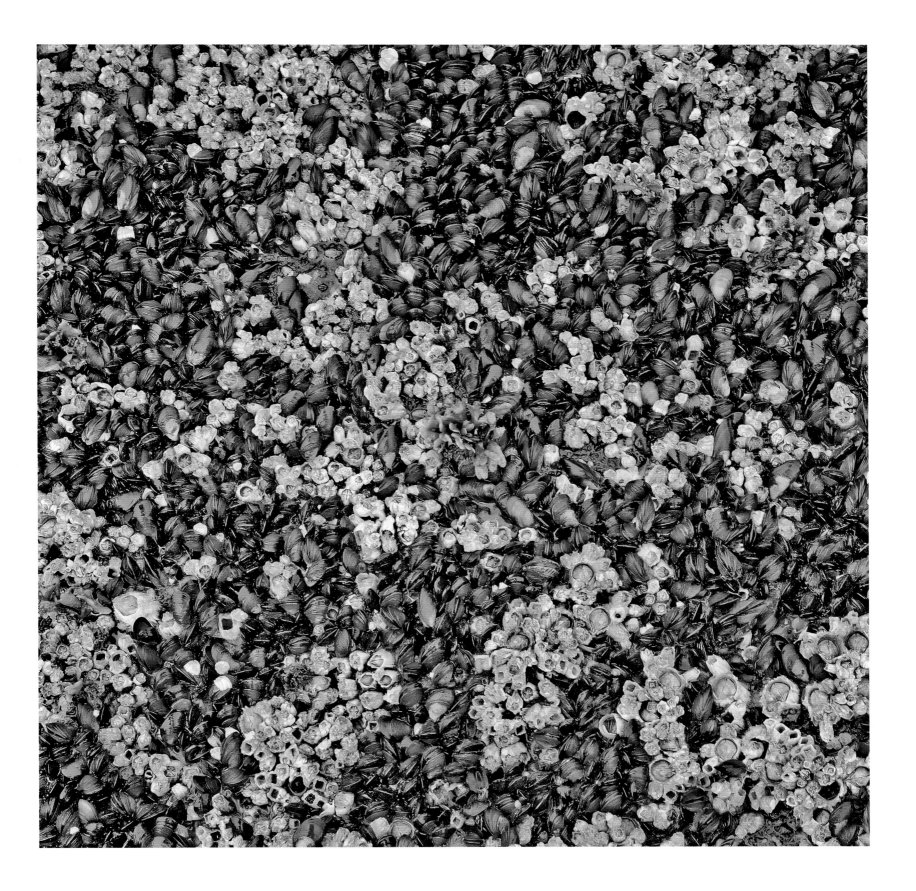

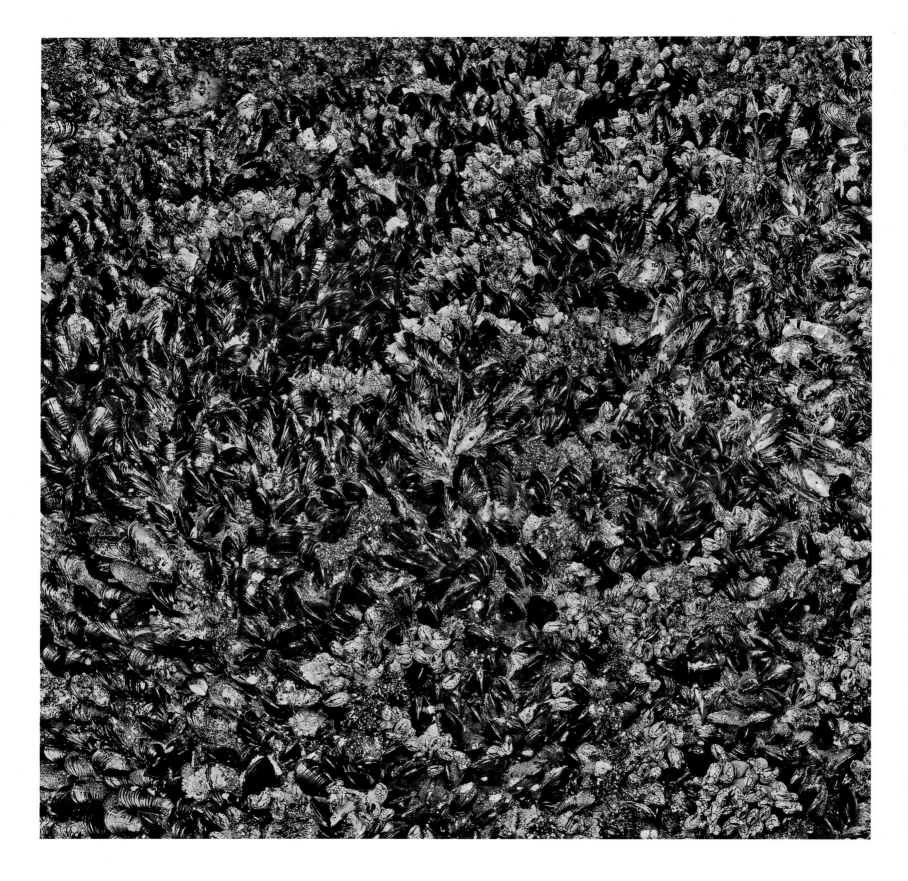

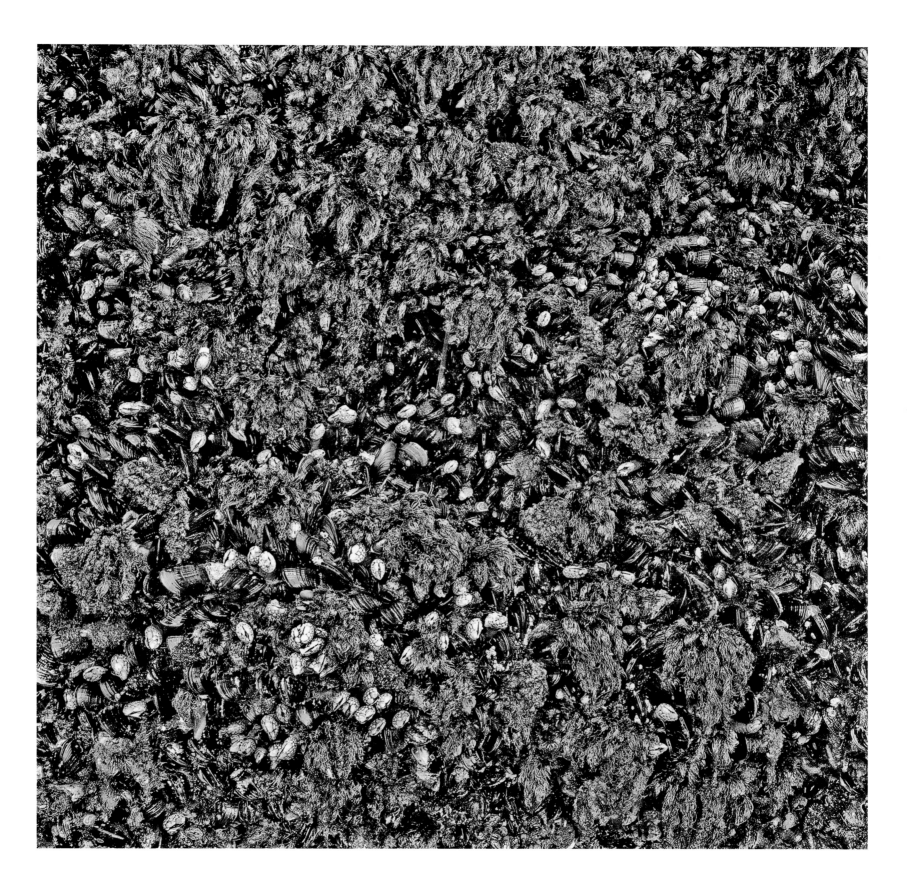

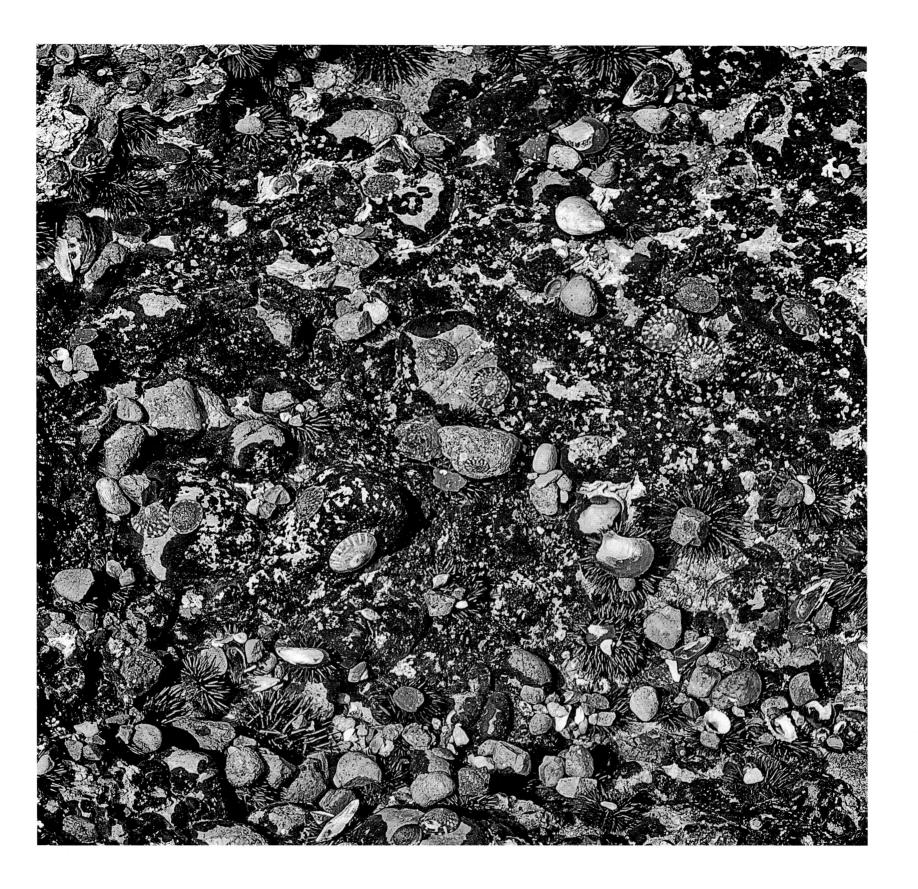

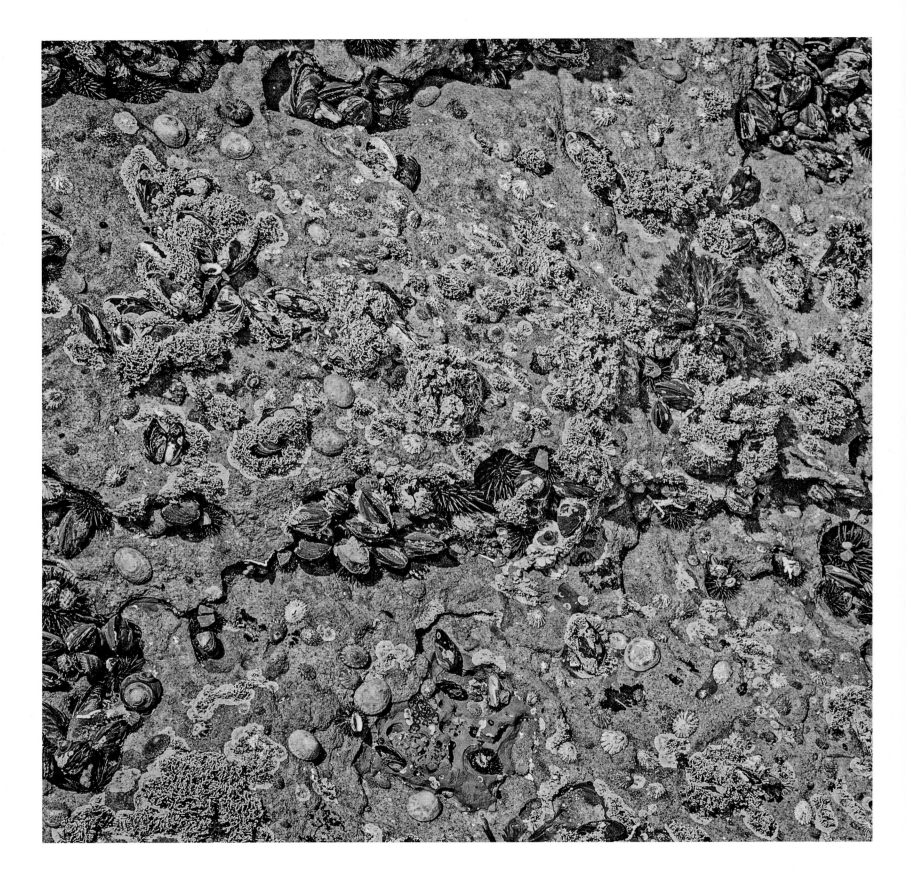

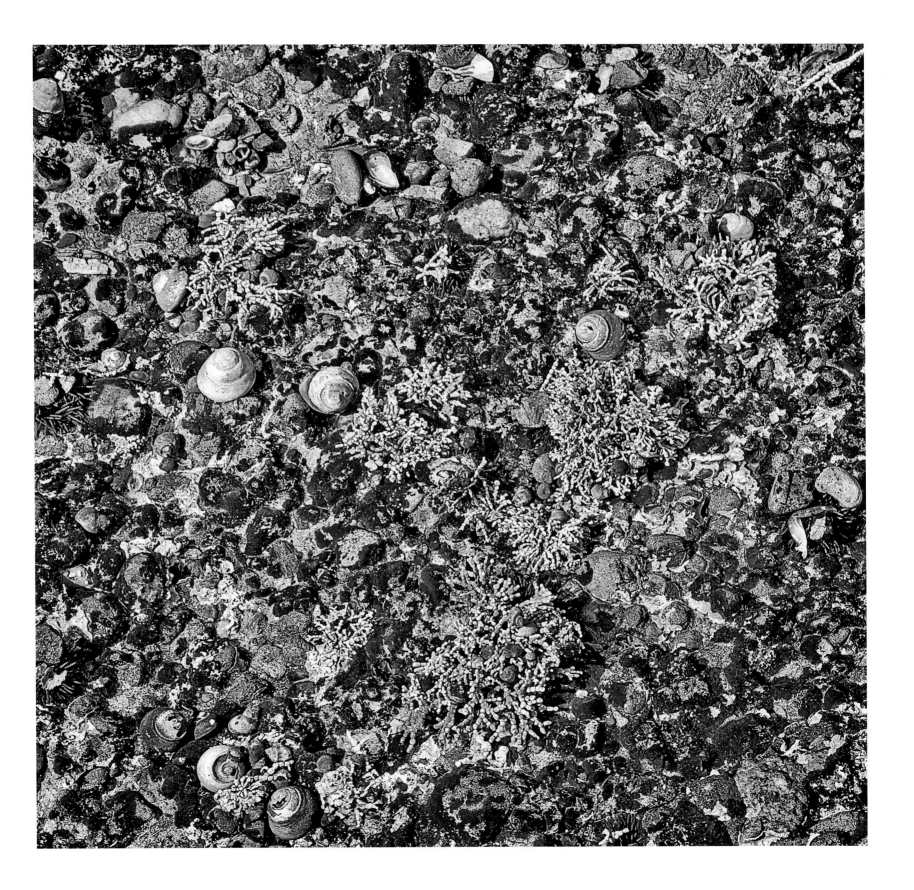

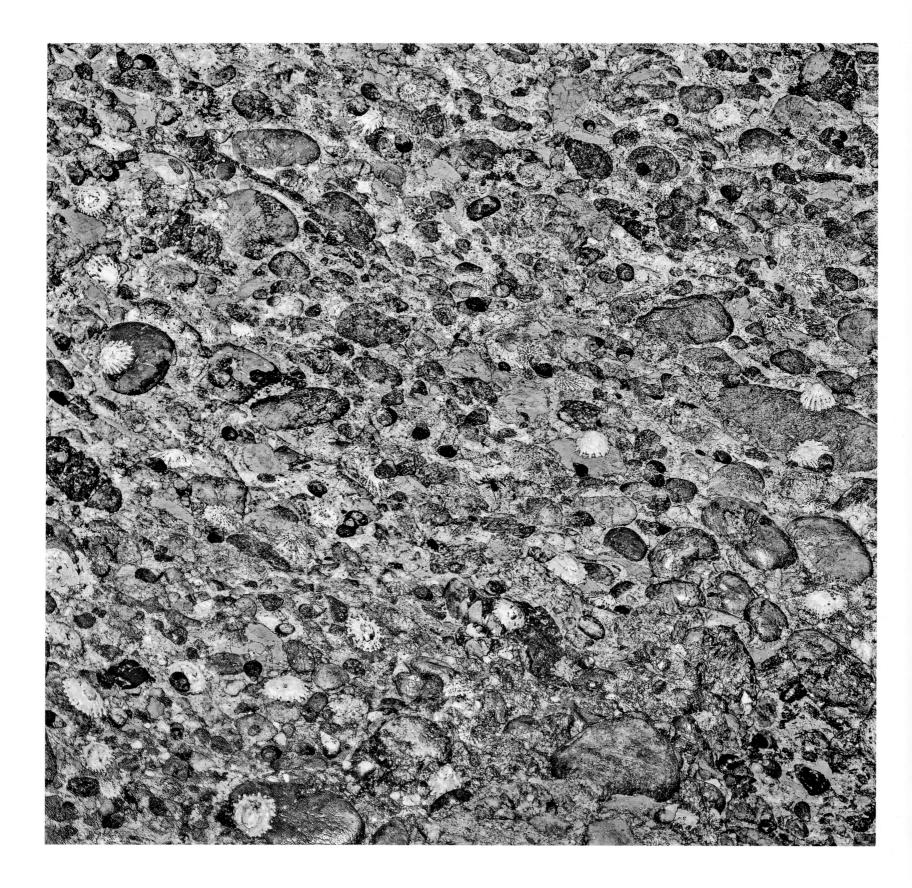

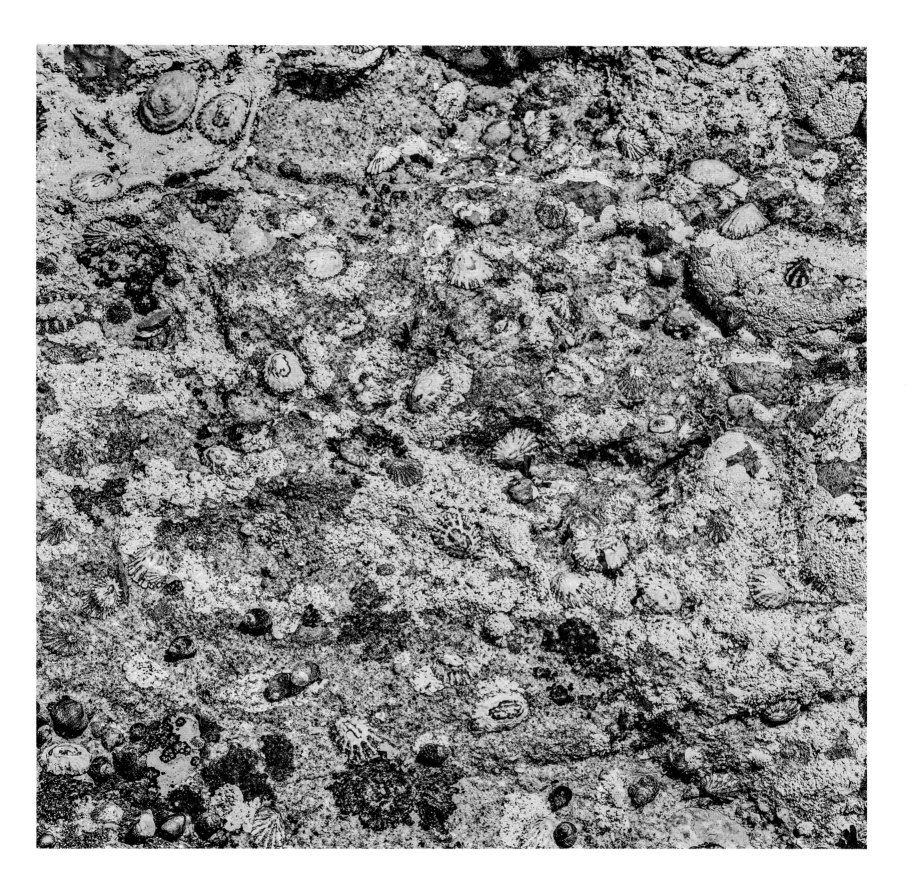

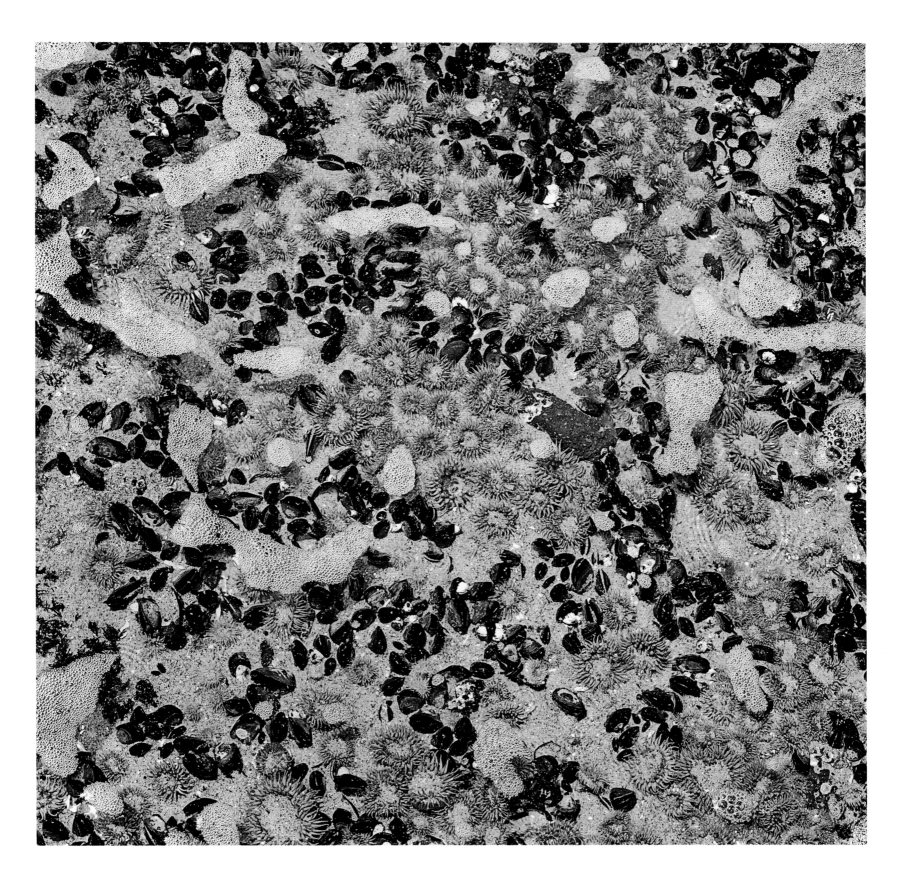

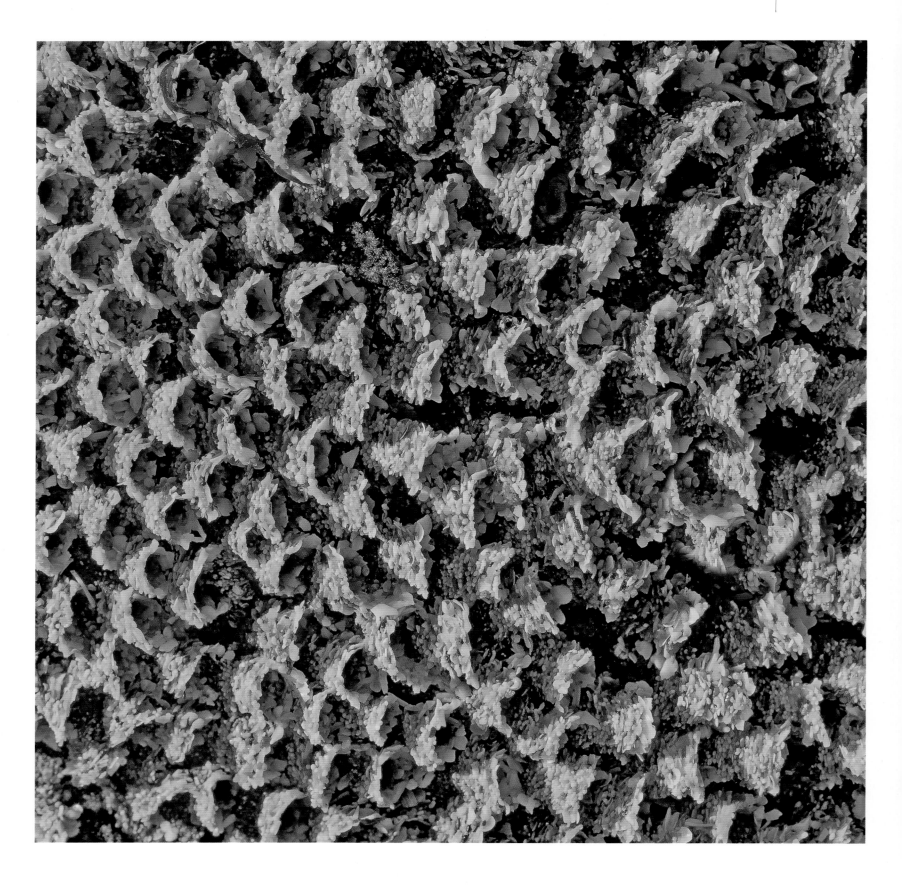

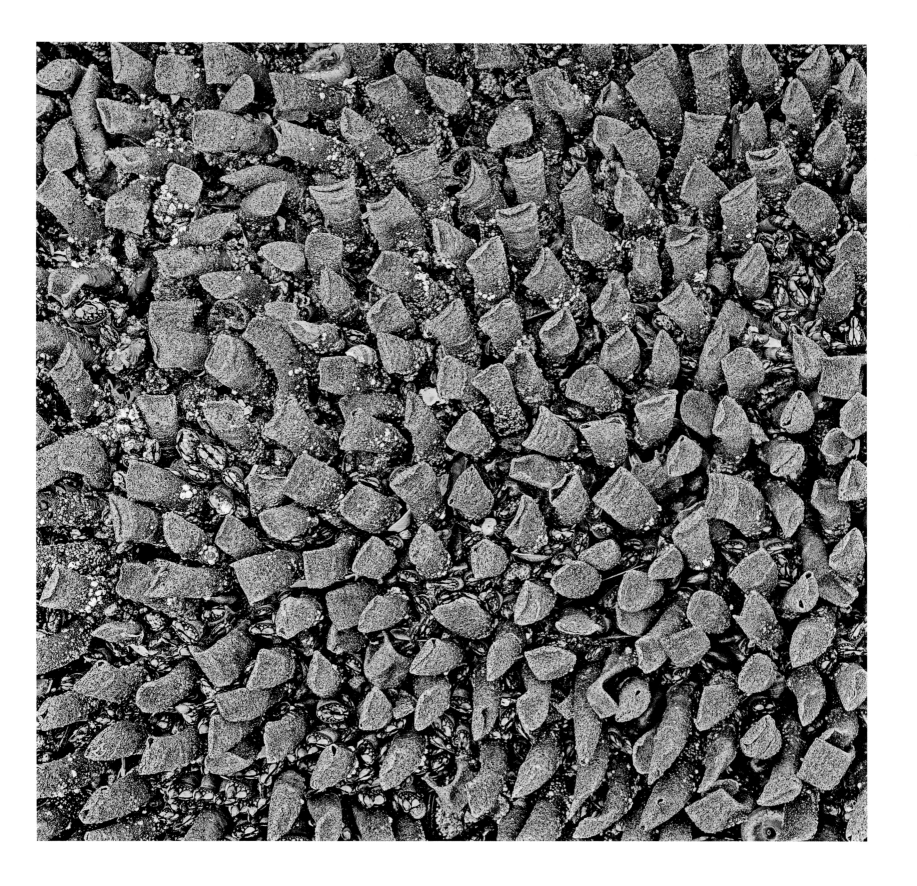

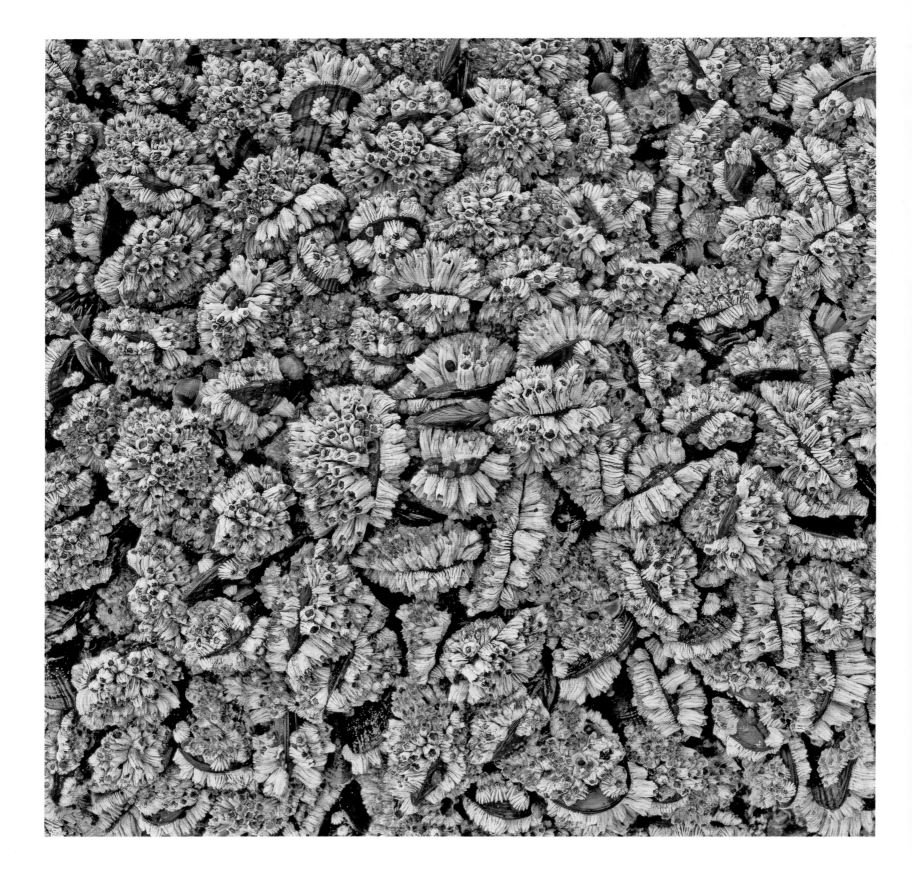

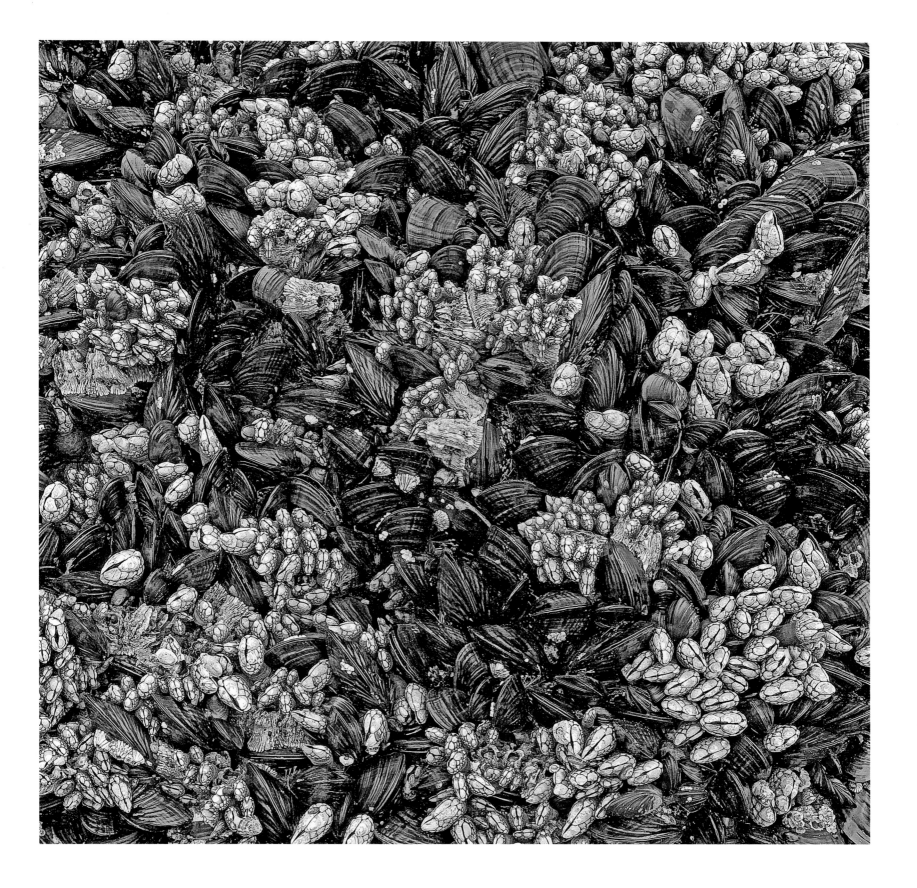

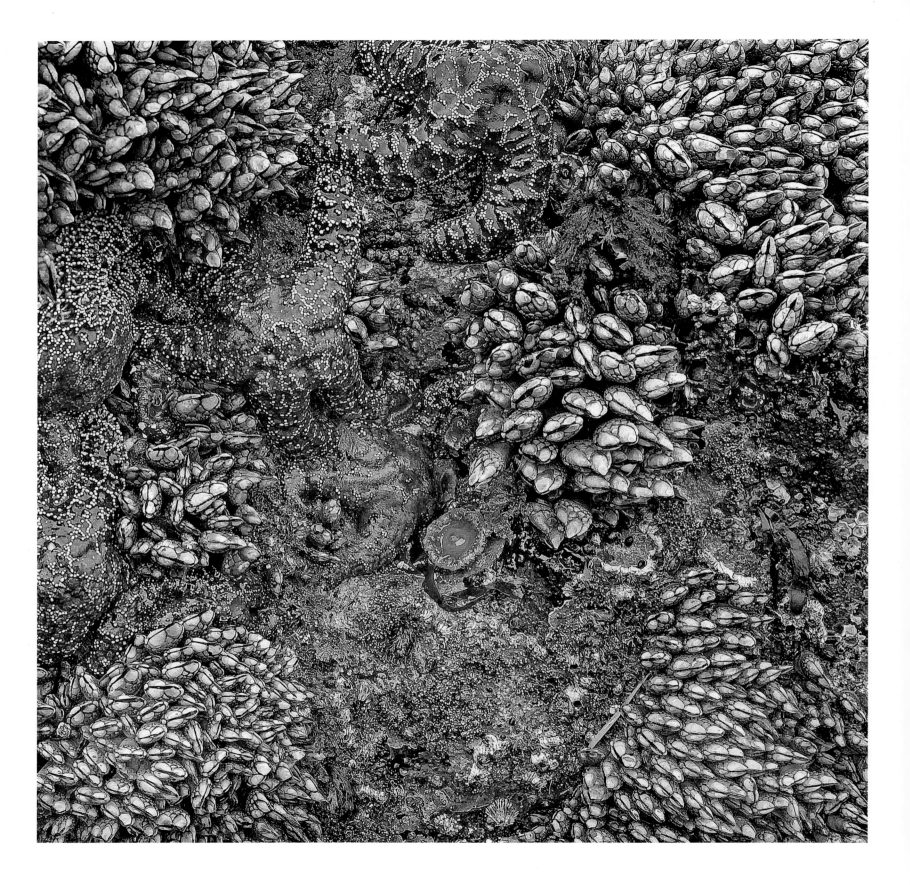

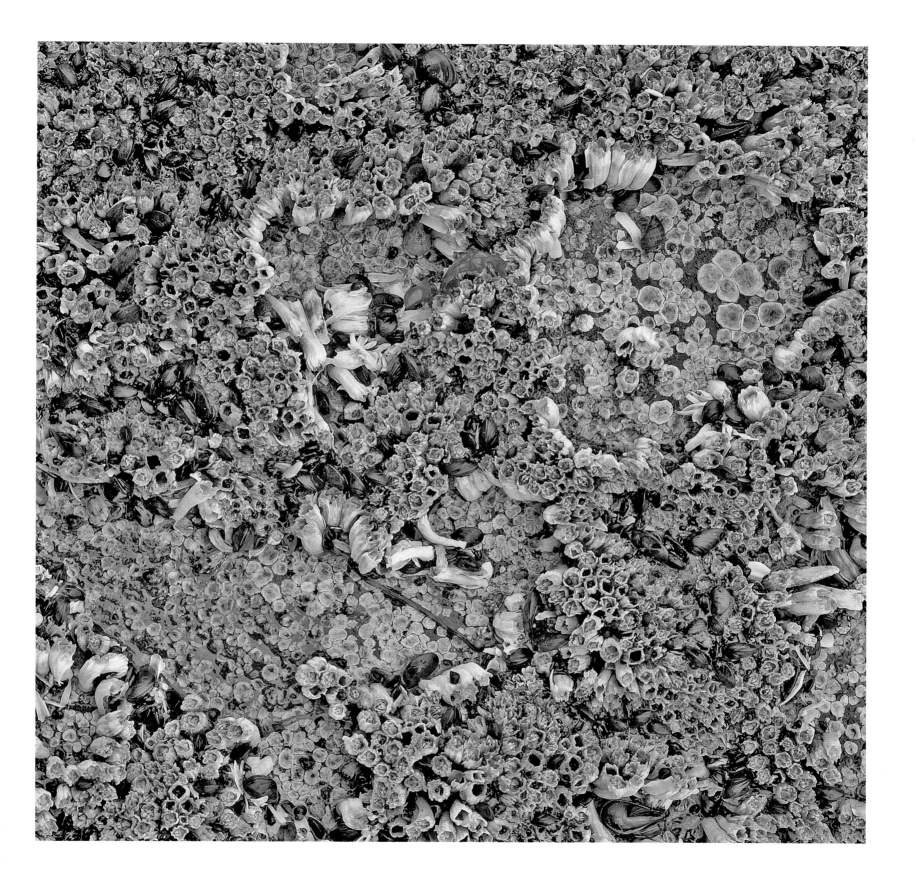

Rocks: Imagining Time

If stones are attached to the tidal zone at all, it's not by byssal threads or holdfasts but by the force of gravity. Of all the objects on shore, they're the weightiest, the slowest to move. Among the short-lived seaweeds and snails they seem ancient.

In the geologic history of stones, though, they are the newcomers. Shrouded in mystery, most of Earth's earliest rocks were long ago crushed under years of pressure, chemically changed, eroded, pushed deep under oceans that no longer exist. We can only speculate about stories their markings might have told us.

From those early eons, fast forward through the next several hundred million years, straight through the Proterozoic and into early pre-Cambrian and, still, nothing much remains. It's only when we reach the Cambrian, 500,000,000 years ago, that some records survive—fossilized impressions of sponges and algae, tiny worms, simple shelled creatures. Since then, the shore has been the churning zone, wave and wind grinding and chipping, producing the tidal zone's one piece of ancient history: a token we can hold in our hands. Even with that violent history, it seems solid, comforting.

Perhaps that's why, on some days, we pick up a few, test their heft, weigh the value of pocketing the one that fits most perfectly in the palm. Some folks even keep it as a "worry stone," a kind of pocket tranquilizer.

In a shifting world of diaphanous bodies, spindly antennae, transient values and quick fixes, a stone feels durable. It exudes no sense of something unknown about to emerge from its interior, no sense it's about to become anything but a smaller version of itself.

On other days, the wet backs of rocks resemble misshapen mirrors. They darken the surrounding sand and remind us that to see the inevitable change in supposedly durable objects requires imagination.

There is, for instance, this possible future: A hundred years hence, snorkelers will swim here in water that will likely have risen at least three feet higher and sub-

merged this rocky edge. Beneath them, these stones will lie diminished, settled in underwater sand. Perhaps the snorkelers will shine their lights through the murky dark, dive down, and pick some up. Perhaps the most imaginative ones will feel the lessened heft and remember that the hand was once, eons ago, a fin that eventually developed an opposable thumb that enabled it to use such a stone to smash the skull of a wart hog. And then to grind grain, to fashion a chisel, a tablet, eventually a masterpiece like Michelangelo's David.

Maybe, too, they will marvel at the hands of a more recent past, our hands, pressing buttons and keys that wrecked or improved our lives, while we rubbed the worry stones in our pockets or didn't.

Does it do us any good to imagine that they, swimming innocently above these rocks in the future, might lament that we, who walk among them today, worried too little and too late?

Even today, under the eye of a fast-motion camera, the stones seem restless, tossed one way and the other, a kind of constant jiggling, unstable swath of pebbles darkening and lightning with the tide, a reminder of flux. Nothing stays the same. There are only illusions of sameness and, sometimes, as Strom's images warn us, a deceptive stillness.

Anything that takes too much pride in its current shape may have trouble remembering its past or imagining a different future.

Imagine that stones can hear talk of climate crisis and call for revolution. The igneous among them might recommend fire; the sedimentary advise pressure; but metamorphosis, the old stones might claim—that's how real change works.

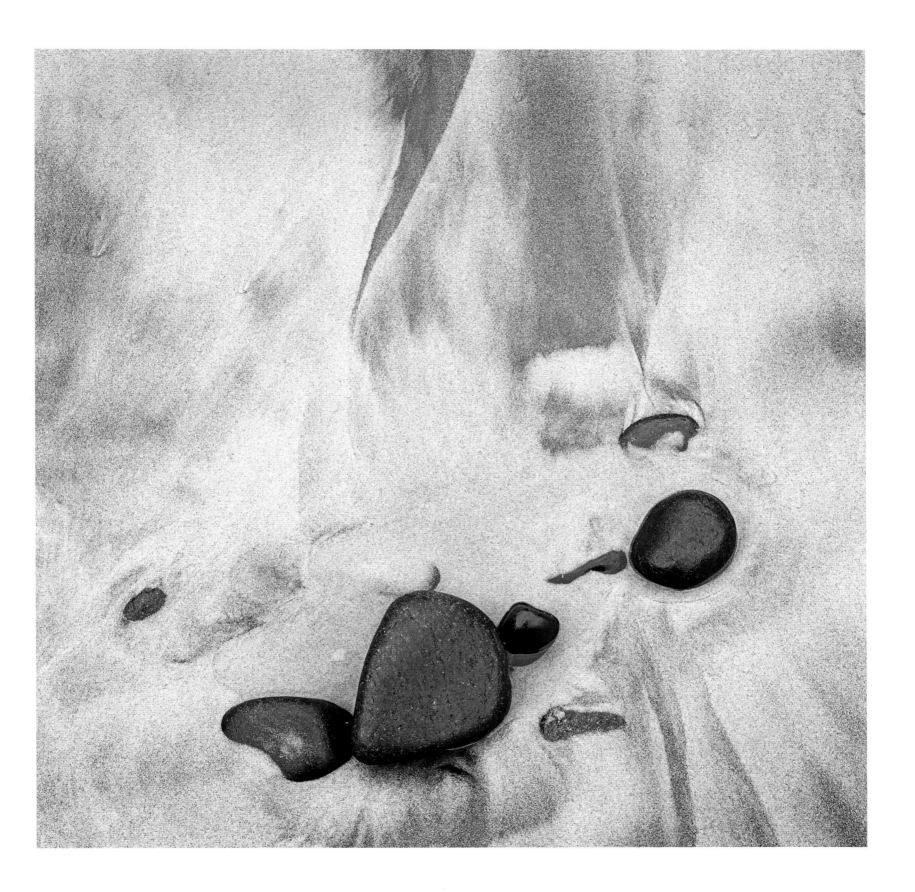

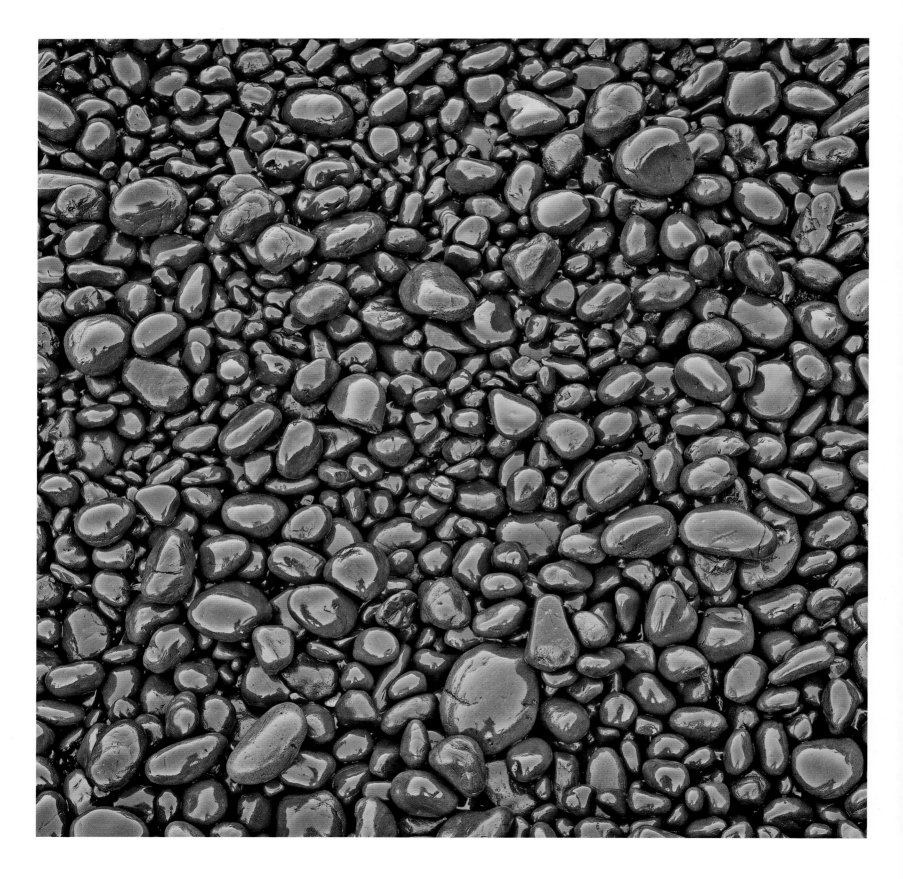

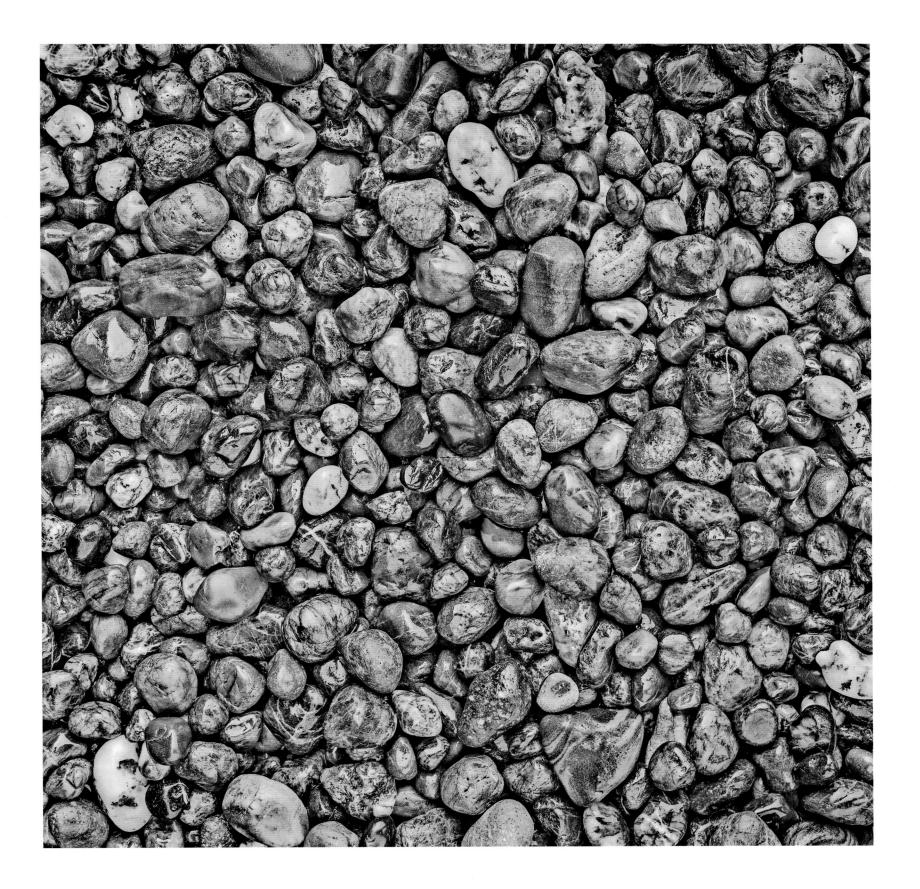

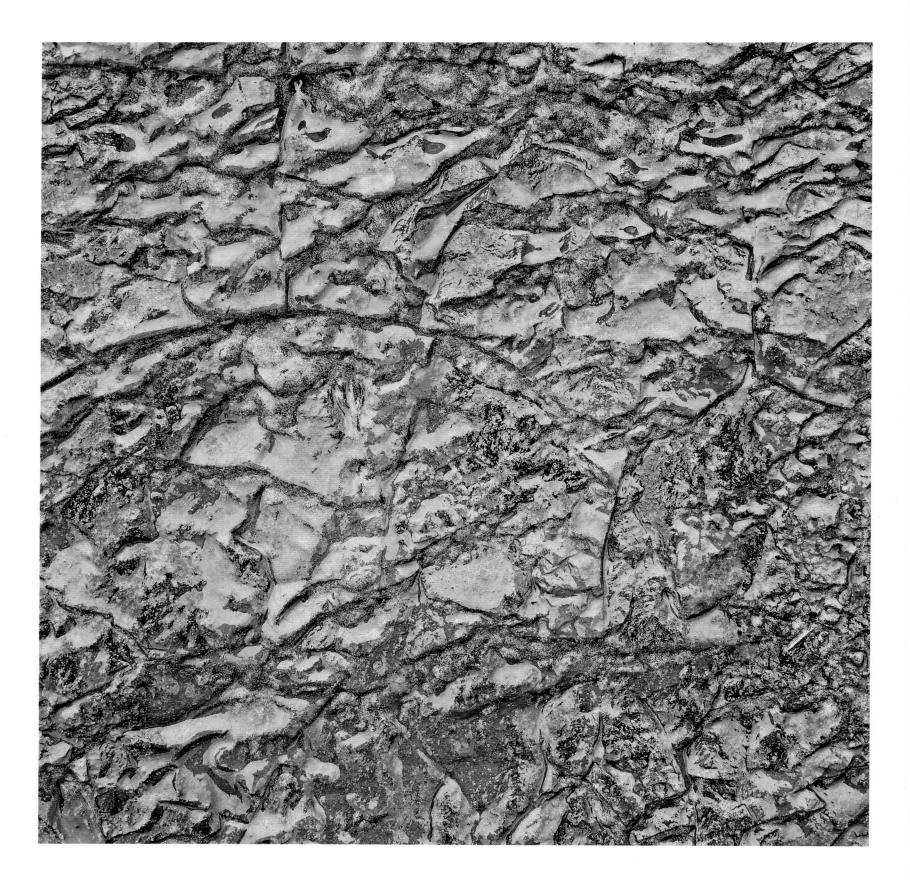

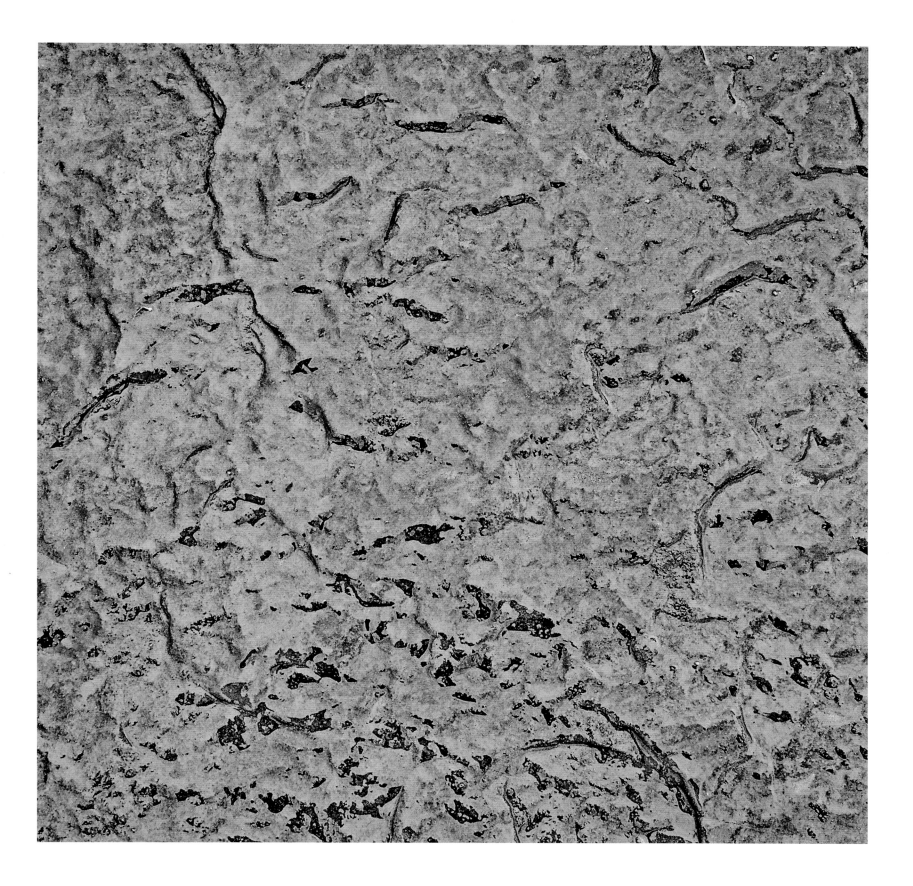

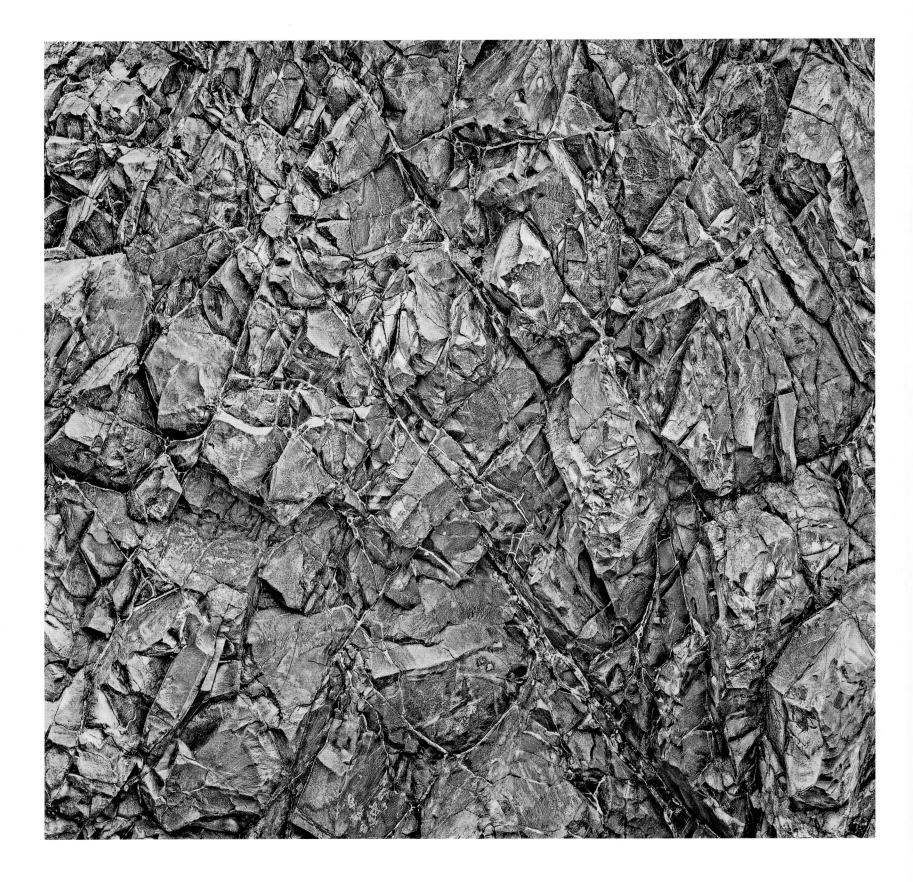

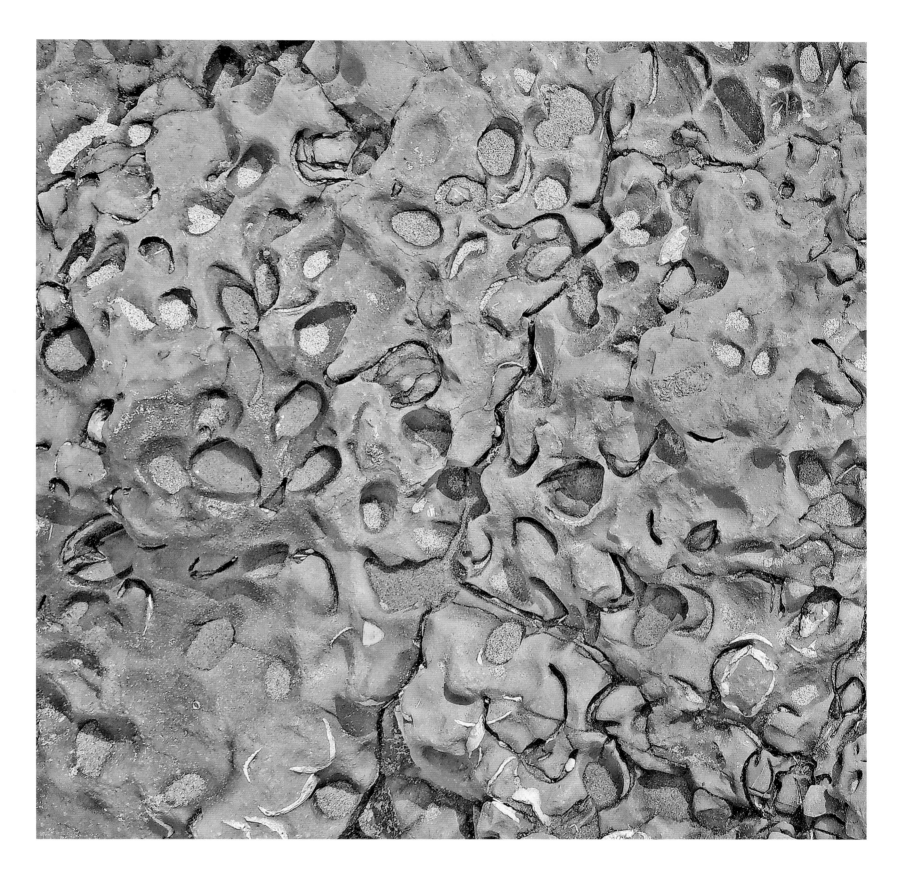

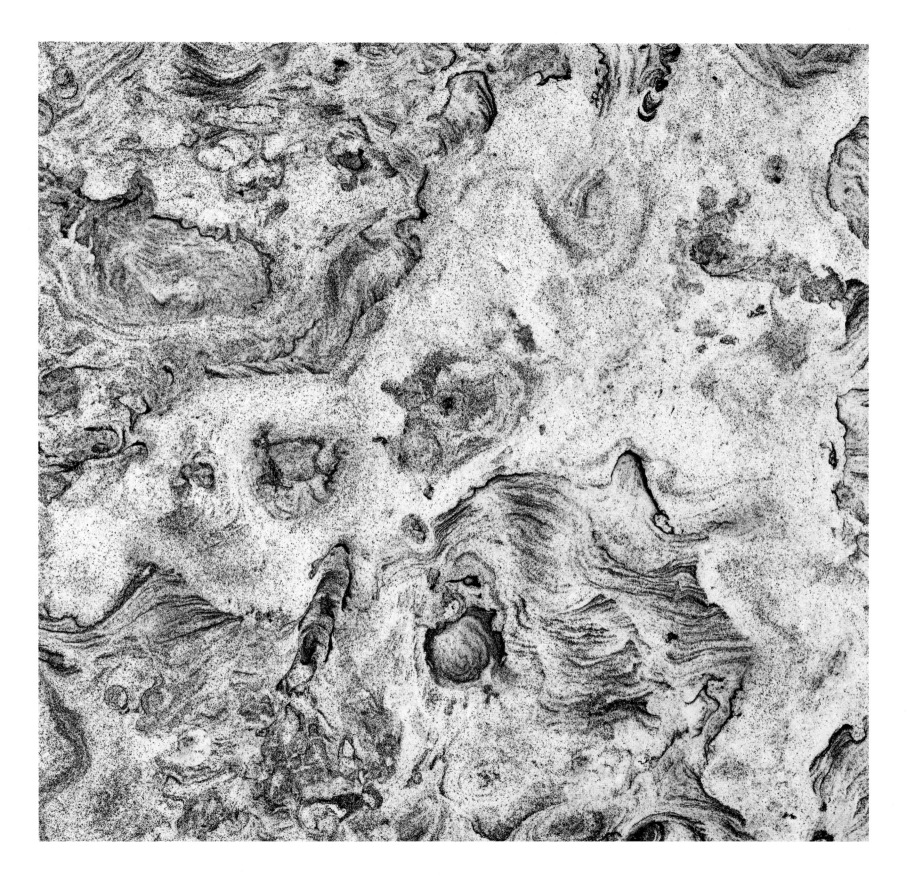

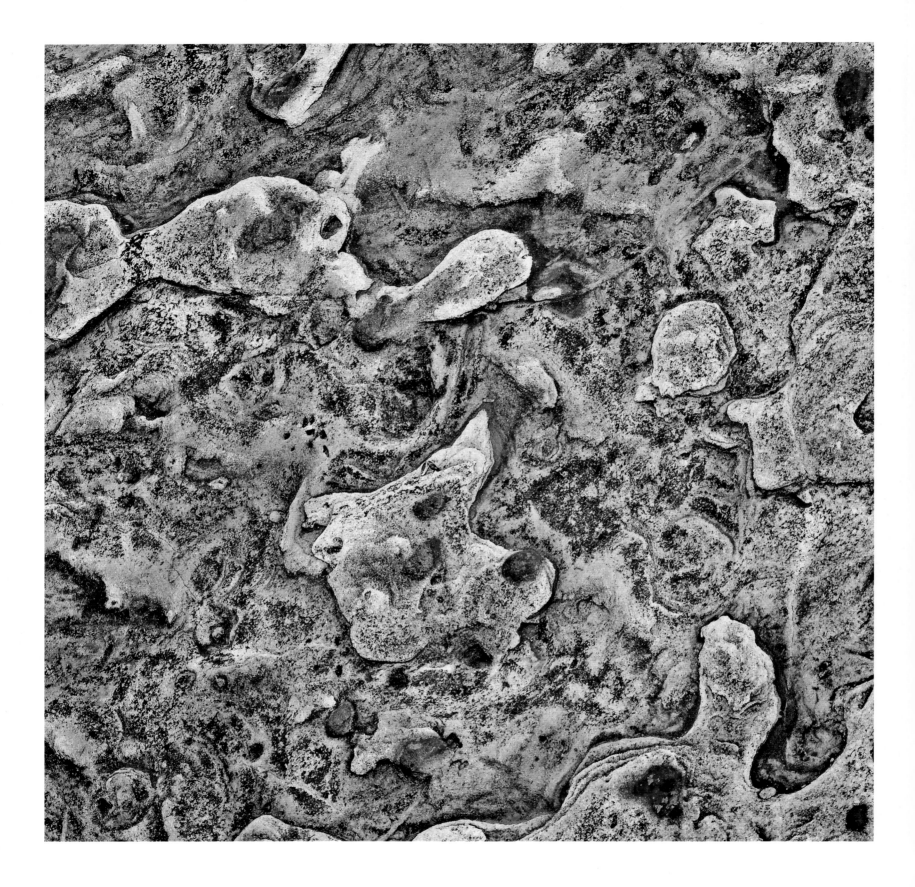

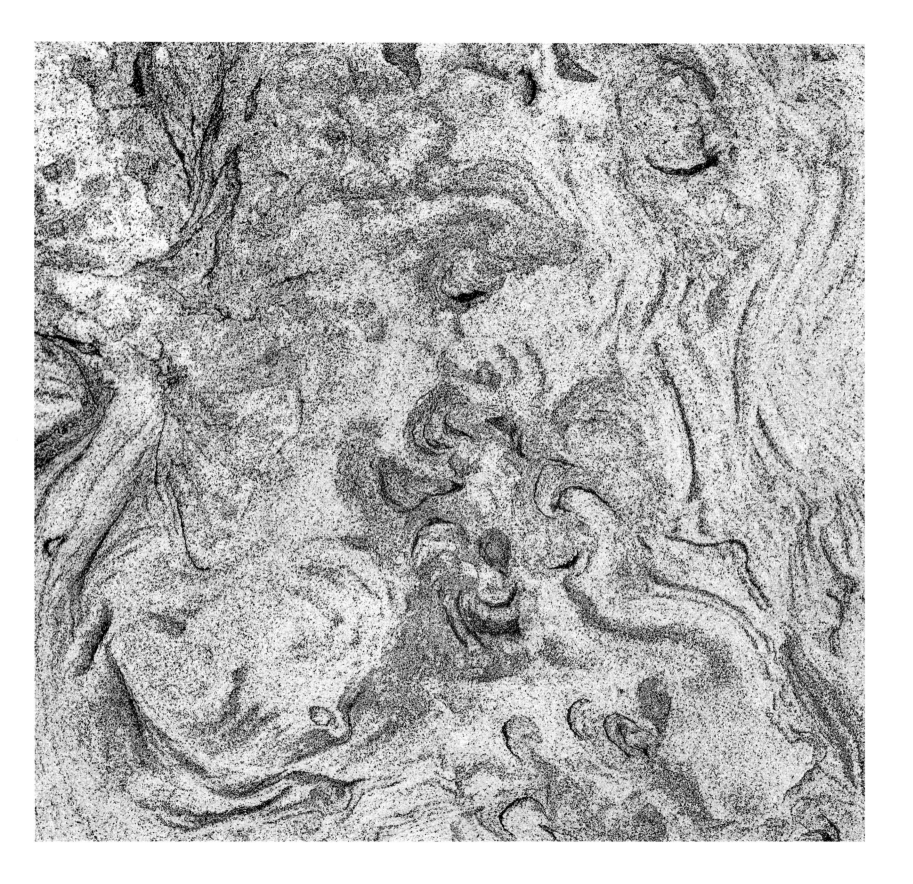

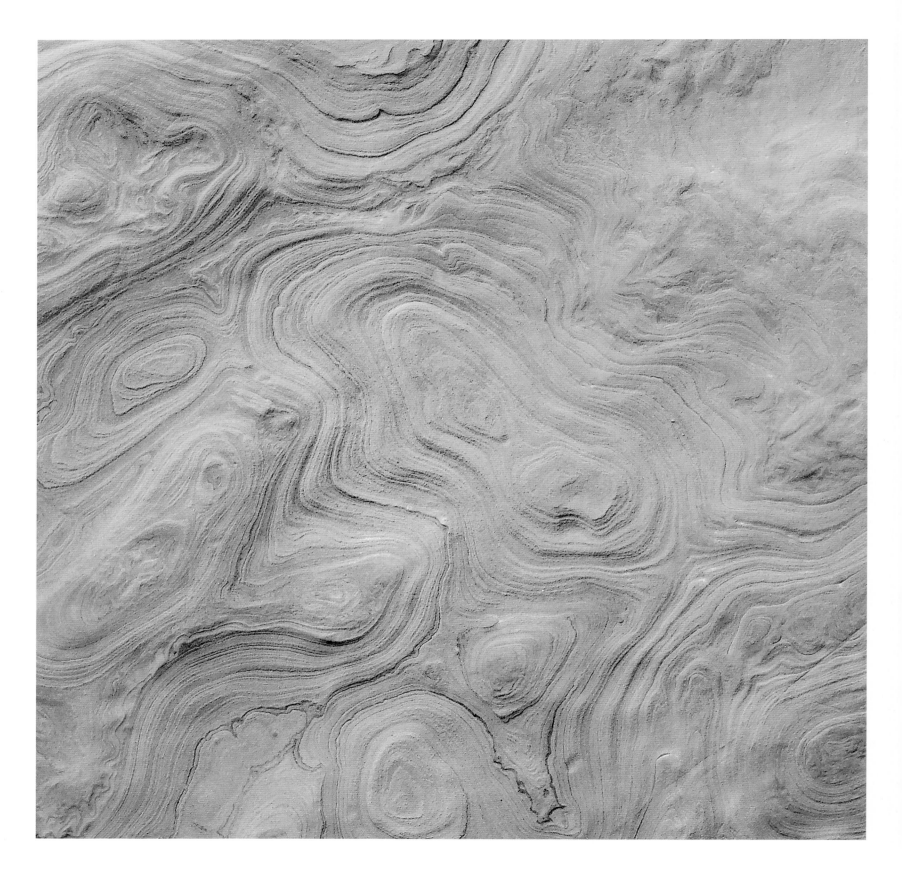

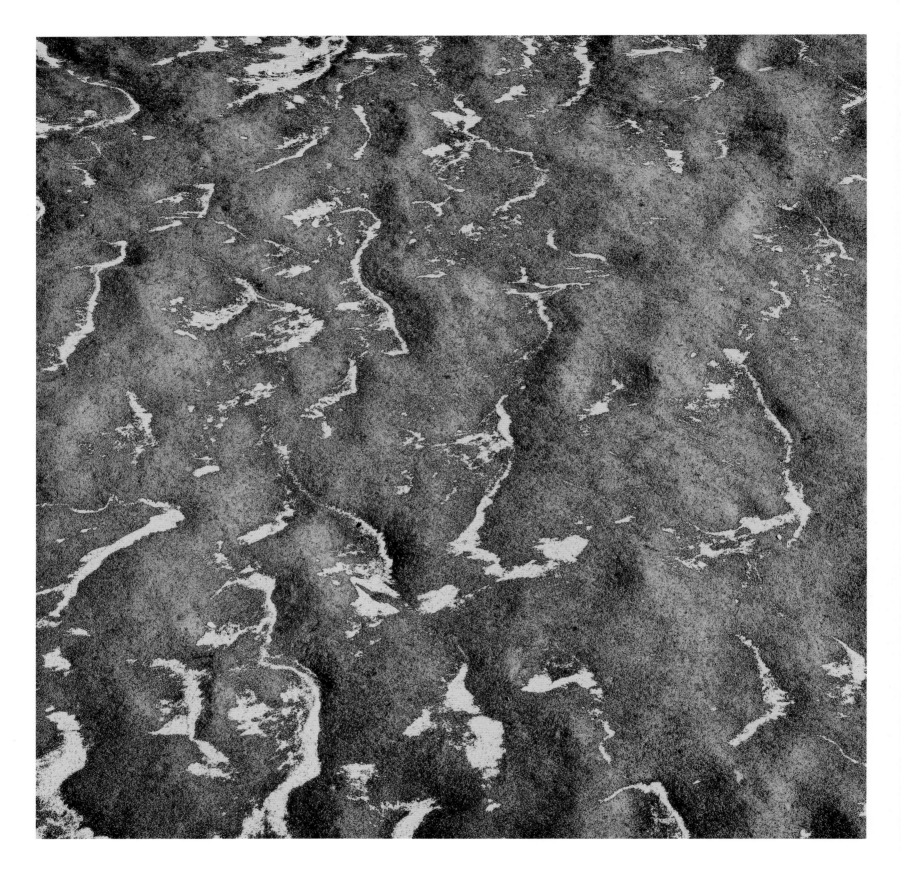

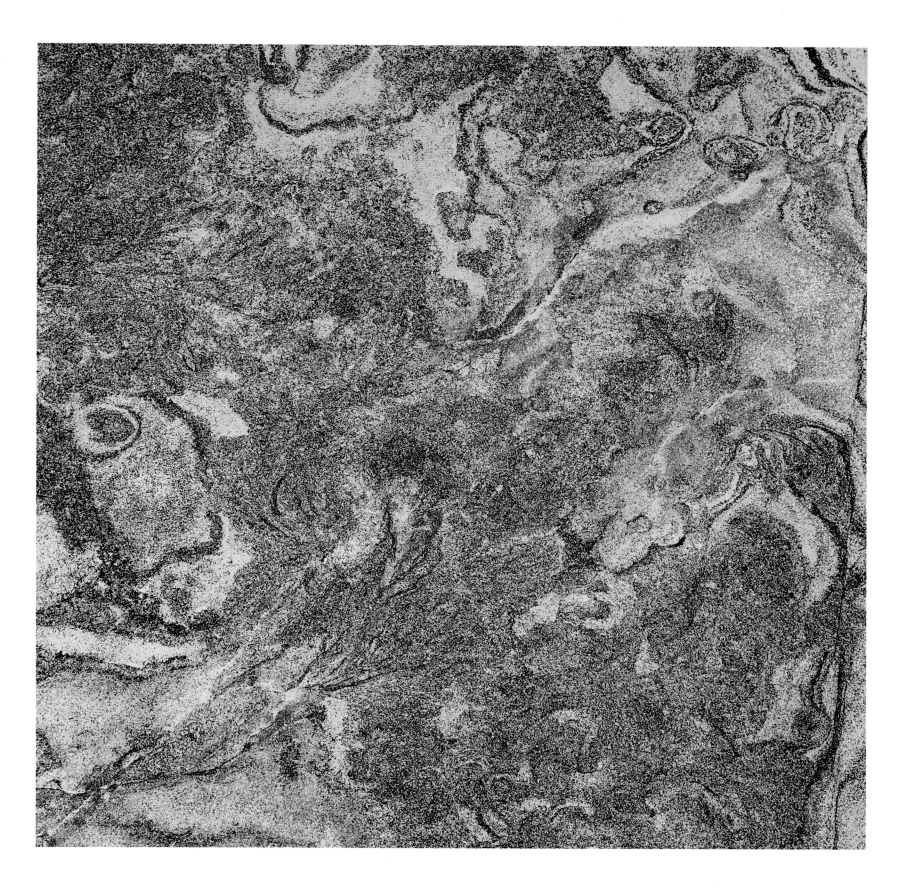

Horizons: What Endures

Here at last are horizons. Now the artist directs our vision up to the gray strips of sky hovering above thin strips of mist above the ocean's surface. Beneath, the oceans recede, uninterrupted, as far as the eye can see. And, thus, we're reminded of how long—too long?—we've been looking down at nooks and crannies, at the small, daily scuffles that fill the days of those life-forms just trying to survive.

Horizons help to establish scale, ratios, proportions. They situate us in relation to what we're seeing. From the perspective of a creature in a tidepool, the world is rock-bound and water-filled. If the creature is plankton-sized, that pool is plenty big. It lives, as most species do, in a world that fits its size and needs.

We humans, though, are unlike most species. Our position on any one scale is never stable. How big a window do we choose to look through? Was it this morning or this century? This tidal edge or coasts all over the world? The changing strength of a mussel's byssal thread or the acidity and temperature of oceans worldwide?

Upright and equipped with imaginations and tools that expand our vision, we alone are doomed and blessed with consciousness to scan that long line between sea and sky, from one edge to the other, and to ask, What's out there?

In Strom's images, there's sand, sea, a scattering of pebbles, the white lines of froth. And when the mist in his horizons lifts, there will be shadows, for there are the stones and seaside rocks, some too big for skipping across the water, too big for turning over to reveal small pools or sand depressions full of life. They're more like isolated monuments to the mountains they once were, on the beach, casting the biggest shadows.

Standing at the edge of their darkened shapes, we can look up at the sun and know something of its light, though it originates some 92,000,000 miles away in a solar system so large and full of mysteries it boggles even the most informed minds. Still, we know the sun is the reason for the shadows, and some of us know something about the barnacles that live on the surface of the stone and the seaweed that sloshes at its base and maybe even a bit about the subatomic microcosms within atoms that make up everything in the universe.

Even so, we're slow at this business of shifting scales. We toggle back and forth between feeling Lilliputian and Brobdingnagian: too incidental or too grand, ignored or repulsed by the grossness of some human habits. It takes a while to adjust to what

new discoveries tell us. After all, our understanding that Earth is not the center of the universe is a mere 500 years old; that the universe is still expanding, just short of a century old; and that the firmament contains oddities like pulsars and black holes, less time than that. And on the other end of the scale: understanding that physical and chemical changes in our bodies and backyards, on the land and in the water, are so minute and frenetic they're barely perceptible. In geologic time, we've known those tiny worlds for fractions of a second.

As our view of the world is extended by scopes of all kinds, we scramble to synthesize the barrage of images from macro to micro: galaxies, continents, ocean depths, tidal edges, zooplankton, carbon atoms all superimposed on one another and understood as intimately related. Trying not to get stuck on one scale at a time, we've become like palimpsests of time and space. "No, this is the crucial measure," we say, scraping off earlier versions and visions of the world, re-working the scales each time technology reveals another dimension we cannot deny.

How to lay a large-scaled world on top of a small-scaled world without obliterating what's underneath or making a mess? How, in other words, to do what restoration artists do with ancient palimpsests: to make visible not just what's on top, but what's begun to vanish underneath? Not just creatures and habitats but perceptions of time and space, paradigms and models, and, finally, definitions of home.

The sea in Strom's images is calm. But we know, before long, wind and tides will kick up a few waves. Everything that rises must converge, claimed Flannery O'Connor; perhaps, also, everything that converges must also sink.

Imagine standing on a beach and watching an incoming wave. It mounds up, the height increasing until shallower water near shore slows its speed, and it destabilizes. This is pure physics: There's no way to avoid what happens next. The wave begins to lean forward. Along its crest the white line of froth appears, much closer than the far horizon and approaching us fast. At a certain point, no matter how beautiful or vibrant or seemingly unstoppable, it rushes headlong towards its inevitable flattening.

With Strom, from image to image, the horizon rises and falls. First there's extended foreground and a sliver of sky. "Look at your feet," Strom seems to say. Where we're about to walk matters more than what's farther away. Then the line lowers,

the strip of land between us and sea shrinks, and what expands is sky. "Now raise your eyes and look way out there." Back and forth between near and far, intimate and beyond, now and next, we try to avoid the limitations of seeing on one scale at a time.

Our survival depends on something we're woefully inept at: gliding easily between the scales of sea stars and galaxies. Maybe, some day, we'll learn about a more graceful turning of the mind— up and beyond, then down and beneath, about seeing the intimate and the global simultaneously.

And about inevitable deflation. In the move from fine scales to large, details are lost. One pebble on a beach disappears within the ecosystem and its large-scale patterns. So, too, a barnacle, a colony of barnacles. For us, this life, this family. Somehow, sometimes, we can bear feeling negligible. And sometimes we can't.

Strom's images provide no solace. They make no assertions.

They ask questions about scale and the illusion that things distant grow smaller. Picture a ship headed out to sea that seems to sink below the horizon. Long ago, people believed such disappearance meant drowning, death.

Like roads in a painting, some paths we're on might now be narrowing in the distance, giving the impression of an eventual convergence. Our eye, led to that point on the horizon, sometimes stops right there.

The best art, though, suggests a continuum. The imagination keeps going, makes us look beyond the vanishing point, beyond abstraction.

What might partially remedy the time-foreshortened mind?

Only catastrophe?

What endures: patterns and forces, older and deeper than that which we call our lives. The universe, incredibly, is still expanding, the world is still mutating, creatures along the edges are still changing stalk sizes, migrating earlier, thickening or thinning their shells.

Who knows which of the new-fangled adaptations will mean that something more survives and something else does not. The good news—some say—is that the great jumble of multitudinous, no-trial-too-strange ongoingness of life goes on, in spite of us. Some force that can do nothing but persist and evolve keeps sloshing ashore.

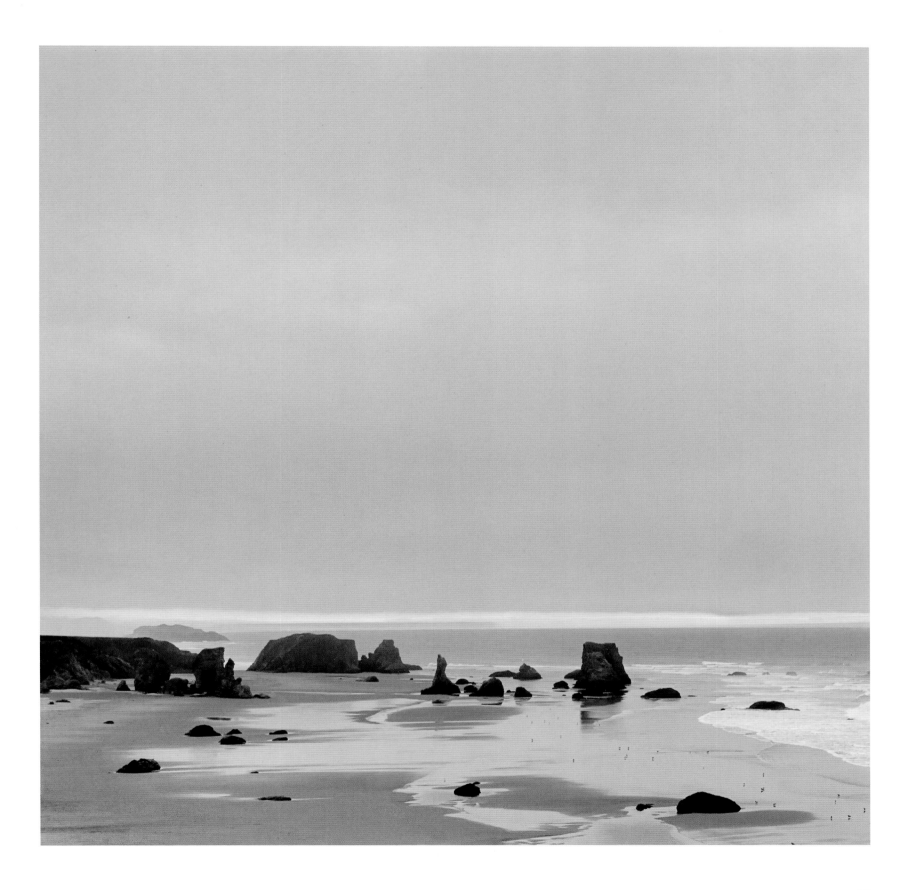

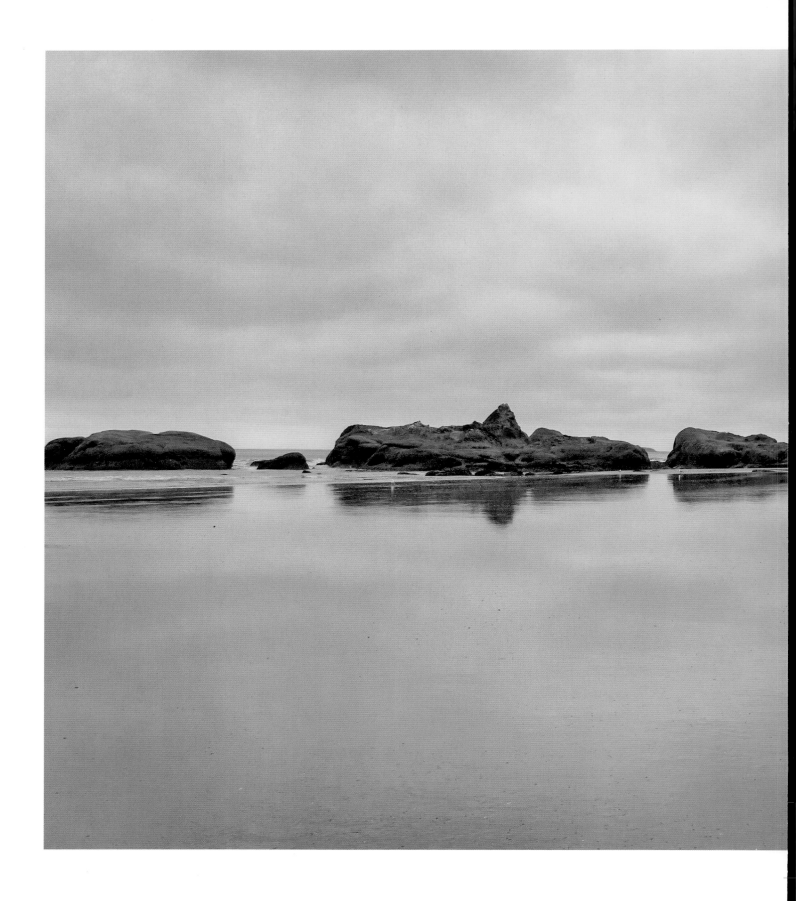

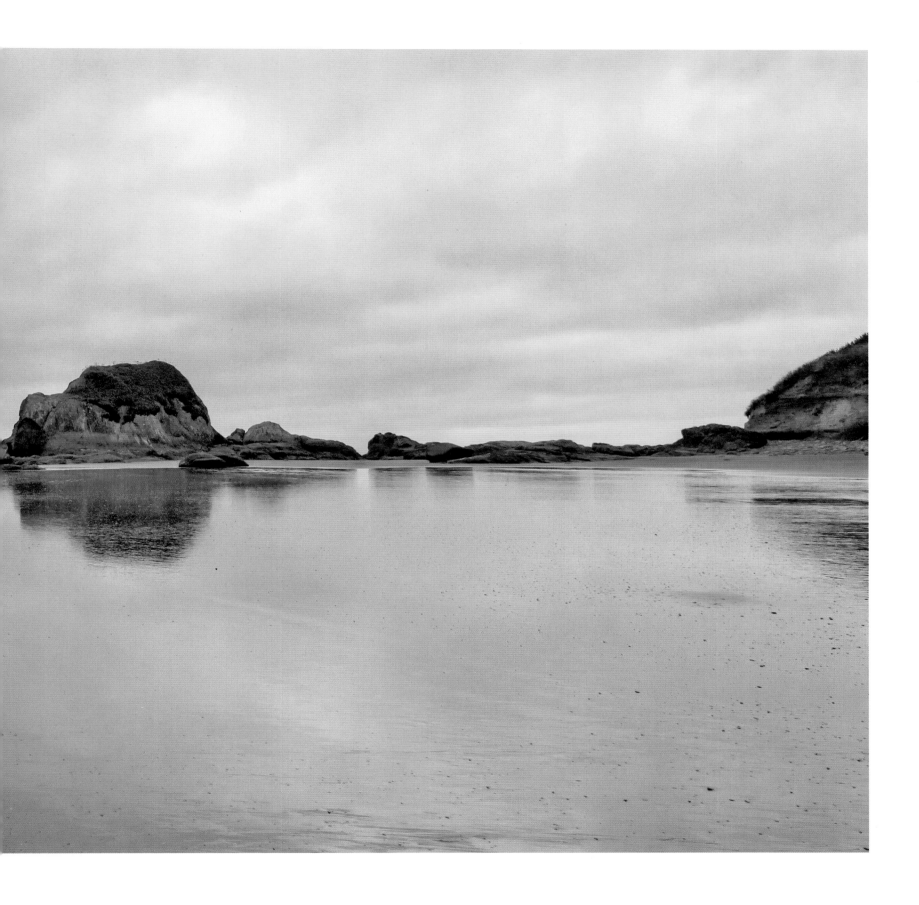

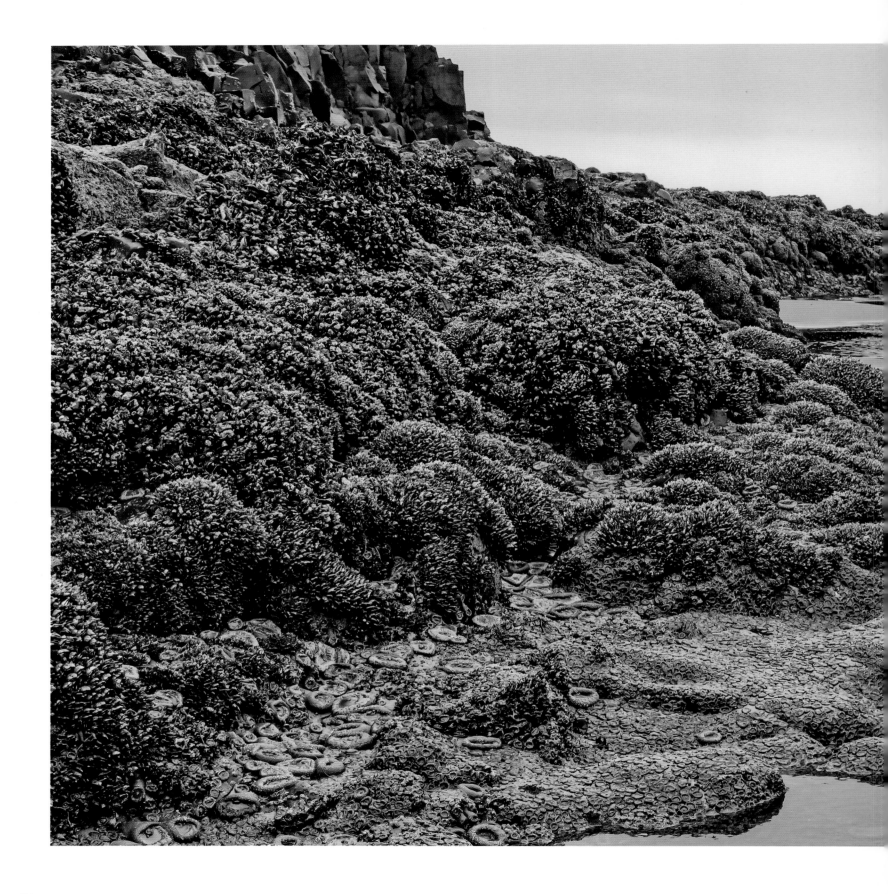

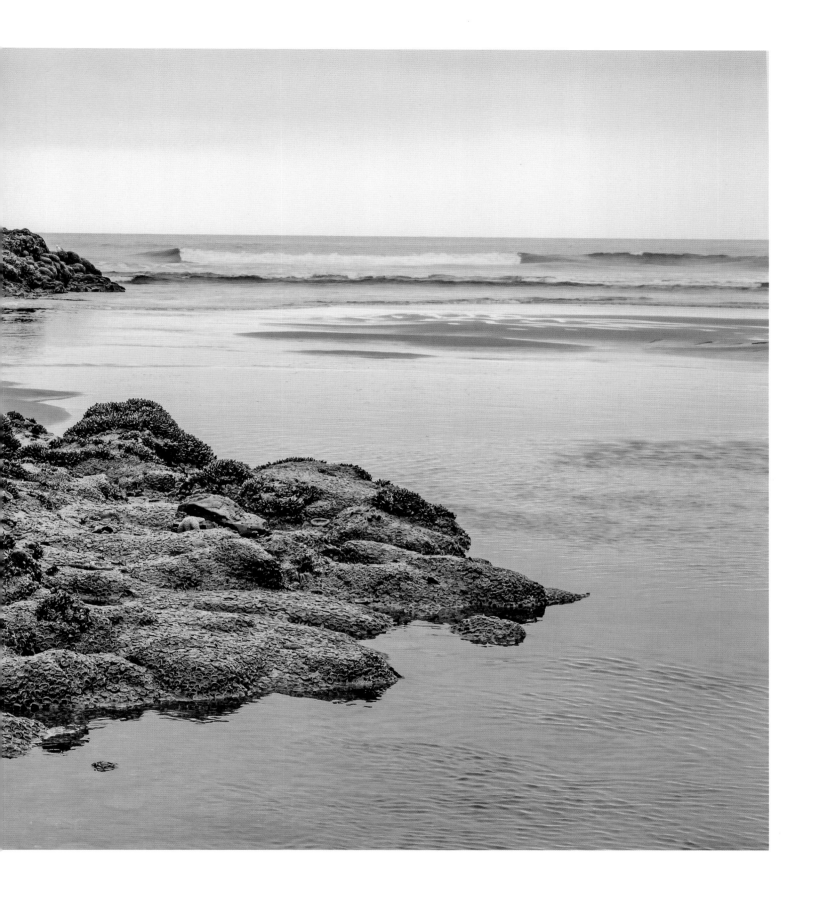

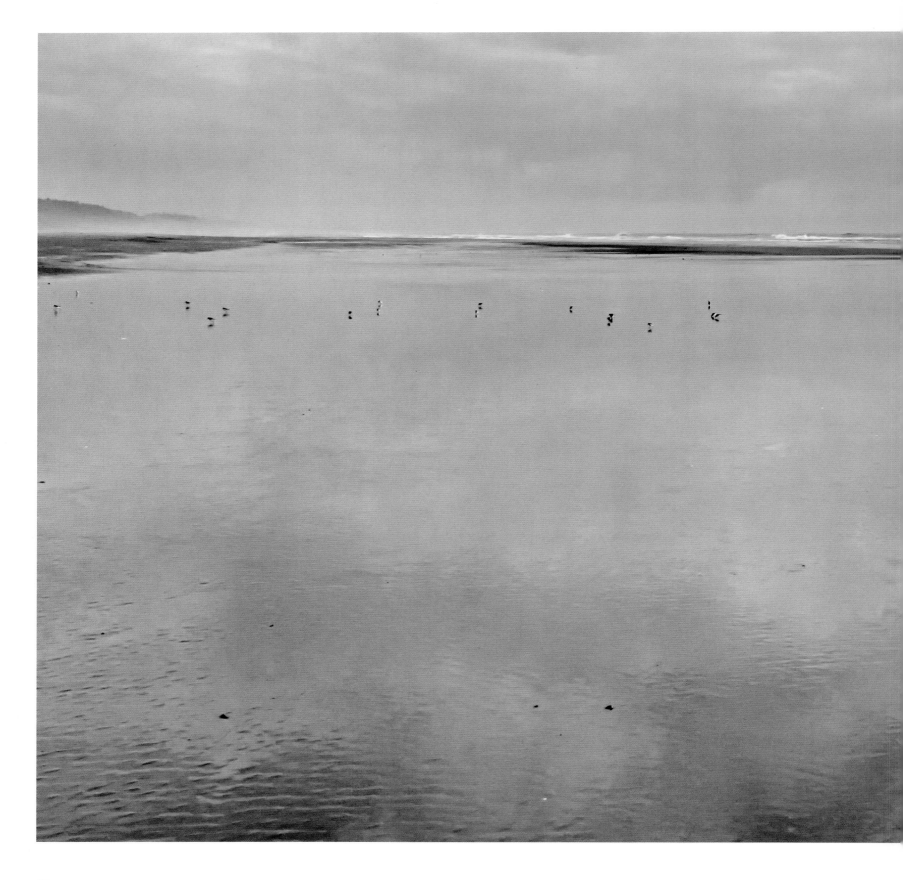

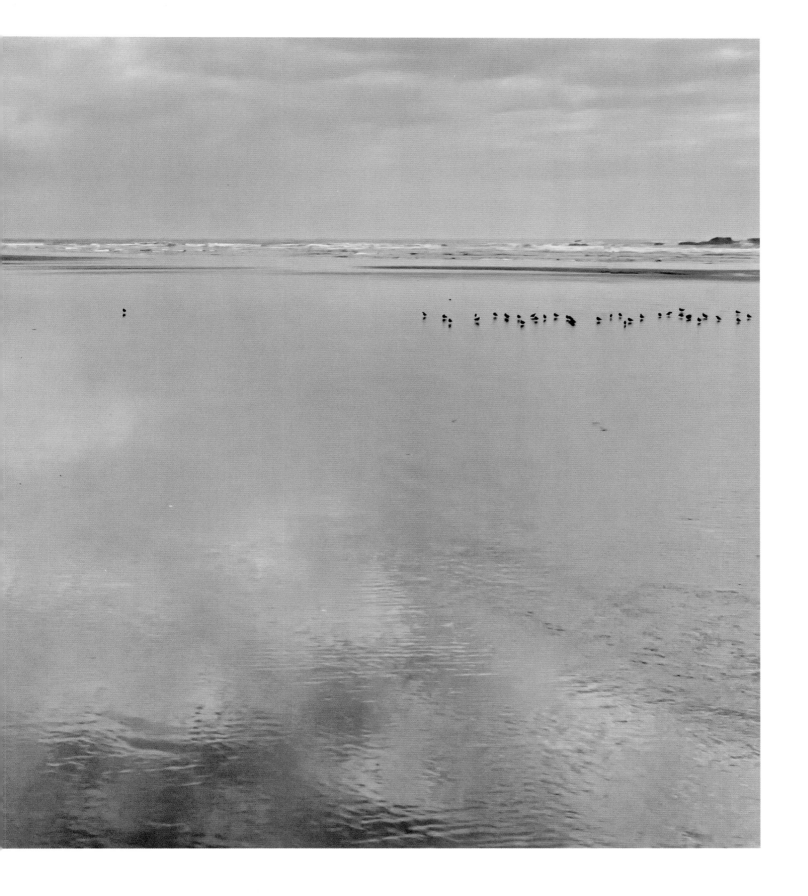

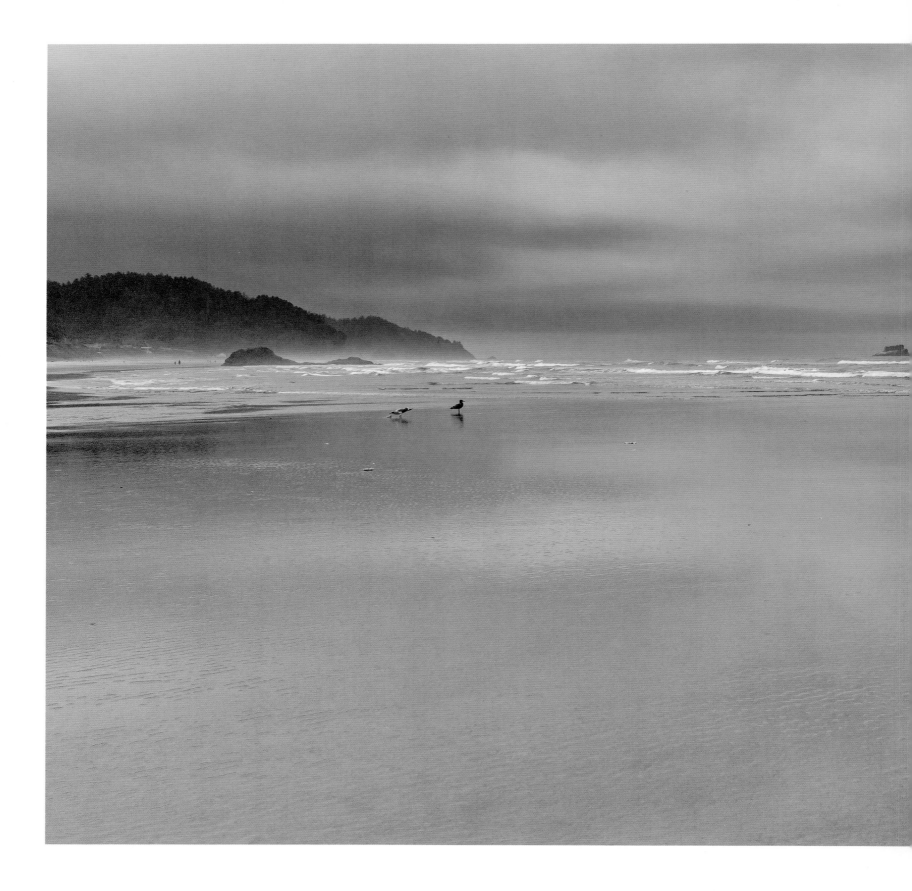

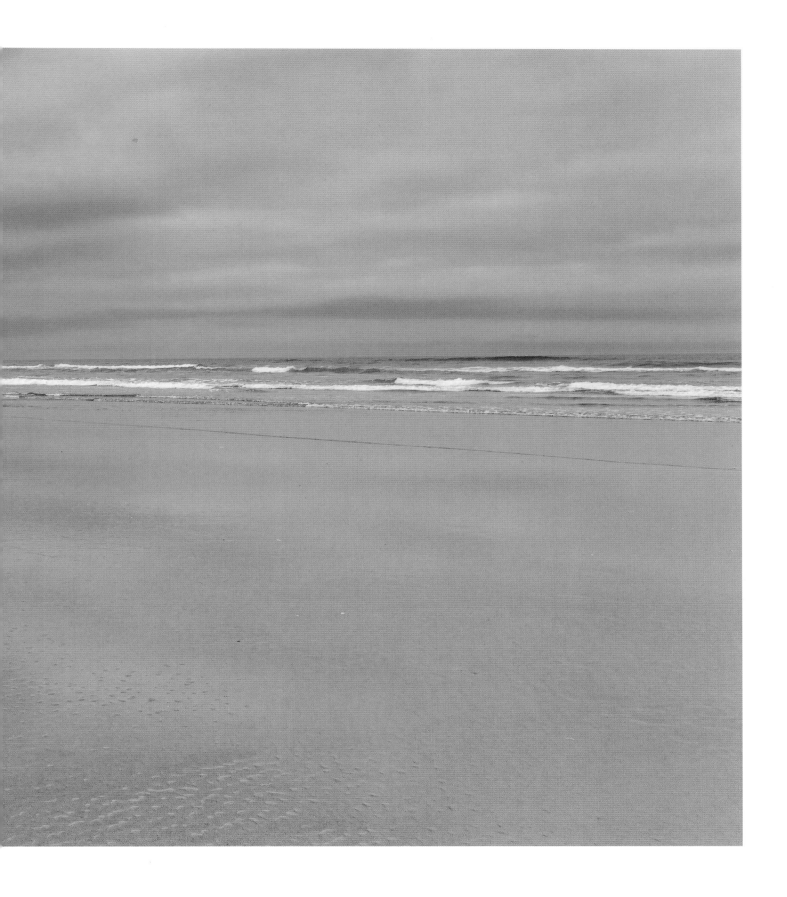

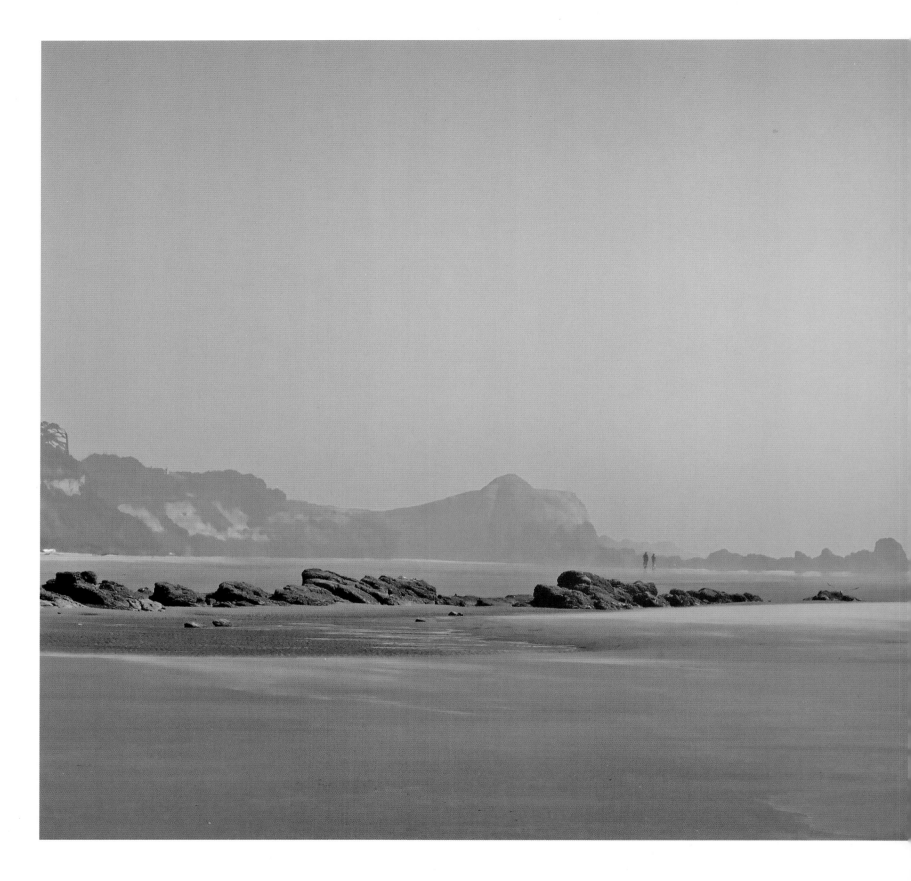

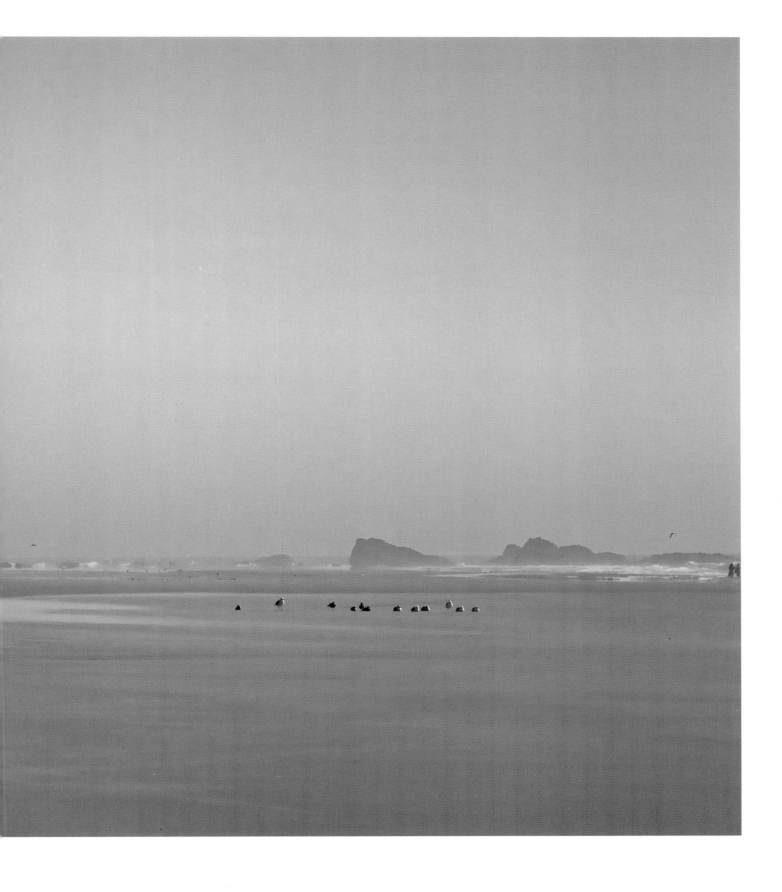

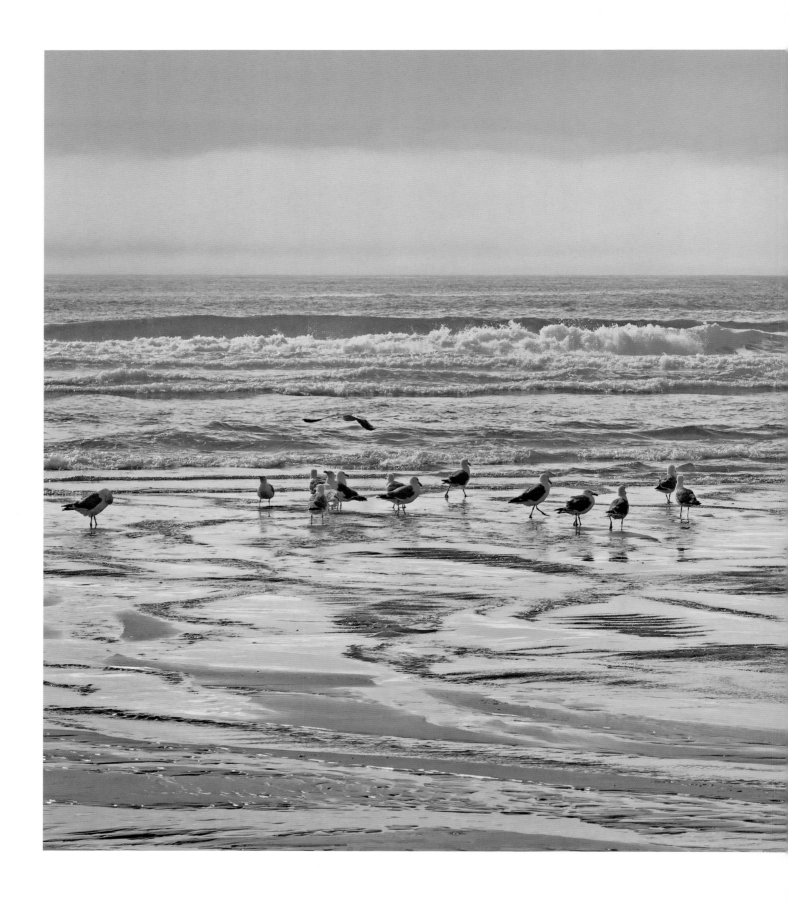

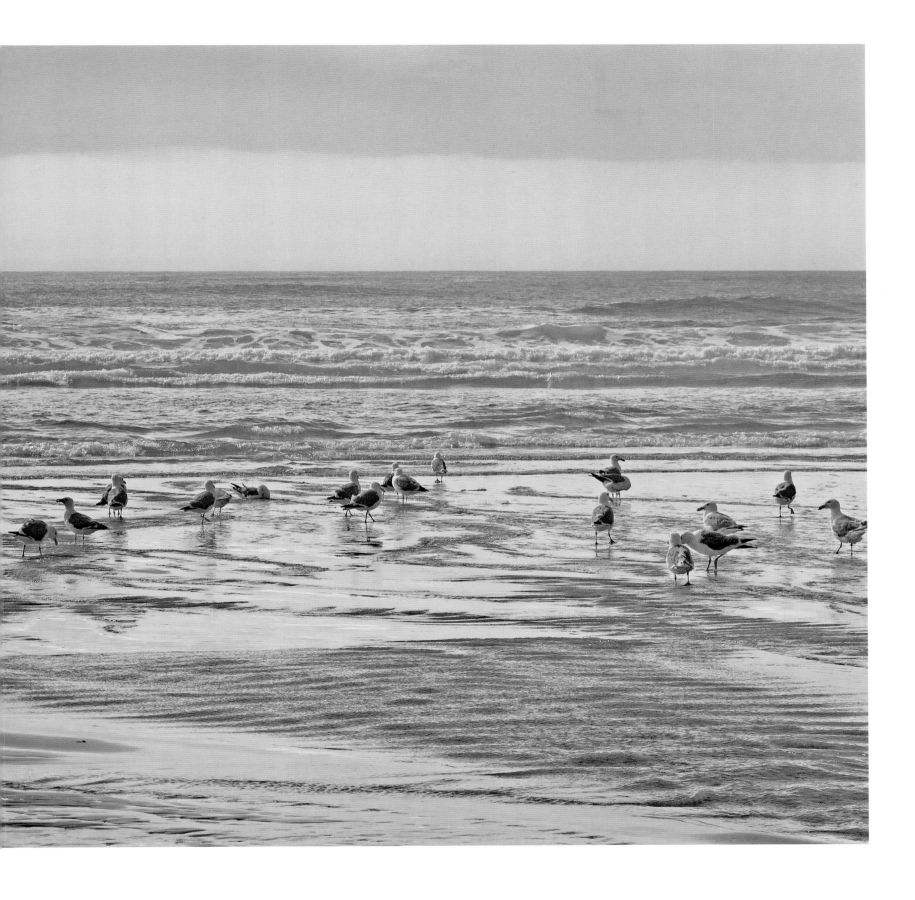

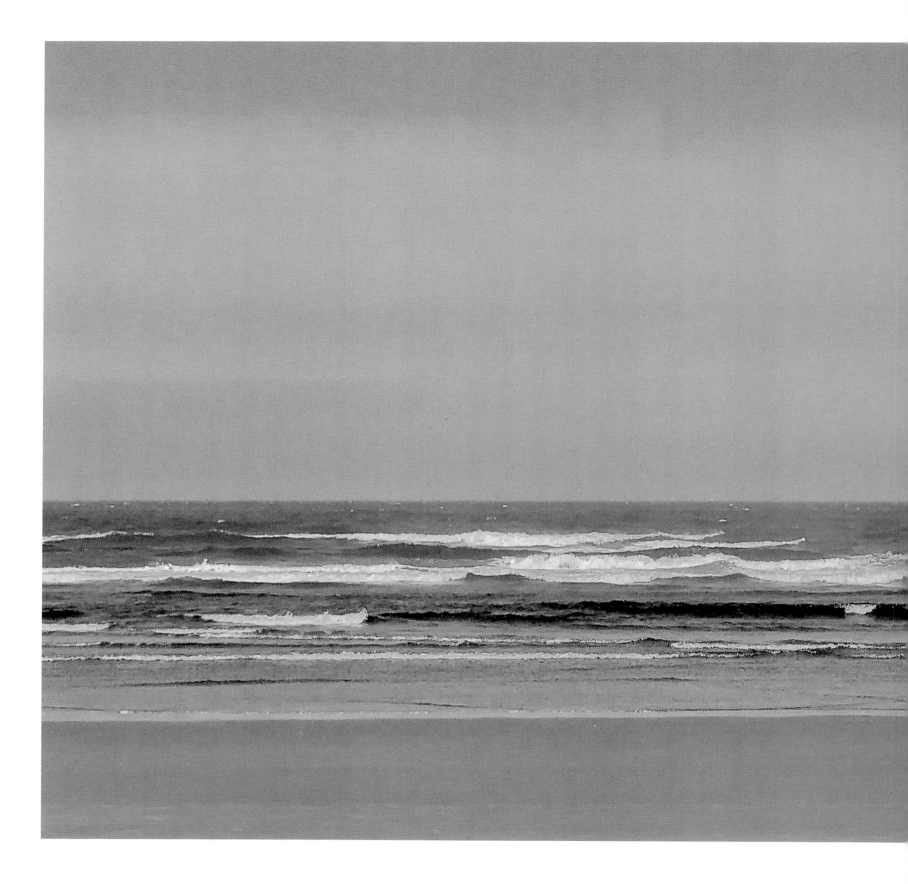

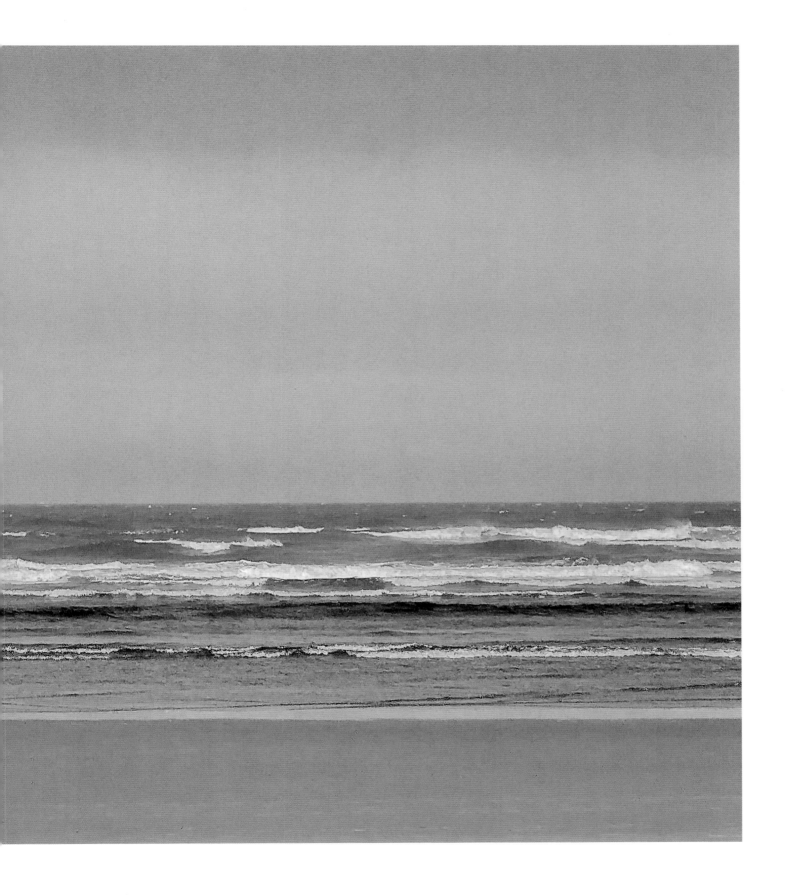

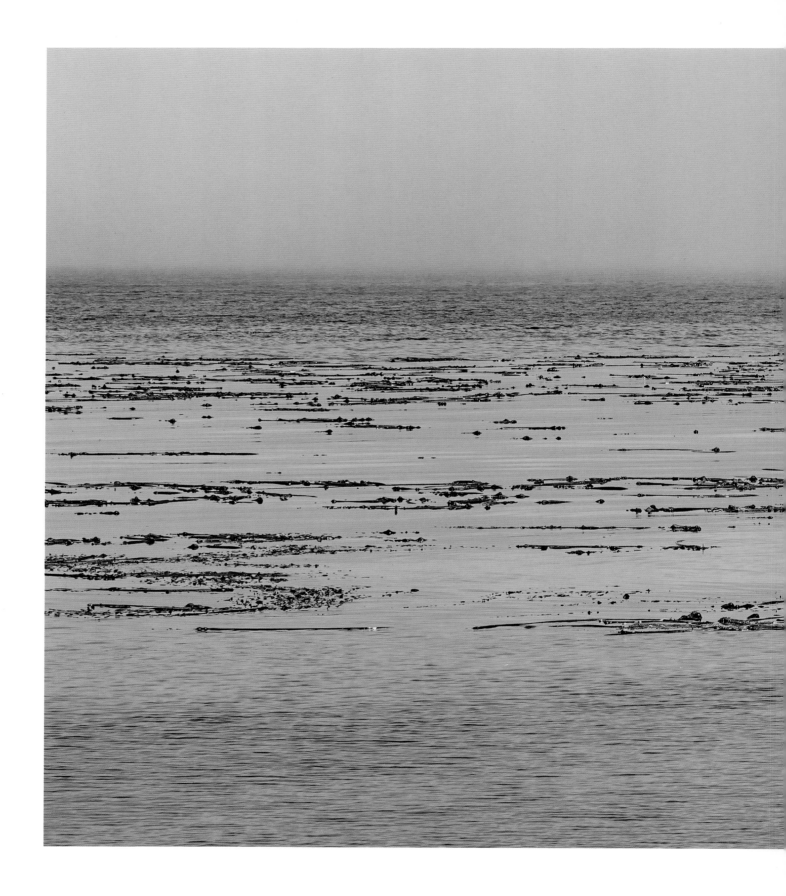

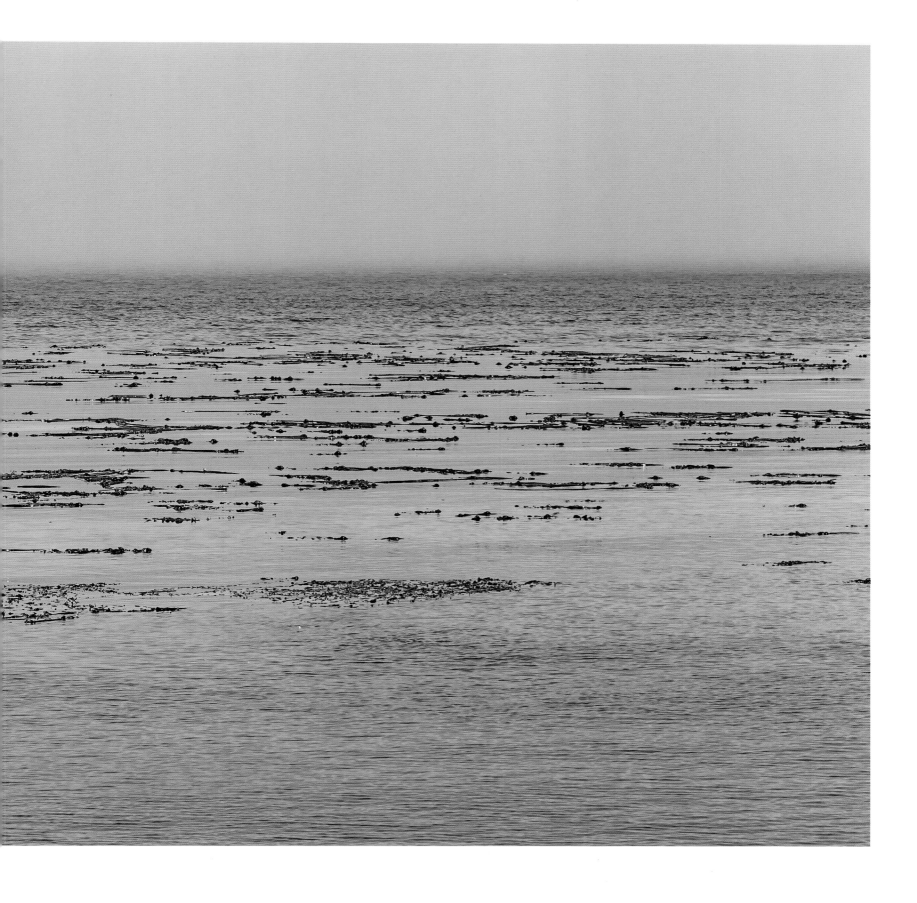

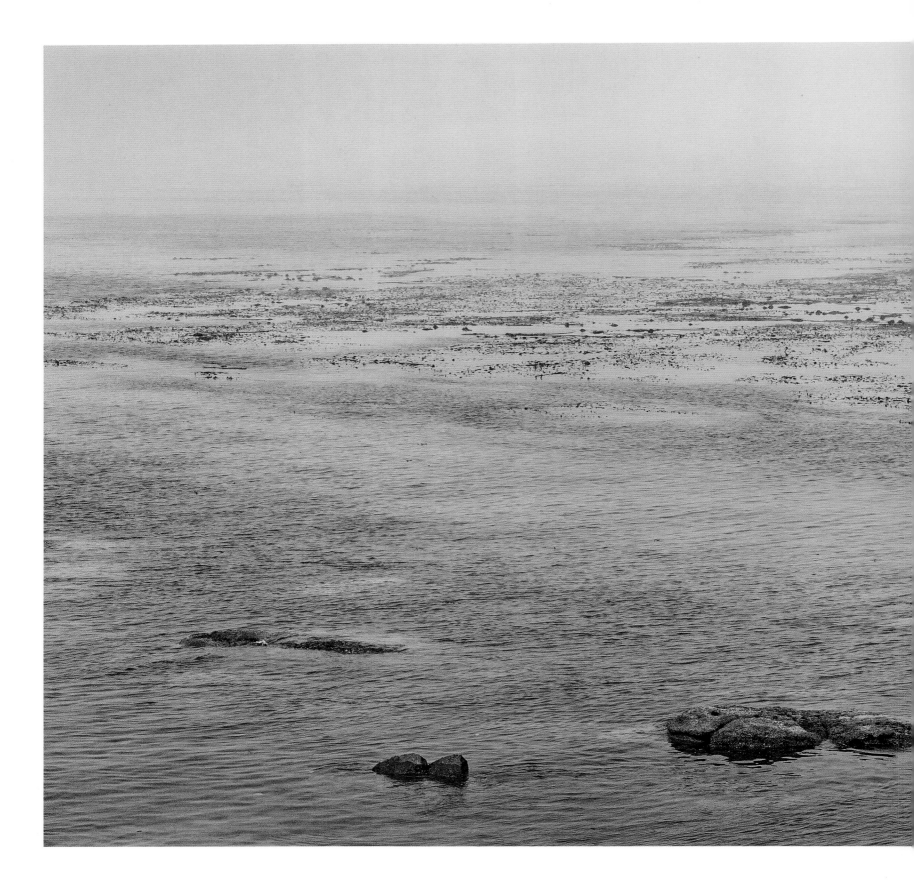

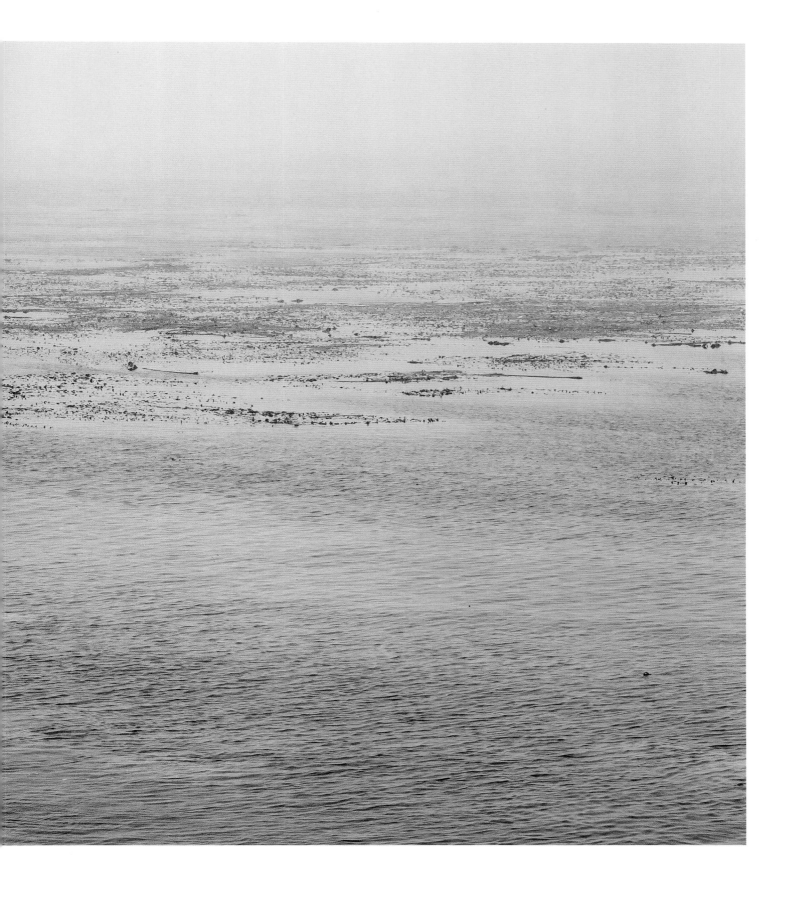

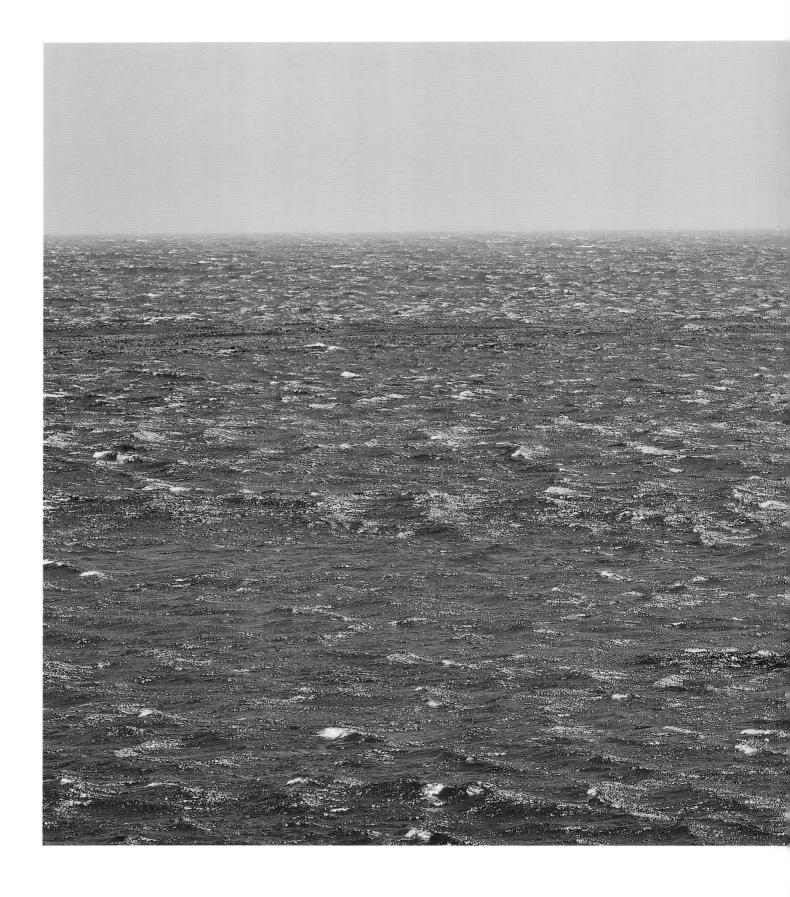

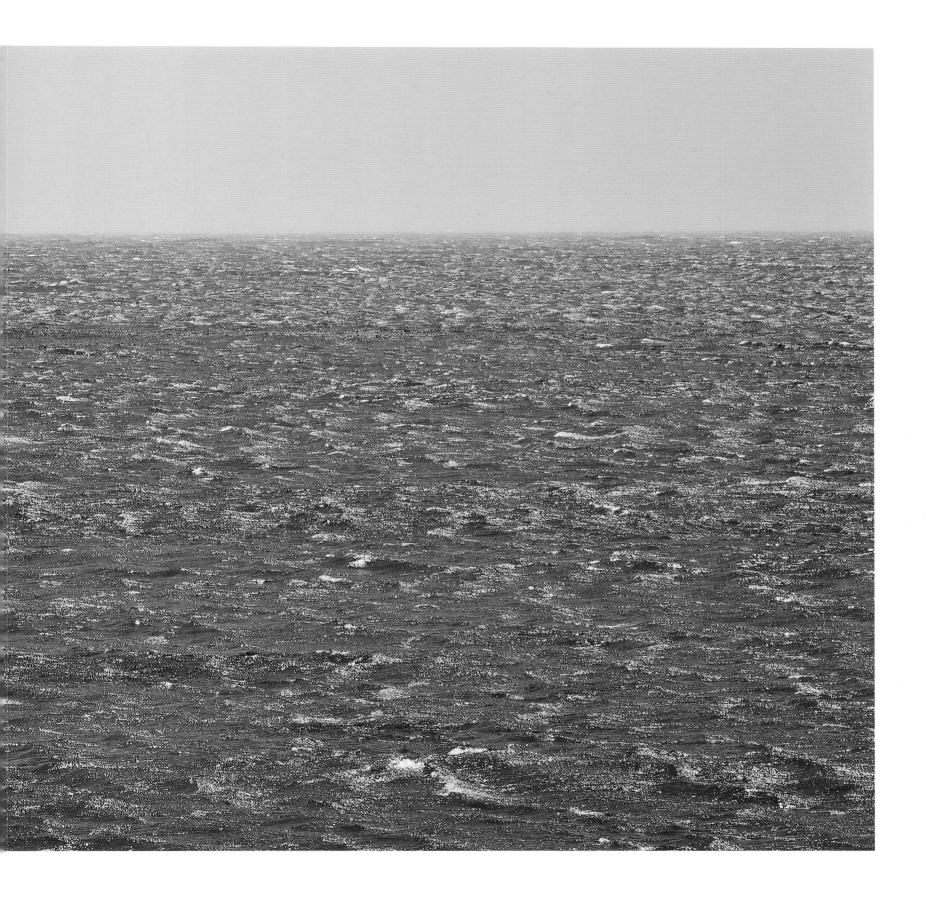

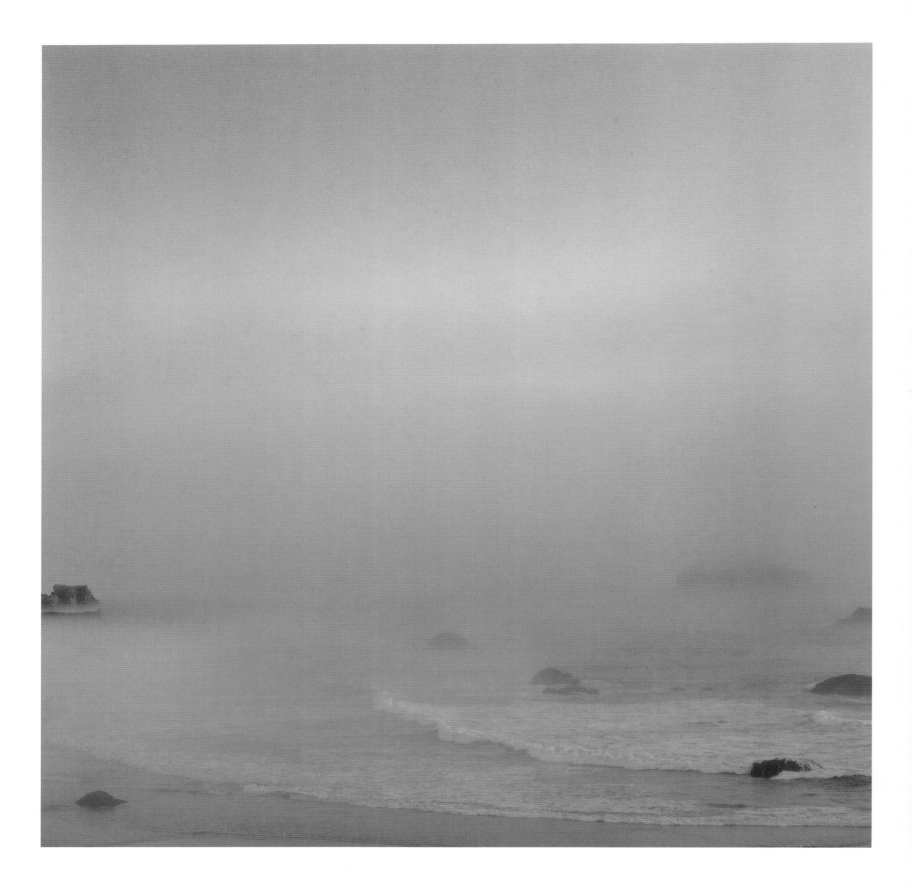

Coda: Rescues and Recoveries

. . . good-bye, good-bye—
the one continuous line
that binds us to each other.
—Louise Gluck, "End of Winter" (1992)

Ancient myths can still instruct us. Consider Ariadne, who thought her famous thread had to do with permanent rescue—Theseus's or hers—and a way out of the labyrinth and her own too-small life on an island. True, it got her out of the house and into his arms but then to a smaller island in the middle of the sea, where he left her for another. What made her think a simple thread could lead her to something other than a different kind of complication?

Ah, Ariadne. Like hers, our first thoughts in the throes of disorder—personal or global—are often ones of safety, like William Stafford's claim about a thread: "while you hold it you can't get lost." How deep the wish to believe in something magical strung through the mazes of our lives, a thrumming hum of connections deep in the oceans and in our blood, some filament we see on starry nights when constellations appear tightened and drawn and we need to feel consoled. We seekers of coherence, problem solvers on the shore eyeing the vastness of sea and sky, are easily swayed by coincidences we don't want to believe are insignificant or merely chance.

In Ariadne's story, as in our own, she likely couldn't hear the warning that few of us can heed: beware that, on the other side of quick solutions, lies the land of disappointment. Or perhaps disappointment is what readies us all for whatever corrective might come next. In her case, since salvation had first meant an Athenian hero with a sense of self-sacrifice and the promise of an orderly ever-after, it's no wonder Dionysus—god of disorder—landed on her island.

With a god like him, she can't expect rescue, which means she's at least been rescued from clinging to false hopes. Perhaps she, walking the shores of her adopted island, even made a little room for wildness in her life. This is not to say that she—like any of us—will do what's best; but that if there is a unifying thread—as Albert Einstein and other physicists have proposed—for the challenges of this universe, it likely leads to other labyrinths.

Stephen Strom's work, in linking images of abstract beauty to those other labyrinths, can shift us away from what we thought we wanted to see towards that which is actually present: the beauty of our deeply ambiguous experiences with home.

Maybe for us, here on Earth in the twenty-first century, the myths that remain viable carry a different kind of reminder. We'll likely discover not only new solutions, more openings, probably a few dead ends, strange turns, and the temptations of footprints, but also the inescapable uncertainties that give us a chance—even as we work on problems far larger than ourselves—of becoming more fully immersed and more fully conscious.

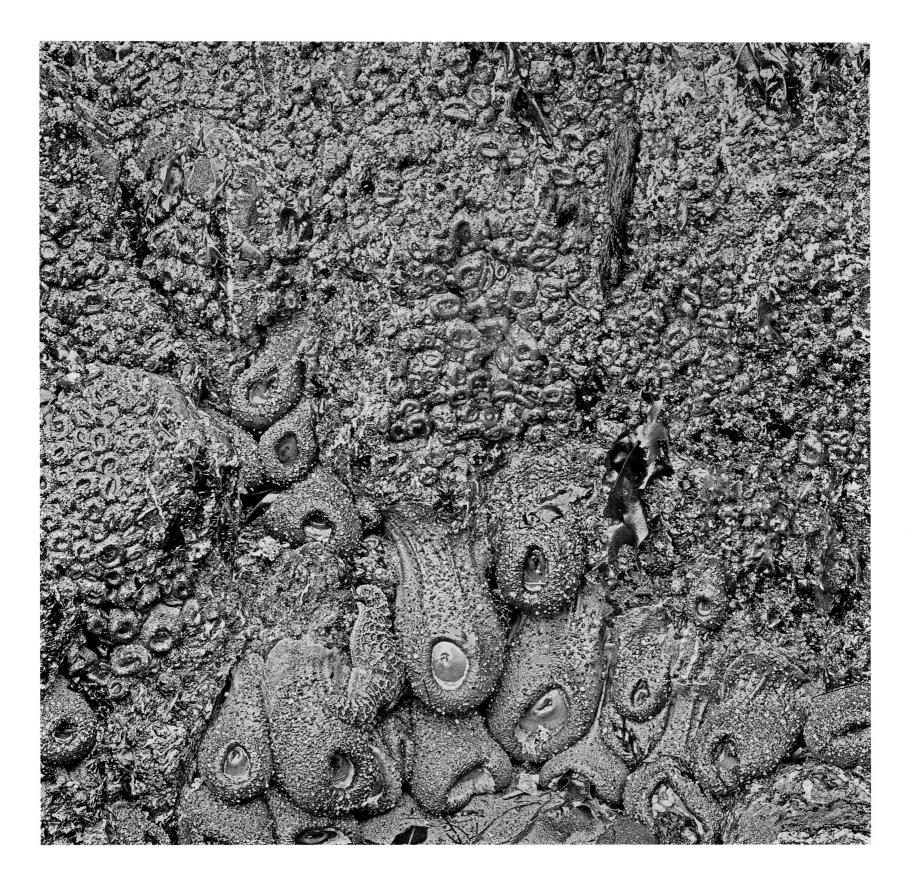

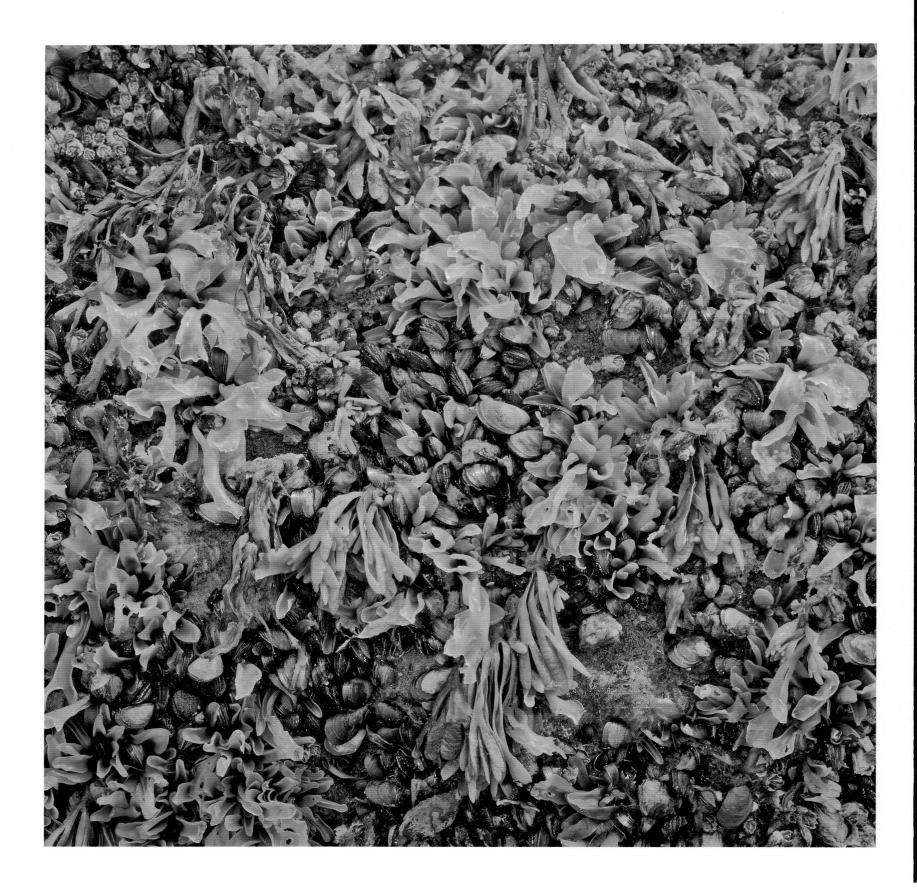

About the Craft

The images in *Tidal Rhythms* were taken from 2007 to 2015 on a variety of beaches located along the Pacific Coast, from Big Sur and Point Lobos State Park near Carmel, California, to Olympic National Park and Neah Bay on the Makah Indian Reservation beside the Strait of Juan de Fuca in Washington. In addition, there are three photographs of the beach of Puerto Peñasco, a century-old city in Sonora along the Gulf of California in Mexico. All but a few of these beaches are notable for their relative isolation and stark uplifted and eroded rocks, many set against a backdrop of richly foliated coastal cliffs.

Over these years, I chose my communion with these beaches to coincide with the lowest tides of the month: at dawn, as a full moon sets and the ocean waters recede. I am often greeted by fog and mist, wind and rhythmic surf, and, from time to time, by the occasional beachcomber seeking agates or clams. For a few hours, another world is revealed: sand engraved with transient patterns imprinted by the ebbing tide and by marine life scurrying for sustenance; flora and fauna clinging to rocks, finding nourishment before the waters return; rocks and shells polished by tide and time, arranged on a canvas of sand.

I am drawn to this world of land and sea by an irrational but nevertheless visceral sense that, somehow, I am connected to a place that might well be similar to one where life first took form a half-billion years ago. My very rational attraction to photographing pattern and rhythm is inherent to my wiring as a research astronomer who, for forty years, sought to discover patterns in the universe and understand their origin.

Capturing tidal patterns is a challenge. Life in its richness and apparent chaos clings to rocks at the edge of the sea, visible for no more than an hour or two and approachable only by careful navigation of sometimes treacherous terrain. Incoming "sneaker" waves can erase an intricately carved sand pattern in an instant. Wave patterns, sumptuous with rhythmic complexity, disappear in seconds. Light, too, can change quickly, as marine fog and sun compete with one another in landscapes first shaded, then quickly illuminated by the rising sun. Time in the intertidal zone is of the essence: for all the creatures who depend on brief exposure to air and sun and for the lone photographer seeking patterns and rhythm in what he sees.

Making photographs under these conditions requires rapid adaptation. The arrival of digital cameras and the ability to adjust the gain of their sensors to changing circumstances was, at least for me, critical to capturing the transient patterns of and by the sea, often in low-light conditions. To be prepared for various conditions, I carried one or two digital single-lens reflex cameras (in my case, a Canon EOS 5D Mark II): one equipped with a 50mm macro lens and the other with a 28–105 zoom. After several years of experimentation in the field, I decided to hand hold the cameras.

Carrying a tripod to tidal pools or stacks at the edge of the intertidal zone compounds artistic and physical risk and reduces flexibility to respond to rapidly changing scenes. Hand holding the camera would normally mean that the exposure time in reciprocal seconds should be approximately equal to the focal length of a lens. Thus, photographing with a 50mm lens requires an exposure time of 1/50 of a second at ISO settings that minimize sensor noise. Image motion-compensating lenses allow me to shoot at 1/25 or even 1/10 of a second, if my hands are steady, and those lenses are a must in order to reduce the need to take images at a high-sensor gain (high ISO), as high-sensor gain captures images with a good deal of noise.

Many of the images in *Tidal Rhythms* cover a wide range of distances, and thus small lens openings (f/22 as opposed to, say, f/4) preserve focus. Determining the combination of depth of field (f-stop), sensor gain (ISO setting), and time of exposure appropriate to a scene is a matter of experience often gained painfully by trial and disappointing error. When everything in the process becomes reflexive (or almost so), however, that experience is rewarded by capturing a precious instant in time as a hoped-for work of art.

Waiting for Cartier-Bresson's "decisive moment," however, is a fool's errand. Ultimately, one has to sense what a photograph might be and use the camera to record it. Where possible, I exploit the digital revolution and make use of the ability to record large numbers of images to experiment: to identify a subject of interest and take multiple images, often from a variety of perspectives. As anyone who visits a beach knows, silicon (a constituent of the chips on which digital data are recorded) is plentiful!

As for processing, I use Adobe Lightroom and Photoshop. My adjustments are relatively modest, mostly cropping and adjusting brightness and contrast. If there is a highlight that needs to be toned down, I make use of the digital equivalents of the dodging and burning I once did in the darkroom. What I seek, of course, is something more enduring than a precious instant in time.

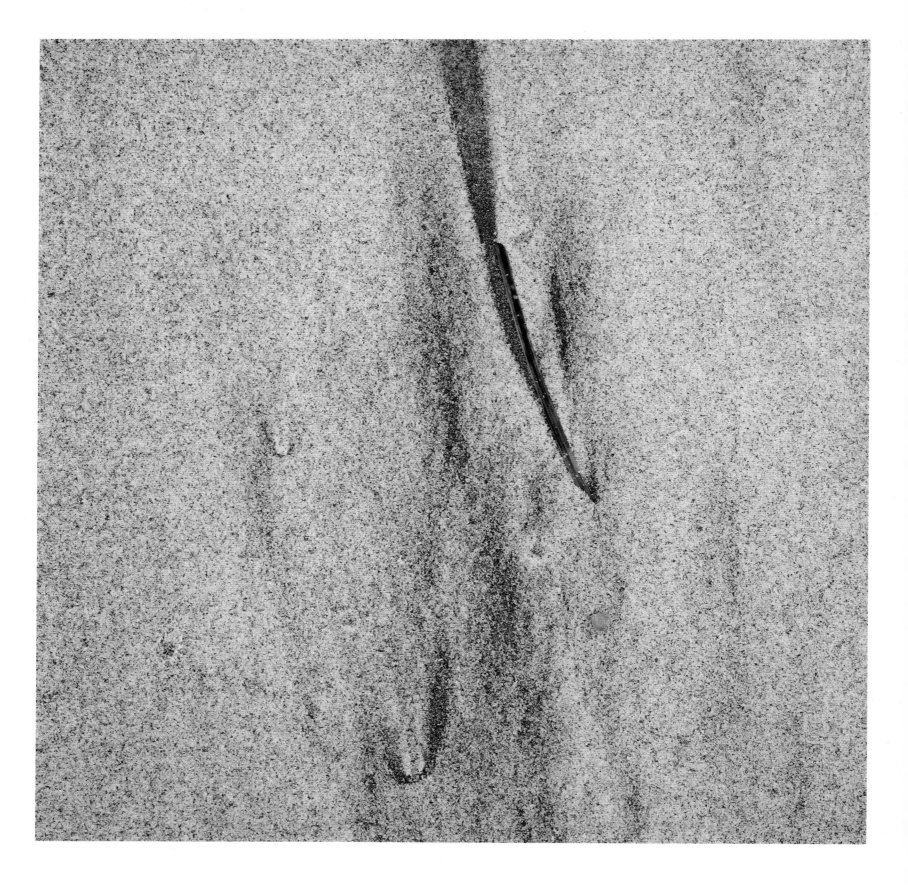

Acknowledgments

First and foremost, I wish to thank Karen, my late wife of fifty-four years, who accompanied me on all but the last of my explorations of the Pacific and Gulf of California Coasts and who provided inspiration throughout. Our long-time friends Richard and Sidney Wolff, Gwyn Enright, and Oliver Ryder provided helpful feedback and good fellowship. The staff at the Etherton Gallery in Tucson, Arizona, and Verve Gallery in Santa Fe, New Mexico, provided both keen criticism and wall space for images from *Tidal Rhythms*. Rebecca A. Senf, Norton Family Curator of Photography at the Center for Creative Photography at the University of Arizona in Tucson, deserves thanks as well not only for her critical insight, but for encouraging me to move forward, following Karen's passing. Julie Strom identified the broad variety of marine life manifest in my images; thanks for your keen eye developed while helping others understand intertidal ecosystems. Thanks go as well to John and Wilson Scanlan, who, during the past decade, have provided support, encouragement, and a superb venue for exhibiting my work. Finally, I wish to express deep gratitude to Barbara Hurd, for bringing her voice and vision to *Tidal Rhythms*, and to George Thompson, Mikki Soroczak, David Skolkin, and GFT Publishing, for the loving care they afforded *Tidal Rhythms* from the beginning.

—STEPHEN E. STROM

Gratitude, always, to my husband, Stephen Dunn, for his discerning eye, steady support, and generous love. Thanks, also, to the "retreat group," for fine fellowship and help with polishing these pieces: Larry and Judy Raab, Madeleine Deininger, and CJ Moll. As always, I am grateful to the writing community in Frostburg, Maryland, for years of camaraderie and keen insights. I also want to thank Stephen Strom, for his brilliant artistry and for inviting me into this project.

—BARBARA HURD

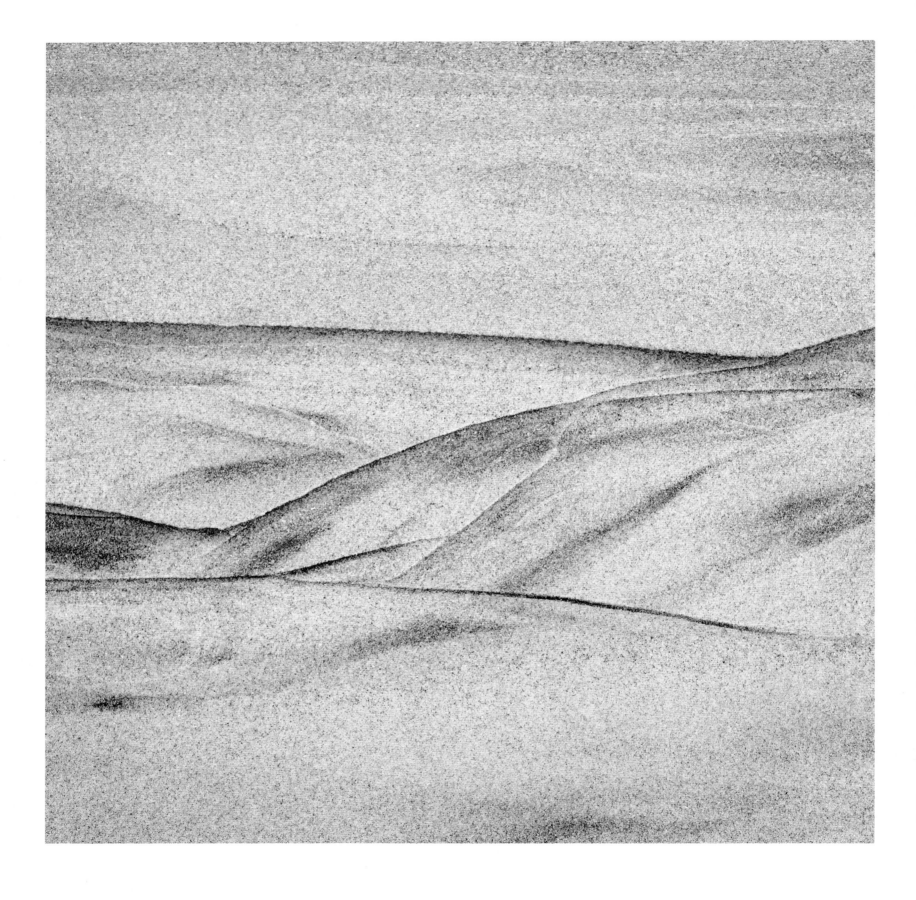

Works Cited

Gluck, Louise, *The Wild Iris* (Hopewell, NJ: The Ecco Press, 1992), 10–11.

Greene, Graham, *The End of the Affair* (London, UK: William Heinemann and New York, NY: Viking Press, 1951), 178.

Klima, Ivan, *Waiting for the Dark, Waiting for the Light: A Novel* (New York, NY: Macmillan, 1996), 40.

Lord Byron, George Gordon, an excerpt from "Childe Harold's Pilgrimage," Canto Four, Stanzas 178–186 (London, UK: John Murray, 1818); available online at http://knarf.english.upenn.edu/Byron/charold4.html.

Melville, Herman, *Moby-Dick, or, The Whale* (New York, NY: Harper & Brothers, 1851), 3.

Milton, John, *Paradise Lost*, Book II, 890 (London, UK, Samuel Simmons, 1667); available online at http://www.bartleby.com/4/402.html.

Pope Francis, *Laudato Si, Mi' Signore,* an encyclical letter on care for our common home (Rome, Italy: The Vatican, May 24, 2015); available online at http://www.vatican.va.

Stafford, William, *The Way It Is* (Saint Paul, MN: Graywolf Press, 1998), 42.

Stegner, Wallace, *Marking the Sparrow's Fall: The Making of the American West* (New York, NY: Henry Holt, 1998), 151.

Valery, Paul, *Sea Shells* (Boston, MA: Beacon Press, 1964), 29.

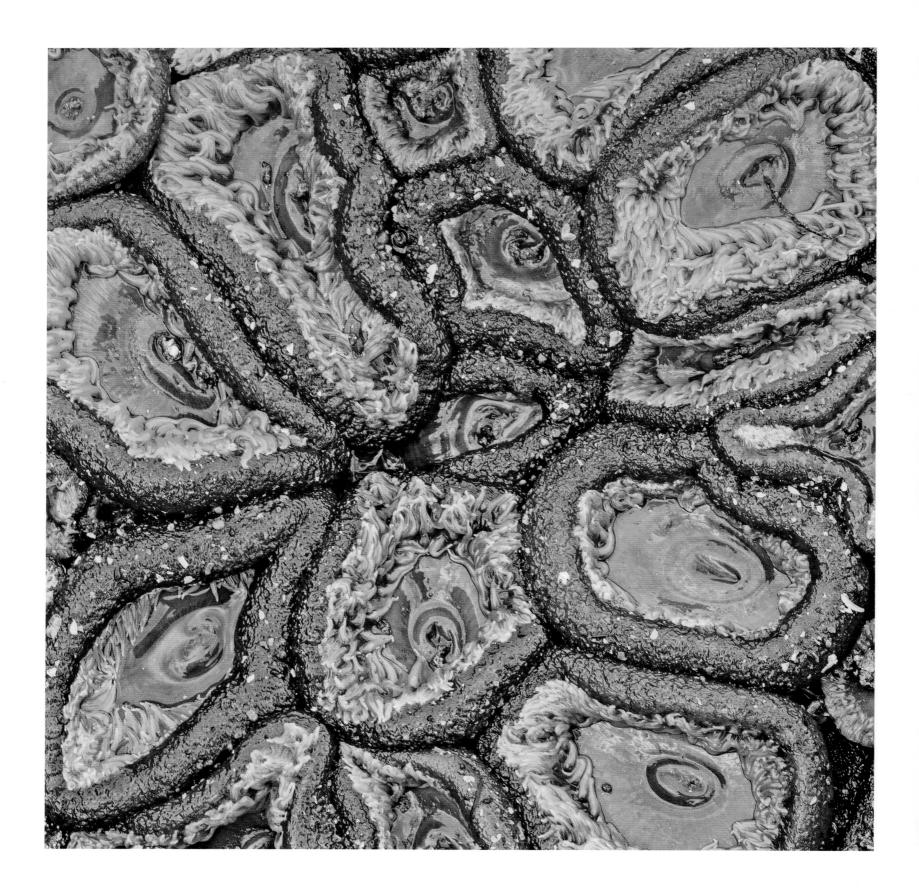

Further Readings

Carson, Rachel, *At the Edge of the Sea* (Boston, MA: Houghton Mifflin, 1955) and *The Sea Around Us* (New York, NY: Oxford University Press, 1951).

Dillard, Annie, *For the Time Being* (New York, NY: Alfred A. Knopf, 1999).

Duncan, David James, *My Story as Told by Water: Confessions, Druidic Rants, Reflections, Bird-watchings, Fish-stalkings, Visions, Songs and Prayers Refracting Light, From Living Rivers, in the Age of the Industrial Dark* (Berkeley, CA: Counterpoint, 2002).

Gosse, Philip Henry, *Actinologia Britannica: A History of the British Sea-anemones and Corals, with Coloured Figures of the Species and Principal Varieties* (London, UK: Van Voorst, 1860).

Hamilton, Edith, *Mythology: Timeless Tales of Gods and Heroes* (New York, NY: Grand Central Publishing, 2011).

Jeffers, Robinson, *The Selected Poetry of Robinson Jeffers* (Stanford, CA: Stanford University Press, 2002).

Keener, Victoria, John Marra, et al., *Climate Change and Pacific Islands: Indicators and Impacts: Report for the 2012 Pacific Islands Regional Climate Assessment* (Washington, DC: National Climate Assessment, 2013).

Kolbert, Elizabeth, *The Sixth Extinction: An Unnatural History* (New York, NY: Henry Holt, 2014).

Kozloff, Eugene, *Seashore Life of the Northern Pacific Coast: An Illustrated Guide to Northern California, Oregon, Washington, and British Columbia* (Seattle, WA: University of Washington Press, 1983).

McPhee, John, *Annals of the Former World* (New York, NY: Farrar, Straus and Giroux, 2000).

Ricketts, Edward, and Jack Calvin, *Between Pacific Tides*, Fifth Edition (Stanford, CA: Stanford University Press, 1992).

St. Augustine, *The Confessions of Saint Augustine*, Book XI (originally published in Latin between 397–400 CE); available online at http://www.ccel.org/a/augustine/confessions/.

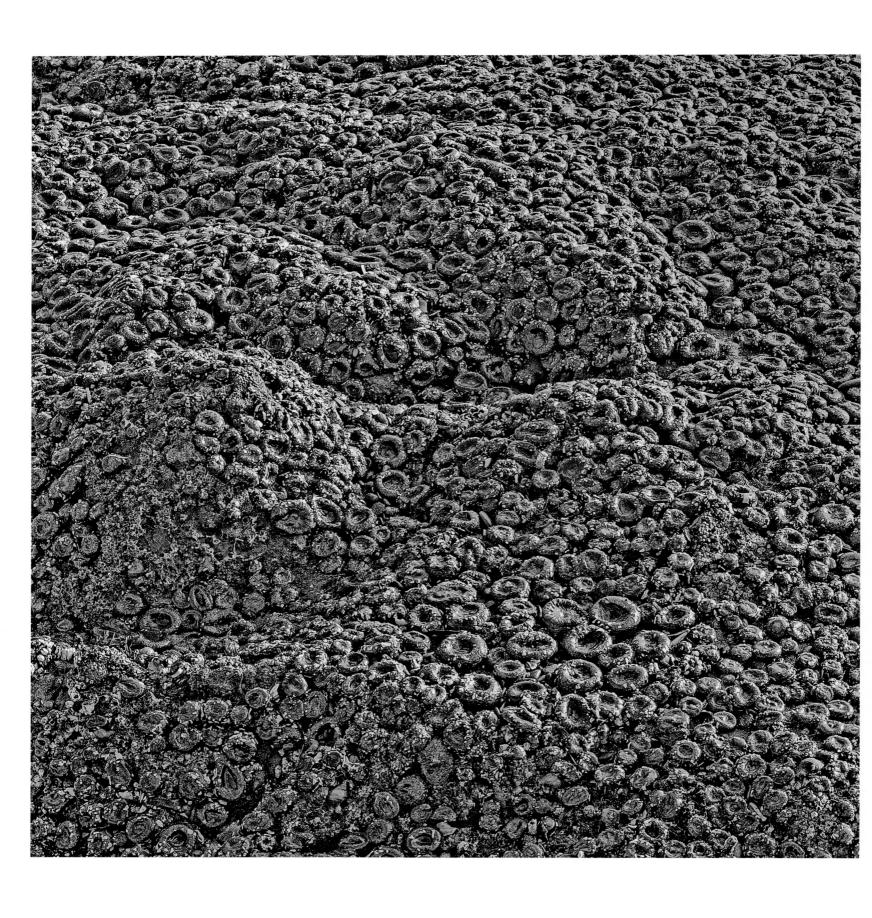

List of Photographs

Compiled with the assistance of Julie Strom.

Front Matter

Oceans: Refrains

Sand: Pattern and Mutability

37 Water on sand reflecting sky, Harris Beach, OR: 2010.

38 Outgoing tide and sand, inlet near Yachats River, OR 2014

39 Sand pattern, inlet near Yachats River, OR 2014.

41 Sand pattern, Gold Beach, OR 2010.

42 Sand pattern, inlet near Yachats River, OR, 2014.

43 Wet sand with a gull's feather, Harris Beach, OR: 2011.

44 Wet sand, Clam Beach, near Arcata, CA: 2010.

45 Snail tracks, Seal Rock Beach, OR: 2011.

46 Sand pattern, inlet near Yachats River, OR 2014.

47 Snail tracks, Smelt Sands Beach, near Yachats, OR: 2011.

49 Wind-blown sand pattern, Clam Beach, near Arcata, CA: 2011.

50 Wet sand pattern, Harris Beach, OR: 2013.

51 Sand pattern, Smelt Sands Beach, OR 2011

52 Sand dune, Clam Beach, near Arcata, CA: 2014.

53 Sand dunes, Clam Beach, near Arcata, CA: 2014.

55 Sand pattern, Harris Beach, OR: 2011.

56 Sand pattern, Harris Beach, OR: 2013.

57 Wet sand and water, Ona Beach, OR: 2014.

58 Sand and ground seashell pattern, Harris Beach, OR: 2010.

59 Sand and ground seashell pattern, Harris Beach, OR: 2011.

Flora: Underwater Forests

65 Close up, algae (*Codium setcheli*) with black turban snail
 (*Tegula funebralis*), Hug Beach, OR: 2015.

66 Intertwined feather boa kelp (*Egregia menziesii*), Face Rock Beach,
 OR: 2014.

67 Feather boa kelp (*Egregia menziesii*), Seal Rock Beach, OR: 2013.

69 Little rockweed (*Pelvetiopsis limitata*), Smelt Sands Beach,
 near Yachats, OR: 2013.

70 Little rockweed (*Pelvetiopsis limitata*) and blue mussels (*Mytilus edulis*), Smelt Sands Beach, near Yachats, OR: 2013.

71 Little rockweed (*Pelvetiopsis limitata*), Smelt Sands Beach, near Yachats, OR: 2014.

72 Surfgrass (*Phyllospadix scouleri*), Ona Beach, OR: 2011.

73 Surfgrass (*Phyllospadix scouleri*), Ona Beach, OR: 2010.

74 Surfgrass (*Phyllospadix scouleri*) and sand, Ona Beach, OR: 2013.

75 Bleached surf grass (*Phyllospadix scouleri*), Smelt Sands Beach, near Yachats, OR: 2010.

76 Sea grass and rock, Ona Beach, OR: 2010.

77 Sea grass and rock, Ona Beach, OR: 2010.

79 Seaweed, ground seashells, and sand, Harris Beach, OR: 2010.

81 Giant kelp (*Macrocustis pyrifera*), surf, and wet sand, Smelt Sands Beach, near Yachats, OR: 2011.

Fauna: Attachments

87 Gooseneck barnacle colony (*Pollicipes polymerus*), Olympic National Park, WA: 2015.

88 California mussels (*Mytilus californianus*) and gooseneck barnacles (*Pollicipes polymerus*), Face Rock Beach, near Bandon, OR: 2011.

89 Blue mussels (*Mytilus trossulus*), acorn barnacles (*Balanus glandula*), and rockweed (*Pelvetiopsis limitata*), Smelt Sands Beach, near Yachats, OR: 2013.

90 California mussels (*Mytilus californianus*), gooseneck barnacles (*Pallicipes polymerus*), and clumps of algae, Seal Rock Beach, OR: 2014.

91 California mussels (*Mytilus californianus*), gooseneck barnacles (*Pallicipes polymerus*), and clumps of algae, Seal Rock Beach, OR: 2014.

93 Mussels, purple sea urchin (*Strongylocentrotus pupuratas*), ribbed limpets (*Lottia pelta*), and black turban snail (*Tegula funebralis*), Point Lobos State Park, CA: 2013.

94 Black turban snail (*Tegula funebralis*), purple sea urchin (*Strongylocentrotus pupuratas*), ribbed limpets (*Lottia digitalis*), empty mussel shells (*Mytilus*), and coralline seaweed (*Bossiella and Corallinales*), Point Lobos State Park, CA: 2013.

95 Black turban snail (*Tegula funebralis*), purple sea urchin
 (*Strongylocentrotus pupuratas*), ribbed limpets (*Lottia digitalis*),
 California mussel (*Mytilus californianus*), and black leather chiton
 (*Katharina tunicata*), Point Lobos State Park, CA: 2013.

96 Ribbed limpets (*Lottia digitalis*), black turban snail (*Tegula funebralis*),
 and encrusted coralline seaweed (*Lithothamnion*), Point Lobos State Park,
 CA: 2013.

97 Ribbed limpets (*Lottia digitalis*), black turban snail (*Tegula funebralis*),
 northern striped dogwinkle (*Nucella ostrina*), and encrusted coralline
 seaweed (*Lithothamnion*), Point Lobos State Park, CA: 2013.

99 Blue mussels (*Mytilus trossulus*), aggregating anemones (*Anthopleura
 elegantissima*), and clusters of acorn barnacles (*Balanus glandula*), Smelt
 Sands Beach, near Yachats, OR: 2008.

100 Seashell fragments and aggregate giant green anemones (*Anthopleura
 xanthogrammica*), Point Lobos State Park, CA: 2011.

101 Northern feather duster worms (*Eudistylia vancouveri*), Olympic National
 Park, WA: 2015.

102 California mussels (*Mytilus californianus*) and acorn barnacles (*Balanus
 glandula*), Smelt Sands Beach, near Yachats, OR: 2011.

103 California mussels (*Mytilus californianus*), gooseneck barnacles (*Pollicipes
 polymerus*), and acorn barnacles (*Balanus glandula*), Smelt Sands Beach,
 near Yachats, OR: 2007.

104 Gooseneck barnacles (*Pollicipes polymerus*), giant green anemones
 (*Anthopleura xanthogrammica*), ochre sea star (*Pisaster ochraceus*),
 and encrusted coralline seaweed (*Lithothamnion*), Smelt Sands Beach,
 OR: 2007.

105 Acorn barnacles (*Balanus glandula*), blue mussels (*Mytilus trossulus*),
 and limpets, Smelt Sands Beach, near Yachats, OR: 2007.

Rocks: Imagining Time

111 Sand pattern and polished rocks, Smelt Sands Beach, near Yachats,
 OR: 2010.

112 Polished rocks, near Yaquina Head, OR: 2014.

113 Polished rocks, Olympic National Park, WA: 2015.

114 Rock wall after rain, Ona Beach, OR: 2013.

Horizons: What Endures

Coda: Rescues and Recoveries

Back Matter

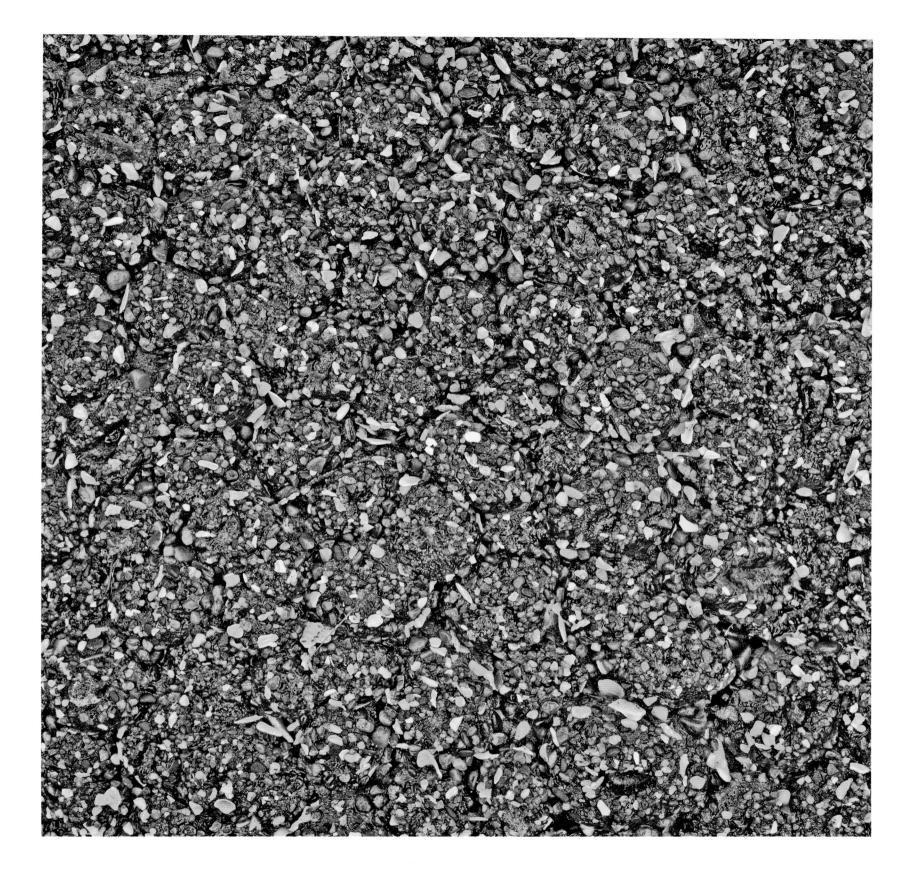

About the Essayist

Barbara Hurd was born in 1949 in Detroit, Michigan, and grew up near Boston and Philadelphia. She completed her B.A. at the College of William and Mary and her Ed.D at the University of Maryland. She taught for thirty years at Frostburg State University and currently teaches at the Vermont College of Fine Arts. Her essays have appeared in *Audubon, Bellingham Review, Best American Essays, The Georgia Review, Orion, Prairie Schooner*, and *The Yale Review*, among others, and her books include *Listening to the Savage/River Notes and Half-Heard Melodies* (University of Georgia Press, 2016), *Stepping into the Same River Twice*, with artist Patricia Hilton (Savage River Watershed Association, 2013), *Walking the Wrack Line: On Tidal Shifts and What Remains* (University of Georgia Press, 2008), *Entering the Stone: On Caves and Feeling through the Dark* (Houghton Mifflin, 2003), which was a Library Journal Best Natural History Book of the Year, *The Singer's Temple* (Bright Hill Press, 2003), and *Stirring the Mud: On Swamps, Bogs, and Human Imagination* (Beacon Press, 2001), a *Los Angeles Times* Best Book of 2001. In 2015, she was awarded a John Simon Guggenheim Memorial Foundation Fellowship in General Non-Fiction. Her other honors include four Pushcart Prizes, five Maryland State Arts Council Awards, the Sierra Club's National Nature Writing Award, and an NEA Fellowship for Creative Nonfiction. She resides in Frostburg, Maryland.

About the Photographer

Stephen E. Strom was born in 1942 in New York City and grew up in the Bronx, New York. He completed his B.A. in astronomy at Harvard College in 1962 and earned his M.A. and Ph.D. in astronomy from Harvard University in 1964. He held an appointment as Lecturer in Astronomy at Harvard University from 1964–1968; as Associate Professor and Coordinator of Astronomy and Astrophysics at SUNY Stony Brook from 1968–1972; as Astronomer and Chair of the Galactic and Extragalactic Program at the Kitt Peak National Observatory from 1972–1983; as Professor of Astronomy and Chair of the Five College Astronomy Department at the University of Massachusetts from 1983–1998; and Astronomer and Associate Director for Science at the National Optical Astronomy Observatory from 1999–2007. In 1978, Strom also began to make fine-art photographs of the American landscape. That photographic work has been exhibited throughout the United States and is held in the permanent collections of the Center for Creative Photography, Mead Museum in Amherst, Massachusetts, Museum of Fine Arts, Boston, and University of Oklahoma Art Museum, among others. His other books of photography include *Death Valley: Painted Light*, with poetry by Alison Hawthorne Deming and an essay by Rebecca A. Senf (George F. Thompson, 2016); *Earth and Mars: A Reflection*, with Bradford A. Smith (University of Arizona Press, 2015); *Sand Mirrors*, with Richard B. Clarke (Polytropos, 2012); *Otera Mesa: Preserving America's Wildest Grasslands*, with Gregory McNamee and Stephen Capra (University of New Mexico Press, 2009); *Earth Forms*, with Gregory McNamee (Dewi Lewis, 2009); *Sonoita Plain: Views from a Southwestern Grassland*, a collaboration with ecologists Jane and Carl Bock (University of Arizona Press, 2005); *Tseyi: Deep in the Rock Reflections on Canyon de Chelly*, with Navajo poet Laura Tohe (University of Arizona Press, 2005); and *Secrets from the Center of the World*, with Muscogee poet Joy Harjo (University of Arizona Press, 1989). He resides in Sonoita, Arizona.

About the Book

Tidal Rhythms: Change and Resilience at the Edge of the Sea was brought to publication in a limited edition of 1,250 hardcover copies. The text was set in Din, the paper is Lumisilk, 157 gsm weight, and the book was professionally printed and bound by P. Chan & Edward in China.

Publisher and Project Director: George F. Thompson
Editorial and Research Assistant: Mikki Soroczak
Manuscript Editor: Purna Makaram
Book Design and Production: David Skolkin

Published 2016. First limited hardcover edition.
Printed in China on acid-free paper.

George F. Thompson Publishing, L.L.C.
217 Oak Ridge Circle
Staunton, VA 24401-3511, U.S.A.
www.gftbooks.com

24 23 22 21 20 19 18 17 16 1 2 3 4 5

The Library of Congress Preassigned Control Number is 2016937459.

ISBN: 978-1-938086-45-8

MGB

MGC & MGB GT V8

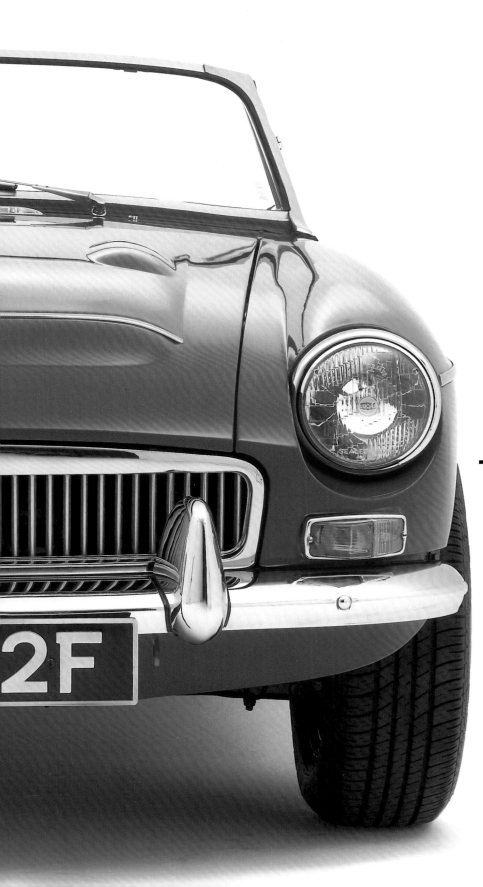

HAYNES GREAT CARS

MGB

MGC & MGB GT V8

A celebration of Britain's best-loved sports car

DAVID KNOWLES

A catalogue record for this book is available from the British Library

ISBN 1 85960 958 9

Library of Congress catalog card number 2004100807

Published by Haynes Publishing, Sparkford, Yeovil, Somerset BA22 7JJ, England

Tel: 01963 442030 Fax: 01963 440001
Int. tel: +44 1963 442030 Int. fax: +44 1963 440001
E-mail: sales@haynes.co.uk
Web site: www.haynes.co.uk

Haynes North America Inc.
861 Lawrence Drive, Newbury Park,
California 91320, USA

Edited by Warren Allport
Designed by Glad Stockdale

Printed and bound in Great Britain by
J. H. Haynes & Co. Ltd

Contents

Introduction

The MGB has become a metaphor for the 'Great British Sports Car' — that also happens to be one of the many memorable advertising slogans coined during its 19-year life. Building on a great pedigree, the MGB followed as the next act after the MGA, itself a remarkable break from MG tradition when it emerged in 1955. When the MGB first appeared on the motoring scene in late 1962, nobody in his right mind would have forecast that it would still have been on sale 19 years later. In the intervening years, however, a great deal happened within the British motor industry leading to problems that, in the end, the MGB — and MG itself — could not overcome. That the MGB proved such an enduring success, even when conventional wisdom suggested that it should have been pensioned off, says as much for the basic excellence of the car itself as it does both for the cleverness of those tasked with selling it and the paucity of credible opposition. In recent years the MGB has often been regarded as fair game for the armchair critic. However, the MGB not only acquits itself well in the lexicons of sports car and motor sport fame but it also paved the way for much of the Classic car industry that nowadays we tend to take for granted.

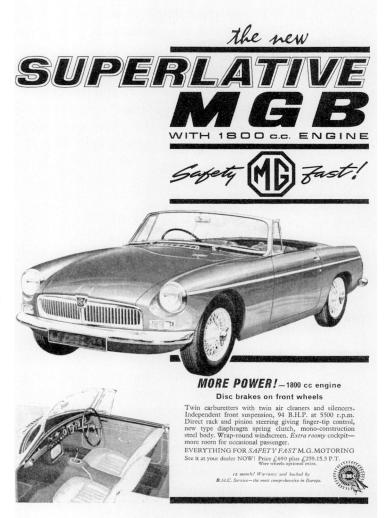

MG's parent company, BMC, joined in the spirit of the launch congratulations with its own full-page advertisement in Autocar.

Acknowledgements

Writing any book tends very much to be a labour of love and this one is no exception. Helping it on its way has been an enormous amount of assistance, support, and encouragement and I am thoroughly indebted to all those people who have given so generously of their time, shared their memories, and provided material for use in this book. The list is too long to be included here in full, so my apologies for the many omissions. Special mention must be made of a few crucial people who have helped with the book. Don Hayter, Jim O'Neill, and Terry Mitchell were key members of the team that created the MGB, so my debt of gratitude to them almost goes without saying. On the US side, I must also thank the able team of Graham Whitehead, Mike Dale, Bob Burden, and Marce Mayhew who between them made sure that sales of the MGB remained buoyant in a hostile marketplace. The featured cars in this book belong to John Watson (early MGB), Tim Hodgkinson (MGC), myself (MGB GT V8), and George Day (black-bumper MGB) with the photography by the talented Tom Wood. Former BL press officer Ian Elliott has probably forgotten more than most of us can remember and I am indebted to him too for ensuring historical accuracy. My thanks must also go to my publisher, in particular to Mark Hughes and Steve Rendle for their forbearance and patience (we authors are an unruly lot!). Last, but by no means least, I wish to thank my wife Shirley and my daughters Katie and Emily for their support and enthusiasm.

David Knowles, December 2003

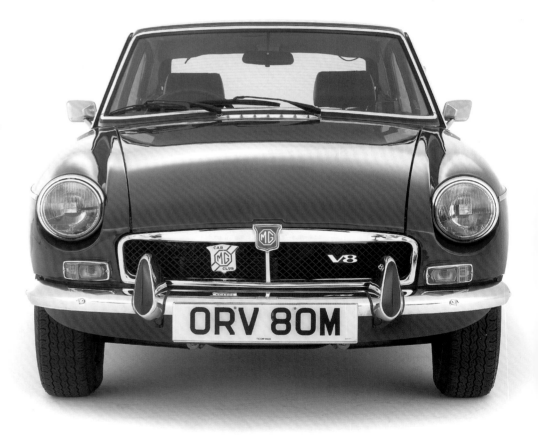

Perhaps the ultimate incarnatino of the MGB – the author's 1974 MGB GT V8.

Design and development

MG heritage

By the time that war broke out in 1939, MG sports cars had already become, in a decade and a half of existence, a household name in Britain and Australia but were little more than a curiosity, known only to an Anglophile few, in the big market of North America. The Second World War changed all that, for American servicemen posted to Britain soon became aware of the pleasures of driving diminutive English sports cars with their minimal bodywork and spindly wire wheels — so unlike the eponymous Buick sedan back home.

With the cessation of hostilities, a number of these MGs accompanied their new owners back to the US but serious sales efforts with the first postwar MG product — the TC Midget of 1945 — were concentrated on satisfying export demand in the traditional 'Empire' markets of Australia, Canada, and South Africa. The TD and TF Midgets followed, leading to the more modern-looking 1955 MGA. The MGB that succeeded it in 1962 marked a radical departure for MG both in engineering and creature comforts.

For many years, until the advent of the MGA, the MG sports car was epitomised by its 'square rigger' styling, seen here on a 1948 MG TC Midget.

The road to the MGB

If MG Managing Director John Thornley and his Chief Engineer, Syd Enever, had followed their original trains of thought, the MGB would have been quite unlike the car that emerged in 1962 and furthermore could hardly have brought them the same level of sales success. There is also room for conjecture that the replacement they initially had in mind for the MGA could have seen the end of Abingdon a great deal sooner than actually transpired. Of course, in the event, the MGB *was* the last MG ever made at Abingdon — but we are getting ahead of the story, which really begins in 1949, just four years after the end of the Second World War.

The semi-independence of MG at Abingdon came seriously under threat in 1949 when the board of the Nuffield Group pondered moving MG production to the Riley factory at Coventry and turning

Abingdon into a minor satellite of the Morris works at Cowley. At the same time various concepts were being hatched at Cowley for possible new MG products that owed little to Thornley's or Enever's thinking. These threats to their existence galvanised the Abingdon stalwarts, who not only began to plan their own product but to lobby for their continued existence.

Thornley and Enever realised that the future lay in more modern coachwork and prototypes eventually led to the creation of EX182, a Le Mans racer for 1955, which was a thinly disguised replica of their new genera-tion sports car. The revolution occurred soon after the Le Mans race when, with the sleekly styled MGA, MG broke with 30 years of tradi-tional styling and abandoned the Nuffield Group's XPAG engine family in favour of the new generation Austin-designed B-series unit.

Perhaps more than anyone else it was MG's Chief Engineer, Syd Enever, who determined the basic parameters that shaped the MGB.

Replacing the MGA

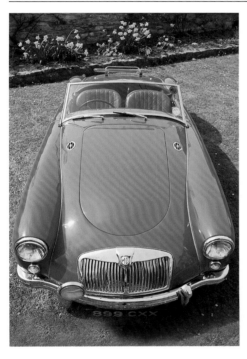

e shape of the MGA d been a striking parture from MG dition in 1955 but e car that followed uld mark a similarly d step.

In the summer of 1955, with the MGA in production, thoughts at the MG factory at Abingdon-on-Thames inevitably turned to its successor. As in most parts of manufacturing industry, once a product is rolling off the production line, it is 'old news' to the design team as commercial pressure forces attention firstly to updating and then replacement.

The MGA had followed MG tradition — and indeed that of contemporary open sports cars in general — by having a separate chassis frame to which the bodyshell was mounted.

Early MG sports cars, in common with most of their peers, featured quite flexible chassis with very little torsional rigidity provided by the minimalist open bodywork. With the MGA, MG had moved towards the more modern ideal of a fairly rigid chassis with a reasonably strong body that enveloped the whole car, and indeed the MGA Coupé had been a relatively strong car. Before the end of 1955 Thornley and Enever jointly penned a paper entitled *Suggested Future Design and Development Programme for Abingdon Products* in which they set out their future design policy for MG.

In November of that year, just after the Earls Court Motor Show, Thornley wrote to S. V. Smith (the BMC director at Cowley in charge of Abingdon) suggesting that 'the great disadvantage of the monocoque form, particularly in the case of relatively small production rates such as our own, is that, unless the general construction of the car is to be very orthodox, one must of necessity tie oneself to a body design too far ahead of production. By using a self-supporting chassis (even though this may ultimately be welded or multiply-bolted to the body) development of chassis and body can proceed independently.

'The complete design then enjoys the benefit of flexibility, such that the style may subsequently be changed without interfering with the chassis, and vice versa.

We consider therefore that all future Abingdon products should have chassis frames.' The idea of an open-topped monocoque body was still seen as radical at that stage — Thornley had not forgotten the danger of farming out too high a proportion of manufacture. 'Yet by the middle of the following year,' Thornley later told me, 'we were scratching out the beginnings of the 'B, which gradually became monocoque!'

Before long, too, another factor entered the equation: production of the Austin-Healey, by now in C-series-engined 100/6 guise, was transferred from Longbridge to Abingdon, along with design authority for it. This was largely due to George Harriman — no doubt having been 'worked on' by memoranda from Thornley — who recognised the benefits of rationalising sports car production, coupled with the additional factors that the 100/6 used a Morris Engines-designed unit (MG being more closely tied to the old Morris part of BMC) and that space was needed at Longbridge for other models.

As a result MG found itself not only looking into the replacement of the MGA — with its mid-range four-cylinder engine and its compact relatively light sports body — but also with the potential of a larger, more powerful sports car to replace the 100/6. It was not long, therefore, before the fertile mind of Syd Enever was churning out all manor of ideas for a new four- and six-cylinder MG sports cars and tourers.

EX205 and the Frua prototype

MG began working up MGA-replacement proposals under the new project code EX205 and at the same time Enever dabbled with a larger grand tourer to sit above this. A full-size model of the EX205 design that emerged — developed by Don Hayter (who had joined the MG design team in February 1956) from initial studies by MG's Chief Body Engineer Jim O'Neill — was built at Coventry by Wilf Silcock in the experimental department. 'It was made of wood,' Hayter recalled, 'and we were looking to make some metal panels off those shapes straight away. But it was done as a coupé, and when you did the open tourer, it didn't quite work, and Syd wasn't happy with it.'

The styles of these creations were often based on literal interpretations of Enever's own pencil sketches and consequently tended to be curvaceous but somewhat lacking in finesse. Perhaps partly because of this, George Harriman at BMC headquarters decided to send an MGA chassis to Italian coachbuilder Frua. According to Don Hayter, 'Harriman went to one of the big European motor shows and he had a look at their cars and said that what we wanted was something "better and newer" for the US market". Of course the Yanks kept on screaming at us for something new, so we knew this anyway.' Harriman asked Frua to build a special one-off for him and Abingdon shipped a chassis out to the coachbuilder. Understandably the end result of this exercise was received with limited enthusiasm at Abingdon but the project's influence upon MG thinking was apparent as soon as the factory received, and weighed, the prototype.

Frua had produced a very Italianate European sports car, with elegant if slightly fussy Maserati-like lines. Even allowing for the fact that it was a hand-built lead-loaded prototype, the greater bulk of the Frua MGA showed that a more intelligent solution was required for a mid-sized and modestly powered sports car. Hayter got the job of measuring and drawing up the Frua car while it remained at Abingdon. MG's model maker, Harry Herring, also made some wood formers for Hayter to use to help him produce a proper layout. The body's lines were swiftly drawn up for posterity as EX205/2 on 20 June 1957, along with an MG interpretation (EX205/3) developed from the Frua car.

Eventually, its purpose served and the necessary lessons learned, the Frua prototype was cut up in order to avoid the payment of substantial import duty. At the same time, Thornley and Enever were gradually coming round to the idea that a monocoque sports car might not be such a bad idea after all.

Another persuasive factor had to be the fact that the Austin-Healey Sprite, which had been concocted by Donald and Geoffrey Healey, went into production at Abingdon in the spring of 1958 and featured chassis-less construction. With other manufacturers of open cars also embracing the monocoque principle (the

Jim O'Neill's EX205 prototype captured in ¼-scale by MG's talented model maker Harry Herring.

Frua's attempt to re-body the MGA had an air of Maserati about it. This model of the prototype is all that survives.

From Frua to MGB, by way of EX214

Rootes Group developed the Sunbeam Alpine from the Hillman Husky floorpan), the future was clear. The main attraction was the potential reduction in weight, since dispensing with the separate chassis would allow significant weight savings to be made. A further peripheral benefit was space utilisation at the factory, for the MGA chassis was fabricated at Abingdon from pressings furnished by John Thompson Motor Pressings; the elimination of this process would obviously free up valuable space and allow production to expand.

So MG prepared to make a further quantum leap into new territory; it had abandoned the traditional style in 1955 with the MGA and now was about to make another leap by jettisoning thoughts of a separate chassis for its successor. To justify the costs, production and sales would have to increase accordingly and more people would need to be persuaded into MG ownership. Without these changes, who can say whether a lower-volume successor to the MGA with a separate chassis would have lasted through the commercial turmoil that would beset BMC in the coming decade? It seems the MGB almost certainly saved MG from earlier extinction.

Hayter maintains that the Frua car made the benefits of change all the more obvious: 'If you do a body, which is stiff enough in its own right, and you put that on to a chassis, which is also stiff enough in its own right, you have got two lots of work being done and the end result is too much weight.' In June 1958, therefore, only a year after EX205 had started — and, coincidentally, just as the MGA Twin Cam was about to be launched — a new number, EX214, was allocated to the MGA replacement project. Studies swiftly got under way and model maker Harry Herring was gainfully employed turning the concepts into attractive quarter-scale models, some of which survive in the Heritage Collection at Gaydon. However, some of the weight saving made by dispensing with a separate chassis would be offset by the incorporation of new luxuries such as winding windows and other measures seen as increasingly important by the customer.

The style of EX214 evolved gradually into a smooth straight-through cigar-shaped body, with modest but fashionable tail fins, and Enever took some influences from the rounded lines and clean flanks of

the MG record breakers EX179 and EX181. At the sharp end, however, there were uncertainties about what form the grille should take; most of the studies at that stage assumed an evolution of the rectangular MGA grille but at the time there was also a trend to lower and wider air intakes — the Sunbeam Alpine of 1959 was just one example.

Then in the spring of the same year that the Alpine appeared, Jim O'Neill accompanied Syd Enever on one of their occasional forays to visit the important Geneva Salon. On the Renault stand was the new rear-engined Caravelle; according to O'Neill, Enever was greatly enthused by it. 'He said to me: "This is what the MGB should be like and there is where we can put the grille," as he gesticulated towards the front of the car. The people on the stand were certainly looking very quizzically at Syd, wondering what he was up to, but then that was typical Syd!' Meanwhile, back at base Don Hayter had developed EX214 towards the definitive MGB shape, albeit retaining an MGA-like grille.

By now, far from being a spare-time activity, the impetus for work on the new car was increased as the MGA was approaching the end of its life. Hayter explained: 'The MGA in production had gone from 1500 to 1600, and the Twin Cam was there, and then eventually we had the 1,622cc MkII MGA. The Twin Cam went out of production [in Spring 1960], and production of the MGA generally was falling off, so pressure came on to get on with the replacement.'

When the MGB eventually reached production, with its 'pocketed' headlamps and broadly similar lines to the Floride, Renault tried to make an issue of the matter, claiming that MG had copied it, perhaps prompted by memories of the visit to the Geneva Salon stand by Syd Enever. Don Hayter still has some of the correspondence: 'Old man Steed at Cowley was Nuffield's legal man and he wrote to them refuting their allegations, and the whole thing eventually just disappeared.'

EX214 was half way between EX205 and the definitive ADO23 MGB. Note how the body lines in this ¼-scale model are nearly there but the radiator grille remains firmly MGA in spirit.

The headlamp of the MGB was set back into the wings — a feature popular with Italian sports cars of the period and one first seen on the 1955 Ferrari California. The 'scallops' were a very distinctive and successful feature but their design and manufacture gave Pressed Steel nightmares.

The MGB tail-lamp lenses were shared with those of the contemporary MG Midget (announced a year previously, in 1961). Contrary to popular opinion, they were not the same units as fitted to the Austin/Morris 1100 (ADO16), which also first appeared at the same time as the MGB. In later years, Jim O'Neill recalls that Roy Haynes — British Leyland's new Director of Design in 1968 — referred to these lamps disparagingly as 'Church windows.'

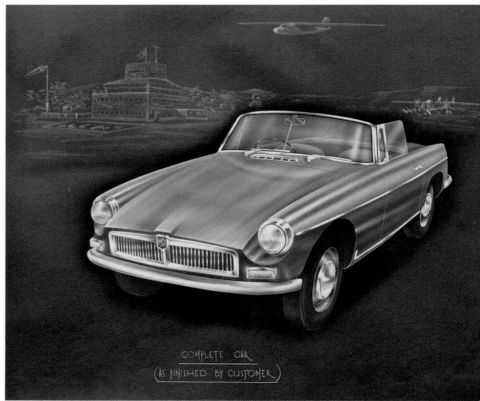

COMPLETE CAR
(AS FINISHED BY CUSTOMER)

Looking at the Renault Floride with the benefit of hindsight, the similarities are tenuous at best, not least because the Renault had no radiator grille.

In the meantime Don Hayter had drawn up full-scale plans for the car and tidied up the front and rear details to give the definitive MGB look that is now so familiar: 'I cleaned off the vestigial fins and altered the tail lamps.' In the process, the 'bean counters' at BMC tried to impose a little rational common sense by trying to get MG to share the similarly shaped rear

Above: By 1960, when this artist's impression was produced, the appearance of what would become the MGB had already been determined and the first prototype built.

Left: The MGB grille wa_ created following inspiration from Syd Enever, after a visit he made to the Geneva Salon in 1959. Previous prototypes had persiste_ with a much squarer grille modelled on that of the MGA. The all-new and much more squat grille shape adopted fo_ production helped give the MGB a more modern, lower, and seemingly wider shape — a master stroke.

lamps from the equally new Morris/MG 1100. However, O'Neill and Hayter wanted a more rounded shape to blend better with the lines running through from the front wings and rounded headlamps and would have none of this. 'So we did our own tail lamp, did the headlamp cut-in, and effectively by cutting the front off the shape of Jim [O'Neill]'s car, there was the site for the radiator grille. I wanted 120 square inches of radiator area, as it had become apparent that cooling was going to be important with the bigger engine, so I drew that grille shape on the front.' Radiators Branch at Cowley produced the grille to match Hayter's drawing and before long the new MG sports car was well on its way.

The monocoque body

Back in 1959 Syd Enever had also tasked his design team with considering how to produce a sufficiently strong and stiff monocoque body. Don Hayter sat down with chassis engineer Roy Brocklehurst at the latter's drawing board and sketched a chassis and a sill section. 'We pulled them together, to produce a composite section which we reckoned would be strong enough. It had to be a guess at that stage, so we said to Syd that what he wanted would depend upon the torsional stiffness in the middle of the car. If you take the doors off, the car is effectively only a few inches thick. We could do a deep tunnel in

the middle but the stiffness at the outer edges would depend upon the sills.'

To establish the parameters they were trying to meet, Brocklehurst and Hayter obtained torsional test figures for a bare MGA chassis and simultaneously set out to test their proposed sill section. 'We got a section made up in the shop which was about four feet long. There were big blocks of steel, which fitted in either end to allow the section to be tested, and we took it over to the basement at Pressed Steel in Cowley, where Pete Finch had his test section. We tested it and found it wasn't quite as stiff — but it was 95 per cent. Of course, what we weren't doing was measuring the whole lot, complete with the central tunnel as well — so we reckoned that by having a sill and a tunnel joined by cross-members, which physically overlapped, we were going to get the equivalent stiffness.'

Hayter says that it was anybody's guess as to how stiff the end result was going to be and one thing the team was determined to avoid was scuttle shake, that dashboard-trembling affliction experienced with many poorly stressed open cars of the

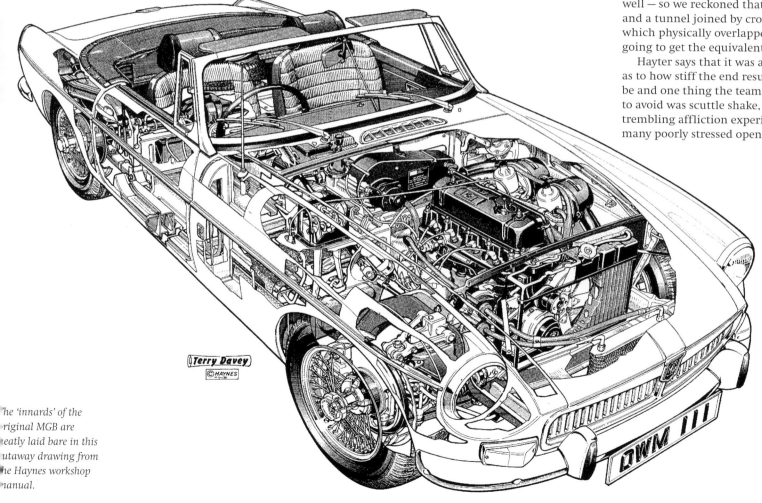

The 'innards' of the original MGB are neatly laid bare in this cutaway drawing from the Haynes workshop manual.

period. Roy Brocklehurst focused on the 'chassis' (the floors and pedal surfaces and bulkhead) while Hayter did everything from there inwards (the wheelarches, inner wheelarches and so on) and joined them on to his colleague's floor and engine mountings. The EX Register records much of this work under project code EX191.

Looked at in hindsight, the MGB bodyshell is clearly an early example of the genre as the form of the major longitudinal box-sections that carry the front suspension and engine are very much as one might suppose a separate chassis would have been laid out. In later years these substantial parts of the body would prove useful in providing the MGB with good crash performance. Another factor which marks the age of the MGB is the comparatively large number of separate panels needed: nowadays more complex pressings would reduce the number of parts to be welded together.

Although MG at Abingdon — assisted by BMC Bodies Branch — came up with the basic design of the MGB bodyshell, much of the 'productionisation' was contracted out to Pressed Steel, which had only recently established a new factory at Swindon, a few miles down the road from Abingdon and Cowley. Many of the Pressed Steel engineers at Swindon had come to car design slant-wise from the aeronautical industry but they proved quick to adapt to the different

requirements of mass-produced steel car bodies, while retaining their high standards of draughtsmanship and structural analysis. The main structural strength of the MGB came from the substantial double-box-section sills and the strong central transmission tunnel. Arguably slightly over-engineered, these members gave the MGB body enormous rigidity for an open car. However, early testing did show up some scuttle shake, which resulted in a square-section tube being added across the car just behind the engine bulkhead, helping to tie together the scuttle, transmission tunnel, and engine bay valances.

Whereas the MGA had featured a marriage of aluminium and steel parts, the bodyshell of the monocoque MGB was mostly steel, with the honourable exception of the bonnet, which was formed from aluminium alloy. At the prototype stage the possibility of using alloy doors was looked at but eventually ruled out, mainly on cost grounds; the alloy bonnet would eventually also fall a victim to cost-cutting in 1970.

The body panels were produced at Pressed Steel's Swindon plant and were welded up into substantial sub-assemblies before shipping out to BMC's own body facility at Coventry. There was a mixture of reasons for this — part political (keeping work in-house at Bodies Branch, which had most recently built the MGA bodyshells) and partly logistical (Pressed Steel was also

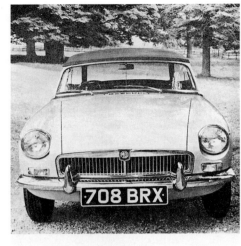

Pressed Steel Company
are proud to be associated with the new MGB

PRESSED STEEL COMPANY LIMITED HEAD OFFICE: COWLEY, OXFORD

In September 1962 various component suppliers, which had been contracted to provide parts or services for the new MGB, were encouraged to share in the launch celebrations by taking out congratulatory advertisements in Autocar. This full-page advertisement was from Pressed Steel, designers and manufacturers of the body tooling and producers of panel assemblies for the MGB.

gearing up for the much larger volumes involved with the BMC 1100 (ADO16) range). After being assembled, painted, and part trimmed at Coventry, the MGB bodies went to Abingdon for final production assembly. In later years, after Pressed Steel had joined the fold, BMC Bodies Branch was closed and Swindon took on complete body assembly, with painting and some trimming carried out at Cowley before shipping to Abingdon as before.

Engine and transmission

When the MGB was launched, it featured an enlarged version of the same basic in-line four-cylinder engine that had powered the MGA for the previous seven years; this was not necessarily the plan from the beginning, however. As part of BMC's rationalisation programme, there were various studies into new engine families to take over from the A-, B- and C-series units during the 1960s. Studies at Longbridge revolved around a family of narrow-angle V4 and V6 units — bearing some modest resemblance to the 'VR' form VAG engines of 30 years later.

Not surprisingly, Abingdon was proposed as a useful test bed for the new

engine and accordingly a crated-up V4 engine arrived at the MG factory for prototype installation in an MGA — under the project code EX216. Roy Brocklehurst told Jon Pressnell, in an interview for *Classic and Sportscar*, that the V4 engines 'were quite a nice power unit ... I'm sure that if that engine had gone into production we could have made a reasonable motor car around it ... it was extremely smooth.' On the other hand, Don Hayter recalls that Syd Enever was not convinced about the V4 engine: 'We had a V4 engine — but not a running unit — at Abingdon, and we fitted that in a car. Syd didn't like the V4 unit but that wasn't in

one of our cars — it would have been built at Longbridge.'

The definitive MGB was being planned by this stage — MG had cause to regret the narrow engine bay and bonnet aperture of the MGA when it came to the Twin Cam — so the space under the EX214 bonnet was kept as wide and generous as possible. As MG was also tasked with looking at a six-cylinder car to replace the Austin-Healey 3000 — whether in-line six or new V6 — the engine bay was also made long enough to cater for either configuration. Professional and DIY MG mechanics have been grateful for this ever since, even though the V4/V6 engine project fizzled out before the MGB

ached production. With regard to the V6 engine, Hayter said: 'We never even saw one of those — we just schemed up an installation from line drawings.'

The V4/V6 family was not the only engine idea that MG explored, however. on Hayter recalls looking at a version of the old Austin four cylinder used in the original Austin-Healey 100. This is recorded in the EX Register as ADO23/624, which is described as 'proposed 2 and 2.5 litre engine based on existing 2.2 and 2.6 litre engine'. As the old Austin engine was by now only used in the Austin Taxi, and was nearing the end of its life, this idea was a non-starter.

Later MG would also look at the so-called Blue Flash straight six, an Australia-only unit derived from the four-cylinder series, but with no other applications planned for British-built BMC cars its fate was sealed as surely as that of the V4 and Austin 2.2-litre four.

With the abandonment of plans for the MGB to be the vanguard for an all-new range of BMC V4 and V6 engines, the choice of engine naturally returned to the existing BMC store cupboard. The seminal B-series engine had its roots in a new 1200cc Austin unit introduced in 1947 in the Austin A40, which in turn appears to have been 'inspired' by an earlier Bedford commercial engine. By 1953, when the MG ZA Magnette was introduced, the engine had evolved considerably and was to become one of the mainstays of the BMC range following the creation of BMC itself the previous year. In this guise the original B-series sported three main bearings and a capacity of 1,489cc. Over the following years, larger capacities were teased out of the unit — most notably for MG applications such as the MGA 1600. By the end of the 1950s a new 1,622cc unit was on the stocks and, with the abandonment of the V4 engines, the MGB was destined to use this engine from the word go. Then fate intervened with the news that BMC also needed a bigger B-series for the 1800 (ADO17) saloon range, so it was agreed that a larger 1,798cc unit could be developed, initially just for the MGB but in due course for the Austin and Morris 1800 ranges.

The bore and stroke of the new unit

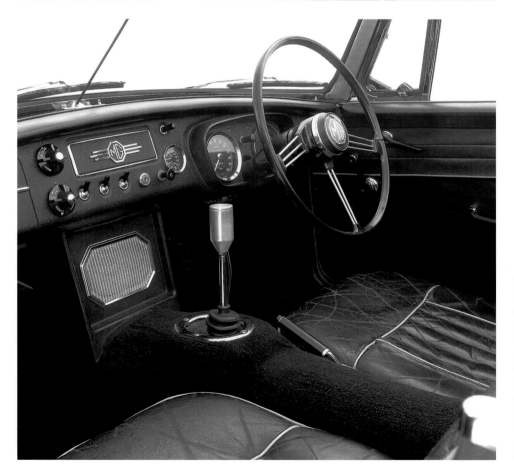

The MGA Twin Cam featured what was virtually a bespoke engine — an idea that would not be followed to the same extent with the MGB.

The plain and simple cockpit of the MGB was dominated by the large steering wheel. Note the octagonal-shaped radio speaker grille (fitted irrespective of whether or not there was a radio) and the neat MG badge on the radio blanking plate in the centre of the dashboard above it.

were 80mm (up from 76mm in the 1,622cc version) and 88.9mm respectively, giving the MGB unit the largest bore size of any B-series engine to date. As moving the bore centres was not an economical production-line option, the bores were siamesed and the first MGB engines retained the three main bearings of the MGA unit, albeit with beefier 2⅛in bearings (at the same time slightly narrower because of the larger bore). Carburation was, in MG tradition, by twin SUs (1½in HS4 instruments with air fed through Cooper filters) mounted on a balanced inlet manifold on the left-hand side of the engine (looking forwards).

The MGA had used a BMC four-speed transmission (with synchromesh on the upper three ratios) and BMC saw little need for much improvement with the MGB other than a slightly lower bottom gear ratio. BMC had a slightly old-fashioned attitude to gearboxes at the time and held out against the trend towards synchromesh on all four forward gears. MGB drivers did have the advantage over the MGA that the gear change acted directly rather than remotely, improving the change quality to more of a rifle-bolt feel. Modernisation only came after five years of production, with the launch in 1967 of the MGB MkII, and then through the need for a new gearbox for the MGC. The clutch was an 8in diameter Borg & Beck single dry-plate diaphragm unit.

Rear axle and suspension

Whereas the MGA had stuck with the tradition of a simple cart-sprung live rear axle, there were thoughts that its successor should try to match the more sophisticated offerings of MG's European rivals, many of whom were moving to coils springs or all-independent suspension. Consequently Enever began experimenting using modified MGA 'mules' or test cars with various coil-sprung rear suspension systems.

Much work was done — some of it recorded in the EX Register against the special project code EX191 ('Development work on MGA') — and there were dalliances with an all-independent rear as well as the slightly more conventional coil springs. 'We had tried three lots of suspension on the MGA,' Hayter explained. 'There was the obviously conventional one, there was a trailing arm and coil spring — which is what the MGB was originally going to have — and we also did an inclined angle swinging arm with a fixed differential in the middle — rather like the Porsche, although before they used it (not that we were the first to consider this idea). That chassis was built and I remember it lay on the bank outside the drawing office for years, rusting away.' However, Syd Enever and the test driver Tommy Haig were not too enamoured of the set-up and things probably came to

something of a head when Roy Brocklehurst and Tony Felmingham managed to flip the trailing-arm MGA coming down from Fox Hill, not far from Oxford. The car landed upside down across the ditch, with roof untouched and occupants shaken but unharmed. 'They opened the doors and fell out into the ditch — no seat belts in those days of course!' Having hitched a ride back to Abingdon in a passing Royal Mail lorry, Brocklehurst did not need to do much to convince his boss of the limitations of the new set-up. 'Alec Hounslow and Tom Haig convinced Syd that this suspension wasn't very good, so he told Roy to change to cart springs.'

The decision in 1960 — at a late stage in development — to continue with a conventional leaf-sprung rear axle meant that the axle and suspension remained similar to the MGA; the banjo-type hypoid axle supplied by BMC's own Tractors and Transmissions Division was suspended on multiple-leaf steel springs. The latter were beefed up from six to seven leaves and were 2.5in longer, while lever-arm dampers were retained. The greater length of leaf spring also necessitated some slight reworking of the rear bodywork dimensions to suit. In later years, with the arrival of the MGB GT, the whole MGB family would move to the stronger and quieter Salisbury axle type.

Front suspension

The front suspension of the MGB — wishbones with the top arms forming part of the lever-arm dampers — was a development of the MG Y-type and MGA installations. The suspension was mounted to a substantial transverse box-section member, supplied by John Thompson Pressings, which was retained by just four substantial bolts — not only adding to structural strength when in place but also a boon to restorers. A front anti-roll bar was optional from the outset, although within four years it would become a standard fitment.

Wheels, steering and brakes

From the outset, all versions of the MGB featured 10.75in diameter Lockheed disc brakes at the front and 10 x 1.75in drums at the rear, together with the option of four-stud steel disc or centre-lock wire wheels with 4J rims. Wheel diameter at 14in was an inch smaller than that of the MGA, while tyres were 5.60-14in Dunlop C41 cross-plies. MG changed the final drive ratio from 4.1:1 to 3.9:1 to suit the smaller wheels. Rack-and-pinion steering, by Cam Gears, had 2.9 turns from lock to lock. The steering wheel was typical of all Syd Enever's MGs — arguably larger in diameter than strictly necessary.

A tradition carried ov from previous MG sports cars was the quite large Bluemel sprung-spoked steerin wheel; perhaps larger than strictly necessary at least in part becau MG Chief Engineer Sy Enever liked it that way. Accessory manu-facturers soon had a field day selling smal spoked steering wheel.

Weather gear

n the MGA wet-weather motoring ad meant that the dedicated motorist ither drove faster in hopeful anticipation of a dry spell or struggled with the rchetypal British sports-car hood and idescreens. Pressure from customers — in articular those in North America —

meant that MG introduced wind-up door glasses, quarterlights, and superior quality hoods for the MGB. Two versions of the hood were available. The basic option featured a detachable frame, which required some effort to assemble or collapse but ensured that the rear

section of the passenger compartment (beneath which lay the twin six-volt batteries) always remained free and unobstructed. As an alternative, for an extra £5 10s, you could opt for the de luxe folding hood.

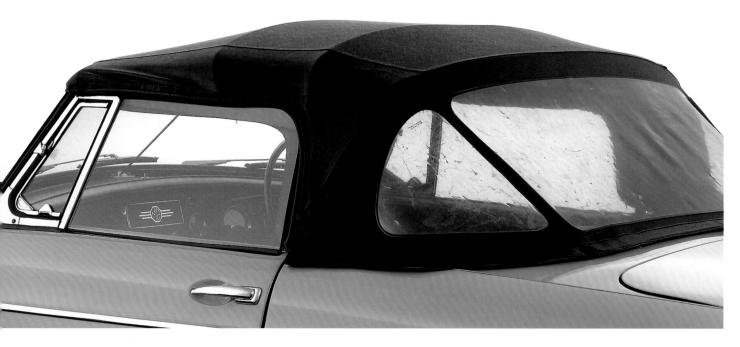

Left: The soft-top (or hood in home-market parlance) was generally a build-it-yourself kit that required some skill and time to erect.

Below: The rear compartment of the MGB allowed one or maybe two small passengers to travel short distances — an idea that would be frowned upon nowadays. Alternatively, this shallow platform, below which the twin six-volt batteries are situated, provided a handy storage space for small bags.

The MGB prototypes

s with the first EX175 prototype, which ad led eventually to the MGA, Thornley nd Enever went to their old ally Eric Carter at BMC subsidiary Bodies Branch for ssistance in building the first full-size rototype. In time-honoured tradition a ooden full-size model was made and, fter inspection and approval by Thornley nd Enever, steel panels were fabricated, ith interior parts made up to resemble he drawings produced by Brocklehurst nd Hayter.

At this stage, as it was still thought that he MGB would feature the new coil prings, the prototype was built with this n mind, with a spare wheel wedged

upright into the boot and the coffin-shaped fuel tank mounted transversely and rearmost under the boot floor, giving clearance to the suspension but placing it 'nearer the accident'. When the decision was made to revert to semi-elliptic leaf springs, Roy Brocklehurst found that the body was too short to get the anchorages where he really wanted them. 'So suddenly I had to lengthen the body by an inch,' Hayter recalled. 'That wasn't too difficult — just body draughting — and so I did a very rapid job of it. Bodies Branch then built the second prototype, which was the black car, which was the one in which we did all the initial development testing.'

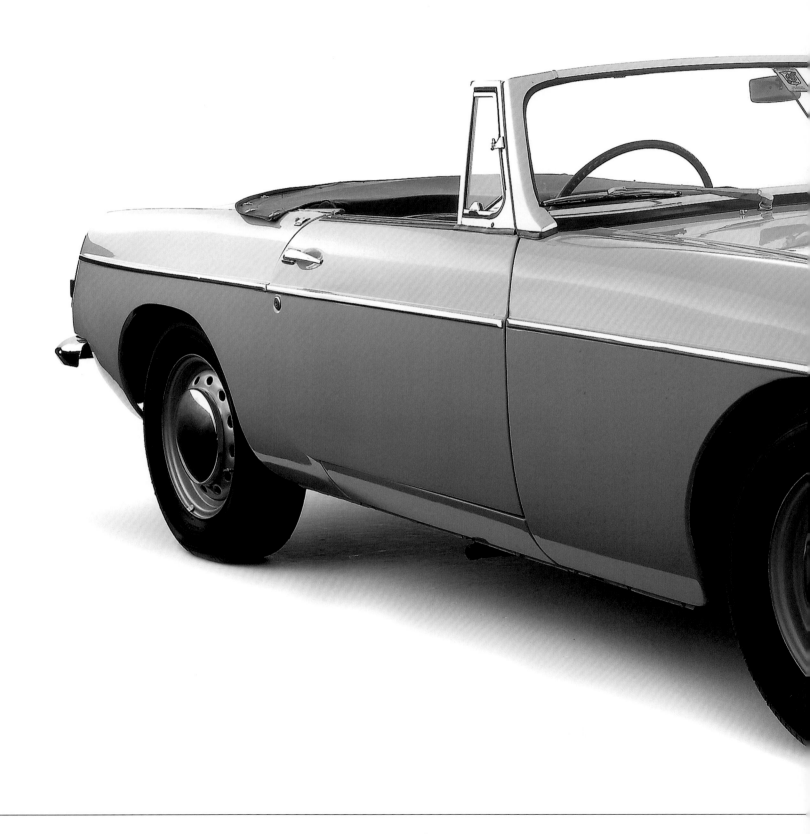

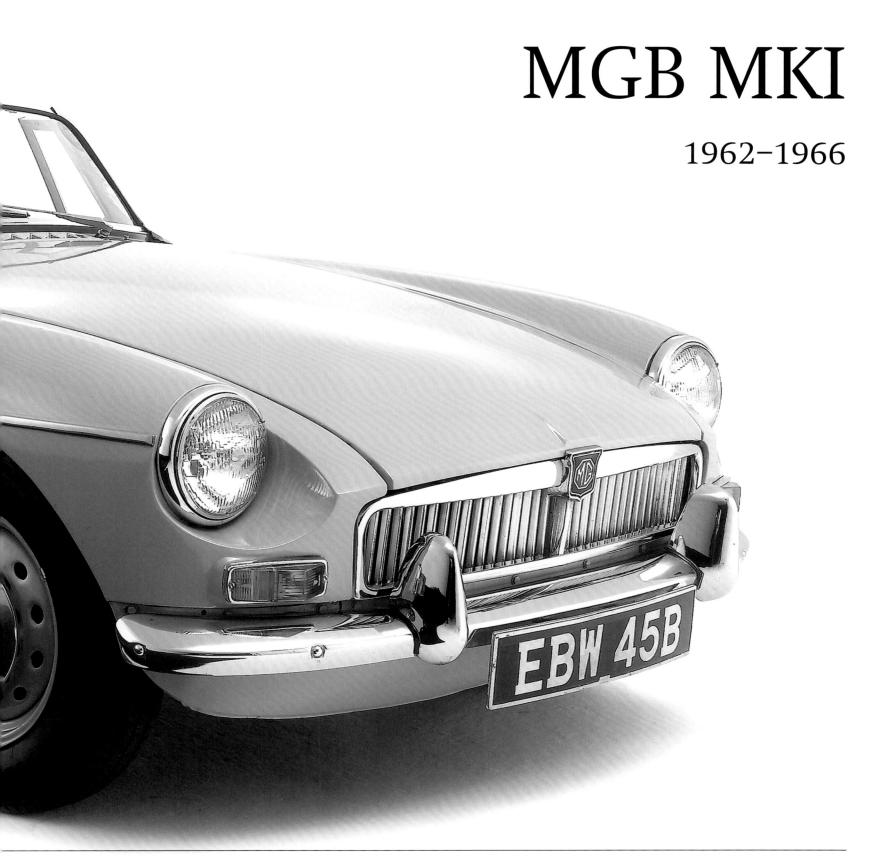

MGB MKI

1962–1966

EBW 45B

1962
'Superlative MGB'

The 'Swinging Sixties' have since become popularly associated with cultural enlightenment and social revolution but the perspective at the start of the new decade was quite different. In the summer of 1960 a recession swept through the US car market — MG sales dropped sharply and much of the workforce at Abingdon was temporarily laid off. British car exports in 1960 had almost halved in comparison with 1959 and for 1961 the figures were even worse. In Britain a credit squeeze hampered new car sales, just as the home market was poised for recovery, and so at MG (as in other companies) there was concern for the short-term future. MG's worries were all the more under-standable since the MGA was nearing retirement.

By the beginning of 1962, the market was recovering slightly and a positive note was the production at Abingdon in March of the 100,000th MGA. Painted in the metallic gold beloved of Syd Enever, with cream leather interior trim and gold-painted spoked wire wheels, it was sent to the New York Motor Show the next month. However, the big event of 1962 as far as MG was concerned was the launch of the MGA's successor — the MGB.

Into production

With all details for the MGB resolved, production at Abingdon began on 22 May 1962 with the US specification left-hand-drive car number bearing 'chassis' number GHN3-102L. The first right-hand-drive car, GHN3-101, was completed on 28 May and ten more cars were finished that month. Left-hand-drive chassis numbers were: 102, 105, 109, 111, 112, 118, 119, 120, 126, and 128. Apart from 101, the only other right-

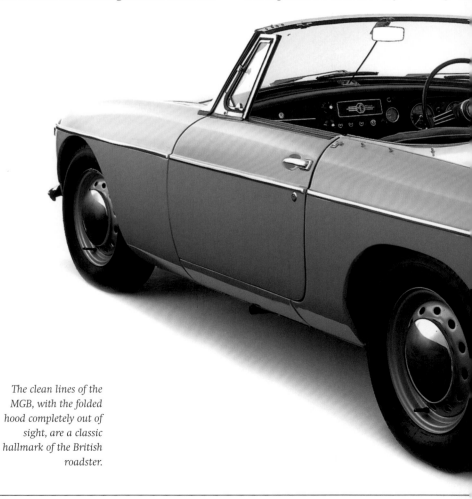

The clean lines of the MGB, with the folded hood completely out of sight, are a classic hallmark of the British roadster.

and-drive car was 318 (a development car).

Then stocks were built up in advance of the launch, set for 20 September: 138 cars n June, 181 in July, 377 in August, and 552 uring September. Both '101' and '102'

were finished in Iris Blue with blue leather interior trim and this colour scheme featured prominently in initial publicity and advertising. Along with the other 199 cars destined for the US market at the start

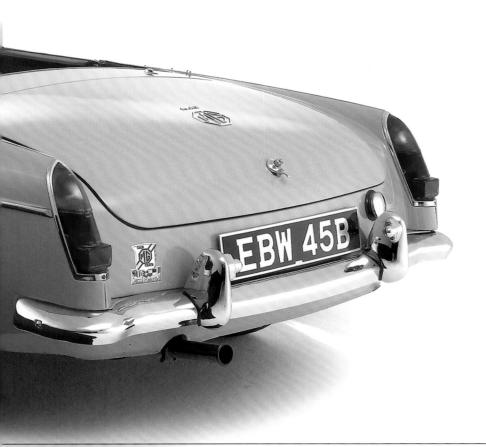

of production, '102' featured chrome-plated wire wheels — normally early MGBs would have the standard disc wheels or optional painted wire wheels. Also, many US-bound cars were fitted with the white-wall tyres that seemed de rigueur in the US but were frowned on in most other markets.

As the first year for the MGB — and an incomplete one at that — 1962 did not see very high numbers of the new model rolling out of Abingdon. By the end of the year, 4,518 cars had been built, of which a significant 2,946, or 65.2 per cent, were specifically intended for North America. By comparison just 3,049 MGAs had been built in the run-out year of 1962, MGA annual production having peaked in 1959 at 23,319 cars. It was a modest but promising start for the MGB and just the beginning of much bigger things to come.

Left: Simple pressed steel wheels with chrome plated hubcaps were standard fitting on home-market cars, although most export cars were fitted with the ubiquitous wire wheels. MG's Managing Director and its Chief Engineer both disliked the heavy and problematical wire wheels but neither was going to deny the customers their prerogative.

EBW 45B

Choice of colours

At the launch, five basic colour schemes were listed for the MGB: Black, Chelsea Grey, Iris Blue, Old English White, and Tartan Red. Within three months, a sixth colour option had been added — British Racing Green. Whilst all of these colour schemes had (and continue to have) their particular advocates, it is probably Tartan Red and British Racing Green that most people now associate with the MGB MkI.

Motor show debut

The first opportunity for most motoring enthusiasts to see the new MG was the Earls Court Motor Show, where the new model took pride of place on the MG stand alongside the equally new MG version of the Issigonis-designed 1100 (ADO16) saloon. (The sister Morris version, launched in August, made its British motor show debut too.) Also new at the Show were face-lifts of the one-year-old 948cc MG Midget MkI and its Austin-Healey Sprite MkII sister, both upgraded to 1,098cc-engined MkII and III versions respectively, the intention being to counter the challenge from Standard-Triumph, which proudly showed off its new Herald-based Spitfire roadster.

How the three-bearing MGB performed

Top speed	0–60mph	Standing ¼ mile	Fuel consumption	
111.8mph	12.1sec	18.7sec	23.0mpg	*The Motor*, 24 October 1962
105.0mph	12.2sec	18.7sec	21.4mpg	*Autocar*, 26 October 1962
106.0mph	12.5sec	18.5sec	24–29 US mpg	*Road & Track*, November 1962

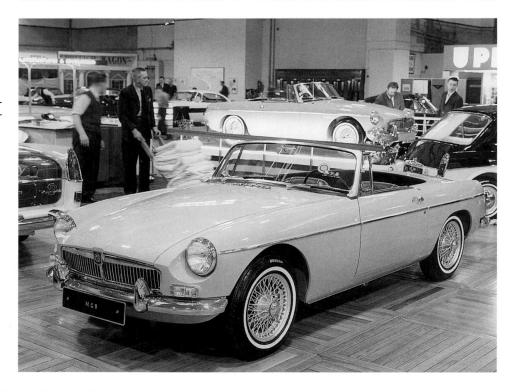

1962 saw the MGB taking pride of place o MG motor show stands

The MGB and its rivals in late 1962

Make and model	Top speed	0–60mph	Standing ¼ mile	Fuel consumption	Price inc tax
Austin-Healey 3000 MkII	117mph	10.4sec	17.8sec	20.0mpg	£1,190
Elva Courier 1600	108mph	10.2sec	17.8sec	28.0 mpg	£966
Daimler SP250	121mph	10.2sec	17.8sec	29.1mpg	£1,451
Lotus Elan	114mph	8.7sec	16.4sec	30.0 mpg	£1,499
MGB	103mph	12.2sec	18.7sec	28.8mpg	£950
MGA 1600 MkII	101mph	13.7sec	19.1sec	27.0mpg	£913
Porsche Super 90 cabriolet	111mph	11.5sec	18.3sec	24.4mpg	£2,876
Sunbeam Alpine Series II	97mph	14.8sec	19.7sec	22.0mpg	£957
Triumph TR4	102mph	10.9sec	17.8sec	26.0mpg	£1,032

MGB vis-à-vis MGA

Some casual onlookers may have looked sniffily at the new MGB and deduced that it was nothing more than a heavily face-lifted MGA; after all, the basic long-nose short-tail sports car proportions were the same, the suspension front and rear was all but identical, and the engine was a further enlarged version of the seemingly ubiquitous B-series. Of course, such an assessment missed the fact that the MGB marked almost as significant a departure as the MGA was from the TF; if nothing else, the lack of a separate chassis saw to that. There were certainly many similarities under the skin between the MGA and MGB — inevitable, given their common heritage and the need to control costs — but there were also subtle differences in components that outwardly looked much the same.

The MGA had been a 'harder' sports car for the less compromising sector of the enthusiast market, whereas the MGB was deliberately made somewhat 'softer' in a move aimed at broadening its appeal. Thus, for example, the spring rates for the front coil spring units were reduced from the MGA's 100lb/in to a more pliant 73lb/in, and the rear springs were longer (a consequence of Don Hayter's lengthening exercise), while under the bonnet there were engine equipment enhancements aimed at

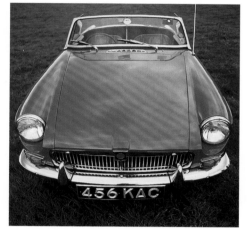

The MGB radiator grille was an even greater break with the established MG convention than the MGA had been from the TF just seven years previously.

liberating more power and improving refinement and durability. Moreover, the new car was roomier for driver and passenger alike. The overall length and wheelbase of the MGB may both have been 3in less than those of the MGA but the toeboard and pedals had been moved forward by 6in and the cockpit was consequently far more adaptable for people of all sizes.

From a viewpoint of more than 40 years later, the MGB is sometimes seen as being pretty but unexceptional, perhaps partly because even now it remains seemingly ubiquitous — and, of course, so often familiarity breeds contempt. Some commentators — design professionals among them — regard the MGA as being a more *interesting* car in design terms, perhaps forgetting that pretty though the MGA undoubtedly is, it owes a great deal to the Jaguar XK120 whose lines had influenced Syd Enever. If we are to look for similar pointers to the MGB style, an honourable starting point has to be the 1955 Pininfarina-bodied Ferrari California.

Back in 1962, *Road & Track* in the US obviously thought that — in the context of its time — the MGB was a better effort than its predecessor. Its November 1962 issue stated: 'Our styling experts ... never really had much good to say about the lines of the 'A'. It was "corny, out of date in 1955, had poor surface development etc." But there's no complaint over the fresh new look for the B.'

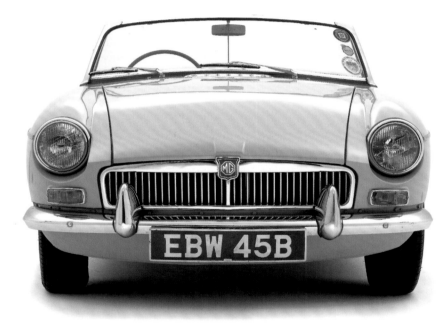

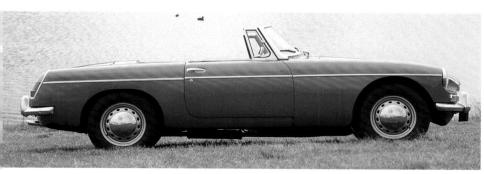

From the front, the MGB looked very different to the MGA — the long, low, and wide radiator grille was a major departure from the traditional, much squarer rectangle.

The side elevation of the MGB was much less 'sculpted' than the MGA, in common with styling trends current at the start of the 1960s.

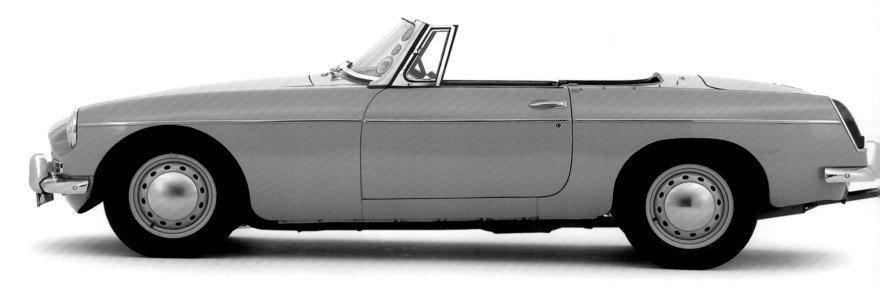

What the British motoring press said

The straight-through lines of the MGB, often described as cigar-shaped, were in part inspired by the shape of the MG record breakers but also made it easier to incorporate better locks and features such as wind-up windows and quarterlights — some of the things that the North American market had demanded.

Until early 1963, simple production statistics as much as delivery schedules meant that irrespective of its merits, the MGB was hardly a common sight on the roads. So at first the majority of MG enthusiasts had to content themselves with a magazine road test coupled perhaps with a visit to their MG showroom, a look over a demonstrator followed by taking home the inevitable sales brochure. Sports car enthusiasts more than any other category of car driver have always placed great store in what is written about a car in the motoring press and, of course, MG fans were no different. Consequently as soon as the news of the MGB had appeared in the newspapers, the readers of leading British weekly motoring magazines *Autocar* and *The Motor* eagerly awaited their first analyses.

Autocar covered the new MGB in the issue of 21 September 1962, heralding the new model's abandonment of a separate chassis and applauding the financial risk that MG — and BMC — had taken. 'The advantages of large-scale production methods can now be enjoyed by our leading sports car specialists,' it proclaimed. 'Monocoque construction, with its superior rigidity and lightness, was a natural line of development, and the British Motor Corporation were early in the field with the original Austin-Healey

Sprite.' In discussing the increase in capacity of the B-series engine from 1, 622 to 1,798cc, *Autocar* also gave a brief insight to the studies that BMC had carried out before making this step: 'experience with a 1,700 c.c. experimental unit proved that the scantlings of the B-series unit were sufficiently sturdy to withstand a third increase in bore size'.

Summing up its first favourable impressions of the MGB, *Autocar* concluded: 'the MGB is an important model, because it completes the BMC's trend away from the traditional British sports car with a separate chassis frame [presumably it had forgotten about the big Healey!]. It is a forward step, too, in that the car is faster than the previous model, and yet more docile and comfortable. Moreover, from any angle it looks good, as the products of the Abingdon design team always have, and it should be as big a success in home markets as it will surely be abroad. Its price of £949 15s 9d with purchase tax makes it about £38 more than the superseded MGA Mark II.'

In *The Motor*, the new car appeared in the issue of 26 September 1962, with the report headed 'New body and bigger engine for the M.G. A's chassisless successor'. As with the *Autocar* description, the MGB had to share top billing with the

important new Ford Consul Cortina and there was the customary cutaway drawing showing the technical details of the MG. 'For seven years the MGA has remained basically unchanged,' began the report, 'from the beginning its road manners proved outstandingly good and steady engine development has kept the performance in line with rising standards, but in comfort, silence and accommodation it no longer conforms to current demands.'

The report went on to hint at possible thoughts of the design team when it said 'in the course of development it was realised that still more room could be found if the engine were moved forward to displace the rack and pinion steering gear but it was decided that MG enthusiasts would not be prepared to sacrifice the latter.' That *The Motor* had been well briefed by the Abingdon engineers was even more apparent when the writer went on to reveal the work that had been done on alternative rear suspension layouts: 'a great deal of experimental work with different forms of rear suspension led to the conclusion that the more elaborate systems tried gave insufficient improvement to justify their extra cost.' Overall, *The Motor* was impressed with the MGB but, of course, final judgement would be saved for the road test.

First road test reports

Both *Autocar* and *The Motor* had long been noted for their technically thorough and detailed road tests and so their subsequent reports of late October were eagerly awaited by MG enthusiasts. *The Motor*'s 24 October 1962 Road Test 42/62, subtitled 'Safety Faster — and More Comfortably', described the MGB as a 'delightful modern sports car with a marked bias towards the "grand touring" character'.

The magazine noted the greater weight of the MGB — 42lb more than the MGA 1600 MkII — and the effect this would have on the competition potential of the car but recognised that justification for this was found 'in ease of entry to a roomy cockpit, the provision of full heating and ventilation systems, and immense sturdiness which becomes apparent when really rough roads are tackled'. The testers noted moderate concerns about the running of the engine in their test car (523CBL). They found it needed full choke to start from cold in certain conditions and that low-speed idle was uneven until the engine had warmed up but once the car was running normally, they were fulsome in their praise of its performance and handling at all speeds. *The Motor* was less complimentary about the folding hood, raising and lowering of which it felt was 'a slow process, at least for anyone not well-drilled in the procedure, suggesting its suitability for California's reliable climate rather than for Britain's erratic weather'.

Over at *Autocar* the testers reported in the issue of 26 October 1962: 'Whatever

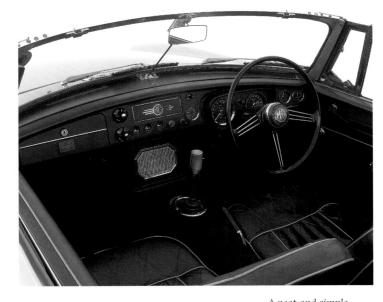

A neat and simple interior, with a black crackle paint finish to the dashboard and the bare minimum of chrome highlights, demonstrates functional sports car minimalism at its best.

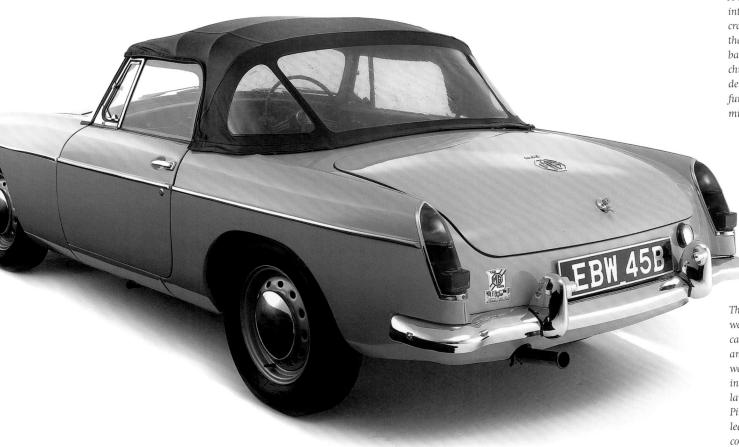

The upright tail lamps were a feature of many cars of the late 1950s and early 1960s and were undoubtedly inspired by similar lamps on contemporary Pininfarina work — not least for MG's parent company, BMC.

the die-hard enthusiast may say to the contrary, and however hard the traditionalist may cling to a superseded model, there is no doubt that the new M.G. MGB 1800 is a much superior car to its predecessor, the MGA in all its forms. One cannot think of any aspect of this new sports car which does not show appreciable advantage in comparison with the previous model.' *Autocar* compared the magazine's test figures for the MGA and MGB, showing that the standing quarter mile was half a second quicker in the MGB, while acceleration to 90mph, at 32.6sec, was 3.5sec swifter. *Autocar* also found the new model more willing to rev freely, claiming that the MGB had 'lost the harshness but none of the low-speed traction' of the MGA. Like their rivals at *The Motor*, the testers at

Autocar could not bring themselves to applaud the optional folding hood fitted to the test car (a £5 10s extra). 'It could not be said that raising and lowering the hood were simply "the work of a moment" ... if the driver is alone he is involved in quite a battle, and a succession of trips from one side to the other, to convert the car from the open or closed condition,' the magazine recorded, expressing sentiments that would find many echoes among MGB owners in the years to come.

Whilst the views of the home market motoring weeklies — as well as seasoned specialist organs such as *Autosport* and *Motor Sport* — were keenly monitored by manufacturer and enthusiast alike, the important place for the MGB to make a good impression was the US. MGA sales in that market had significantly exceeded contemporary sales in the UK and this would prove little different with the new model. Two of the more highly regarded US motoring publications were the rival *Road & Track* and *Car and Driver* monthlies, both of which harboured dedicated sports car fans in their midst. Both publications covered the introduction of the MGB in their November 1962 issues and there were special tailor-made advertisement inserts cleverly styled like letters to the magazine editors from Tony Birt, the Advertising Manager of BMC's US importer Hambro Auto-motive (and son of Hambro's President, Ted Birt). In the case of *Road & Track*, this letter was addressed to Editor and founder, John Bond; in *Car and Driver* the equivalent was addressed to the Publisher, Brad Briggs, whose magazine also featured an MGB on the front cover along with 'Old No 1'.

'Here is our brand new MGB,' the copy stated. 'It represents the first all-out MG change since the MGA series made its debut seven years and more than 100,000 vehicles ago. Everything is new but the Octagon. Production of our new thoroughbred is now in full swing.' North American customers had to wait awhile, however, for the MGB would not be seen on the highways in significant numbers until April 1963, when the car was one of the undoubted stars of

the New York Motor Show — the local show to Hambro HQ. The *Road & Track* test of the MGB was headlined 'Civilizatio has come to Abingdon-on-Thames' and, being American, used a much less formal writing style than the comparatively stuffy British magazines. 'The loudest wails in the land were heard back in 1955,' the report began, referring to the way some enthusiasts had greeted the changeover from MG TF to MGA. 'The new "B" isn't quite as much of a change a the "A",' the magazine went on, 'and no wails have been heard around our office.' The *Road & Track* team was very impressed overall: 'our enthusiasm did not wane during 700 miles of driving. In fact, it grew stronger, and frankly this is the first British car in several years which created no arguments among the staff – even the Italian and German sports car owners forgot their private battle and admitted they liked to drive this new English job.' The testers summed up their report by suggesting that 'this is the best engineered, the best put-together MG we've ever seen'.

Over at rival publication *Car and Driver*, the road test highlighted the fact that the MGB was BMC's answer to the Sunbeam Alpine and Triumph TR4. 'No MG has discredited the slogan "Safety Fast", ' wrote *Car and Driver*, 'but compared with its predecessor the MGB is faster and certainly safer ... a safer sports car would be hard to imagine.' *Car and Driver* was disappointed that the new car still lacked synchromesh on first gear (this would not appear until the MGB MkII in late 1967) but overall the drive train drew praise. There were a few dislikes: the testers thought that single-speed wipers (very much the BMC norm!) were inadequate, the engine a little rough at idle, and the instrument illumination rather feeble. These minor quibbles aside, they concluded that 'the MGB holds great promise as a world-market success ... more than any other it seems the ideal car for learning to go fast — and with racing modifications it looks a likely contender in the Triumph-dominated under-two-litre class of club racing.'

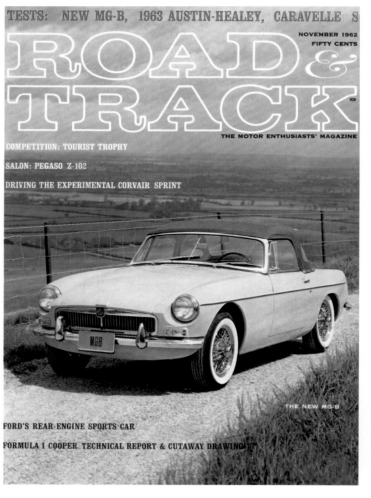

Road & Track *magazine gave over the cover of its November 1962 issue to MG's fine new sports car.*

Mr. John R. Bond, Publisher
Road and Track
834 Production Place
Newport Beach, Calif.

Dear John:

Here is our brand new MGB. It represents the first all-out MG change since the MGA series made its debut seven years and more than 100,000 vehicles ago. Everything is new but the Octagon. Production of our new thoroughbred is now in full swing.

...ght: MG importer ...mbro Inc took the ...vel approach of ...oducing an advertis-...g insert in leading ...rth American car ...agazines — this is ...m Road & Track — ...the form of an ...ustrated 'letter to the ...itor'.

The B is designed to appeal to:

PRACTICAL GUYS who like wind-up windows with adjustable side vents, a wrap-around windshield and wide opening doors with outside handles and locks.

AESTHETIC GUYS who flip their lids over subtly sculptured, aerodynamic lines and magnificent trim and finish.

HEEL AND TOE GUYS who revel in supple suspension, cyclonic acceleration and on a dime braking.

AND GALS.

...r right: Early MGB ...ille badges were reflec-...re, as can be seen in ...s surviving example. ...all accounts the local ...nstabulary was not ...used and the design ...as swiftly modified.

...ght: The multi-part ...ated MG badge on the ...ot lid was a very neat ...d unostentatious ...uch — coupled with a ...screet MGB script ...dge just above it.

...low right: The MGB ...atured paired rear ...verriders from the ...tset as standard (those ...the front were initially ...arged as optional ...tras). These overriders ...d the illumination ...mps for the rear licence ...ate set into their ...ward-facing surfaces.

...r right: The boot space ... the MGB was quite ...nerous for a sports car ...d was unlined, as were ...ost cars in the same ...ice bracket. The spare ...heel lay flat — in this ...se the steel wheel pro-...des a useful storage well.

The reflective grille badge

For virtually every MG sports car since 1928, the distinctive chrome MG grille had been fronted by an attractively enamelled MG badge in either cream and brown or — during much of the 1950s — white and black. The MGA had continued this proud tradition but for the Austin-Healey Sprite-based MG Midget MkI of 1961 — and the MGB that followed a year behind — it was decided to make a break with tradition in terms of badge material and colouring. Don Hayter drew up the radiator and badge, including the distinctive shield shape (shared with the MG Midget) and MG's model maker Harry Herring created a wooden mock-up. The idea at first was to have this shape die-cast and plated, with the MG badge enamelled. However, Hayter discussed the design with Ron Goddard at BMC's Radiators Branch, who suggested producing the centre bar and the shield as a single die-casting, with the badge either inset in the casting or with a plastic insert for it.

With an eye on saving the cost and complication of having the badge plinths enamelled, Radiators Branch had already been talking through the idea of a plastic substitute with Lucas, which had agreed to explore the idea. At first, as the idea was worked up, the initial prototype Diakon acrylic badge had four pegs on it, which would be matched to corresponding holes in the die-casting for the badges to clip in. However, the transparency of the badge made these pegs visible from the front, so Lucas suggested that the fixing pegs could be dispensed with if the badges were glued in place. According to Hayter, this needed 'a good thick back paint — which turned out to be this lovely "glowing" red paint. So what they had was a surface finish which acted as a reflector. The police said that these cars were parked the right way in the road but apparently showed a red reflector — so what we did was to go to a matt red paint. The genuine early MGBs still have them — but the change took place within the first year of production.'

What the MGB cost in September 1962

	Basic	Purchase tax	Total UK price
Roadster	£690	£259 15s 3d	£949 15s 3d
Extras			
Wire wheels	£25	£9 7s 6d	£34 7s 6d
Interior heater	£12 5s	£4 11s 11d	£16 16s 11d
Folding hood	£4	£1 10s 0d	£5 10s 0d
Tonneau cover	£8	£3 0s 0d	£11 0s 0d
Anti-roll bar	£2	15s 0d	£2 15s 0d
Oil cooler	£6 10s	£2 8s 9d	£8 18s 9d

Meccano Dinky Toys

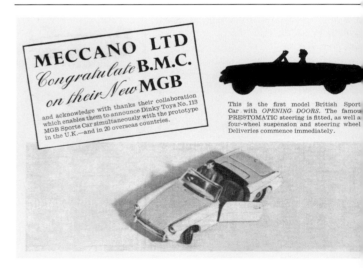

The MGB on paper

Notable omissions from the options list include overdrive and front overriders, not fitted on the preview cars and originally intended to be optional extras.

For the launch of the MGB, a series of brochures was printed by BMC's in-house Nuffield Press subsidiary at Cowley, using the slogan 'Superlative MGB' and subtitling this with the declaration that the MGB was 'Maintaining The Breed with Streamlined Power'. 'Maintaining the breed' cleverly alluded to thoroughbred breeding — it was a theme that had been exploited in MG's past and was the title of a book written by MG's own General Manager, John Thornley. The first brochures hinted at the contents within by featuring simple white covers with two steering wheels and the text 'Power in hand ... Lovely to handle'. These brochures are rather quaint to modern eyes — photography was the exception rather than the rule, a consequence as much of tradition, the limitations of the coloured lithography process, and a desire for the creative licence that was easier with hand-drawn illustrations. It was also an obvious fact that the location costs were rather less for a draughtsman and artist than a cameraman or studio on a photo-shoot.

Surely every boy in 1962 loved his model cars and undoubtedly the best-known name in Britain and much of the world was that of Dinky Toys, a range of pocket-sized die-cast toys that was produced by the mighty Meccano concern in Liverpool. Meccano had managed to secure arrangements with some leading British car manufacturers to develop some of its models alongside the real thing, so that both the toy and its full-sized prototype could be unveiled officially at the same time. Meccano pulled this off with BMC by producing a model of the MGB (number 113 in the Dinky Toys range) that first appeared in the pages of the *Meccano Magazine* — the 'bible' of Dinky Toy collectors — in the October 1962 issue, with a price of 5s 9d. Meccano always liked to make a splash about some new feature — gimmicks were becoming all-important in the battle for small-boy custom — and so the MGB model was no exception, featuring spring-loaded opening doors, sprung suspension with steering front wheels, and a moulded plastic windscreen. Sadly the opening doors were rather a crude fit and did little to add to the charm of the otherwise inoffensive model, which was finished in Old English White with a red interior. Interestingly the model appears to have been based upon the first

Meccano (makers of the world-famous Dinky Toys) acknowledged the special assistance that BMC had given, allowing it to 'launch' the model MGB on the same day that BMC announced the full-size version.

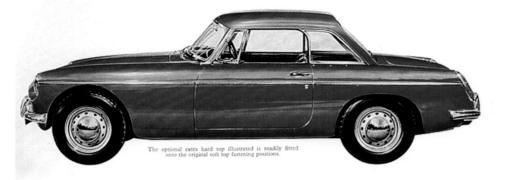

The optional extra hard top illustrated is readily fitted onto the original soft top fastening positions.

Early advertising for the MGB — particularly for the home market — featured the theme 'Superlative MGB'.

GB prototype, since it includes some ~~atures not seen on the production car,~~ ~~ch as a groove on the tonneau panel~~ ~~presenting an opening hood stowage~~ panel. The MGB went on to be a feature of the Dinky Toys range until it was finally withdrawn in 1969. A very rare South African-assembled variant was also produced for a short time in 1963, finished in red in place of white, and one of these fetched £2,232 at an auction in London in July 2002 ...

Specifications: MGB MkI

ENGINE

Description
In-line overhead valve pushrod four-cylinder with cast iron block and wet liners, cast iron cylinder head. Roller chain-driven side camshaft. Solid skirt four-ring aluminium alloy pistons, steel connecting rods, and copper-lead shell bearings. Three-bearing (five-bearing from 1964) crankshaft

Capacity
1,798cc (109.7cu in)

Bore and stroke
80.26mm x 88.9mm (3.16in x 3.50in)

Compression ratio
8.8:1

Maximum power
92bhp (net) @ 5,400rpm (five-bearing 95bhp)

Maximum torque
106lb ft (143Nm) @ 3,000rpm (five-bearing 110lb ft (149Nm))

Carburettors
Twin 1½in SU HS4

TRANSMISSION

Gearbox
Four speed with synchromesh on top three gears. Optional Laycock-de Normanville overdrive on top and 3rd gear from early 1963

Ratios
1st	3.636:1
2nd	2.214:1
3rd	1.373:1
(O/d 3rd	1.101:1)
Top	1.000:1
(O/d top	0.802:1)
Reverse	4.755:1

Clutch
Borg and Beck, 8in single dry plate

Propshaft
Hardy Spicer, needle roller bearings

Rear axle
Hypoid bevel, ratio 3.909:1

BRAKES

Front
Lockheed disc, 10.75in

Rear
Lockheed drum, 10in x 1¾in

Operation
Lockheed hydraulic

Handbrake
Lever with cable to rear drums

SUSPENSION

Front
Independent. Coil springs, wishbones with integral Armstrong lever-arm dampers

Rear
Live rear axle, semi-elliptic springs, Armstrong lever-arm dampers

STEERING

System type
Cam Gears rack and pinion

Number of turns lock to lock
2.9

Turning circle
32ft (9.75m)

Steering wheel
Bluemel sprung steel three-spoke, 16.5in diameter

WHEELS AND TYRES
4J x 14in steel disc wheels. Optional 4½J x 14in 60-spoke knock-off wire wheels

Tyres
5.60-14in Dunlop Gold Seal C41 cross-ply. Dunlop Road Speed optional at extra cost

PERFORMANCE
Autocar roadster road test, 26 October 1962

Top speed
103mph (165kph)

Acceleration
0–50mph (80kph)	8.5sec
0–60mph (96kph)	12.2sec
0–70mph (112kph)	16.5sec
0–80mph (128kph)	22.9sec
0–90mph (144kph)	32.6sec
Standing quarter mile (402m)	18.7sec

Average fuel consumption
20–29mpg (14.1–9.7l/100km)

DIMENSIONS

Length
12ft 9.3in (3.89m)

Width
4ft 11.7in (1.52m)

Height
4ft 1.4in (1.25m)

Wheelbase
7ft 7in (2.31m)

Track
Front: 4ft 1in (1.24m)
Rear: 4ft 1.25in (1.25m)

Ground clearance
4.5in (114mm)

Weight
2,030lb (920kg)

1963
'Winning ways — all through the range'

MGB accessories: hardtops and ocelots

Although the MGB was launched in September 1962, the remainder of that year was spent in ratcheting up production for a full-on sales campaign in the US the following spring, with appearances for the new model at important venues like the New York International Motor Show, held every April. Early production changes were relatively few and far between — the replacement of the reflective radiator grille badge being one obvious but barely noticeable exception. The December 1962 addition of British Racing Green (colour GN25) to the MGB palette was overtaken in August 1963 by the substitution of Dark British Racing Green (GN29). This change coincided with minor changes to the specification of the optional folding hood, which for the first time was available in black in addition to the red, grey, or blue hoods also on offer. The majority of changes during 1963 were little more than running specification improvements, often prompted by early warranty return information; this was still a new model and there was not yet any real need to change things.

If there were few changes required to the MGB itself during 1963, in the aftermath of the launch MG began to introduce new options and accessories to give the customer greater choice. The first significant development was arguably the optional hardtop, an attractive glass-fibre affair with glass windows, that became available a couple of months after the MGB's announcement.

The shape of the MGB hardtop was developed in conjunction with MG's old friend Eric Carter at Morris Bodies at Coventry; thereafter the task of developing the new hardtop largely fell to Jim O'Neill's assistant, Don Butler, who worked with Ferranti Laminations in Bangor, North Wales. According to Butler, these early MGB hardtops were very light and strong: 'they were pure resin and glass — there was no filler in them. I remember Les Pritchard of Ferranti came down to Abingdon and asked Syd if he would like Les to run a car over one of the hardtop

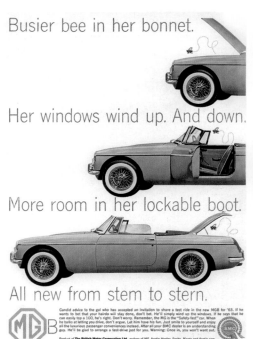

Left: By the time of this advertisement in Road & Track *in December 1962, Hambro's advertising was using a bumble bee as a marketing prop. 'Busier Bee in her bonnet,' proclaimed the headline.*

Above: The grille badge was made of clear plastic with the badge letters and octagon formed in the back, then plated and painted. Some early cars had badges with red reflective paint — swiftly changed after representations from the police.

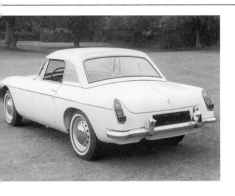

shells to prove how flexible they were. Syd took him up on the offer, and sure enough, the shell buckled but sprang back into shape.'

A high finish to the exterior skin of the hardtops — moulded with black pigment to avoid the need for painting — was achieved by the use of highly polished slate moulds. A significant obstacle to sales however was the relatively high cost of the hardtops and, as we shall see, the availability of the

MGB GT would limit sales of hardtops to an extent. According to Don Butler, Mr Bennett from Watsonian Sidecars came to Abingdon offering an answer to this problem, promising to produce the hardtops at a lower unit cost, and before long production was transferred. However, not everyone was impressed: 'They used a lot of chalk to make the resin go further,' bemoaned Don Butler. 'They were both heavier and more brittle.'

While the hardtop was a fairly expensive extra at £72 10s, there were many accessories introduced for the more impecunious MGB owner, even if some items (with the benefit of 40 years of hindsight) hardly seem to add much to the MGB in terms of value or good taste. Naturally BMC was at the forefront of accessories for the new MG, with everything on offer from mock ocelot seat covers (yours for ten shillings a set) to MG-badged exhaust tailpipe trims and clip-on Ace wheel discs; it seemed that there was something for every pocket and taste. Rather more appropriate for a sports car were the tuning accessories, which were developed by MG's own competitions department.

With the extensive range of performance parts that had been developed, tried, and tested for the MGA, it was hardly surprising that the MGB was soon able to boast a growing catalogue of parts to allow the owner to set his or her car apart from the herd.

The MGB hardtop was added as a competition-inspired accessory at the beginning of 1963. Until 1966 it could be supplied in black, blue, grey, Old English White or red (or in primer-finish if sold separately) although in later years it only came factory-fitted in black.

Not only did the MGB benefit from the availability of a wide variety of competition-developed parts from the BMC Competitions Department, it shared the dubious benefits of the rest of the BMC fancy trim portfolio — from decorative chrome tailpipe fittings to fake ocelot seat covers.

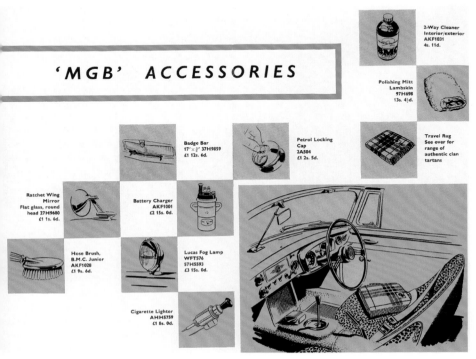

'MGB' ACCESSORIES

2-Way Cleaner Interior/exterior AKF1031 4s. 11d.

Polishing Mitt Lambskin 97H698 13s. 4½d.

Travel Rug See over for range of authentic clan tartans

Badge Bar 17" x ⅜" 37H9859 £1 12s. 6d.

Petrol Locking Cap 2A504 £1 2s. 5d.

Ratchet Wing Mirror Flat glass, round head 27H9680 £1 1s. 6d.

Battery Charger AKF1001 £2 15s. 0d.

Hose Brush, B.M.C. Junior AKF1028 £1 9s. 6d.

Lucas Fog Lamp WFT576 57H5593 £3 15s. 0d.

Cigarette Lighter AHH5759 £1 8s. 0d.

Optional overdrive

Throughout its development, the MGB had been intended to receive the option of a Laycock-de Normanville overdrive. Syd Enever ran a gold MGA 1600 Coupé fitted with an overdrive (never offered on the production MGA) as his personal car and it was obvious that the higher gearing would be invaluable, particularly in the US where longer journeys were the norm. However, prior to the launch, the North American importer, Hambro, expressed the worry that an overdrive-equipped MGB might eat into Austin-Healey 3000 sales, so the option was shelved for the time being. The advantages of higher gearing were so obvious, and the development work largely done, that it was not long before overdrive (operating on third and top gears, with a ratio of 0.802:1) became an optional extra — in the UK at first in January 1963 — at a cost of £50 plus £10 8s 4d purchase tax. For the time being, however, Hambro had its way and US customers were denied this option.

Sebring 1963: a cold beginning

The BMC Competitions Department had grown swiftly from a modest beginning in 1954 (to tackle such world-famous events as the famous Le Mans 24-hour race the very next year), so it was clear from the outset to fans of British sports cars that the MGB should soon carry the torch for MG motor sport. However, as far as the MGB was concerned, it could be said that there were one or two flies in the Abingdon ointment by the time that the new model arrived on the scene. First and foremost of these was the Mini-Cooper, which had moved rapidly to the forefront of European motor sport. In the process the giant-slaying antics of the little brick-on-wheels were doing a power of good for BMC's image as a whole. Further up the range, too, the powerful 'Big' Healey was proving an effective force in rallying, so when the MGB arrived it found itself the meat in a formidable sandwich.

On the run-up to the MGB launch, there was also a change of management at 'comps', as veteran Marcus Chambers moved on and his place was taken by the 27-year-old former Editor of *Motoring News*, Stuart Turner. He knew the marketing and motor sport potential of the Mini and Healey and, other than in the all-important US market, Turner considered the MGB as a much lower priority for the attention of his team. As the other cars had already proved their ability to win races outright, the lower-key efforts with MG models such as the 1100, Midget, and MGB were aimed at winning classes and categories.

One event that did deserve particular focus on the MGB, however, was the Sebring 12-Hours race, held every spring in Florida. Not only had this race established itself as a prime showcase of European motor sport talent, the MG marque — with local marketing support — had performed with distinction within the all-important classes in which it had participated. Even before the launch of the production MGB, therefore, work began at Abingdon on developing a competition variant with the prime focus on the Sebring race scheduled for Saturday 23 March 1963.

In addition to the massive 'back-catalogue' of readily available competition parts that had been built up for the MGA, MG suppliers were usually keen to lend a hand with special one-offs and production variants of components for motor sport use.

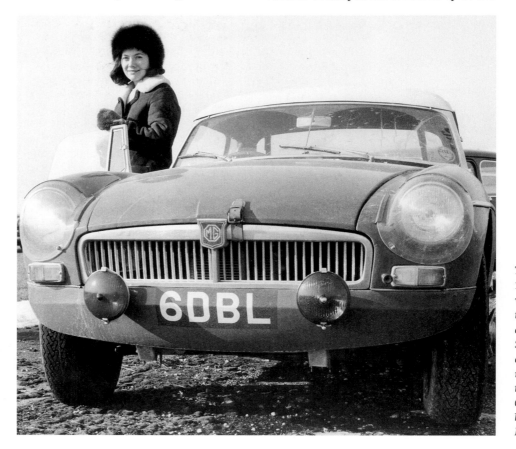

The British winter of 1962/63 was one of the worst on record and testing conditions ahead of the 1963 Sebring race were consequently far from ideal. This is the car that would be shared Christabel Carlisle (see here) and Denise McCluggage.

Among this list of keen supporters was the Pressed Steel factory at Swindon and quite often over the years Dave Nicholas and his chums would help out with body panels specially pressed in thin-gauge aluminium alloy. Such alloy pressings would be made when the presses were still warm after a session of pressing steel panels — followed by the extensive 'patching' that would be required with the results.

For a successful outing at Sebring, however, new parts and designs in themselves were not enough: a properly planned series of endurance tests would be needed in the months running up to the actual race. With a new model only just launched in the marketplace, it was clear from the outset that this would be a tough call — particularly as the Sunbeam Alpine rivals from the Rootes Group had been gaining on the outgoing MGA. Unfortunately, the British winter of 1962/63 was about as far from the warm spring Florida sunshine as one could hope to get; some of the coldest

and bleakest blizzards since 1947 swept in across the British Isles, with drifting deep blankets of snow lasting for weeks and causing chaos in the south of England. As a result of this 'comps' had a terrible job finding anywhere suitable to test the MGBs.

Meanwhile, with a shrewd idea of a publicity exercise, Stuart Turner and his colleagues decided that one car in the BMC factory team — entered under the guise of Ecurie Safety Fast — would be driven by an all-female entry, with the US journalist and racer Denise McCluggage sharing her charge with a British driver to be selected from a potential line up of Christabel Carlisle, Liz Jones, and Pauline Mayman.

On Wednesday 28 November 1962 the three Britons turned up at an icy-cold Silverstone for a series of 15-lap sessions. Christabel Carlisle proved the fastest, with a time of two 2min 17.9sec, and so she was chosen to partner Denise McCluggage. Americans Jim Parkinson and Jack Flaherty would drive the other car. Flaherty worked

Sebring MGB racer 8DBL during testing at a snow-covered Finmere Airfield in the harsh British winter of 1962/63.

for Kjell Qvale at British Motor Car Distributors in San Francisco and Parkinson was an MG/Austin-Healey sports car dealer in Burbank, California; together they had won their class at Sebring in 1961 in an MGA 1600 Coupé.

However, as the winter bore on the weather in Britain worsened; the usual testing haunts were simply buried under

MG and Sebring had close ties, as this 1970 photo of the Safety fast! bridge shows.

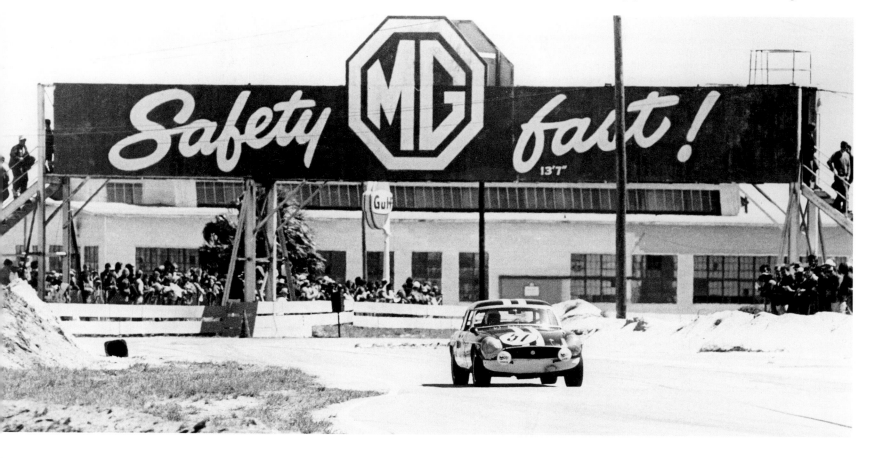

snow. Bill Price of 'comps' remembered: 'I was living at Boars Hill — between Abingdon and Oxford — and many of the roads were impassable; if they were open, they were single tracks between walls of snow. I tried ringing Silverstone, only to be told that the circuit had been under snow for weeks.' At this point, someone came up with the idea of trying Finmere Airfield, a former Second World War aerodrome just west of Buckingham. 'Harry Shillabeer — an ex-Hendon police driving instructor — ran the BMC Advanced Driving School there,' Price said. Finmere was also fairly snowbound but one of Shillabeer's instructors went out to have a look and put forward the suggestion of using one of the giant BMC Service training vehicles as a crudely improvised snowplough to clear a path.

Christabel Carlisle managed to steer 6DBL through the narrow corridor between the banks of snow while Donald Morley was able to try out the other car, destined for Flaherty and Parkinson. 'Of course there was no grip,' Price pointed out, 'it was very slippery and wet and that combined with the narrowness of the path cut through the snow didn't allow us to corner the cars very effectively. During the day, it thawed a bit, so it was even wetter under foot. There was therefore no real chance for us to discover any problems with purgative oil surge.'

The consequence of the poor weather was inadequate testing, particularly simulation of some of the tighter turns that would be experienced at the Sebring circuit. The new larger-capacity engines proved to be the undoing of the MGBs at the race on Saturday 23 March; both cars ran their big-end bearings early in the race and had to retire, despite a promising early showing. After the race the strip-down showed that the sump baffles were unable to cope with the degree of surge experienced at Sebring, particularly during the heavy braking necessary on those corners. First and second places in the MG's class were taken by factory Porsche Abarth Carreras (ninth and tenth overall), but to rub salt into MG's wounds, the only other finisher in Class 10 was a privately entered Volvo P1800 from New York. There were red faces all round: this was not what MG's new sports car was supposed to have done on its first major outing.

Sebring and the MG connection

Sebring, situated in the remote orange groves of Highland County, on the shore of Lake Okeechobee, Florida would never have been linked with the world of motor sport had it not been for the use of its Hendricks Field airfield as a B-17 bomber-training base during the Second World War. By 1950 the training base had fallen into disuse, so Alec Ulmann — an official in the Sports Car Club of America who longed to see an American equivalent of Le Mans — secured the assistance of wealthy race driver Sam Collier to plan a circuit at Hendricks Field. Sadly Collier was killed in a race at Watkins Glen in September 1950 before the dream was realised, so when the first (six-hour race) was held on the last day of December of that year, it was titled the Sam Collier Memorial Sebring Grand Prix of Endurance in his memory. Five MG sports cars competed (all but one of which finished).

The first 12-hour race — modelled on the famous French 24 hours — took place on 15 March 1952. Eight MG sports cars took part, the highest finisher being Dave Ash and John Van Driel in their MG Mark II Special, which finished in sixth place, beaten only by more exotic opposition including the winning Frazer Nash, a Ferrari 166MM and a brace of Jaguar XK120s. Over the following years — up until 1978 — there were usually at least two MG sports cars on the grid, the only fallow year for some reason being 1958. In total, MG cars have raced at Sebring more than 70 times but, at the time of writing, the best overall finish achieved in the 12-hour race remains that sixth place right back in 1952!

For most of the 1950s, MG racing at Sebring was down to the privateers but by the end of that decade the race had been recognised by MG's US importers, Hambro Inc, as a highly beneficial advertising tool and so there were a number of official entries, many with active participation from MG at Abingdon. By the beginning of the following decade, the MGA was beginning to come under increasing pressure from the opposition in its class — especially the Sunbeam Alpines — and so the MGB's debut at the circuit in 1963 was welcome.

If 1963 was a failure for the MGB, fortunately the next few years were much more successful; the plucky MGB would never achieve top-ten results — hardly surprising when the lead cars were typically Ford Mark II, Porsche, or Ferrari prototypes — but it regularly finished high up or at the head of its class.

The MGB down under

In 1963 the link between BMC and Australia was a strong one, for Lord Nuffield had established an Australian offshoot many years before. The combination of plentiful local labour, space for factories, tax incentives, and the relatively high costs of shipping complete vehicles right round the world, made it entirely logical that a 'back home' company should set up shop in the Sydney area. A substantial business had developed back in the UK — mainly focused at Cowley — in the packaging of kits of parts for BMC cars that could be shipped off in crates to various overseas locations for local assembly; Australia was one of the biggest markets for this process.

Before the MGB, the MGA had been shipped to Australia (and other markets, including South Africa) for local assembly. The MGB followed this pattern and was built up from crated panels using jigs before painting, trimming, and final assembly. At first nearly all the parts needed were imported as constituents of the kits but in due course progressively more components were sourced locally where this was prac-ticable and so the Australian MGB became just a tiny bit distinctive from its English cousin.

Australia's Abingdon: home of the CKD MGB

The MGB built in Australia from 1963 looked very similar to its British cousin. This a MkII version dating from a few years later but note how the fitment of overdrive warranted a special boot badge on this Australian version.

The history of MGB production in Australia involves three place names — but only two main factories — and this can be a source of confusion. MGAs had been assembled by Pressed Metal Corporation at Enfield, a suburb of Sydney, and this is where the early Australian MGBs started life. Before the Nuffield Organisation established its own factory in 1950, the assembly of Nuffield (and indeed the still separate Austin) products tended to be handled by the major distributors in each state. 'Some built their own bodies,' explained John Lindsay (a former BMC Australia apprentice), 'while others sub-contracted the work. In New South Wales, the Larke Hoskins Group, founded in 1907 (and an Austin distributor since 1918) formed Pressed Metal Corporation as a 70 per cent owned subsidiary and built a factory on a 22-acre site at Enfield in order to build the Austin A40 and Land-Rover.' Before the introduction of the Holden, John Lindsay pointed out, the Austin A40 was Australia's best-selling vehicle.

Pressed Metal Corporation — or PMC — went on to build the MGA and subsequently the MGB until 1968, when BMC Australia purchased the plant. After the main BMC factory at Zetland closed in 1975, production of the Mini, Moke and Land Rover continued at Enfield until 1981.

Back in March 1950 Lord Nuffield had purchased the site of the former Victoria Park racecourse in Zetland — another suburb of Sydney — and began the construction of what would become the company's main Australian production facility at Zetland. The entrance and administration building at this time — on the northern side of the factory — was in Joynton Avenue, Zetland but ten years later a new administration building was built at the southern end of the site, which was on South Dowling Street, Waterloo.

Waterloo is therefore the third Sydney suburb in this story but the new official address still referred to the old Zetland plant. 'To old-timers like myself, it will always be Zetland,' explained John Lindsay, 'but to newer employees or those of

Leyland background, it is more likely to be called Waterloo!'.

BMC had a habit of using the letter Y to start prefixes of project codes and chassis numbers for Australia; one assumes that somebody had noticed that a Y loosely resembled an upside down letter A. As a consequence, the Australian MGB chassis numbers differed from the British counterparts by having a Y in front; the first Australian CKD MGB was completed at Enfield on 4 April 1963, less than a year after the first British-built production MGB.

Over the ensuing years Australian MGB specifications kept reasonably well aligned with their British counterparts; sometimes changes lagged slightly behind and there were noticeable trim, paint, and even minor badging differences but overall it takes someone with a reasonably knowledgeable eye to spot the differences.

Vingt-Quatre Heures du Mans 1963

If the MGB's first official outing at Sebring had been a disaster, nobody at Abingdon was about to give up hope; immediately after everyone was back from Florida, there were concerted efforts to solve the oil-surge problem. Some cause for optimism had been given by the first US race outing of an MGB just before Sebring, when American Ronnie Bucknum had racing success at California's famous Riverside Raceway. The MGB would subsequently go on to perform well in the hands of local

tuners at SCCA-managed races in the US.

Back at Abingdon, however, they were thinking of taking an MGB to Le Mans in June 1963. There was a great deal of enthusiasm for this race but there was a major sticking point: BMC had imposed a ban on factory participation at the race, in the wake of the tragic Mercedes-Benz accident there in 1955, and so neither MG nor BMC would be able to stage a full works entry. In its time-honoured artful fashion, MG managed to contrive the situation where a factory MGB would be

'loaned' to a private competitor — in this case Alan Hutcheson — who would enter the car for Le Mans under his own name. Naturally the factory would offer every reasonable assistance (above and beyond the call of duty ...), with Paddy Hopkirk helping with the driving. This arrangement had the dual benefit that while credit for success could be shared, factory responsibility could be denied if everything went wrong.

In 1963 Peter Browning (nowadays involved in MG motor sport again with the MG Car Club) was based at Abingdon in the *Safety Fast!* office as BMC competitions press officer and became involved in each of the MGB forays to Le Mans as pit manager. 'There was some — but not really a lot — of help from Abingdon,' he suggested. 'John Thornley told me to go down and do the time-keeping and everything, and so we got some MGCC members to do the

signalling, and about 3–4 mechanics went over, and that was the extent of the support we provided.' Meanwhile the MGB itself — 7DBL — received a specially shaped teardrop nose, drawn up by Syd Enever and draughtsman Jim Stimpson and manufactured out of alloy by Car Panels Ltd of Nuneaton.

As Browning pointed out, simply getting to Le Mans was not enough: to be sure of taking part, you had to qualify and that

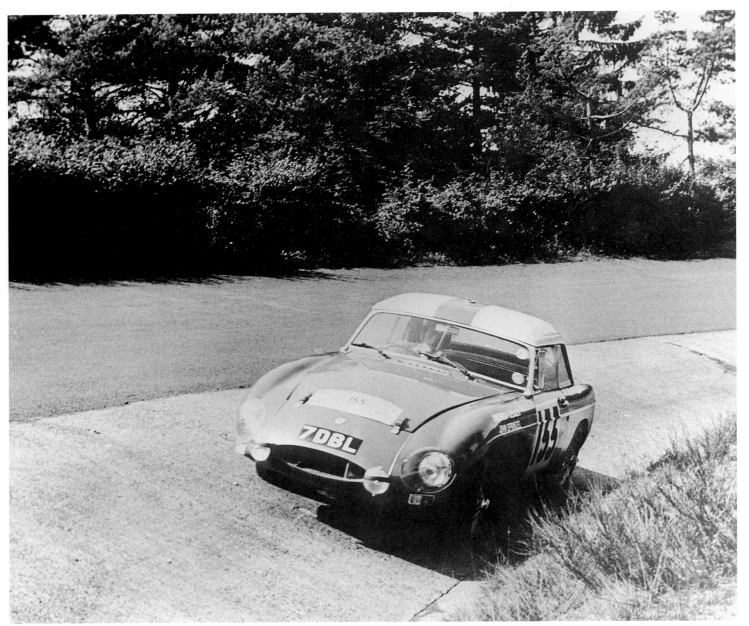

The MGB was raced with a distinctive aerodynamic nose cone penned by Syd Enever and draughtsman Jim Stimpson at Le Mans in June 1963. Here the MGB is racing in the Tour de France Automobile the following September.

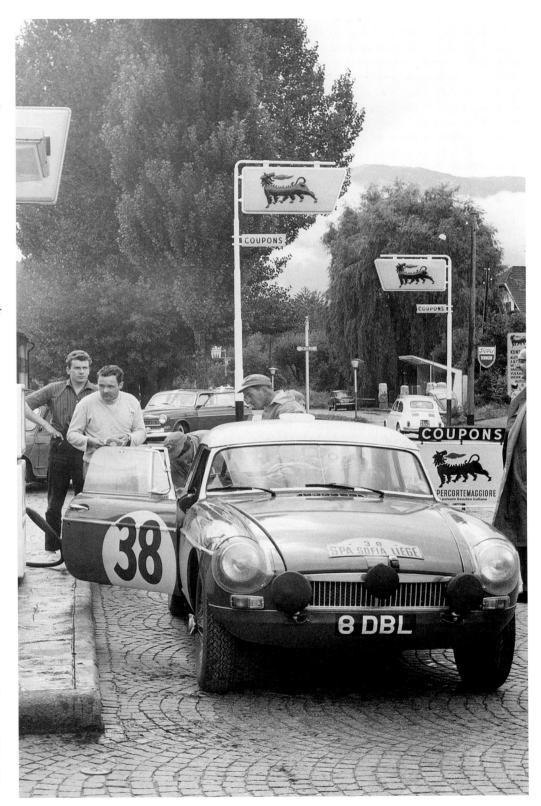

David Hiam and Rupert Jones stop at a petrol station during the Spa–Sofia–Liège rally in August 1963. The atrocious road conditions in Yugoslavia eventually led to their retirement.

was not a foregone conclusion for a comparatively low-powered car like the MGB. 'When the MGB did race, it did so very well — just by staying there, really,' he commented. 'The problem at Le Mans was qualifying in the first place — it was very nearly impossible to do a five-minute lap in an MGB. We used to worry — and it was our main fear — that there would be an incident in practice, and we would miss the qualifying session. We used to get somebody to give us a "tow" — a friendly driver in one of the more powerful cars would be approached by Paddy.'

This ploy obviously worked, for the MGB — bearing race number 31 — made the starting line-up and set off with Hutcheson at the wheel. Browning and his colleagues in the MG pit were rather worried when Hutcheson failed to appear after the first lap but it transpired that the car had gone off into one of the dreaded Le Mans sand traps at the Mulsanne corner. Hutcheson had to spend nearly an hour and a half digging the car out and lost 16 laps against the competition. Undaunted, the MGB eventually rejoined the fray and ran without major fault for the remainder of the 24-hour race, finishing in 12th place — out of 13 survivors — having achieved an average speed of 91.96mph. It was a good result and paved the way for a return under the official BMC flag in 1964.

What the MGB cost in October 1963

	Basic	Purchase tax	Total UK price
Roadster	£690	£259 15s 3d	£949 15s 3d
Extras			
Overdrive	£50	£10 8s 4d	£60 8s 4d
Hardtop	£60	£12 10s 0d	£72 10s 0d
Wire wheels	£25	£5 4s 2d	£30 4s 2d
Interior heater	£12 5s	£2 11s 1d	£14 16s 1d
Folding hood	£4	16s 8d	£4 16s 8d
Tonneau cover	£8	£1 13s 4d	£9 13s 4d
Anti-roll bar	£2	8s 4d	£2 8s 4d
Oil cooler	£6 10s	£1 7s 1d	£7 17s 1d
Whitewall tyres	£6 5s	£1 6s 1d	£7 11s 1d
Road Speed tyres	£4 15s	19s 10d	£5 14s 10d

1964
'MG — proved on the track — right on the road'

Monte Carlo or bust

Up until 1964 the MGB was the only BMC car to feature a 1,798cc version if the B-series engine — all other applications at this stage used smaller capacities of, typically, 1,489 or 1,622cc. However, as we saw earlier, this was only because MG had been used as a litmus test for a larger engine and September 1964 saw the launch of BMC's big hope for success — the Austin 1800. BMC's design chief, Alec Issigonis, wanted greater refinement for the new saloon and so the bottom end of the engine was redesigned with five (instead of three) main bearings; this new unit duly took its place in the MGB a month after the big Austin was launched.

Work started at around the same time to explore the possibility of stretching the capacity still further — to give a 2-litre unit of 1,998cc — and in due course six prototype engines were built. The 2-litre size was also of some benefit in certain motor sport events and BMC competitions at Abingdon — in cahoots with its friend Eddie Maher at Engines Branch — used more than one engine bored out to this capacity. However, in the end the production engine project was put on the shelf and would only be dusted off many years later as the basis of a very different engine project.

By 1964 it was abundantly clear that there were two really important cars in the BMC competitions line-up and neither of them were MGs. The Mini-Coopers and 'Big' Healeys were the cars of the moment and the MGB was a worthy second-ranker. Mini-Coopers would sweep all before them in the January Monte Carlo Rally in 1964, and were set to do the same in 1965, but there was just room to allow an MGB to come along for the ride on the coat-tails of its little cousin.

The Morley brothers — Donald and Erle — were farmers and semi-professional drivers and piloted 7 DBL with distinction, winning the GT class and finishing 17th overall. This was not without drama, however, for during the race the MGB's radiator sprang a leak and it seemed that the only sensible answer would be to bring out a replacement from Abingdon by car. 'The Morleys got to the service control at Frankfurt, where the car park was literally like a sheet of ice — a skating rink,' Bill Price explained. 'We had a look at the radiator, and decided it needed a new one. We went to get some water to top it up in the meantime, and found that like idiots

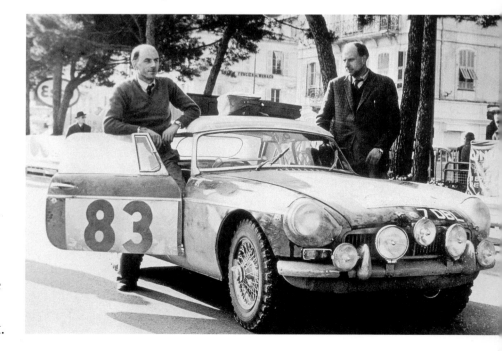

we had left the water container — an old oil tin — on the roof of our Austin Westminster service barge, and of course it had frozen solid!' Price and his colleagues managed to get some water from the Saab team and one of the BMC mechanics started to play a welding torch over the water can in an attempt to thaw it.

'Raymond Baxter was driving an MG 1100 with Ernie McMillan, and Ernie happened to be standing there passing the time. Ernie spotted the lad warming the can with the welding torch and said "I'll do that for you" — so he took over

the torch, and in next to no time he had burnt a hole right through the can!' At this point, Price made a call back to Abingdon, as he knew that BMC competitions stalwarts Doug Hamblin and Robin Vokins would be coming down to Dover and across to Boulogne on the ferry with a load of spares to be ready at the Boulogne service point, which was being used that year. 'Unfortunately, on the way from Abingdon, their car hit a patch of ice near Henley-on-Thames, spun into the path of an oncoming car, and poor Doug was killed.'

Needless to say, the MGB radiator never did get to the Morley's car; 'somehow we fixed the problem as best we could, and the Morleys still went on to secure the GT category.' Although this was, of course, a good result for the plucky MG, all eyes — and indeed the main team effort — was focused on the Mini-Coopers, one of which was driven to an outstanding outright victory by the up-and-coming Paddy Hopkirk. Understandably, the subsequent celebrations were tinged with sadness for the team at the loss of one of its number.

Left: Don and Erle Morley drove an MGB to finish 17th overall in the 1964 Monte Carlo Rally.

Right: The typically businesslike interior of an Abingdon-built competition MGB. This is the 1964 Monte Carlo Rally car, 7 DBL.

Far right: 7 DBL in action during the 1964 Monte Carlo Rally, where it finished 17th overall.

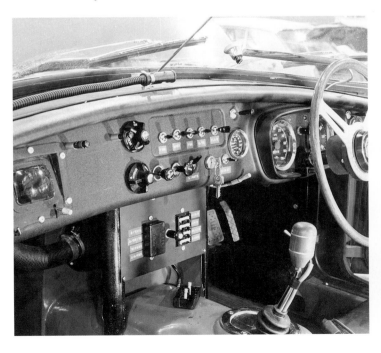

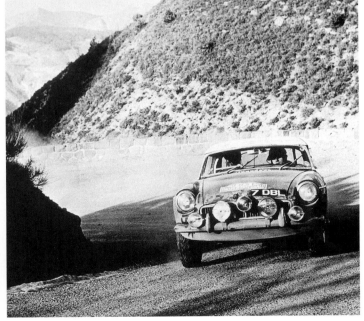

MG Belgique: the Coune MGB Berlinette

Jacques Coune was an Abarth dealer in the Avenue de la Couronne in the centre of Brussels, from which he sold Abarth cars and exhausts as well as the Iso Rivolta, an Italian-American confection created by combining Italian coachwork and a 5.4-litre Chevrolet V8 engine. The former Belgian army officer maintained a healthy business servicing and repairing these exotic cars and staffed his operation with Italian mechanics and coachbuilders, who found that the wages in Brussels were rather better than they could expect back home in Milan or Turin.

Coune soon found a lucrative business in producing one-off specials and was encouraged to build a limited production special of his own. The annual Brussels Motor Show was an ideal showcase for his wares and so in the autumn of 1963 Coune set to work modifying an MGB roadster into an Italianate sporting GT for display at the January 1964 Brussels show. A completely new outer rear section was grafted on to the structure, which from the rear door shut-line remained recognisably MGB in origin. However, the headlamps were set back into the wings below transparent cowls, in the manner of the Jaguar E-type.

Interest in the car — dubbed by Coune the 'MGB Berlinette' — was sufficient to bring customers to the Avenue de la Couronne in search of replicas. The contemporary MGB cost £690 (£834 including UK taxes) and this indulgence added about £480, which could be inflated by various optional extras at the customer's whim. Looked at objectively, this was a lot of money for a car of fairly humble origins but at the time of its launch there were few obvious rivals in its price segment.

Whereas the prototype had featured all-metal hand-formed bodywork, this would have been neither practicable nor economical for series production and so Coune opted for a hybrid steel and glass-reinforced plastic (GRP) monocoque. The new roof, rear wings, and back panel were all formed of the latter material and carefully bonded on to the basic MGB floorpan and inner wing structure. Cutting away the bulk of the MGB's rear bodywork was hardly a recipe for a stiff structure so, to put back as much of the original car's high torsional strength as possible, Coune had his men weld in a fairly crude but effective three-sided box structure, fixed across the car between the inner rear wings. Taking this a stage further, additional steel panelwork was introduced to stiffen the side and rear area supporting the roof.

The roof itself was GRP, except for the slender windscreen pillars, which were sensibly formed of steel, whilst the outer skin was matched by an inner shell, sandwiching steel reinforcement and sound-deadening materials. The all-new rear wings, integral with the large flat 'Kamm' effect tail, were also GRP and gave the back of the car an appearance not unlike the rather more expensive Ferrari GTO — not a bad car to imitate. A neat luggage compartment lid was fitted with simple external hinges and — still a novelty for 1964 — a remote-control internal

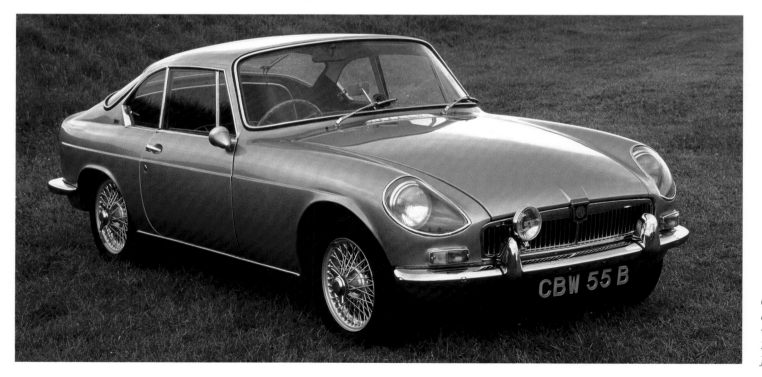

Only one right-hand-drive MGB Berlinette was built in the Brussels workshop of Jacques Coune.

release, reached from just behind the right-hand seat back.

The normal MGB chrome trim strip on the side of the car was discarded, the resultant rivet holes and wing joints necessitating a fair bit of reworking of the existing steel panelwork. Instead, a new chrome strip was applied to the sill, extending between the wheelarches and running just below the bottom of the door. However, the pièce de résistance of the panel-beaters' craft certainly lay at the front of the car where, even on the 'production' Coune MGB, the headlamps still had to be let into the existing steel wings by hand.

Inside the car much of the trim remained standard, with the exception of a new headlining (standard 1960s perforated off-white vinyl on most cars, believed to have been quilted on the original red

ght: The rear of the GB Berlinette was ite unlike that of the ndard production GB roadster.

r right: Like all rrossiers, Jacques une proudly played his badge on MGB Berlinette.

ght: The headlamps of Coune MGB rlinette were mounted a completely different nner to those of the ndard MGB. They re recessed behind ss covers à la Jaguar ype.

r right: The engine of s particular MGB rlinette (built cially for Walter dfield of BMC's bsidiary Nuffield ess) was largely touched. Note how Tartan Red engine y has been left as iginally finished.

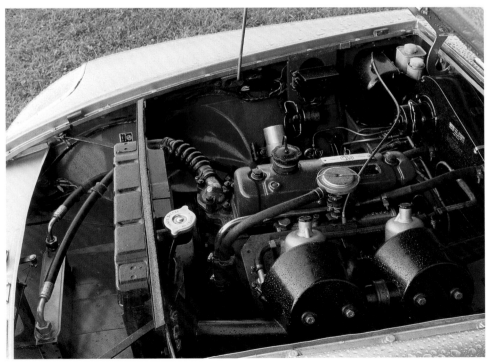

prototype) and the rear passenger compartment and luggage area, which were lined with very Italianate quilted vinyl. Of course, customers could opt for further trim changes, the limit only being governed by the depth of their wallets, but apart from the inevitable wood-rim steering wheel, there are few other trim changes known on the surviving dozen or so cars.

Performance testing of the Coune MGB does not appear to have been carried out by a recognised reliable source but surprisingly Coune claimed that the finished car was actually lighter than the standard MGB roadster — by 126lb — which meant that some six per cent had been shaved from the standard MGB's 2,072lb kerb weight. Coupled with the lighter weight, the smoother shape extended top speed to a claimed 112mph. Despite the high price output picked up, Coune rather optimistically and flamboyantly proclaiming that he was building up to a dozen per week. (All told no more than 56 cars would be built during the three-year production run.) The show car had gained some publicity in the motoring media, not to mention interest from those visiting the show on BMC's behalf, and so it was not long before MG's parent decided to commission a right-hand-drive car from Jacques Coune.

Initially an informal approach was made to Coune by BMC's engineering supremo, Alec Issigonis, and apparently there may have been some coffee-table talk of a royalty arrangement, whereby Coune would have been granted a licence to build his cars as MGs in return for a steady supply of components. Coune would have liked to have arranged a deal for British assembly of his car at around four per month. However, before any of these plans could develop, it was arranged that Walter Oldfield — Director of the Nuffield Press for almost 30 years — would place an order for a right-hand-drive MGB Berlinette.

A standard Tartan Red MGB, GHN3-36122, was shipped straight off the line to Brussels in April 1964 and by June the car was back at Cowley, from where it passed between the BMC factories for

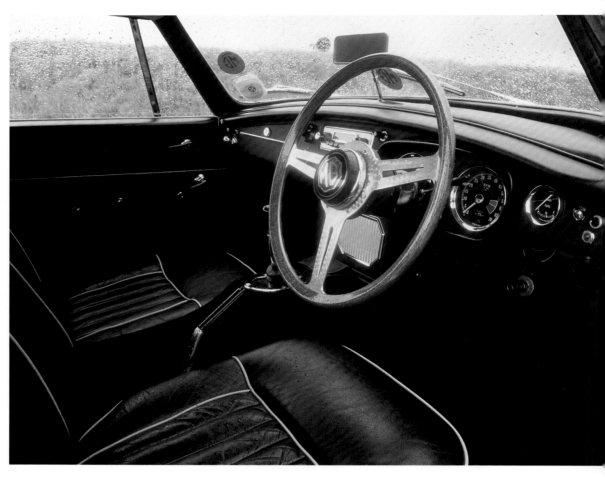

management appraisal. George Harriman, Leonard Lord, Syd Enever, and Alec Issigonis all had turns at borrowing the car. According to Mike Akers, who bought the car from Oldfield, Harriman and Lord must have quite enjoyed it: 'They had it for about a week or so, and Walter told me that he had to ask what had happened to it — trying to track it down. He discovered that one of the two had driven it and then passed it on to the other.'

Although everyone was impressed by it — in the context of what Coune had achieved — the future of the low-volume Coune car as the basis of a serious MG production car proved to be a non-starter. Add in the 'not invented here' mentality prevalent in the British car industry in those days and one can quite believe that Issigonis, the eccentric genius, was sniffily dismissive of the car as 'too Italian looking'. One-off prototypes — many of

which cost an absolute fortune to build — are often destroyed, once their usefulness is at an end, to avoid paying import duty. However, the duty payable on CBW 55B was obviously not so great and, being a director of BMC, Walter Oldfield was able to persuade the company to allow him to keep the car for his own use.

The launch the following year of MG's own GT coupé dealt a body blow to the Coune MGB Berlinette. Undaunted, Coune exhibited a targa-roofed MGB at the 1966 Turin Show, retaining some elements of the rear styling of his Berlinette but with thicker C-pillars and a removable roof panel. The result was less satisfactory; despite the undeniable novelty value of the removable roof panel — a concept still quite rare in 1966 — the prototype remained unique and Jacques Coune transferred his attention elsewhere.

The cockpit of Walter Oldfield's MGB Berlinette featured an attractive alloy steering wheel but the majority of the forward part of the interior remained fairly standard.

A Hydrolastic MGB successor?

The shiny new MGB was hardly out of its box before the fertile brain of MG's Chief Engineer, Syd Enever, was looking at how it would be replaced. Of course, this was not unique to MG — every car manufacturer begins thinking of the next move as soon as a project has passed from design into production. At Abingdon, Enever and his boss, John Thornley, wanted to make sure that they had planned their own preferred route to the next MG sports car rather than waiting for someone else within BMC — in particular Alec Issigonis — to dictate what they should do.

During development of the MGB, as we saw earlier, there had been plans to feature a more sophisticated rear suspension than the semi-elliptic springs eventually adopted and Enever was acutely aware that a modern sports car should ideally have a modern suspension system. BMC had introduced the intriguing Hydrolastic fluid-based suspension on its new mainstream saloons and so there was interest at Abingdon in the new system — not to mention the political expediency in adopting it for an MG. Syd Enever had

already started looking at various options for a 'new Midget' to replace the adopted Austin-Healey Sprite and before long his thoughts began to settle on a common successor for both the Midget and MGB that could be offered with a choice of A- or B-series engines to bridge the customer base of both cars.

Serious study at Abingdon started in February 1964; the EX Register records the first entry against EX234 — 'Hydrolastic sports car'. A certain amount of publicity had surrounded a single-seater racing car in the US called the Liquid Suspension Special, which had little to do with the actual Hydrolastic suspension (and did not make that much of an impression in racing circles) but nevertheless helped bring the novel Moulton-designed system to the attention of the American public. Two underframes were prepared, one of which was shipped to Pininfarina along with a packaging drawing. Pininfarina clothed it with an attractive body, which in aesthetic terms was effectively a cross between an MGB and an Alfa Romeo Giulia Spider.

Rod Lyne of MG's development department was impressed with the Pininfarina body: 'It had cable operated boot and petrol filler flaps — very unusual in those days. The fascia was also designed to be easy to reverse for LHD/RHD applications, with a modular instrument unit.' The prototype was fitted with an A-series engine but it was intended that the 1,798cc B-series engine would have powered what would presumably have been dubbed the MGD, although there was never any serious work done on a larger-engined version.

Despite showing much promise, EX234 became a victim of being just not important enough; MGB sales were going well but as the decade wore on there came the growing burden of meeting US legislation. By the time of the subsequent mergers, EX234 had been relegated to a corner of the development shop and only re-emerged from its resting place in the boiler room in 1976, when it was registered REW 314R (the initials of Bob Ward, MG Plant Director at the time) before being passed to MG collector Syd Beer, whose family owns it to this day.

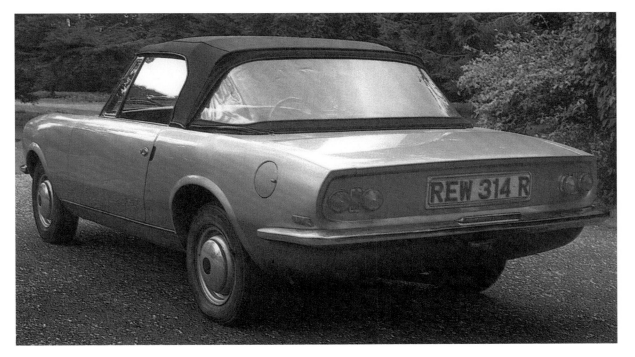

EX234 was an Abingdon concept to replace both the MG Midget and the MGB and featured BMC's favoured Moulton Hydrolastic suspension — at this point only used on front-wheel-drive BMC saloons.

Sebring 1964

The debut of the MGB at Sebring in 1963 was one that many at MG would rather forget but from such failures lessons are always learned and by the next season a wealth of experience in racing the MGB had been built up on both sides of the Atlantic. MG's West Coast distributor was Norwegian-born Kjell Qvale and his competition manager was the highly respected Joe Huffaker. Qvale entered three cars, driven by an all-American team. Two of the three MGBs lasted the course;

Ed Leslie and John Dalton came third in class and 17th overall, the all-Canadian crew of Frank Morrill/Jim Adams/Merle Brennan came next in class (22nd overall). Jim Parkinson and Jack Flaherty in the remaining car had an accident early in the race and were forced to retire. The key thing was that, this time round, not just one but two MGBs had lasted the 12 hours of Sebring; the car would certainly be back among the orange groves the following year!

Advertising the MGB

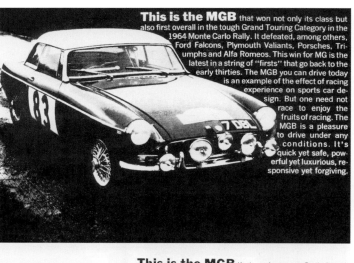

This is the MGB that won not only its class but also first overall in the tough Grand Touring Category in the 1964 Monte Carlo Rally. It defeated, among others, Ford Falcons, Plymouth Valiants, Porsches, Triumphs and Alfa Romeos. This win for MG is the latest in a string of "firsts" that go back to the early thirties. The MGB you can drive today is an example of the effect of racing experience on sports car design. But one need not race to enjoy the fruits of racing. The MGB is a pleasure to drive under any conditions. It's quick yet safe, powerful yet luxurious, responsive yet forgiving.

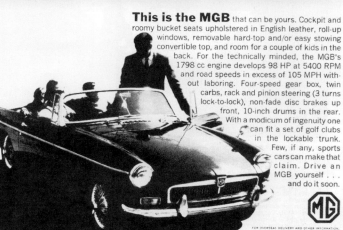

This is the MGB that can be yours. Cockpit and roomy bucket seats upholstered in English leather, roll-up windows, removable hard-top and/or easy stowing convertible top, and room for a couple of kids in the back. For the technically minded, the MGB's 1798 cc engine develops 98 HP at 5400 RPM and road speeds in excess of 105 MPH without laboring. Four-speed gear box, twin carbs, rack and pinion steering (3 turns lock-to-lock), non-fade disc brakes up front, 10-inch drums in the rear. With a modicum of ingenuity one can fit a set of golf clubs in the lockable trunk. Few, if any, sports cars can make that claim. Drive an MGB yourself . . . and do it soon.

FOR OVERSEAS DELIVERY AND OTHER INFORMATION, WRITE: THE BRITISH MOTOR CORP./HAMBRO, INC., DEPT. B-4, 734 GRAND AVENUE, RIDGEFIELD N.J.

Keep it bright—it deserves that.

Wear it modestly—it speaks for itself.

The medallion rewards MGB's overall win in the Grand Touring Category in the 1964 Monte Carlo Rally. It can be mounted on every new MGB—standard equipment, you might say. And deservedly: You too, can command the 1798 c.c. engine that put-down Ford Falcons, Plymouth Valiants, Porsches, Triumphs and Alfa Romeos (among others). It turns up road speeds in excess of 105 mph without breathing hard.

You can experience the G.T. dependability of race-tested non-fade disc brakes, the extraordinary control of rack and pinion steering (3 turns lock-to-lock) and the instant reflexes of twin carbs and 4-speed gear box. You can enjoy such amenities as contoured bucket seats upholstered in English leather, stowaway convertible top, padded dash...plus the other refinements which make the Grand Touring car

the most luxurious machine in fast motoring. Getting back to that medallion, read it now and then: "1964 GT Winner Rallye Monte-Carlo." Quickens the pulse. Boosts the ego.

FOR OVERSEAS DELIVERY AND OTHER INFORMATION, WRITE: THE BRITISH MOTOR CORP. /HAMBRO, INC., DEPT. T-21, 734 GRAND AVENUE, RIDGEFIELD, NEW JERSEY

Above: For the MGB's second outing at the famous Sebring circuit BMC entrusted the preparation and running of the three-car team to Kjell Qvale and in particular, his team manager Joe Huffaker. Butch Gilbert was able to locate and restore this ex-1964 race car (seen here in 2003). The other cars were white and blue, making a patriotic team.

Far left: BMC's US importer Hambro was tickled pink with the success of the MGB in the prestigious Monte Carlo Rally (many Americans had heard of Monte Carlo even if not for winter rallying!).

Left: Hambro ran a series of advertisements in the spring of 1964 and offered MGB owners the chance to acquire a special commemorative plaque celebrating the success at Monte Carlo.

y the time that the MGB had arrived in he US, in that market more than any ther, the advertisement was king; dvertising agencies handled major ulti-million dollar client budgets for dvertising in print, radio, and the ncreasingly important television media. each, McClinton & Co was just such a ompany and became involved with MGB dvertising in 1964. From that time ght up to the end of the MGB in 1979 rom 1970 as Bozell & Jacobs), every ational US advertisement for the MGB as generated under the direction of each, McClinton's team. The firm's reative director, Marce Mayhew, a lented Canadian, was an accomplished hotographer as well and many of he photographs taken in the MG and

Jaguar photo-shoots over the years were Mayhew's own.

Reach, McClinton's polished touch showed in the 1964 advertisements, starting with a series that followed the Monte Carlo Rally class-winning success. There was a unifying theme to them aimed at cleverly contrasting but comparing racing and road cars — the top half invariably showed the Monte Carlo MGB against a dark background, with wording in white, while the lower half depicted a road car, with the text in black against a pale background, subtly selling the message that the MGB had a foot in both racing and road-going camps and had a real race pedigree.

Later the same year saw an advertisement that played upon the

success of Sean Connery's latest James Bond 007 film, *From Russia With Love*. The advertisement featured bold white Cyrillic text against a black background, with the translation 'from MG with love', set above a moody photograph of a mysterious female model. Completing the air of special agent mystery, the text read: 'He pockets the Walther PPK, toes the accelerator and in seconds loses the Maserati in the convolutions of the Grande Corniche. Once again, MGB triumphs over Spectre ... and every other marque in Europe!'

Back home, meanwhile, the more conservative British motorist was presumably less ready for such modern marketing; the style of advertising in Britain was only just emerging from the

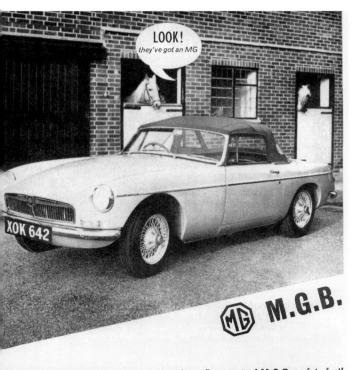

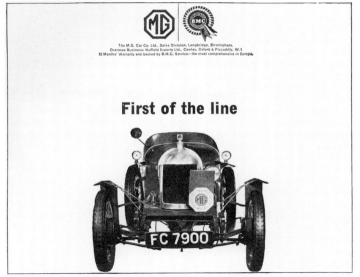

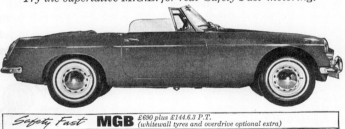

Far left: Advertising in the UK was clearly not at quite the same level as that in the US. This advertisement appeared in Autocar in August 1963.

Left: BMC precipitated years of argument and controversy among some of the more ardent MG enthusiasts with advertisements such as this one, from May 1964, which set out to establish 'Old Number One' as the beginning of the MG line.

tweedy illustrated style of the 1950s. August 1963 had seen an advertisement in *Autocar* that was excruciating in its awfulness, with an MGB tourer supposedly being admired over their stable doors by a pair of horses, one of which was saying: 'Look! — they've got an MG'.

In the UK MG focussed on stressing the 'thoroughbred' association of motor sport and wins — no matter how minor — were celebrated by 'success advertising'. Usually advertisements — such as one featuring Wilson McComb with a road-going MGB parked in the pits at the Le Mans circuit, alongside the 1964 long-nose MGB of Hopkirk and Hedges. 'MG — proved on the track — right on the road', proclaimed the proud headline.

Back to Le Mans

The honourable result for the MGB at Le Mans in 1963 was enough to help Thornley persuade the powers at BMC to sanction an official factory effort the following year. This time the car would be entered and fully supported by the factory instead of hiding behind the pretence of a privateer. The long aerodynamic nose used on 7 DBL the previous year now graced BMO 541B and this time Paddy Hopkirk was accompanied by Andrew Hedges. The previous September a privately owned MGB had been driven with some success in the Tour de France Automobile by a pair of French drivers and one of them — Patrick Vanson — was engaged to act as reserve to Hopkirk and Hedges at the 1964 Le Mans race.

In the wake of the experience gained in 1963, the performance of the MGB was significantly improved by the time of the 1964 Le Mans race in June and this showed during practice, where 'BMO' rocketed down the famous Mulsanne straight at 139mph with a fastest lap of 104.9mph. The race started well enough until Hedges had an unscheduled argument with a sandbank but he managed to get going again. Hopkirk took over but after just one lap returned to the pits; Hedges's altercation had damaged one of the wheels.

The car returned to the fray after a quick pit stop and the next few hours were relatively uneventful although, four and half hours in, a race official managed to break the special fuel filler cap. A temporary fix was lashed up but a couple of hours later Marcus Chambers — Stuart Turner's predecessor, who was now managing the rival Sunbeam Tiger effort for Rootes — chivalrously donated the cap from an expired Tiger.

Hopkirk subsequently found that the brakes were practically useless; the backing plates of the brake pads had welded themselves to the calliper pistons. 'This happened quite often,' Bill Price explained. 'It usually sprang from an underestimation of brake wear, leading to the brakes wearing down to the backing plates, which got red hot and welded themselves to the pistons, making them very difficult to prise free. You could also get the added problem of the brake fluid boiling off, and you could end up with no brakes at all!'

This problem overcome, the indomitable MGB just kept trundling round the circuit and cruised to a highly respectable 19th place overall (seventh in its class). The average speed had been 99.95mph, and as a bonus BMC won *The Motor* Trophy for the highest placed British car at the finish.

Greater refinement: the five-bearing engine

The B-series engine in the MGB had started life in 1947 as a 1,200cc Austin engine first seen in the A40 Devon, the first postwar Austin saloon, along with a planned but abortive 1,000cc variant. This original engine was never called the B-series — it was known at the time simply as the 1200 and in fact the parts are not interchangeable — but nevertheless the 1200 led to the first B-series, so named as part of Leonard Lord's master plan for a family of Austin engines starting with the 803cc A-series. The B-series was a simple overhead valve four-cylinder cast-iron unit with three main bearings and was conceived just as the rival Austin and Nuffield organisations were merging; the first car to feature the 1,489cc B-series engine was an MG — the Z Magnette of 1953. Thus began a trend where MG was used as a sort of test bed for BMC engines prior to their roll-out into the mainstream Austin and Morris ranges. Logically the MGA, which superseded the last of the square-rigger T-series MG sports cars in 1955, also featured the 1,489cc B-series and in 1959 the MGA gained a unique 1,588cc version of the engine. By the end of that decade plans were advanced for 1,622 and 1,798cc versions of the B-series — while retaining much of the basic architecture of that first engine of 1953. The MGA 1600 came along in 1961 and at first it had seemed that the MGB would have started life with a 1600 unit, had performance concerns not prompted the early substitution of the 1,798cc engine. The 1,798cc unit that appeared in the original MGB proved problematical; it may have been liked by MG's competition department but the problems at Sebring in 1963 were only part of the trouble; quite a few early cars had replacement engines fitted under warranty. Fortunately salvation was in the wings: BMC had decreed that greater engine refinement and durability would be needed for its new ADO17 'big Mini' saloon and that required two more bearings to be squeezed into the block — not an easy exercise due to the location of the

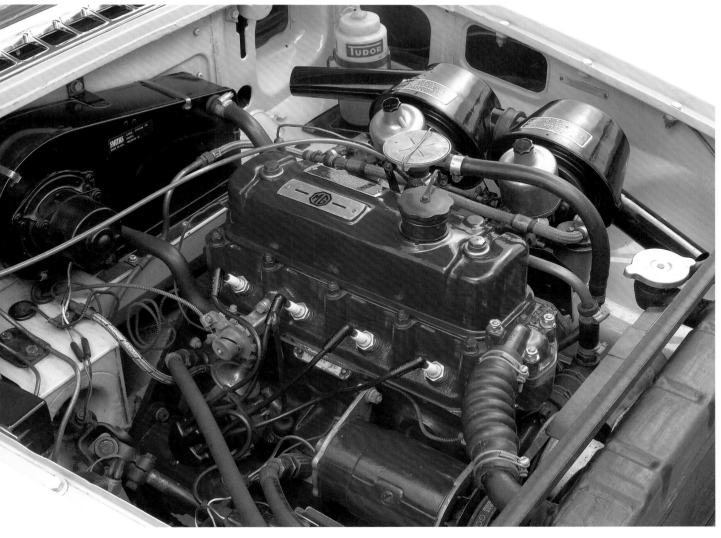

The MGB persisted with the BMC B-series engine, despite early investigation into other more exotic units. For the time being at least, the 1,798cc configuration was unique to the MG.

stributor drive and oil pump. The task as achieved, however, and once again MG d the privilege of receiving the new gine slightly ahead of the rest of the MC family. There is a striking parallel tween the B-series and the current MG ver K-series engine; both started life as nall' engines intended for the 1,000– 400cc range, then grew in due course to st 1,600 and ultimately 1,800cc pacities. The 1.8-litre versions of both 798cc B-series and 1,796cc K-series, with rtually identical bore/stroke ratios) made eir debuts in MG sports cars (MGB and GF respectively) and in both cases there ve been experiments to extend capacity en further to 2 litres.

Far left: The engine bay of the MGB was long, as can be seen from the set-back position of the radiator, providing ample room for expansion to six cylinders at a later stage.

Left: On early models the crankcase breather on top of the inlet manifold interfered somewhat with the aesthetics of the engine compartment.

1965
'The marque of the successful sportsman'

By the time that the MGB was reaching its third birthday, all was well at Abingdon: the MGB roadster was selling prodigiously in most world markets and there would be a new model variant with a closed coupé roof alongside the open car. The five-bearing engine may have been slightly less sporting but it brought useful refinement and longevity, while the usual production changes as a result of natural development made the MGB of 1965 a better car than its antecedents. A minor change in March saw the replacement of the MGA-style fuel tank with a new deep-drawn pressed steel tank developed specially for the MGB; the new tank was cheaper, better, and of larger capacity, so the change was for the better.

The following month saw another change — safety concerns at the rear-hinged pull-out door handles (there had been accidents involving pedestrians with similarly equipped Minis) led to the adoption of new push-button handles. It was a modest first sign that safety was going to be an important factor in the future development of the MGB.

The early MGB featured pull-out door handles, a concept that was later dropped with the advent of early safety legislation following accidents where doors flew open.

How the five-bearing MGB performed

Top speed	0–60mph	Standing ¼ mile	Fuel consumption	
107.2mph	12.6sec	18.8sec	21.3mpg	*Motor*, 9 January 1965
106.0mph	12.9sec	18.9sec	22.0mpg	*Autocar*, 12 February 1965
113.1mph	8.9sec	17.3sec	24.5mpg	Downton-tuned MGB, *Motor*, 4 December 1965

Sebring 1965

When it was agreed that BMC should sanction a team of MGs for the 1965 Sebring race, responsibility for the race entry and much of the preparation was retained by Abingdon. The American and Canadian drivers were picked by the importers and the small crew of British mechanics was supported by an enthusiastic retinue, who drove down from BMC Canada in Ontario. With two MGBs and the two 'Dick Jacobs' MG Midgets, all was therefore set for a determined crack at two different classes in the mild Florida spring weather.

Sebring in March was often a pleasant

change for the overseas contingent but the weather could be treacherous and 1965 was no exception. Local preparations, setting up, and testing usually took most of the week preceding the race and, although the weather in late March 1965 was reasonable, there were severe storm warnings for the weekend of the race. The 12-hour Sebring race started as always in the morning and at first was relatively uneventful. Then, almost halfway into the race, the rains came with a vengeance. Within a matter of minutes the relentless monsoon-like downpour had flooded much of the airfield and spectators were treated to the unusual sight of tyres floating out of flooded pit areas like bizarre lifebuoys.

This weather sorted the men from the boys and soon showed up the weaknesses of some of the more exotic competition: while the Ferraris and Fords had to slow down, the plucky little MGs just kept going, water streaming into every nook and cranny but apparently having minimal effect. After a couple of hours the worst part of the storm was past and the exotica managed to regain lost ground but for a while those MGs and their drivers had surprised the onlookers. By race end both the MGBs were down the field at 25th and 32nd overall — second and sixth in their class; Al Pease in the latter car had had an excursion off the circuit necessitating lengthy repairs. A few days later an MG advertisement appeared that said: 'Sometimes it rains when you are out driving ...'

Right: By 1965, when this advertisement for the MGB appeared in various influential US publications, the value of the original 1948 TC as an investment was already an established fact.

Far right: BMC made great play of the fact that its sports cars resolutely kept going during the downpour at Sebring in March 1965 while other more exotic competition fell by the wayside.

Left: The local team of Frank Morrill, Jim Adams, and Merle Brennan drove this MGB at Sebring in 1965 to finish fourth in class. Atypically for Sebring, the weather turned bad during the course of the race and the drivers had to cope with torrential rain, despite which the BMC team won three classes.

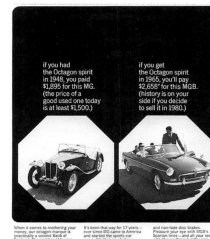

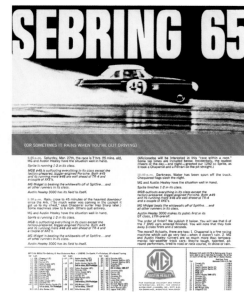

Third and last time at Le Mans

Many motor sport professionals will tell you that to have a chance of doing well in a race there is little point in trying just once. The best approach — finances permitting — is to plan for three attempts: the first (as in 1963) being a learning experience, the second a race in earnest, and the third applying the lessons from mistakes made previously with the aim of winning. This may or may not have been BMC's game plan but the MGB was back at Le Mans for a third time in June 1965.

The distinctive aerodynamic nose cone was used once more but this time on DRX 255C and with some alloy strip inserted to make the aperture slightly smaller and therefore less likely to allow overcooling. Almost as if the French had been hoping to outdo the escapades at Sebring, the weather for the Le Mans practice was poor and there were problems with sand being blown out of the sand traps and on to the circuit. Paddy Hopkirk and Andrew Hedges were back, sharing the drive for a relatively uneventful race, which they finished in 11th place overall, achieving an average speed of 98.25mph.

Sadly this was to prove the swansong for MG at Le Mans — at least until an entirely new chapter opened up 35 years later. The opposition was getting too specialised and too fast and it was consequently becoming harder for the relatively humble MGB to qualify, let alone compete seriously. Syd Enever did give some thought to building a special alloy-bodied Le Mans MG, loosely based on the MGB, but BMC saw insufficient justification in making a special car for one race that not only looked totally unlike the showroom cars but stood little chance of making much of an impact.

The Italian job: Pininfarina and the MGB GT

Right from the moment he watched a group of three Aston Martin DB2/4 coupés pass by him in the 1950s, MG Managing Director John Thornley knew that he wanted to see an MG coupé with the elegance and style that would not disgrace a captain of industry. The MGA Coupé was a nod in the direction of two-door close-coupled modern MG motoring but even its most fervent admirers must grant that the styling is an acquired taste. Closer to Thornley's ideal was a special fastback version of the MGA, penned by Don Hayter for Ted Lund to race at Le Mans, and the 'Dick Jacobs' Midgets showed how neat a small MG coupé could look.

By January 1962, just months before the MGB arrived, the EX Register records

EX227, which some have incorrectly associated with the MGB GT. However while this project was further described as a '1600 GT coupé two-seater', the detailed references throughout this portion of the register show that EX227 had little or no common heritage with ADO23 other than the badge.

For the story of what became the MGB GT, we only have to look back at the EX205 coupé study (shown on page 10) from the early days of the creation of the MGB to see evidence that Thornley and Enever foresaw a coupé variant of their new sports car; it was just a simple fact of economic priorities that the open roadster had to come first in the interest primarily of US sales. Early efforts at making an elegant

MGB coupé were not that successful, however. Somehow the car looked overtly squat or beetle-browed with a roof that allowed enough headroom and it was only when the decision came to dispense with the standard shallow competition-compliant roadster windscreen that the styling began to develop.

Who was responsible for this is nowadays open to debate; Thornley gave all the credit to Pininfarina, the Italian styling house that produced the polished end result, while another version of events has it that Enever raised the windscreen header rail but the Italians finished the job. Added to this was the fact that Jacques Coune had utilised a taller windscreen from a Simca for his Berlinette Coupé — shown in January 1964.

Irrespective of the inspiration, the end result was unquestionably superb and is regarded by Sergio Pininfarina as one of his most successful pieces of production work for his BMC client. 'As far as I remember, BMC was only asking for a transformation of a convertible into a coupé with no specific indications. The hatchback solution was conceived and realised in Pininfarina: it was certainly the preferred option between some others conceived for the car — as shown by the coloured sketch which survives, showing a

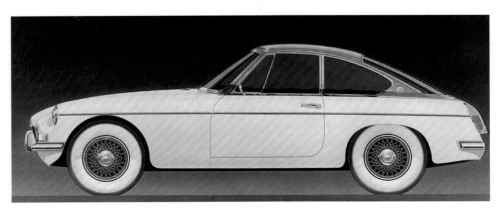

Pininfarina's original idea for an MGB coupé was this smoothly style[d] offering. Some element[s] of the eventual MGB G[T] can be seen here.

ifferent top without a hatchback,' he ecalled in 1999.

A Chelsea Grey MGB roadster (chassis umber GHN3-9359, with the destination marked 'EXP' for experimental) was ispatched to Turin in February 1964 and ne skilled designers and artisans of ininfarina set to work styling and build-ng the first prototype. 'The prototype self was made straight to steel,' onfirmed Sergio Pininfarina. 'It was ompletely finished in every detail, and eady to be used. To build it we realised a ooden model which had at first the nction of a styling model in three

dimensions and then that was used as a tool to realise the body panels and structure.' Once the finished car came back to the UK in June 1964, it was seen at Longbridge and Abingdon and was met with universal acclaim. Everyone was full of admiration for the manner in which Pininfarina had cleverly married the curves of the MGB roadster to the crisper Farina lines of the roof and had included the neat opening tailgate — quite a novelty in a world where the word 'hatchback' had yet to be coined.

There was little doubt in any quarter of BMC that the MGB coupé had the potential

to be a great hit, and so without much delay the process of turning Pininfarina's prototype into a production reality was put in train. The first production MGB GT was built in September 1965 and the car made a starring appearance on the MG stand at Earls Court the following month. There were a few changes under the skin apart from the new roof and glasshouse: the rear suspension was beefed up and a tube-type Salisbury axle fitted in place of the banjo type on the roadster, there were some new colours on offer, while on the tailgate there were chromed MGB and GT letters on either side of the MG octagon.

Building the MGB bodies

rom the start of MGB production the nal body assembly, painting, and imming took place some 70 miles away the Morris Bodies plant in Coventry — ven though Pressed Steel had been sponsible for the body design, tooling, anel and sub-assembly manufacture. Of ourse, Pressed Steel was at that time a ontractor to BMC and Morris Bodies was n house', so there was a certain amount f logic even though the painted and immed bodies still had to travel back outh to Abingdon.

Some of the logic for keeping separate lants busy in this way evaporated in 1965, owever, when BMC acquired Pressed Steel: ow Morris Bodies and the Pressed Steel lants at Swindon and Cowley were all dopted into the same family. The new ressed Steel Fisher division brought ogether plants at Castle Bromwich, oventry, Cowley, Llanelli, Swindon, and irmingham's Ward End. Despite onsiderable investment in 1960 in a new aint shop, Morris Bodies at Coventry was ne oldest. As this amalgamation was in and, spare capacity became available Swindon and Cowley and so Morris odies became surplus to requirements; ressed Steel Fisher's Managing Director, e Edwards, therefore took little time programme Morris Bodies' run-down closure.

The transfer was not an immediate one; roduction of the Morris Traveller at

Morris Bodies was due to continue until 1971 and so for a while many MGB roadster bodies continued to be finished there. However, the production body-engineering of the MGB GT was carried out at Swindon and so the bodies were manufactured there (where MG Midget bodies were already built), with painting and trimming at nearby Cowley. Gradually the GT was joined there by its open sister, with the changeover completed by 1969.

The arrival of the MGB GT posed its own special problems for the men on the sub-assembly line at Pressed Steel, as Ted Gowland (former Pressed Steel foreman) explained: 'The roof was located with templates on the jigs from the front, and so any errors ended up at the aperture at the back.' These were due to heat distortion: 'What many people do not realise is that when you weld panels together, you get expansion during a continuous run of welds — it could be quarter of an inch in 20 inches.'

The solution, as was often the case, had to be worked out on the line. 'So we had to control the aperture depth with an angle iron bar,' Gowland continued, 'and instead of welding in one run, we would tack each corner, tack each point in the centre, and then weld inwards — and it all came out alright. It cost a little more, because of having to stop and re-set the gun each time, but it worked.'

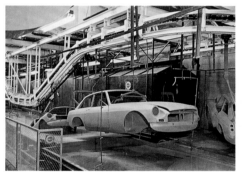

For the MGB, BMC developed a brand-new electrophoretic primer facility, in conjunction with paint specialist ICI. This photo shows an early MGB GT bodyshell emerging from the deep tank of pinkish primer at the BMC factory at Cowley.

The simple door trim of the early MGB, with basic but functional equipment.

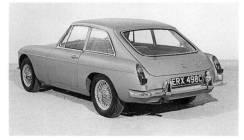

By the time that MG's production version of the MGB GT was ready, it was hardly different from Pininfarina's visualisation.

The MGB GT goes on sale

The first chance that the British public had to see the new MGB GT was at the Earls Court Motor Show in October 1965; in fact the car was officially unveiled on 19 October, on the eve of the Show, to maximise publicity. *Autocar*'s London Show Report issue included the MGB GT in its line up of '66 models — entering into the American model-year vogue — and began its description by suggesting that the MGB GT was: 'Perhaps one of the prettiest sports coupés ever to leave the B.M.C. drawing boards ... Whether it should be classed as a roomy coupé or as a potent estate car, it certainly combines the merits of both types.' Interestingly *Autocar* stated that the heater, long a controversial option for the open MGB, was now standard in the MGB GT: it was not and would remain an extra until 1967, although in most export markets the cost appears to have been included. US sales of the 'MGB-GT' did not really get under way until after the New York Show in April 1966.

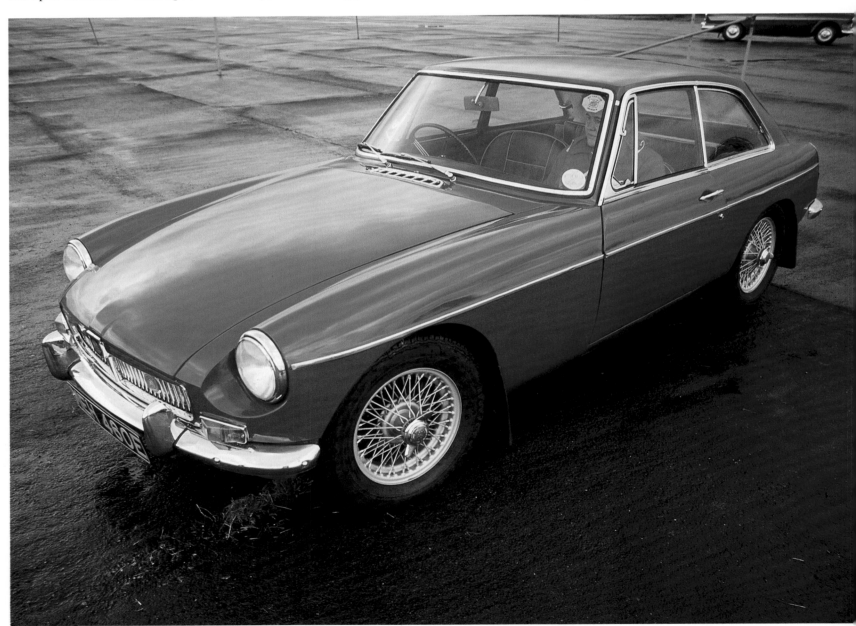

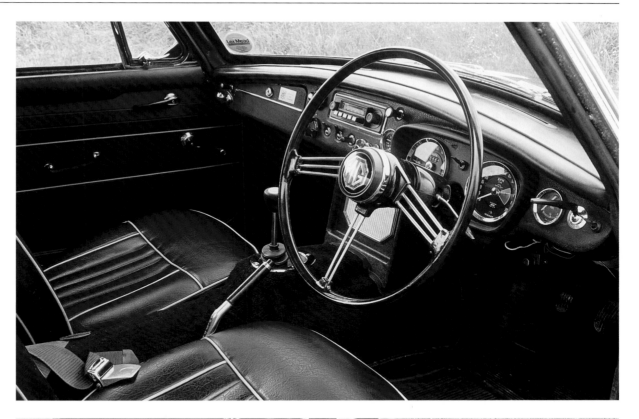

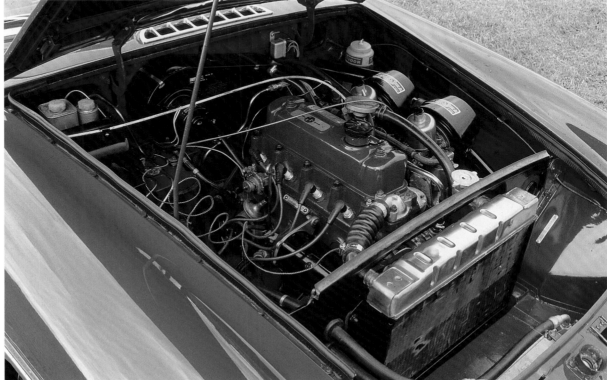

Above: BMC used this advertising prop in the US to support the introduction of the new 'MGB-GT'. The use of the 'bumble bee' was an echo of the theme adopted for the original MGB three years earlier.

Right: The interior of the MGB GT differed only in detail from that of the roadster: door trims were altered slightly, incorporating an added line of piping below the door pull-handle.

Left: The Pininfarina-styled roof of the MGB GT provided an intriguing, but very successful, marriage of crisp contemporary Italian lines over the typically curvaceous English roadster body of the MGB.

Right: Under the bonnet, the MGB GT was to all intents the same as the MGB roadster. MGB engines were finished entirely in red until the advent of the much-modified '18V' engines in 1971.

1966
'MGB drivers never travel alone'

In 1966 BMC was on a high; its crucial 1100 (ADO16) range was leading the UK car market. For MG, too, these were halcyon days: the MGB was selling strongly, the MGB GT had just been added to the range (US sales of this new model were about to get under way), and on the near horizon there was a six-cylinder version of the MGB to reinforce BMC's dominant position in the sports car sector.

BMC's bold acquisition of Pressed Steel in 1965 was matched in 1966 by an alliance with Jaguar; the resultant conglomerate — a giant in UK motor industry terms — was called British Motor Holdings. Behind the scenes, however, all was not quite as it seemed; BMC had been suffering from many woes and there was mounting political pressure in Britain for yet more consolidation in the UK car industry. The company that seemed best placed to drive this process was not BMC but the much smaller Leyland Motor Corporation, which included Triumph and, from the middle of 1966, Rover cars. The relative calm of 1966 was a prelude to the storm that would follow.

How the MGB GT MkI performed

Considering *Autocar*'s enthusiasm for the new model, it is perhaps surprising that it was not until the spring following the London Show Report issue, in the issue of 4 March 1966, that the magazine subjected an MGB GT to the rigours of a full road test. It was also not until May that the two leading US publications, *Road & Track* and *Car and Driver*, tested the car.

Top speed	0–60mph	Standing ¼ mile	Fuel consumption	
107mph	13.2sec	19.5sec	20.9mpg	*Motor*, 19 February 1966
102mph	13.6sec	19.1sec	22.8mpg	*Autocar*, 4 March 1966
105mph	13.6sec	19.6sec	20–26 US mpg	*Road & Track*, May 1966
108mph	12.1sec	18.5sec	22–28 US mpg	*Car and Driver*, May 1966
108.2mph	12.2sec	—	24.0mpg	12,000-mile report, *Motor*, 15 April 1967

Sebring '66: a truly international team

The recipe in Florida for 1966 was slightly different. Two cars were entered — nothing unusual in itself — but one was equipped with a special 2,009cc engine, which may have been taken from the BMC Engines research programme to develop a bigger B-series. The engine was certainly very special — it had a one-off cast-iron head reworked to take offset 'Big' Healey valves, nitrided five-bearing crankshaft, special pistons, and MGA Twin Cam con rods. This car was to be piloted in the prototype class

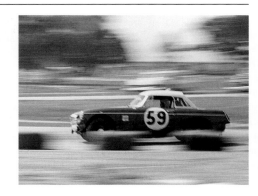

by the Anglo-Irish crew of Hedges and Hopkirk, while the second car — a comparatively conventional MGB — was driven by a truly mixed-nationality crew of Peter Manton (an Australian with a string of successes in Minis), Roger Mac (British), and Emmett Brown (American).

There was a lot of interest in the rather special 2-litre engine, which suffered from a broken rocker shaft quite early in the race. The problem was swiftly remedied in the pits but, despite climbing impressively up the field, a piston rod dramatically punched a hole through

the block when Hopkirk was just an hour and half from the end. Meanwhile the remaining car upheld MG honour and came home as the first British car to finish, though in 17th place overall — first in class and six laps ahead of a Triumph TR4.

Right: DRX 255C was one of the factory cars (or perhaps it would be better to say 'persona') as so many parts of cars were interchanged between races that it is sometimes difficult to be precise 40 years afterwards in attempting to tie a registration number to a particular car!

Left: Australian Peter Manton and Americans Roger Mac and Emmett Brown shared the driving of this MGB at Sebring in 1966. They finished first in their class and third in the GT category.

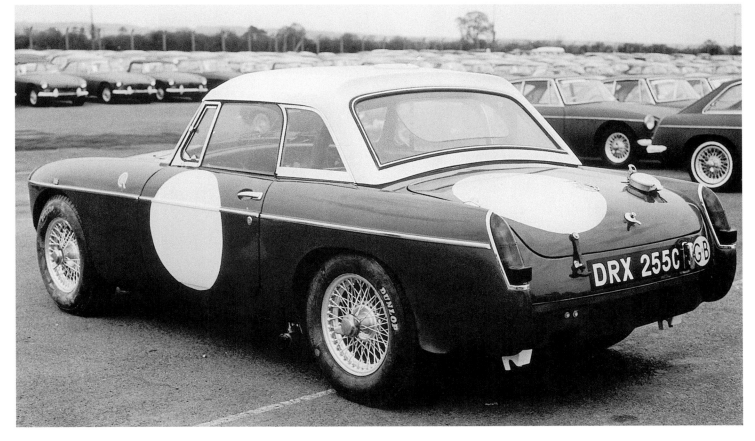

April in New York: debut of the MGB/GT

An important event for BMC was the New York International Motor Show, staged in April; it was the local show for the East Coast BMC offices and was a useful focal point for entertaining and meeting with dealers and the various movers-and-shakers of the North American motoring world.

In April 1966, MG had a new attraction — the MGB GT or, as it was rebranded exclusively for the US market, the

'MGB/GT'. The idea of the '/' graphic was purely down to the US import arm; Bob Burden of that august operation recalled: 'We felt at the time that a 'graphic' was needed to pull the elements together, and in retrospect I still think we were right'.

MG made quite a splash at the New York show; an MGB/GT was cut in half and mounted on a floodlit turntable with a

special concealed mechanism that moved the two halves of the car open and shut in scissors fashion. This sort of floor show was still quite a spectacle in 1966 and the MGB/GT made the local newsreels and papers as a result. The two halves were subsequently returned to Abingdon, updated and re-used for other exhibition purposes; both now survive in the Heritage Collection at Gaydon.

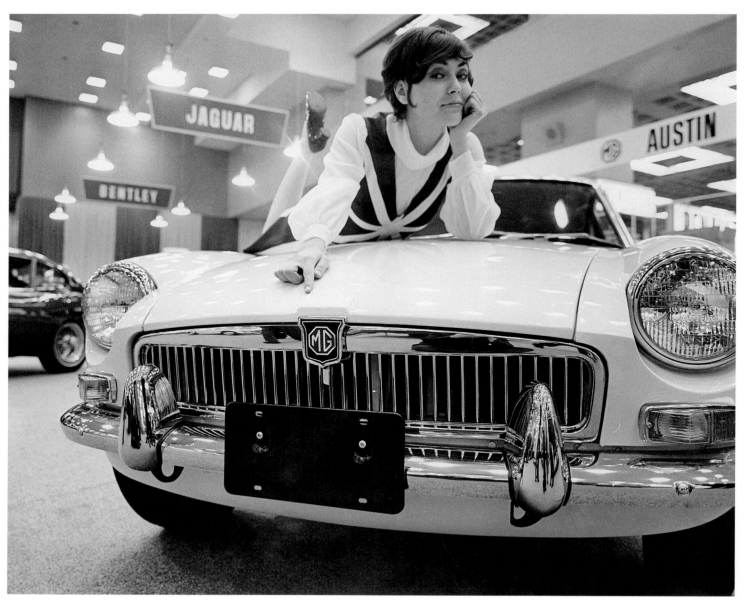

Left: The MGB/GT made its US show debut at the New York International Motor Show in April 1966. Bob Burden and his creative team at Reach, McClinton & Co (the advertising agency responsible) kitted out the models with Union flag vests.

Right: Hambro's creative director, Marcel Mayhew, adopted the idea of an elegant female model lying improbably across the roof of the new MGB/GT for this expensive four-colour advertisement in various US periodicals.

MG and Jaguar in the same family: the BMH merger

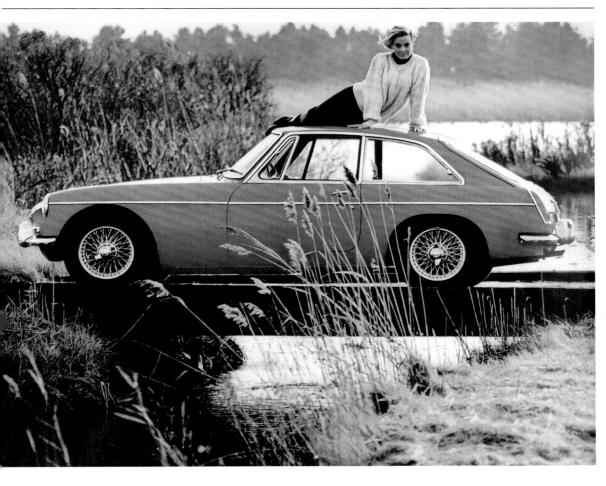

**INTRODUCING THE MGB/GT.
A QUIETLY SENSATIONAL TOURING MACHINE
STEEPED IN BRITISH LUXURY.
YET PRICED AT A MODEST $3,095.**

Now you can stop envying the men who race sports cars at Sebring and Le Mans. Because now you can get the same kind of thrill at the wheel of an MGB/GT. The pure excitement of eating up miles in a machine all MG to its British core. The MGB/GT (with enough gusto to reach speeds of 105 mph plus) whistles you from here to there before your favorite lady has time to change her mind. As you take a curve along the way its race-proved suspension keeps you on the level. And its fade-free disc brakes never vary in stopping power—no matter how much braking you do.

Along with authentic MG sports car performance, you get a car full of luxury bits as standard equipment. Hide leather upholstered bucket seats. Padded, no-glare dash. Full instrumentation (complete with tachometer). Electric windshield wipers.

Windshield washer. Wall-to-wall carpeted luggage area. 60-spoke wire wheels. And sound-proofing throughout so you can catch her slightest whisper at turnpike speeds. If all this makes the MGB/GT sound outrageously extravagant, it is. All except the price—an astonishing $3,095* for MG magic in an exciting new shape. See it at your nearest MG/Austin Healey dealer. And may we urge haste lest you keep the lady waiting.

With the acquisition by BMC of Pressed Steel in 1965, many of the smaller independent players in the British car industry became understandably nervous. The two most obvious of these were the respected family-managed businesses of Rover (with its world-renowned Land Rover subsidiary) and Jaguar (ruled fairly patriarchally by founder Sir William Lyons). The worry was that with Pressed Steel now largely subservient to what had previously been just its biggest customer, the independents would soon find that the costs associated with the bodies of their cars would be vulnerable to rises, coupled with the fact that some degree of commercial confidentiality had been lost. The result of this was two mergers; Rover moved into a union with the Leyland Motor Corporation (already home of Standard-Triumph) while Jaguar moved into bed with BMC. The latter union was a slightly reluctant one on Sir William's part: doubtless part of the equation was the fact that Jaguar's founder had lost his only son and heir in 1955 and so he felt that, for his company to continue to prosper in the future, some kind of merger would be the only solution. As the BMC and Jaguar talks proceeded in May 1966, however, there was a counter-proposal by Leyland's Deputy Chairman, Sir Donald Stokes, who proposed a tripartite merger between BMC, Leyland, and Jaguar. However, there was insufficient meeting of minds for this to happen and so on 6 July 1966 BMC and Jaguar announced their agreement to join forces and form British Motor Holdings. One of the almost immediate effects of this marriage was the redundancy of the grand BMC sports car projects fostered by BMC Chairman Sir George Harriman. He had supported the development of a monster 4-litre Austin-Healey sports car with striking styling; with the Jaguar E-type now in the fold, such an extravagance was no longer

needed. Similarly, the attractive Jaguar six and small Daimler V8 engines were added to the portfolio and it was possible for the MG team to contemplate their adoption in Abingdon-built sports cars. Some initial desktop studies were undoubtedly carried out in this vein but none ever came to anything. Sir William continued to exercise directorial authority over most matters Jaguar and was very resistant to any ideas that threatened the exclusivity of his products — indeed it is notable that there was little obvious cross-pollination between the BMC and Jaguar marques in this period. However, one positive benefit was in sales and marketing, particularly in the all-important US market: with MG, Austin-Healey, and Jaguar more closely aligned, British Motor Holdings promised to be a force to be reckoned with in North America — although, as we shall see, there were storm clouds looming on the horizon ...

The plastic 1:32-scale MGB

In 1966 if you had asked any British schoolboy to name a plastic model kit maker, he would unhesitatingly have said Airfix; his American counterpart could just as easily have said Revell. These were certainly the heydays of do-it-yourself plastic models — mainly aeroplanes but increasingly other subjects including cars. Arguably the Americans were some way ahead of the game as many of their local car models — usually to a larger scale than the British models of the time — sprang from the basis of assembled models given away in car showrooms as promotional gifts. However, from humble beginnings Airfix had developed a popular and growing range of modern car subjects, including the MGB.

The Airfix MGB came in a cardboard box and comprised a series of injection-moulded ABS plastic sprues with all the parts needed to build your own miniature, complete with a reasonably detailed engine under an opening bonnet. The hood could be either raised or represented by a half-tonneau. If the assembly process was accomplished successfully without everything ending up as a sticky mess, all you had to do was apply a coat of Airfix enamel and a 1:32-scale MGB was yours. Not to be outdone, Revell produced its own different MGB model kit to the same scale and for a short time both were on sale. Just three years later, in 1969, the Airfix MGB disappeared from the catalogues: popular rumour was that the tooling had been damaged. In the late 1980s, however, the Airfix MGB made a surprise comeback and at the time of writing it is still on sale.

The 1966 Motor Show: a lilac MGB

BMC sports car affairs at the October 1966 Motor Show at Earls Court were dominated by the MGB's smaller brother, the Midget, which appeared in 1,275cc MkIII guise (along with the inevitable Austin-Healey Sprite MkIV). The MGB GT had already appeared the previous autumn and major revisions to the MGB family as a whole — still just four years into production — were some time in the future. BMC nevertheless decided to show off the MGB — already a major earner of export currency for both the corporation and the country — by painting a US-specification roadster in pale metallic lilac and exhibiting it on a spit-like display.

After the Show, the lilac MGB sat neglected in a corner of the Abingdon complex for several years, being occasionally plundered for useful parts, until BMC Special Tuning supremo Basil Wales rescued it and used it for a short while before storing it in a barn for several more years. More recently, Wales stripped out much of the US-specification equipment and restored the car in time to use it as a wedding car for his daughter.

Marathon de la Route: achieving the impossible

Nowadays the idea of a road race (other than as a Classic car rally) would be almost unconscionable but until 40 years ago some of the most exciting motor sport activities took place on public streets. A small taste of the excitement survives in events such as the Monaco Grand Prix with its carefully cordoned and fenced streets within the circuit, the forest rallies where spectators are able to get incredibly close

Boys were delighted when Airfix produced this kit to build a plastic scale model of the MGB (still availabl[e] at the time of writing!)

o the cars, and modern Historic events out the spectacle of cars racing in anger at maximum velocity past front doors in narrow streets and down country roads is lost to us.

One of the better-known and longer-lasting series of these great road races took place each year over a varied route that generally took in the towns of Liège, Spa, Sofia, and Rome and MG sports cars competed with reasonable distinction on a number of occasions. By 1966, however, the practicality, if not the spirit, of the road race had run its course; the very last of these great road races had taken place two years earlier. In 1965 what was then known as the Marathon de la Route had been transferred to the race circuit at the Nürburgring, where competitors were pitted against one another in an incredible 72-hour endurance race.

For 1966 the race had been toughened further and the duration lengthened to 84 hours. BMC sent over a brace of MGBs, one of which was GRX 307D — already something of a racing veteran, rejoicing in the name of 'Old Faithful' — driven by Andrew Hedges and Julien Vernaeve. A well-used development hack (2 GLL), which had been used as the basis of a Shell Oil publicity campaign, was the second, driven by the youthful pairing of Roger Enever (son of the MG Chief Engineer) and Alec Poole (son of the Dublin MG importer).

The race did not begin auspiciously for the two cars, which both managed to spin off the circuit within the first two laps, but once they had recovered they soon clawed their way to a remarkable enough placing of third and fourth overall (the race leader was a Ferrari GTO). The complicated Marathon race rules meant that the MGBs had to maintain laps of 16 minutes in the daytime and 19 at night, while there were distance penalties for overly long pit stops; avoiding the penalties if these targets were missed more than compensated for the lack of hazards endemic in the old-style road race.

BMC competitions sent Peter Browning along to watch over the two MGs. He believes that the MG team had a major tactical advantage and that the departure of the Ferrari late in the race, when it went off the road in heavy rain, was a clear demonstration of this. 'I remember that one of the things we did with the MGB, and which we subsequently did for the MGC, was that we ran long spells of six hours — much longer than most people — so that the drivers could really get some rest. Some of the opposition had a most terrible time. I remember in my report on the 1966 Marathon, Bianchi and de Keyn had an 'Ecurie Nationale Belge' GTO Ferrari, and although Bianchi was brilliant, his co-driver just couldn't keep sufficiently awake to keep the car on the road. They were doing three-hour stints; we felt we were much better off.'

Once the Ferrari was out of the equation, the two MGBs were only fighting for glory against a Ford Cortina-Lotus, and at one point it looked possible that there would be a one-two result for MG. Unfortunately, however, the punishing race finally took its toll on the Enever/Poole car, which had to retire, but the Hedges/Vernaeve MGB went on to win the Marathon outright — a stunning achievement. Peter Browning recalled that when he telephoned his boss Stuart Turner with the news, there was a stunned silence at the other end of the line, 'he just couldn't believe it!'.

Andrew Hedges and Julien Vernaeve have good reason to celebrate after they have just won the 1966 Marathon de la Route outright in 'Old Faithful'.

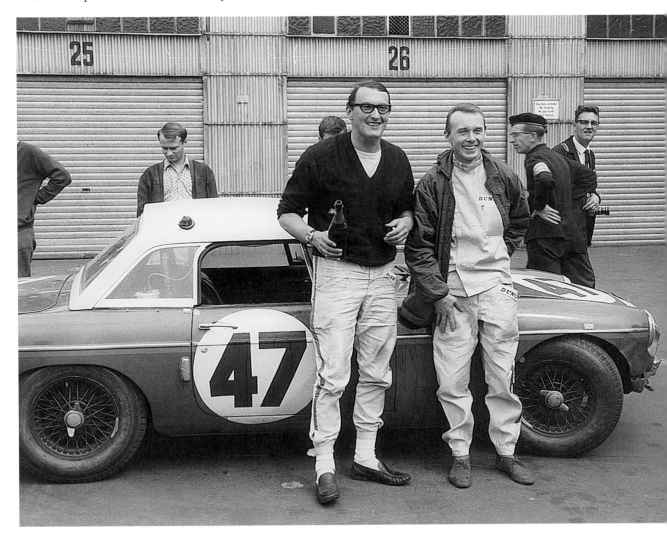

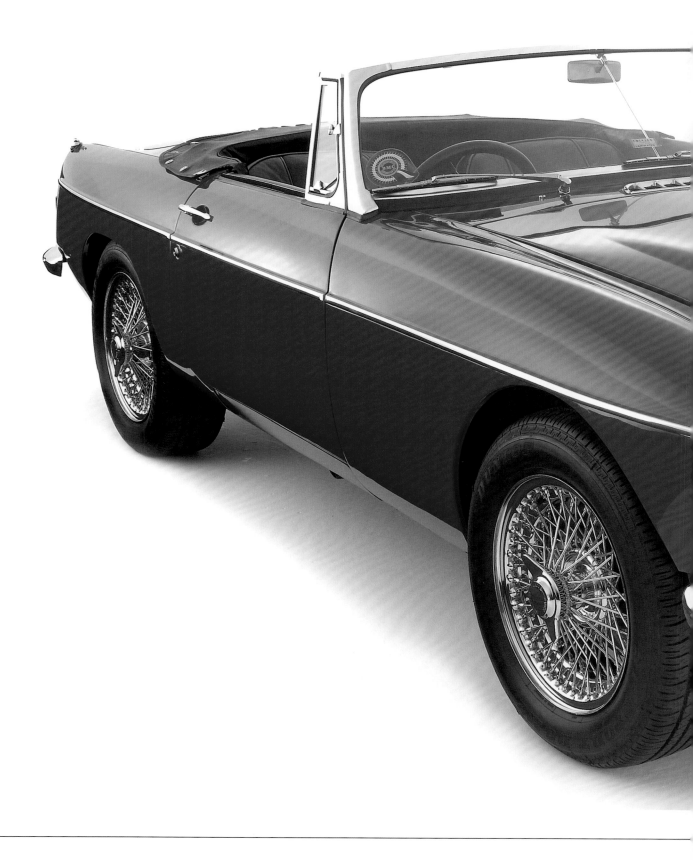

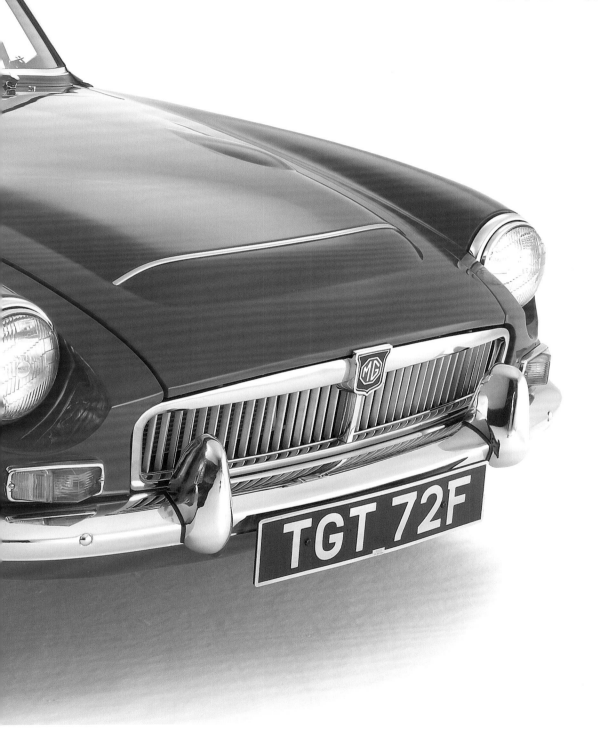

MGB MKII

1967–1971

1967
'The sign of the octagon'

Building a better MGB: the MkII

For the MGB, 1967 would prove to be a watershed year; the MkI was nearing the end of the road and, with the many changes needed to cater for the new six-cylinder MGC and the new issue of American safety legislation, in the following years the MGB would move further away from John Thornley's and Syd Enever's ideals. There were changes that were welcome enough — the new all-synchromesh gearbox and better GT-type back axle on the roadster among them — but, in the eyes of the MG purist, the honeymoon would shortly be over.

The MGB had been in production for a little over five years when it underwent a whole series of improvements that were gathered together as a package sufficient for the car to be called the Mark II. In time-honoured fashion, these alterations, which coincided with the introduction of the MGC in October 1967 (see later), resulted in a change of chassis number prefix from GHN3 to GHN4 (with the GT models similarly moving to GHD4). Of course, the addition of the new MGC variant was justification enough for many of these changes, especially where they were common to the MGB and MGC, but the many changes being forced on MG by the demands of US legislation also played a major role in the process.

Perhaps the most welcome aspect of the arrival of the MGC as far as the MGB was concerned was the new gearbox it brought with it. While there was nothing inherently bad about the original MGB gearbox, the fact that it still lacked synchromesh on first gear was an increasingly eccentric omission in a marketplace where such a feature was usually taken for granted. The new MGC — and the new ADO61 Austin 3-Litre that was intended as a new BMC flagship — needed a new common gearbox with improved refinement that could handle the torque of

The tailgate of the MGB GT featured a multi-part badge until the introduction of the 1970 model-year cars.

A new feature on MGB and MGB GT models from April 1967 was a pair of reversing lamps mounted just inboard of the main Jim O'Neill-styled tail lamps.

the more powerful engine, so a new C-type gearbox was commissioned for new six-cylinder cars. Logically, this new gearbox was to be shared with the humbler MGB and the EX Register records the start of this work in March 1966.

The larger and stronger new gearbox would not fit cleanly without fouling the MGB's slim transmission tunnel, so one of the bodywork changes was to substitute a wider tunnel that was also able to accommodate the Borg-Warner 35 automatic gearbox, which also became an option – the first time that an MG sports car had featured a modern torque-converter type of automatic transmission. The automatic option was undoubtedly aimed at the US market but in the event it was never offered there – at least not on the MGB, although it was available on the MGC. Two MGB automatics were supposedly built for the US market but these appear to have been one-off experiments.

There may be more than one reason for this strange state of affairs – strange on account of the American predilection for automatic gearboxes. Firstly, the onslaught of legislation was making life complicated enough without an automatic transmission variant; secondly, the importer might have thought that an MGB automatic would dent sales of the similarly equipped MGC (just as there had been a hiatus in offering overdrive as an option back in 1963); finally, there was always the worry that an automatic MGB sports car would not have been particularly fast.

J. Yeates fitting a chrome windscreen trim (a notoriously difficult job) to a Pale Primrose MGB GT MkI on the trim line at Pressed Steel's Cowley plant, some time in 1967. This photograph shows just how much trim was fitted to the MGB before it even passed through the hallowed Abingdon portals.

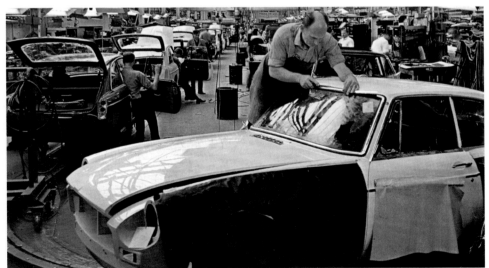

How the MGB MkII performed

Top speed	0–60mph	Standing ¼ mile	Fuel consumption	Price	
104mph	12.1sec	18.7sec	21–27 US mpg	$2,810	*Road & Track*, July 1968
107mph	11.1sec	18.0sec	26.0 mpg	$A3,325	*Modern Motor*, Australia, March 1969

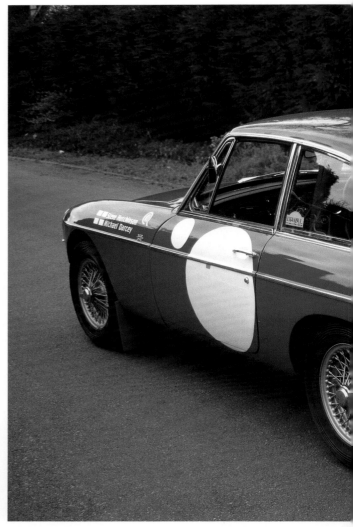

The MGB/GT races at Sebring

On 1 April 1967 two MGB variants lined up at the start of the Sebring 12-hour race: one was the MGB 'Old Faithful', while the other was an MGB GT (MGB/GT to the locals), which was to be driven by that famous double act, Hopkirk and Hedges. The GT (bearing UK registration LBL 591E and painted the usual Tartan Red) was entered as a prototype and equipped with a 2,004cc engine, while the MGB — in the capable hands of Timo Makinen and John Rhodes — ran with a 1,824cc unit in a lower class.

The race was fairly uneventful for Makinen and Rhodes, who finished a more than respectable 12th overall (second in the 1300–2000 GT class, third GT overall). The MGB GT had a more hectic race, with damage to the rear wheels and the steering arm due to an argument on the track. Despite the contretemps, the GT came home ahead of its team-mate, winning its prototype class and eclipsing all other prototypes other than the winning brace of 7-litre Ford MkIV and MkII mid-engined exotica.

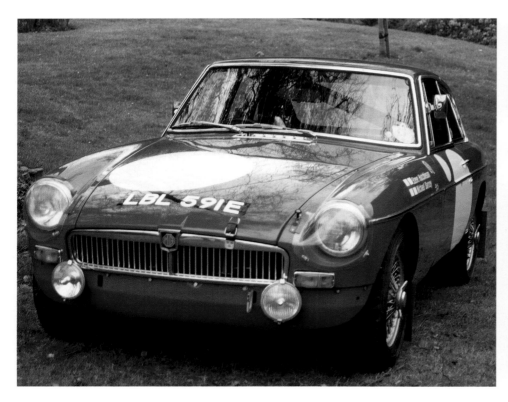

The birth of 'Mabel': a sexy lady

In the autumn of 1966, as the MGC was moving towards production, BMC had begun to plan a lightweight version of the MGC GT with a view to competition use. It was obvious that there would be marketing mileage in racing the new car and, to give it an edge on the circuit while attracting customers from other sports car brands, it was decided to build a small number of cars with aluminium alloy bodywork. The longer-term goal was to develop a rallying replacement for the 'Big' Healey, known to be nearing the end of its life, and it was obvious that a roll cage-equipped GT body would be much stiffer than the old separate-chassis BN8 Healey. The MGC GTS could also, it was hoped, bring success further up the field as the Mini-Cooper began to be outclassed further down. BMC had long been able to tap into the enthusiasm of some of the competition fans at Pressed Steel; with the commercial tie-up of 1965 and the role of Pressed Steel in both the GT

and the MGC, the opportunities were even better.

Unfortunately time, priorities, and the simple fact that the production car had yet to be launched had prevented the lightweight MGC GT being ready for Sebring in April 1967. However, the first car (registered MBL 546E and thereafter christened 'Mabel') was already under construction and it was decided to give it a trial outing the following month at the comparatively remote setting of the Targa Florio in Sicily.

At first the new car was to be painted in the usual BMC colour of Tartan Red but when it came to the Targa Florio, this proved to be a problem. 'I remember that halfway through MBL being built in the shop by Gerald Wiffen, we got the regulations for the Targa Florio,' Bill Price recalled. 'Soon Stuart Turner, Peter Browning and I were going through these, and we suddenly realised that if we were going to enter the car in the "prototype" category, one of the rules was that the car

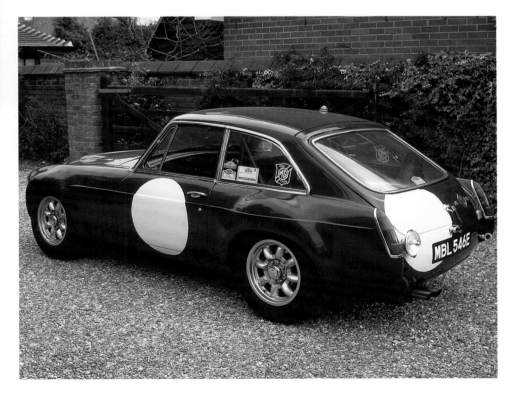

Far left: Restored to its former glory, and resplendent in the correct 1967 colour of Tartan Red, the 1967 Sebring MGB GT is now owned by Mick Darcey.

Above: LBL 591E was the first Abingdon-built 'comps' version of the MGB GT and it appeared at Sebring in 1967, where it raced with a 2-litre engine.

Right: The final form of MBL 546E ('Mabel') was the ultimate expression of the MGB/C GT shape, with purposeful wheelarches.

Left: The interior of the 1967 Sebring MGB GT (photographed in 1998) shows how comprehensively trimmed the car remained despite its racing purpose.

When MBL 546E was first built, it was finished in Tartan Red — the normal BMC 'comps' racing colour scheme. Then, when the regulations for the Targa Florio race were checked, it was found that entries had to race in their national colours — hence the hasty external respray in British Racing Green.

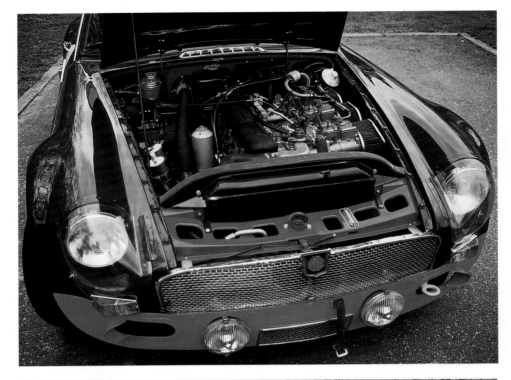

had to be finished in its national racing colour — and there we were with a bloody red car! There was no time to strip it out and do it properly as we would want to, so all we could do was to paint the exterior British Racing Green — and so that is how MBL 546E is still Tartan Red inside and British Racing Green on the bits that show!'

'Mabel' had elegantly flared wheelarches, which have since been emulated by many MGB and MGC racers; she was certainly a very sexy lady but many of her secrets were literally hidden beneath her skirts. Under the bonnet was an unexceptional if potent 150bhp twin-SU equipped 2-litre B-series four but the suspension was all MGC. Browning and his colleagues simply hoped that there would be few British journalists at the race sufficiently curious to crawl underneath and take a look at the underpinnings.

The ruse certainly seems to have worked: those magazines which did report on the car referred to it variously as an MGB GT or an MGB GT-Plus; the badging on the tailgate was also ambiguous due to the omission of the model suffix letter — 'Mabel' was badged as an 'MG GT', with the holes remaining where the missing letter should have been. At the factory, however, the car was known as the GTS and there were some tentative thoughts that, once the MGC was in production, a limited run of lightweight MGC GTS models could have found their way into the hands of wealthy customers for road or race use.

For her first foray to Sicily, 'Mabel' was accompanied by a brand new MGB roadster: Paddy Hopkirk and Timo Makinen would drive the GTS, while for once Andrew Hedges had a different co-driver in the form of Alec Poole. Despite persistent problems with the brakes, 'Mabel' eventually finished a very satisfying ninth but the MGB roadster was less fortunate, being written off after leaving the road and striking a tree.

The Targa Florio took place on May 14th – by the time that Mabel made her next appearance, the MGC would be on sale and subterfuge would no longer be necessary.

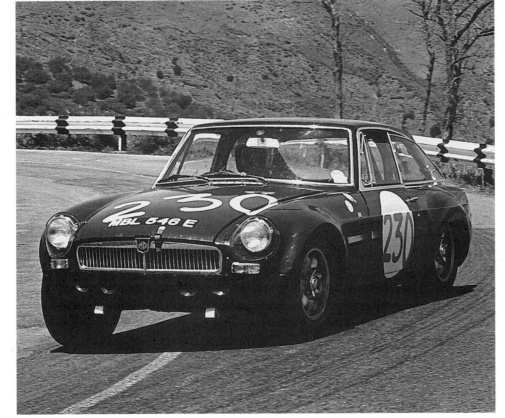

The first competition outing of MBL 546E (or 'Mabel', as the car became known affectionately) was the 1967 Targa Florio in Sicily. There the car raced as an 'MG GT' with an MGB engine but the then still-secret MGC front suspension.

The limited edition MGB/GT Anniversary Special

No one had any doubt that the MGB GT was a beautifully styled sports coupé but, as far as the US market was concerned, the MGB/GT was at first seen as almost an irrelevance: an unnecessary distraction from the important job of building and selling as many MGB roadsters as the market could stand. Initially the significance of the MGB/GT as a car escaped Bob Burden, who recalled: it was, instead, the standard marketing challenge of the time — introduce yet another new model with virtually no advertising budget!'

The MGB/GT was heralded by Burden and his colleagues in the US market place

Above: This specially made plaque was fitted locally in the US during 1967 to mark the first anniversary of the launch there of the 'MGB/GT'.

as 'MG magic in a new shape' and BMC made great play of its modest price for what they were proclaiming as 'a quietly sensational touring machine steeped in British luxury'. The trouble was that even if the magazines liked it, the American sports car buyer — traditional in his or her tastes — preferred the open MGB. As local stocks of the MGB/GT built up to alarming levels, the BMC North America office came up with the idea of a 'limited edition'; not quite a new idea in 1967 America but still something of a novelty among sports car buyers.

The result of this exercise was the MGB/GT Special, marketed as a limited edition of 'only one thousand cars', intended to celebrate the first anniversary of the MGB/GT going on sale. It was a clever ruse: in addition to wire wheels there were a special wood-rim sports steering wheel, matching gear knob, racing mirrors, and a small brushed-alloy plaque that was applied to the side of the wing — all of them fitted by the dealer using a kit of parts, sourced by the importer variously from Australia, California, and the Bronx. The experiment proved something of a success: about one and half year's stock had been dispersed within 90 days and nowadays the North American MGB Register has a special registrar for owners of the MGB/GT Anniversary Special.

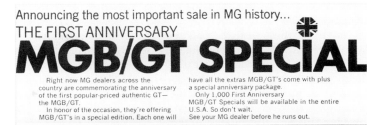

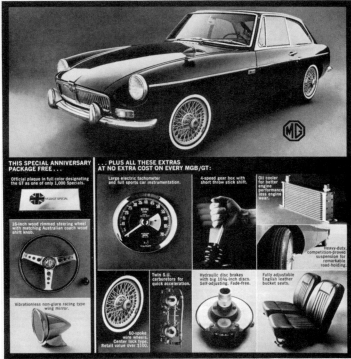

Above: MG's US importer established a new precedent for the MGB with the 'MGB/GT Special' — an idea drummed up between local marketing people Bob Burden, Mike Dale, and Marce Mayhew to help shift stocks of the slow-selling MGB/GT. The idea worked ...

'Big Brother' is watching you: US pollution and safety legislation

The development of the US automotive scene in the 1960s and 1970s was marked by two powerful pieces of legislation; respectively the Clean Air Act and National Highways Traffic Safety Act. Both were designed to tackle major problems connected with the motor car but not only were they in some ways potentially contradictory (the cruder approaches to safety can promote pollution) but they

were inevitably hijacked in due course by other political agendas.

The 1963 Clean Air Act established the basis of reducing air pollution from stationary sources such as power stations but to deal with vehicle emissions the US Senate passed the Motor Vehicle Air Pollution Control Act in 1965, which set various vehicle emissions standards to be effective from 1968. At the same time the

State of California, which had been studying the effects of photo-chemical smog since the end of the Second World War, set up the California Air Resources Board (CARB) in 1967, when Ronald Reagan was California's Governor.

Attention was focused on the unwanted by-products of engine combustion — in particular nitrous oxide, carbon monoxide, and unburned hydrocarbons — and the car

industry was galvanised into finding means of tackling and controlling these emissions. In the longer term, catalytic converters would prove an invaluable tool in this respect.

The first of these Positive Crankcase Ventilation, or PCV, systems was mandated by California's Motor Vehicle Control Board (precursor to CARB) in 1961; the first MGBs to feature closed engine circuit breathing were those sold in February 1964 but this was just the start of the avalanche.

The 1966 National Highways Traffic Safety Act was intended to tackle the growing levels of carnage on US roads, a consequence in part of the mushrooming levels of car ownership but also of poor driving and inadequate vehicle safety. National automotive safety requirements were promulgated on a regular basis by the US Department of Transportation as Federal Motor Vehicle Safety Standards (FMVSS). The first tranche of these focused largely on areas of passive safety — such as protection of the occupants of the vehicle

cabin — and the integrity and safety of fuel systems. As these were due to take legal effect from 1 January 1968, the Abingdon engineers were increasingly busy as the MGB MkI era drew to a close.

The US legislators sub-divided vehicle safety into three main aspects: crash avoidance, taking in factors such as brakes, steering, and lighting; crash-worthiness, how safe the passengers were in an accident; and finally post-crash safety, a measure of how the vehicle systems such as the fuel line behaved after an accident.

Below left: Doug Adams of the Longbridge experimental bodyshop helped develop the so-called 'Abingdon pillow' in conjunction with MG's Chief Body Engineer, Jim O'Neill.

Below: The MGB GT MkII appeared in tandem with the larger-engined MGC in late 1967, in time for the 1968 model year. The 1960s US advertising, overseen by Marce Mayhew (who took this photo), was somehow classier than the home-market equivalent.

Crashing with impunity: the 'Abingdon pillow'

It would be fair to say that in 1967 the use of seat belts was the exception rather than the rule — even assuming that they were fitted; airbags had yet to make their mark outside the experimental laboratories. As a result, many laceration and fracture injuries sustained by car occupants during higher-speed crashes were due to the unrestrained person colliding with sharp-edged or hard surfaces within the vehicle interior. A key facet of the new safety legislation for the 1968 model year was

therefore a range of rules governing surface curvatures and the use of impact-absorbing materials that could cushion the blow — particularly against the face of the dashboard in a high-speed frontal collision.

MG was hardly exempt from this rule and yet there was no question of a complete redesign. BMC was in problems elsewhere that made MG's concerns seem like small beer and so the Abingdon engineers found themselves more or less left to their own devices to create a quick

fix for the MGB. The changeover to the MkII from the autumn of 1967 provided a good opportunity to achieve this, and for the first time the US or NAS (North American Specification) versions of the MGB began to diverge noticeably from models sold in other markets.

Undoubtedly the most strikingly visible change came inside the cockpit, where MG's efforts at meeting the new safety standards resulted in a massively padded ABS plastic-covered foam dashboard

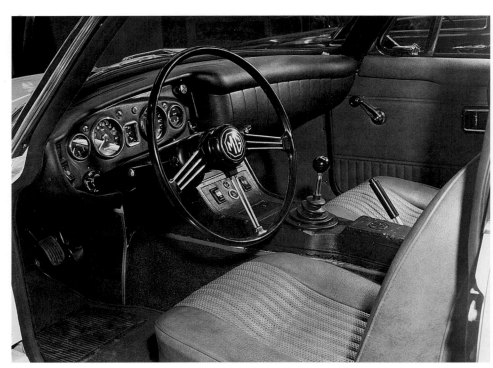

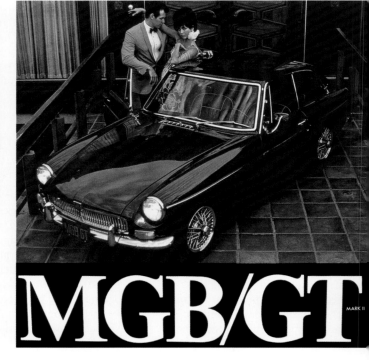

MGB/GT MARK II

verlay, which was dubbed the 'Abingdon illow' on account of its extremely ounded profile. MG's Chief Body ngineer, Jim O'Neill, worked on the ashboard design with Doug Adams of he Longbridge experimental shop and oam supplier Vitafoam. Because of the nerous requirements for knee impact rotection, it proved impossible to retain he glovebox.

The soft-faced dashboard was just one of he more visible safety-related changes — nost only for the US models at this stage. Other modifications included: amber front idelamp lenses (previously white on US-narket cars); a driver's door mirror plus a ving mirror on the opposite side; a omplement of clearly labelled rocker witches; twin column stalks controlling ights, indicators, and two-speed wipers; an nergy-absorbing steering column with a edesigned cowling concealing the gnition barrel; a safety interior rear-view nirror, designed to break off if struck luring an accident; Kangol lap and liagonal seat belts; and a dual-circuit oraking system. Cars equipped with wire vheels now had octagonal 'knock-on' nuts vithout 'ears'.

What the MGB MkII cost

	Basic	Purchase tax	Total UK price
Roadster	£770	£178 3s 7d	£948 3s 7d
GT	£888 10s	£205 6s 8d	£1,093 16s 8d
Extras			
Overdrive	£50	£11 9s 2d	£61 9s 2d
Automatic transmission	£80	£18 6s 8d	£98 6s 8d
Interior heater	£12 5s 0d	£2 16s 2d	£15 1s 2d

In the shadow of Healey: the MGC

Right from the beginning of the process that led to the MGB, John Thornley and Syd Enever had been thinking about a six-cylinder MG sports car, a concept that had died with the last of the prewar MG Magnettes. Their reasons were not just based on misty nostalgia; there were sound reasons for considering such a car. For a start, the performance potential of a sports car as a long-distance tourer would be limited with the existing four-cylinder B-series engine and BMC had a tradition of using modest but useful straight-six engines in its big Austin and Wolseley saloons, which meant that the basis for a six-cylinder MG would be available.

Then there was the added factor that, from 1957, MG at Abingdon had assumed responsibility for production (and most of the production engineering) of the 'Big' Healey — then in 100/6 guise but soon to be further developed into the 3000. MG was a good step-parent to the Austin-Healey but the fact was that Thornley and Enever preferred to grow their own and were determined that a future Abingdon-built large sports car should also be an Abingdon-born one.

Perhaps the most important factor though was the shock that Thornley had received when he discovered the costs of developing and tooling the monocoque MGB bodyshell. He realised that BMC would be unlikely to sanction another totally different sports car in the mould of the Austin-Healey and so the MGB was developed with the intention that there would be a variant with a bigger engine — initially to have been the V6 based on the V4. When that was abandoned various ideas included shoehorning in the existing Austin C-series or a six-cylinder derived from the B-series that was in production use in Australia but not in the UK.

Another early thought had been to use another big engine from the BMC family — the old Austin big-four that in various guises had powered Austin saloons, the Austin-Healey 100/4, and remained in use (in diesel form) in the Austin FX4 taxi. Don Hayter schemed this engine, which was proposed for capacities of 2.0 and 2.5 litres, and this idea met tacit approval from the

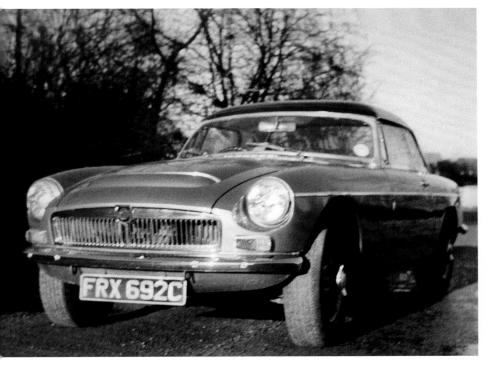

FRX 692C

Former MG apprentice Bob Neville purchased the prototype MGC from the factory and ran it as his everyday car. He took this photograph of it in 1969.

Healey family — in particular father Donald and son Geoffrey, who had amassed much experience with the unit and could see it forming a useful basis for a new Austin-Healey. Geoffrey Healey thought that this engine could be coaxed up to nearly 180bhp but his enthusiasm was countered not only by the sheer bulk of the unit (it would have fouled the MGB cross-member) but also because the engine had no other obvious use within BMC (other than the diesel taxi) and so the

necessary investment could not be justified.

So the focus shifted from the Austin four to the two main six-cylinder options and studies began in 1961 under the dual project codes ADO51 and ADO52 — standing for the 'Austin-Healey 3000' replacement and the 'six cylinder MGC' respectively. Like the Austin four, the six-cylinder options would prove hard to squeeze under the bonnet of the MGB, for the suspension cross-member once again

conflicted with the space to be occupied by the engine sump.

Not long after MGB production started, a crate arrived at Abingdon with a rather interesting content; it was a six-cylinder derivative of the B-series engine and had been shipped in from BMC's Australian subsidiary. Back in the 1950s Austin Engineering at Longbridge had developed this promising concept from the basis of the then-current 1,489cc three-bearing four-cylinder B-series engine as used in the

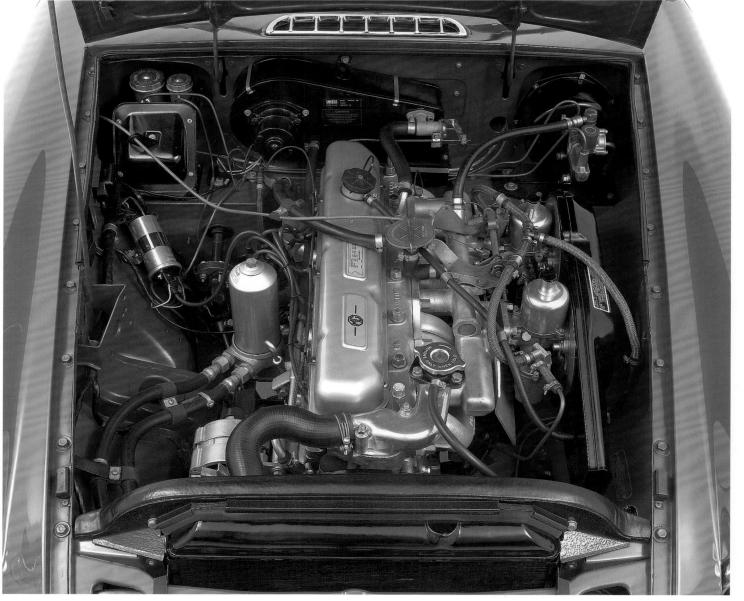

Left: The engine in the MGC was a newly designed unit with seven main bearings, shared with the Austin 3-Litre (ADO61). The long engine bay that Syd Enever and his team had schemed for the MGB proved highly beneficial in the effort needed to squeeze this substantial six-cylinder unit into place.

Right: The MGC engine was unquestionably more refined than the old C-series six cylinder, which had seen service in the Austin-Healey 3000 as well as various large BMC saloons, but the power output in the standard production application was disappointing, while the weight of the cast-iron unit did the car's handling no favours.

MGA, Magnette, and most of the mid-range BMC models. The new four-bearing six-cylinder unit was never used in the UK, as the larger C-series made it superfluous, but it was snapped up by BMC Australia to extend the power and endurance of locally assembled derivatives of Austin, Morris, and Wolseley saloons, which had to compete with the six-cylinder Holden.

The engine in the crate was the definitive 2,433cc version of what had become known as the Blue Flash Six; in Austin Freeway guise it produced a modest 80bhp but MG believed that a reliable 115bhp could be coaxed out of it quite easily. The unit was also nearly a hundredweight lighter than the existing six-cylinder in the Austin-Healey 3000.

Don Hayter remembered that the brown MGB into which the Australian engine was fitted bore the registration number AMO 340B and that ADO51/175 was the project number. The EX Register records that work on this car started in October 1963. The Blue Flash-engined MGB, driven by Roy Brocklehurst, went through a police speed trap at over 126mph! Speaking to Jon Pressnell, Brocklehurst said that, like the V4, this engine was promising: 'It was a very nice, desirable engine ... good and smooth, and quite energetic ... the handling was a bit "front-endy" with it fitted, but it wasn't desperate.' However, the engine was not wanted for any other BMC products in the UK and was effectively an Australian orphan as far as the Austin and Morris engine plants in Longbridge and Coventry were concerned.

Eventually, the other options having been exhausted, political expediency and commercial need elsewhere within BMC dictated the choice of engine for the Austin-Healey replacement. Sir George Harriman wanted a new big Austin Westminster/Wolseley 6/110 replacement at the head of the range, so a more refined (seven-bearing) version of the existing 2.9-litre C-series engine and a new gearbox (with a modern automatic option) were decreed to propel ADO61 — intended to be BMC's technical tour de force.

MG's views were listened to but not always heeded: when Syd Enever said the engine was too big and asked for the stroke (and consequently the height of the engine) to be reduced, BMC Chief Engineer Alec Issigonis ignored his request. Equally disappointing was the weight; Morris Engines had promised that the new engine would be a substantial 136lb lighter than the old C-series — lighter even than the Australian Blue Flash — but in the end the saving was less than a third of that.

The seven bearings may have improved refinement slightly but they also sapped power; MG claimed 145bhp net for the MGC when it was launched, which was respectable but hardly earth-shattering. Furthermore, the sheer bulk of the engine — and the need to accommodate the optional Borg-Warner 35 automatic gearbox — limited the scope of moving the engine back within the engine bay and so the layout was bound to be front heavy with a tendency to understeer.

The Austin-Healey 3000 MkIV and MGC were destined therefore to be saddled with a heavy engine with inadequate power and

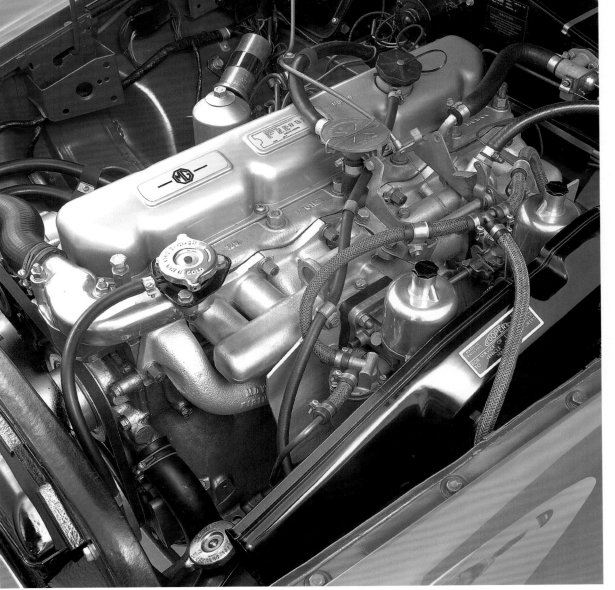

with handling inferior to that of the similar-looking but cheaper MGB: not a promising start in life. Squeezing the engine in also necessitated fitting a bluff square-fronted bulge in the low MGB bonnet, with a further teardrop-shaped bulge to clear the forward carburettor. These features have become talismans for MGC fans in more recent years

but at the time they were viewed by many observers as desperate and ugly.

By 1965 the Healey family was already somewhat uneasy at the way that the Austin-Healey/MGC project was going and it was not long after a prototype was built with a pastiche of a Healey grille (ADO51/182) that the Austin-Healey version

slipped into oblivion. While Abingdon continued to develop an MG-only six-cylinder sports car, the Healeys experimented with trying to prolong the life of the 'Big' Healey, while BMC HQ dabbled independently with a 'super Austin-Healey', which became superfluous once Jaguar and BMC had joined forces in 1966.

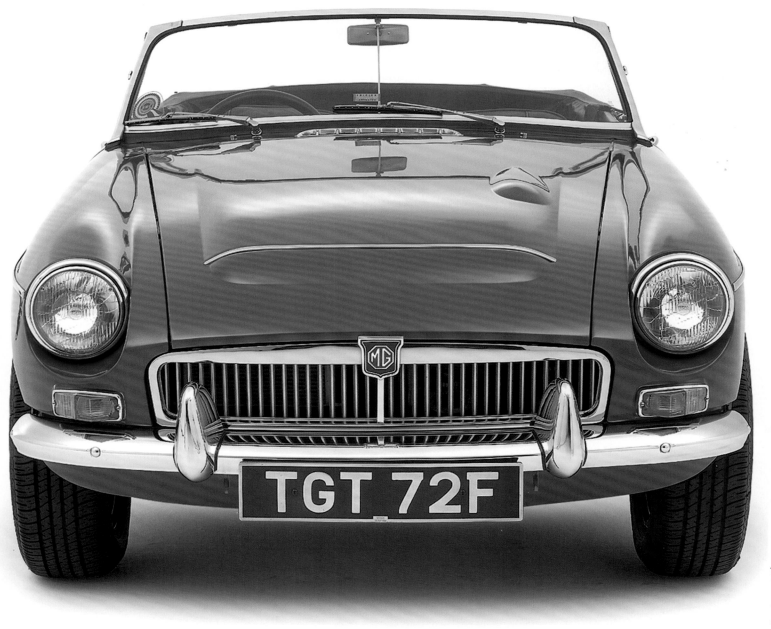

Left: The slightly different stance, bigger wheels, and the bonnet bulges lend the MGC a more purposeful masculine air than the MGB.

Right: The bonnet bulge of the MGC was arguably its most controversial feature, although MG's Chief Body Engineer, Jim O'Neill, tried to make a virtue of a necessity by styling a transverse chrome strip across the forward edge of the bulge. The nearside 'teardrop' bulge was needed to clear the carburettors.

The MGC goes into production

Although pilot build cars were being assembled from the beginning of November 1966, serious production of the MGC did not get under way until the following summer. At the same time the famous 'Big' Healey neared the end of the road: the last series production Austin-Healey 3000 MkIII was built in December, a victim as much as anything of the new US safety legislation. The MGB and MGC — in both open tourer and GT coupé variants — were built for the US from the outset and featured all the various safety measures described earlier. So much of the budget had been soaked up that there was little other than the bigger wheels (15in instead of 14in), bonnet bulges, and some new paint colours to distinguish the MGC from the MGB.

The MGC made its public debut at the Earls Court Motor Show — five years on from the MGB — and, in addition to the MG stand, an MGC took top billing on the Pressed Steel stand. The Rover 3.5 Litre (P5B) — an intriguing marriage of the patrician Rover and the sporty light-weight alloy V8 that Rover had bought from Buick — also made its first UK public appearance at the Show; comparisons with the Austin 3-Litre (ADO61) — new at the same show and sharing its much heavier cast-iron straight-six engine with the MGC — were not particularly favourable.

Left: A discreet MGC script was fitted above the MG boot lid badge.

Below: The MGC was usually seen shod with wire wheels, although some home-market cars were offered with the standard steel type.

Changes afoot: 'Cortina man' at Cowley

By 1967 it was apparent that all was not well in the house of BMC; financial performances fluctuated disconcertingly and although the Mini was a monumental success, this was at the expense of money leeching out of the company as observers claimed that each Mini built made a loss. All of this might have seemed to be a world away from the affairs of the sleepy Vale of the White Horse where MG sat but, as always in such cases, the problems of the parent company cascaded down through all levels. The MGC could be seen as endemic of this; in an ideal world the MGC would have received much more

development, would have differed more obviously from the MGB upon which it was so obviously based, and there might still have been an Austin-Healey variant to capitalise on the obvious marketing strengths of that famous marque.

The tie-ups with Pressed Steel and Jaguar, which had enlarged the organisation under the umbrella of British Motor Holdings, had not solved BMC's basic problems. These were deep seated and to a great extent a consequence of the company's tortured history, muddled oligarchic management, and ill preparedness for the coming market challenges. A

major change was necessary and one of the signs that this might be on its way came when Sir George Harriman managed to tempt Joe Edwards to move over from Pressed Steel to act as his deputy.

Edwards began planning drastic changes including significant staff reductions (BMC was notorious in the industry for being chronically over-manned) and as part of his game plan decided that BMC needed new blood. The company with the best reputation in the car industry at the time was Ford, so Edwards went shopping and recruited some senior Ford people — including Roy

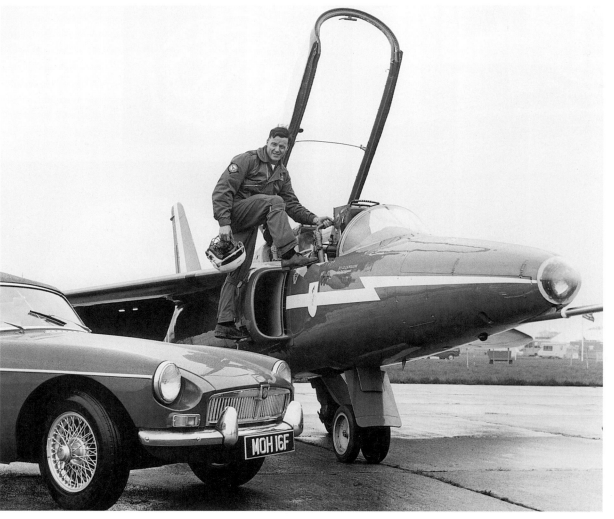

As a publicity exercise BMC supplied MGB roadsters for use by the RAF's famous Red Arrows aerobatic team.

Corgi MG: the MGB GT model

In the keenly contested world of model cars, there were three main British contenders: Meccano Dinky Toys, Matchbox, and Corgi Toys. Matchbox models were small pocket-money toys, and although the firm had produced miniature replicas of the MG TD and MGA the MGB rather surprisingly passed it by – a matter of considerable annoyance to the author at the time!

As we saw earlier Dinky Toys had led with the MGB and so when deadly rival Corgi Toys looked at the MG range the company chose the stylish new MGB GT. At this stage toy cars were gaining more and more features (with the aim of fostering loyalty in the fickle but vitally important small-boy market), so when the MGB GT appeared as Corgi model 327 in March 1967 it sported simulated wire wheels, jewelled headlamps, opening doors, tipping seat backs, an opening tailgate, and a miniature opening plastic suitcase.

The MGB GT was well received and in the eagerly awaited 1968 Corgi Toys catalogue a 'competition version' was promised as 'available later'. In the ensuing months, however, the full-size MGC GT made a bow, so the Corgi MGB GT was modified to receive the latter's

Haynes, who had been responsible for overseeing the cleanly-styled Ford Cortina MkII in 1966. The announcement of Haynes's appointment as BMC's new Director of Styling came on the second day of the 1967 London Motor Show.

It did not take long for Haynes's arrival to take effect and, although his main priority was to address BMC's mainstream problems, the MG range did not escape his attention. A longer nose was tried on the MGB and various more 'modern' trim ideas were explored: it would be two years afterwards that the first fruit of these studies would germinate.

our variants of the orgi Toys' MGB GT nd MGC GT models ere produced. The ightly battered xample on the left is a omparatively rare range MGC GT version.

distinctive bonnet bulges and the new model that eventually emerged in the 1968 Corgi Toys range was the MGC GT (number 345), with optional self-adhesive race numbers supplied in the box. It was perhaps ironic that the Corgi Toys MGB GT and MGC GT (including a later variant, number 378, with Whiz Wheels) would go on to sell over 700,000 models until they were finally withdrawn in 1972, around 150,000 of which were the MGC models. If only the full-sized MGC had proved as popular ...

Specifications: MGB MkII

ENGINE

Description
In-line overhead valve push-rod four-cylinder with cast iron block and wet liners, cast iron cylinder head. Roller chain-driven side camshaft. Solid skirt four-ring aluminium alloy pistons, steel connecting rods, and copper-lead shell bearings. Five-bearing crankshaft

Capacity
1,798cc (109.7cu in)

Bore and stroke
80.26mm x 88.9mm (3.16in x 3.50in)

Compression ratio
8.8:1

Maximum power
95bhp (net) @ 5,400rpm

Maximum torque
110lb ft (149Nm) @ 3,000rpm

Carburettors
Twin 1½in SU HS4

TRANSMISSION

Gearbox
Four speed with synchro-mesh on top three gears. Optional Laycock-de Normanville overdrive on top and 3rd gear. Optional Borg-Warner 35 automatic transmission

Ratios	Manual	Auto
1st	3.636:1	2.39:1
2nd	2.214:1	1.45:1
3rd	1.373:1	—
(O/d 3rd	1.101:1)	—
Top	1.000:1	1.00:1
(O/d top	0.802:1)	—
Reverse	4.755:1	2.09:1

Clutch
Borg and Beck, 8in single dry plate

Propshaft
Hardy Spicer, needle roller bearings

Rear axle
Hypoid bevel, ratio 3.909:1

BRAKES

Front
Lockheed disc, 10.75in

Rear
Lockheed drum, 10in x 1¾in

Operation
Lockheed hydraulic, optional servo

Handbrake
Lever with cable to rear drums

SUSPENSION

Front
Independent. Coil springs, wishbones with integral Armstrong lever-arm dampers

Rear
Live rear axle, semi-elliptic springs, Armstrong lever-arm dampers

STEERING

System type
Cam Gears rack and pinion

Number of turns lock to lock
2.9

Turning circle
32ft (9.75m)

Steering wheel
Bluemel sprung steel three-spoke, 16.5in diameter

WHEELS AND TYRES
4J x 14in steel disc wheels. Optional 4½J x 14in 60-spoke wire wheels

Tyres
5.60–14in Dunlop Gold Seal C41 cross-ply. Dunlop SP68 optional at extra cost

PERFORMANCE
Motor road test, 27 December 1969

Top speed
105mph (169kph)

Acceleration
0–50mph (80kph)	7.8sec
0–60mph (96kph)	11.0sec
0–70mph (112kph)	14.9sec
0–80mph (128kph)	19.8sec
0–90mph (144kph)	17.5sec
Standing quarter mile (402m)	18.2sec

Overall fuel consumption
23.7mpg (11.9l/100km)

DIMENSIONS

Length
12ft 9.3in (3.89m)

Width
4ft 11.7in (1.52m)

Height
4ft 1.4in (1.25m)

Wheelbase
7ft 7in (2.31m)

Track
Front: 4ft 1in (1.24m)
Rear: 4ft 1.25in (1.25m)

Ground clearance
4.5in (114mm)

Weight
Roadster 2,140lb (970kg)
GT 2,190lb (993kg)

1968
'The great escape car'

To the casual observer at the time, 1968 seemed to promise the start of an exciting new chapter in the history of the British motor industry. Encouraged by the Government, the gargantuan British Motor Holdings and the relatively diminutive Leyland Corporation announced their formal betrothal at the start of the year. More informed industry watchers were less convinced; BMH was notorious for its lacklustre management and had an ageing range. The British public was also getting tired of increasingly cynical 'badge engineering', from which MG was not immune. On the home market Ford's Cortina was climbing rapidly up the sales charts and BMH learned from Roy Haynes that Ford was planning to muscle in on the 'sporty coupé' sector with what would become the Capri — a home-market adversary for the MGB and MGC GT. Nissan would also enter the same sector with its six-cylinder Datsun 240Z within 18 months of the BLMC merger. MG now had deadly rival Triumph in its camp and, as Triumph management soon began to usurp the old Austin-Morris guard, MG management's fears were undoubtedly justified. Finally, the new US safety legislation took effect on New Year's Day 1968. It was obvious that tough times lay ahead.

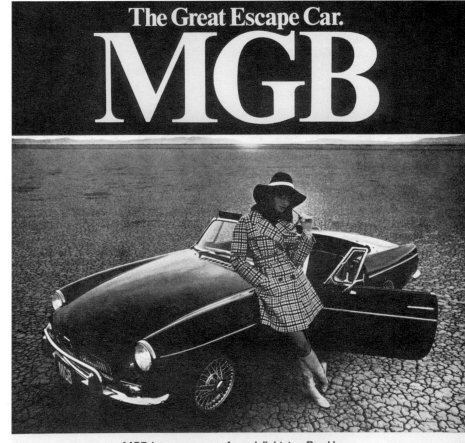

The Great Escape Car.
MGB

MGB lets you escape from dull driving. Read how.

Boredom evaporates the minute you settle into those foam-padded bucket seats of genuine English leather. A twist of the key brings the race-proven 1798cc engine to eager life. Slip the short-throw stick into first, (it's synchronized now), and head for the most challenging stretch of road you know.

The MGB's heavy-duty suspension is designed to arrow down the longest straight and hold the road through all manner of curves, from high-speed sweepers to low-gear hairpins. Just think of the extra margin of safety this sophisticated handling can provide on any road you drive.

The MGB's dual braking system with disc brakes up front is capable of stopping the car time and time again—without swerve, nosedive or fade. Comforting to know if you drive in heavy traffic or through areas where children play.

Even the MGB's aerodynamic, wind-cheating body is functional. Aside from looking attractive, it means quieter running with less wind noise, and greater fuel economy.

Comfort? The MGB is snug and warm in any weather. Roll-up windows, a tight-fitting top, and an effective heater/defroster make sure of it. And there's plenty of room in that lockable trunk.

Escape from dull driving in the MGB Mk. II. All it costs is $2670.*

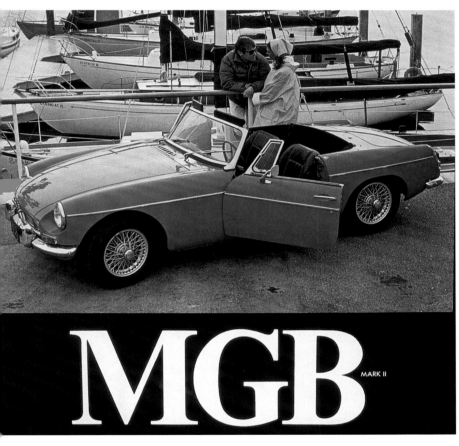

MGB MARK II

Assault on all sides: the Leyland way

The announcement that BMC and Leyland were to become one giant organisation was greeted with shock or resignation, dependent upon the viewpoint of those affected: and neither of these qualities was exclusively one sided. The affairs of Abingdon — a small but busy, currency-earning outpost of the BMC empire stuck out in the countryside to the south of Cowley — may not have seemed very significant to the power-brokers and other interested parties in the various corridors of Whitehall, Longbridge, and Cowley. However, with the shift in management came the gradual dark clouds of change: there was a definite feeling that while a better and more disciplined corporate structure might be beneficial in the longer term, playtime at MG was definitely over and there was something of a chill in the air.

MG was already struggling to cope with the changing requirements and increased bureaucracy of the US market, while trying to retain some hold over control of its own destiny. As the new faces moved into offices at Longbridge and Cowley, some of the old ways of doing things began to change: the engineers and management at Abingdon found that in

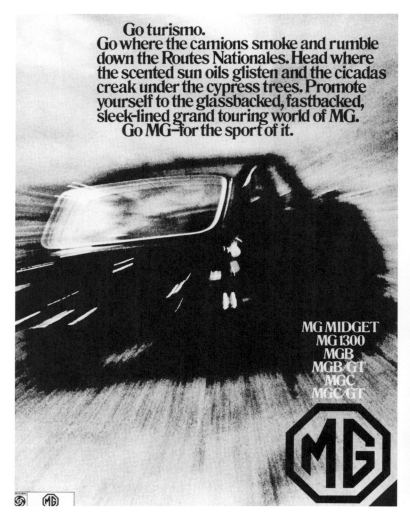

Go turismo.
Go where the camions smoke and rumble down the Routes Nationales. Head where the scented sun oils glisten and the cicadas creak under the cypress trees. Promote yourself to the glassbacked, fastbacked, sleek-lined grand touring world of MG. Go MG—for the sport of it.

MG MIDGET
MG 1300
MGB
MGB/GT
MGC
MGC/GT

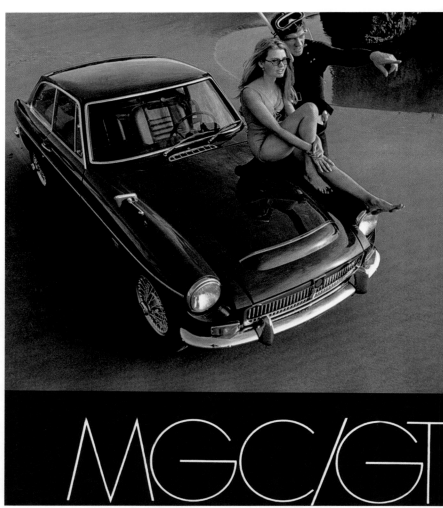

MGC/GT

areas where perhaps they had formerly been left to their own devices, they were now being questioned more closely in terms of accounts, engineering, and styling. Much of this new focus was hinged on cutting costs — a logical concept in principle, so long as the process did not end up destroying the magic — and the people at Abingdon soon became convinced that that this could well be the outcome.

In due course the evidence of these cost savings began to filter through to the MGB: cheaper bent aluminium rear quarterlight hinges for the MGB GT in place of the previous elegant, but arguably over-engineered and over-specified, chrome-plated brass piano hinges were perhaps a more reasonable example but other things

— paint, trim components, and assembly processes — were all being 'decontented' and thereby cheapened. In itself this might have not been so bad had the savings been ploughed back into the factory and its products but inevitably much of the cost 'liberated' in this constant nibbling was used to shore up other parts of British Leyland.

Customers who bought MGB and MGB GT models in 1968 would have been forgiven for not noticing this process, and indeed may have seen the changes as potentially positive, for at first much of the product action — including the MGB MkII and MGC — had been initiated before the merger. What they could not have known, however, was that behind the scenes a new design team at Cowley, headed by Roy

Haynes, was looking at ways to give the MG range the sort of 1960s spark and vim that it was thought the sports cars needed. In the autumn of 1968 an MGB GT suffered the indignity of being decked out with a matt black bonnet and tailgate, blacked out grille bars, high-backed seats, and 'B-Type' badging — both on the back of the car and in the form of rather tacky sill stripes — as per the Ford Mustang and GT40. Here then was the Ford influence — or more particularly the styling influence of various 'pony' cars such as the Ford Mustang, Chevrolet Camaro, and Pontiac Firebird. The new graphics accompanied new sheet metal on the US cars but at MG it was case of trendy new make-up being plastered insensitively over a familiar pretty face.

Above left: By 1968, U[S] advertising for the MG[?] was moving through [a] far-out phase inspired [?] by hippy poetry: 'Go turismo. Go where the camions smoke and rumble down the Routes Nationales ...' I[t] was trite, but stylish, [?] nonsense.

Above: The big push into North America fo[r] the MGC and 'MGC/G[T]' was made in 1968.

What the MGC cost

	Basic	Purchase tax	Total UK price
Roadster	£895	£206 16s 6d	£1,101 16s 6d
GT	£1,015	£234 6s 6d	£1,249 6s 6d
Extras			
Overdrive	£50	£11 9s 2d	£61 9s 2d
Automatic transmission	£80	£18 6s 8d	£98 6s 8d
Interior heater	£12 5s 0d	£2 12s 2d	£15 1s 2d
Wire wheels	£25	£5 14s 7d	£30 14s 7d
Folding hood	£4	18s 4d	£4 18s 4d

How the MGC performed

Top speed	0–60mph	Standing ¼ mile	Fuel consumption	
126mph	9.8sec	—	—	MG factory, 15 October 1967
120mph	10.0sec	17.7sec	19.0mpg	*Autocar*, 16 November 1967
123.8mph	10.0sec	17.6sec	19.3mpg	*Motor*, 4 November 1967
120mph	10.0sec	17.6sec	17–20mpg	*Autosport*, 1 December 1967
120mph	8.4sec	16.3sec	20.2mpg	*Motor Sport*, March 1968
130+mph	8.2sec	16.5sec	22.5mpg	Downton-tuned MGC, *Autosport*, 22 November 1968
116mph	10.9sec	18.2sec	20.0mpg	MGC Automatic, *Autocar*, 7 November 1968

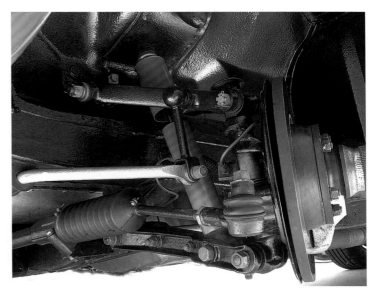

Above: Inside the MGC the story was similar to that of the exterior. Anyone other than a dedicated MG enthusiast would be hard pressed to spot the telltale signs that this is an MGC and not an MGB.

Above right: The launch of the MGC coincided with that of the MGB MkII, with which it shared several driveline improvements. The fuel tank on all MGB and MGC variants is suspended beneath the boot floor, with the single nearside exhaust running between the tank and the leaf spring.

Left: The unlined boot of the MGC was as simple as that of the original MGB. Note how the spare wire wheel is mounted with the spindle uppermost — robbing the boot of useful storage space and limiting the size of luggage that could be accommodated.

Above: The real differences between the MGC and the MGB lay under the skin — in particular the torsion bar front suspension, which was unique to the six-cylinder car to accommodate the bulk of the massive engine.

The MGC and its rivals

Make and model	Top speed ¼ mile	0–60mph	Standing	Fuel consumption	Price inc tax
MGC	123.8mph	10.0sec	17.6sec	19.3mpg	£1,102
Austin-Healey 3000 MkIII	122mph	9.8sec	17.0sec	17.7mpg	£1,190
Reliant Scimitar GT 3-litre	121mph	10.0sec	17.1sec	22.1mpg	£1,516
Triumph TR5	117mph	8.1sec	16.5sec	20.0mpg	£1,212
Triumph GT6	106mph	12.0sec	18.5sec	20.2mpg	£985
Fiat 124 Sport Coupé	102mph	12.7sec	18.8sec	24.0mpg	£1,298
Sunbeam Alpine MkV	98mph	13.6sec	19.1sec	25.5mpg	£893

Sebring 1968: Abingdon's finest effort

Perhaps the title gives the story away but no matter: Sebring 1968 was a fitting finale for the run of full factory team entries at the Florida circuit. When preparations for Sebring began the previous autumn, few could foresee the major ructions that would soon take place at the top of the company. Sebring remained an important showcase for the MG marque, proving its continuing racing pedigree, and the import side of the business keenly supported the factory MG entries alongside those of its Healey colleagues, the latter under the watchful eye of Geoffrey Healey.

The added impetus as far as North America was concerned was the fact that the MGC and MGC/GT were new on the scene for 1968 and Sebring was seen as an ideal venue to prove that the new car was more than the jumped-up MGB that some critics had suggested. For the first time, therefore, 'Mabel' was able to assume her real vocation as a racing MGC GTS. Supporting 'Mabel' was an MGB GT, which bore the same registration (LBL 591E) as the 1967 entry but was in fact a new car (the shell of the first version had been damaged); 'Mabel' would be driven by Hopkirk and Hedges and LBL by the American/American/Canadian trio of Gary Rodriguez, Richard McDaniel, and Bill Brack.

The race would prove to be a magic one for the MGC; the car ran flawlessly, the

Left: Typical BMC success advertising followed by MG's excellent showing at Sebring in 1968.

Below: The 1968 Sebring race was certainly the MGC's finest hour. MBL 546E finished in tenth place overall — the highest t[o] date for an MG.

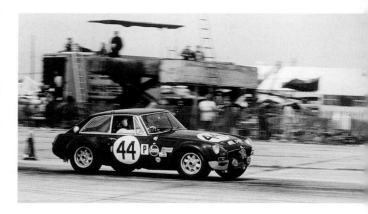

only unscheduled pit stop being to remove a piece of paper that had blown on to the front of the car. In the 11th hour the MGC moved up into tenth place overall and stayed there to the end of the race. The result was superb: not only had the MGC finished in the highest position since 1953 but the tenth place was also the highest ever placing for a factory MG. It would not be until the dawn of the New Millennium over two decades hence that MGs would begin to rise to such levels at Sebring and by that time the race cars were not based on any road-going MG.

To fully appreciate the achievement of the MGC, it is instructive to consider the cars which finished ahead of it; in order they were a pair of factory Porsche 907s (Jo Siffert's winning car having held the lead for all but the first two hours), a pair of 5-litre Chevrolet Camaros, a Shelby 427 Mustang, a 7-litre Corvette, and a trio of Porsche 911s. Five places behind the MGC GTS came an MG Midget entered by the Healeys, while the MGB GT finished an honourable 18th.

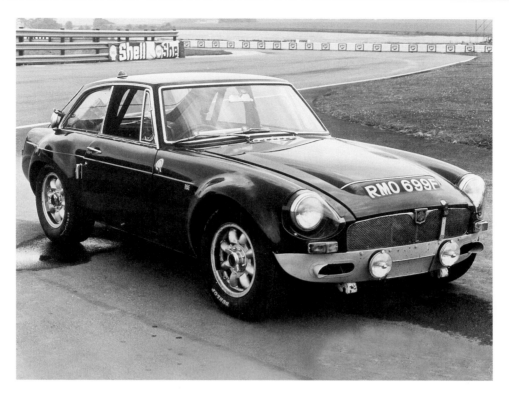

After the 1968 Sebring race the second lightweight MGC GTS, RMO 699F, was completed at Abingdon. By late July (when Bill Price of 'comps' took this photo) both cars were being developed and tested, as here at Thruxton.

Competition swansong: the Marathon de la Route

With the formation of British Leyland, new management muddied the waters of competition policy. Perhaps not unreasonably, the new people in charge at Longbridge saw greater benefit in trying to lift the dowdy image of the corporation's mainstream models, so the major effort within 'comps' for 1968 was put behind entries for the big Austin-Morris 1800 (ADO17) 'landcrab' saloons in the East African Safari and London–Sydney Marathon. Peter Browning wanted to see the MGC GTS concept being developed for rallying as well as circuit racing and fostered the hope that a small production run of road-going MGC GTS replicas could be made available for sale at a premium.

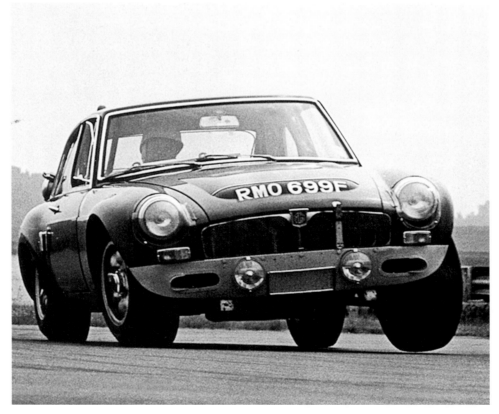

The second factory-raced MGC GTS, undergoing testing at Thruxton in early August 1968. Again it was photographed by Bill Price, on hand with his trusty Rolleiflex.

By the summer of 1968 there was a second MGC GTS racing car (RMO 699F) and in July the two were put through their paces at the Thruxton race circuit. Despite suggestions in some quarters that this new car had an alloy version of the heavy six-cylinder engine, several insiders have confirmed to the author that this wasn't the case. There were certainly plans for such an engine — and indeed there had been alloy-engined 'Big' Healeys and at least one alloy

RMO 699F was entered in the autumn 1968 Marathon de la Route. It is seen here in 1998.

MGC engine was built subsequently using the parts — but the factory MGC GTS never raced with an alloy unit.

Following the completion of testing at Thruxton in early August, the two cars were shipped out to compete in the Marathon de la Route at the Nürburgring circuit. Andrew Hedges was without his chum Paddy Hopkirk for this mad 84-hour race, being partnered instead in 'Mabel' by Tony Fall and Julien Vernaeve, while RMO 699F

was driven by Alec Poole, 23-year-old Clive Baker, and Syd Enever's son Roger (aged 22).

For the first day both cars ran very well but the strain soon took its toll of the engine in RMO, which was forced to retire. 'Mabel' kept going strong, although there was great drama three quarters of the way through the race when the brakes failed; a pit-stop attempt to make repairs proved insufficient as time penalties had to be avoided and so for a while the car ran on

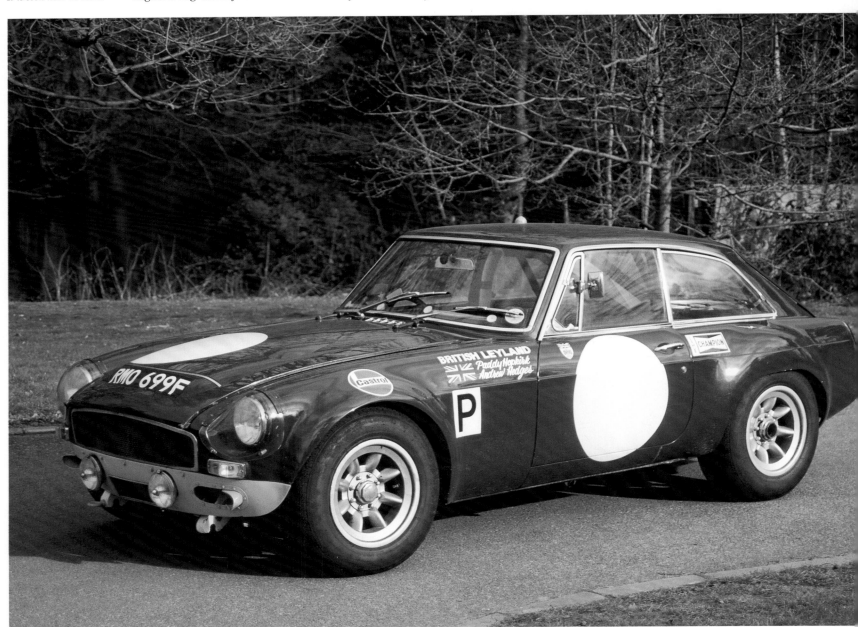

Alan Zafer was a key member of the BMC publicity team that supported Abingdon's competition exploits. He took this atmospheric night shot of MBL 546E during the 84-hour-long Marathon de la Route. The car eventually finished in sixth place. RMO 699F was forced to retire.

the circuit without brakes. Eventually 'Mabel' was brought in (stopping with difficulty!) and the necessary repairs were effected. The car re-entered the fray, penalised to the tune of 20 laps because of the pit time for the brake repairs, but finished the race a very honourable sixth overall. According to Peter Browning, honour was at least upheld: 'we finished up only ten miles behind the leading Porsche'.

If the 'comps' team was reasonably

pleased, however, its joy would be fairly short-lived. A little more than a month after the cars returned to Abingdon, BLMC boss Donald Stokes announced that 'comps' would be ending the MG racing programme: for some of the old hands it seemed like a replay of Leonard Lord and 1935 all over again. November's discontinuation of the MG factory-produced *Safety Fast!* magazine only compounded the sense of gloom.

Specifications: MGC

ENGINE

Description
In-line overhead valve pushrod six-cylinder with cast iron block and wet liners, cast iron cylinder head. Roller chain-driven side camshaft. Solid skirt four-ring aluminium alloy pistons, steel connecting rods, and copper-lead shell bearings. Seven-bearing crankshaft

Capacity
1,912cc (177.7cu in)

Bore and stroke
83.36mm x 78.90mm (3.28in x 3.106in)

Compression ratio
9.0:1

Maximum power
145bhp (net) @ 5,250rpm

Maximum torque
170lb ft (230Nm) @ 3,400rpm

Carburettors
Twin 1¾in SU HS6

TRANSMISSION

Gearbox
Four speed all synchromesh. Optional Laycock-de Normanville overdrive on top and 3rd gear. Optional Borg-Warner 35 automatic transmission

Ratios	Manual	Auto
1st	2.980:1	2.39:1
2nd	2.058:1	1.45:1
3rd	1.307:1	–
(O/d 3rd)	1.072:1	–
Top	1.000:1	1.00:1
(O/d top)	0.820:1	–
Reverse	2.679:1	2.09:1

Clutch
Borg and Beck, 9in single dry plate

Propshaft
Hardy Spicer, needle roller bearings

Rear axle
Hypoid bevel, ratio 3.071:1 (3.307:1 overdrive and automatic)

BRAKES

Front
Girling disc, 11.06in

Rear
Girling drum, 9in x 2½in

Operation
Girling hydraulic, servo

Handbrake
Lever with cable to rear drums

SUSPENSION

Front
Independent. Torsion bars, wishbones, telescopic dampers, anti-roll bar

Rear
Live rear axle, semi-elliptic springs, Armstrong lever-arm dampers

STEERING

System type
Cam Gears rack and pinion

Number of turns lock to lock
3.5

Turning circle
34ft (10.36m)

Steering wheel
Bluemel sprung steel three-spoke, 16.5in diameter

WHEELS AND TYRES
5J x 15in steel disc wheels. Optional 72-spoke wire wheels

Tyres
165SR-15 radial-ply

PERFORMANCE
Autocar road test, 16 November 1967

Top speed
120mph (193kph)

Acceleration

0–50mph (80kph)	7.6sec
0–60mph (96kph)	10.0sec
0–70mph (112kph)	13.8sec
0–80mph (128kph)	18.0sec
0–90mph (144kph)	23.1sec
Standing quarter mile (402m)	17.7sec

Overall fuel consumption
19.0mpg (14.9l/100km)

DIMENSIONS

Length
12ft 9.2in (3.89m)

Width
5ft 0in (1.52m)

Height
4ft 2.25in (1.28m)

Wheelbase
7ft 7in (2.31m)

Track
Front: 4ft 1in (1.24m)
Rear: 4ft 1.25in (1.25m)

Ground clearance
4.5in (114mm)

Weight
Roadster 2,460lb (1,116kg)
GT 2,620lb (1,188kg)

1969
'You see only so many MGBs'

The MGB and MGC ranges on sale as 1969 dawned looked very similar to those that had been in the showrooms a year earlier; you would have needed a particularly sharp eye to notice that the sidelamps had been shifted a fraction of an inch closer to each side of the still-familiar chrome radiator grille. Behind the scenes, however, change was certainly coming. British Leyland was beginning to plan its long-term sports car programme and, to keep sales of the MGB going past its then forecast ten-year lifespan, the stylists decreed that the appearance would need to be dragged screaming into line with the contemporary US 'pony car' trends. The year would also see the death of the well-meant but botched experiment that had been the MGC. At the time few believed anyone would mourn its passing, although barely would the last cars have left the showrooms than former critics would suddenly discover that the MGC hadn't been so bad after all — particularly if it had been breathed on by Daniel Richmond's Downton Engineering Works. Isn't hindsight wonderful?

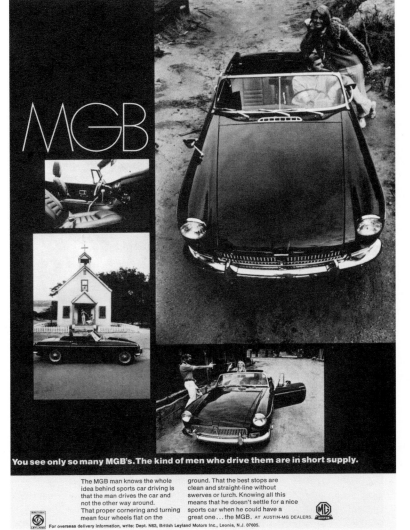

In 1969, the appeal in US advertising was focused on the male: 'You see only so many MGB's. The kind of men who drive them are in short supply.'

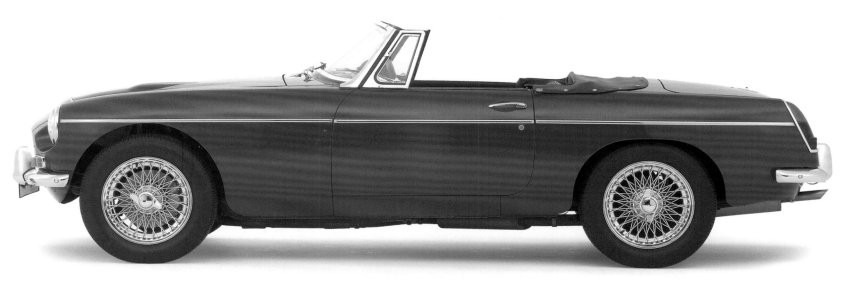

How the MGC performed in the US

Top speed	0–60mph	Standing ¼ mile	Fuel consumption	
118mph	10.1sec	17.7sec	17.8 US mpg	*Road & Track*, May 1969
109mph*	9.9sec	17.3sec	18 US mpg	*Car and Driver*, June 1969
*estimated				

From the side the MGC roadster retained the clean and simple lines of its MGB progenitor.

Fiddling with the details: the 1969 model year

Each autumn the motor industry traditionally sets out its wares for the coming year — historically, this has often coincided with the Earls Court Motor Show in the UK. In the US the major shows take place early in the New Year (April in the case of the New York Show) but the model-year changes are no less important. The drive to change models annually really gathered momentum in the 1950s, when manufacturers wanted to encourage their customers to buy into the newest and latest fashion; this year it might be bigger fins, that year twin headlamps, another time two-tone paint, or pillarless roofs. By the following decade, however, the real significance of the model-year change was to comply with the —

invariably annual — alterations demanded by ever-stricter safety and anti-pollution legislation.

As we saw earlier, for the 1968 model year, MG had already introduced notable changes for the US market such as the 'Abingdon pillow'; the following year saw more of the same, albeit not quite as drastic a step. New visibility (side-marker) requirements meant that small rectangular reflectors were added to the sides of the front and rear wings (for US models), whilst new standards of outward vision for drivers meant that MG adopted the novel approach of fitting three windscreen wipers to the MGB and MGC roadsters to ensure enough of the shallow screens were kept clear in spray conditions. Allied with the need for better wipers, new standards also required improvements to interior screen demisting, MG's solution being to lengthen the slots in the top of the dashboard.

Further safety measures inside the cars meant the standard fitment (again only on US models) of substantial headrestraints (unique to 1969), while at the front of the car a subtle and often overlooked change was the movement of both the side/indicator lamps closer to the radiator grille.

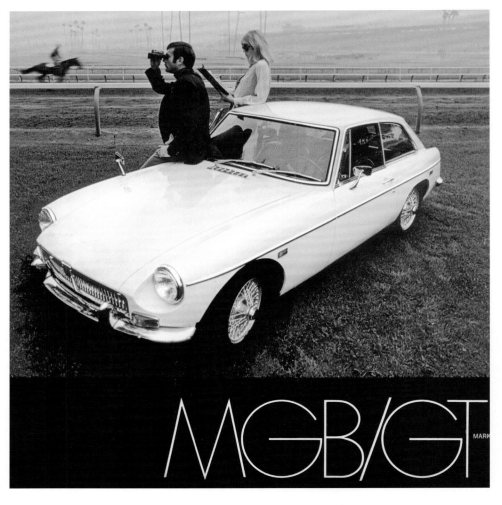

Changes to the MGB family, including the MGC, for 1969 were not particularly obvious. Small telltale signs included the movement of the sidelamps slightly closer to the edges of the radiator grille and, on this US-market car, small rectangular reflectors on the wings.

Selling the MGB in the US: the Leonia operation

In the immediate postwar years MGs were imported into the US by a handful of independent distributors. With the formation of BMC, and the integration of the Austin and Nuffield dealer networks which followed, Nuffield's preferred partner Hambro — the merchant bank — took responsibility for handling principal distribution and service back-up on BMC's behalf.

The first change to this arrangement occurred three years prior to the MGB, in May 1959, when former Wolseley apprentice and Nuffield Exports sales representative Graham Whitehead was persuaded to take up a post in a new office at 680 Fifth Avenue, New York. The name

over the door was BMC USA Ltd and the role of the office was to act as a liaison between BMC and Hambro. 'There were three of us,' recalled Whitehead. 'Roderick Learoyd was in charge, I was the Sales Executive, and Fred Horner was the Office Manager. We technically reported to BMC Canada's Managing Director, Lester Suffield, along with his Finance Director Ron Lucas.'

Then in 1962 there was some discussion between George Harriman of BMC and Ted Birt of Hambro Bank to increase BMC's control of US sales. A deal was eventually brokered where BMC and Hambro would each hold 49 per cent shares in the joint BMC/Hambro company, with an

intermediary holding the remaining two per cent. At the same time new offices and ample warehousing for parts were acquired at Ridgefield, New Jersey. Lester Suffield was President and 'Babe' Learoyd looked after sales.

Next door to the main office was a separate building — known as the 'White House' (solely on account of its exterior finish!) — that housed the offices of BMC USA Ltd, which continued as an import business. Graham Whitehead stated that the idea was that BMC USA Ltd. sold the first 'arms-length' sales to the main company; this meant that the sales tax paid in the US was actually paid on the first sale, which was lower in value

han the subsequent sale to the independent distributors. This rather nifty tax dodge was the reason why some BMC staff in the US offices had two business cards!

With the merger of BMC and Jaguar, which led to the formation of British Motor Holdings, plans were put in motion to move from Ridgefield to new, larger premises at Leonia, New Jersey. In the meantime, however, the British Leyland merger took place and it was quickly realised that the new premises could be adapted to accommodate Rover and Triumph alongside the BMC and Jaguar operation. The Triumph side had been headed by Chris Andrews, assisted by Bruce McWilliams and his wife Jimmy, who had

first come into the Leyland side of the company from their involvement in Rover. Mike Dale was Whitehead's deputy, in charge of MG, Austin, and Jaguar affairs. 'I had to try to meld the company together,' admitted Whitehead, who became President of the new British Leyland Motors Inc, 'and although it was a big task at the time, we were able to make it work well.'

Leonia would be an increasingly active focus for British Leyland's US operations; it became involved not only in sales and marketing activity but also served as a conduit for the increasing raft of safety and pollution legislation that MG had to contend with from 1968 onwards. The basic set-up remained

virtually unchanged through most of the following decade, until the formation of Jaguar Rover Triumph Inc, which was swiftly followed by the closure of first MG and then Canley (Triumph TR7) and Solihull (US-spec Rover SD1). The US operation had to shrink accordingly and a number of faces left the company. Both Graham Whitehead and his deputy Mike Dale remained, however, to oversee Jaguar's continuing presence; Whitehead not only continued as President of Jaguar Cars of North America until his retirement in 1990 (some time after the Ford takeover) but Mike Dale took over as Jaguar President and remained in office for another ten years.

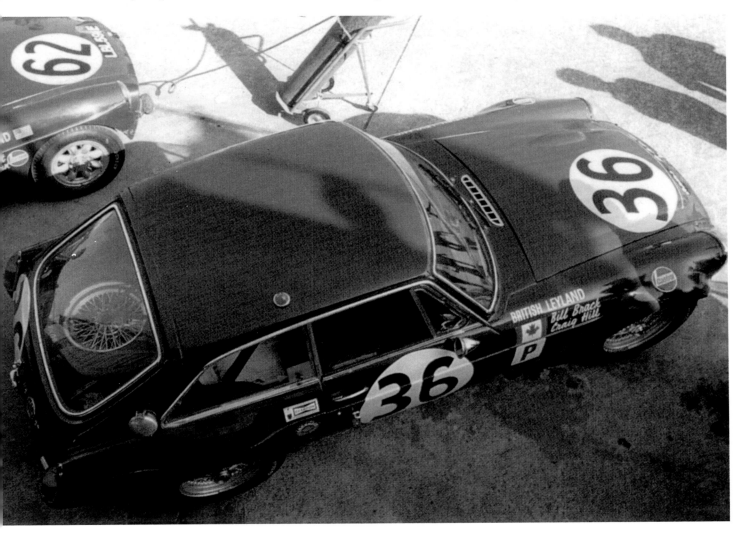

The 1969 Sebring race saw both MGC GTS cars racing, as well as a totally new version of the MGB GT (LBL 691E), seen here in the pits behind MBL 546E.

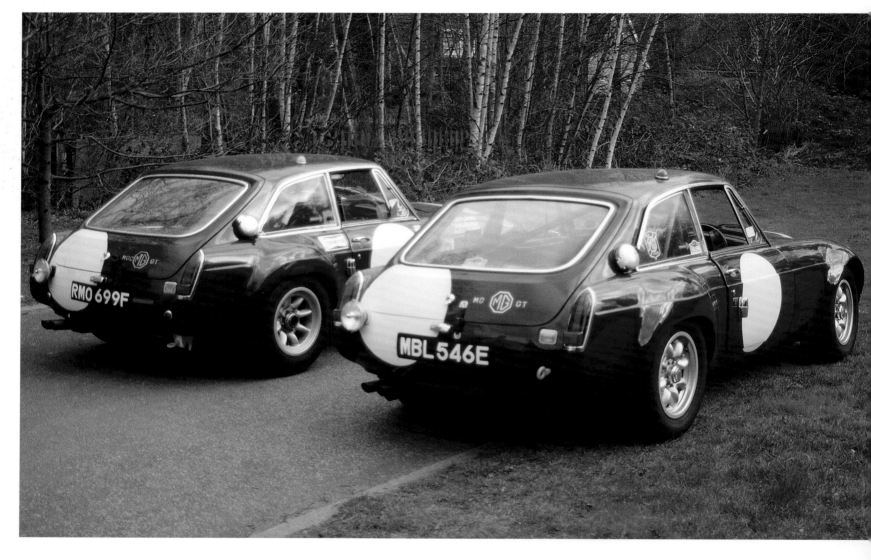

MGs at Sebring in 1969

In between the planning for the 1969 season and its first events, there were significant changes at the British Leyland competitions department; Chairman Donald Stokes decreed that for the foreseeable future, any motor sport endeavours would be based on mainstream cars (including, as it transpired, the new Austin Maxi). The competitiveness of the Mini-Cooper had passed its peak and Peter Browning's plan to build a race or rally programme around the MGC was suddenly in tatters. However, the US import side of British Leyland still wielded considerable power, influence, and budgets, and so through its support and endeavours the MGC was allowed one final fling at the Florida race circuit on Saturday 22 March 1969.

Now, of course, there were two factory MGC GTS cars available and so, for the first and last time, both 'Mabel' and RMO ran at Sebring together, accompanied by the MGB GT LBL 691E. Paddy Hopkirk and Andrew Hedges drove RMO (racing as number 35), Americans Craig Hill and Bill Brack drove 'Mabel' (as number 36). The MGB GT was driven by Jerry Truitt and Logan Blackburn. As in 1968 the race was fairly uneventful for the three 'factory' MGs, all finishing, but they had slipped against the strengthening opposition. Their best place was 15th overall (Hopkirk/Hedges), while Hill/Brack achieved 34th overall (sixth in class), and Truitt/Blackburn came in 28th (fourth in class). So ended the factory 'GT' racing story — leaving a strong sense of 'if only ...' on the lips.

The Sebring race saw two factory MGC GTS cars race there together for the one and only time with factory support. 'RMO' finished 15th and 'MBL' came in 34th overall. The cars are pictured here together in 1998, both being owned by the extremely fortunate Mick Darcey.

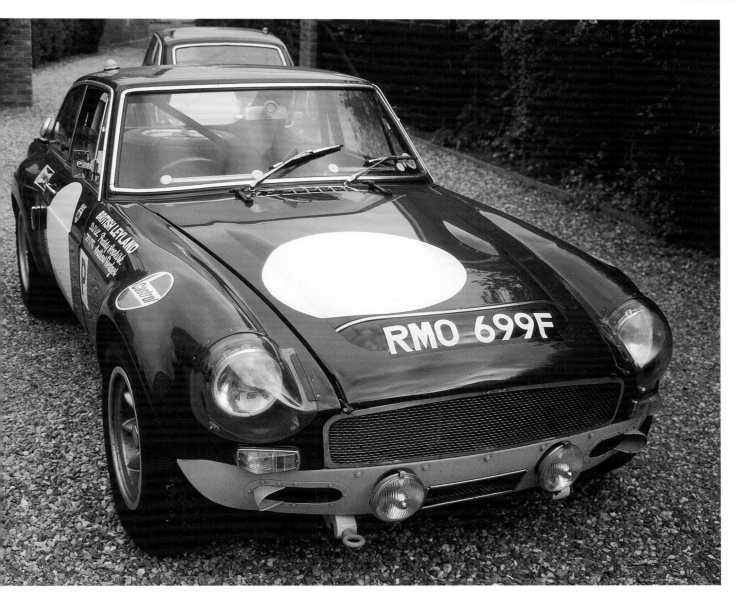

Royal connections: Prince Charles's MGC GT

In 1969 Her Majesty The Queen had a royal slant on the vexatious problem that some fortunate few have to consider: what to buy for one's eldest son to mark his 21st birthday — and, in this case, his consequent investiture as the Prince of Wales. With the help of BMC, the problem was solved: let him have an MGC. Presumably a GT was seen as more befitting an heir to the throne — and doubtless

was a little more secure and comfortable for the inevitable burly police bodyguard — and so an MGC GT was the choice. The car (registered SGY 776F) was constructed with the sort of care and dedication normally reserved for show cars — with carefully applied welds, dressed seams, and blemish-free components throughout.

The first specially built bodyshell had

to be replaced after it was struck by a forklift truck at Abingdon! 'I happened to be at Abingdon at a meeting with Les Lambourne when the accident happened,' Dave Nicholas of Pressed Steel told the author, 'and someone came into the office, ashen faced, and said "we've got a little problem ..."' Fortunately, a second body had been prepared 'just in case'.

Goodbye MGC

Even the most fervent admirer of the MGC will have to admit that its gestation, launch, and production life were no happier affairs than the mauling the car received at the hands of much of the motoring press. The shame is that by 1970 there could have been a much-improved MGC and — if the money had been available — the Datsun 240Z need not have had the close-coupled US sports coupé market to itself. As it was most of the money that there was available for MG had to be channelled into keeping the main-stream MGB and Midget on sale in the US and so the funds for upgrading the MGC — selling slowly at this stage — were limited.

Nevertheless, some changes had been made to the MGC in time for the 1969 model year and these included new sportier gear ratios; those few road testers who tried the modified cars noted the improvements. Sadly not enough notice was taken of these changes, for by 1969 the MGC had become a talisman for all that had been wrong with the old BMC organisation in its dying days and the new management was hardly keen to promote a failing six-cylinder MG when there was a comparatively successful and popular Triumph TR5, with a TR6 waiting in the wings.

The crucial US market had been under-whelmed by the MGC; it was seen as a typi-cally cheapskate BMC badge-engineered answer to the enforced demise of the classic 'Big' Healey and there is little doubt that a lot of former Austin-Healey owners defected to other camps. From September 1969 such people had the option of the Japanese ver-sion of the 'Big' Healey, the elegantly styled Datsun 240Z. By the summer of 1969 the end was nigh for the MGC; in July the life-support was finally terminated and the last cars left the factory with barely a whimper.

When it first tested the MGC in May 1968, the US magazine *Car and Driver* had said of the MGC: 'The idea of an MGB with more guts is appealing ... unfortunately ... the job was botched. By stuffing the great cast-iron Austin-Healey 3000 engine into a cringing MGB chassis, they've managed to destroy most of the good features of the B without appreciably improving perform-ance.' Just over a year later the same maga-

From the rear, the MG closely resembled the contemporary MGB. The small square reversing lamps seen o this car were fitted as standard after April 1967.

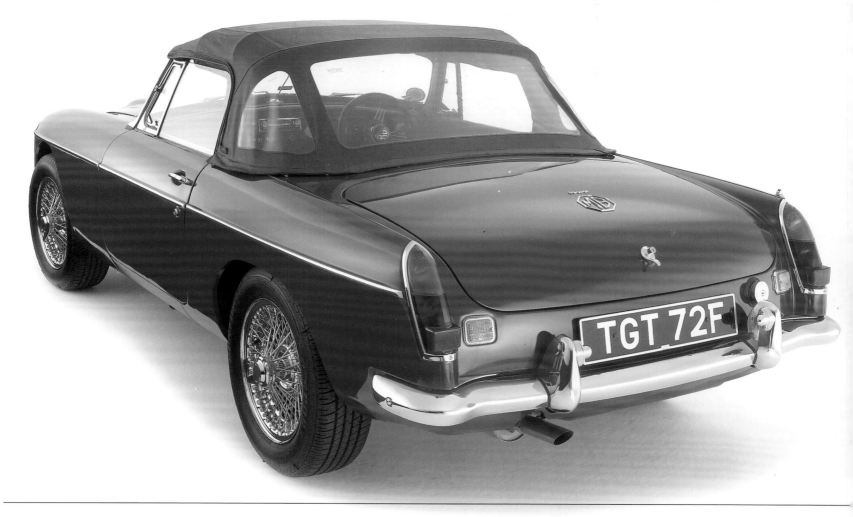

ne carried what turned out to be one of
e last tests of the MGC in its production
fetime. This time the testers concluded:
's up to the MGC to carry on the tradi-
on. Unfortunately, the burden is too great
it isn't that the MGC is a lousy car — it
n't. It's just that the C isn't much of a
ports car, even less an MG sports car —
hich, as readers of the Sacred Octagon
ill tell you, is something totally apart
nyhow.'

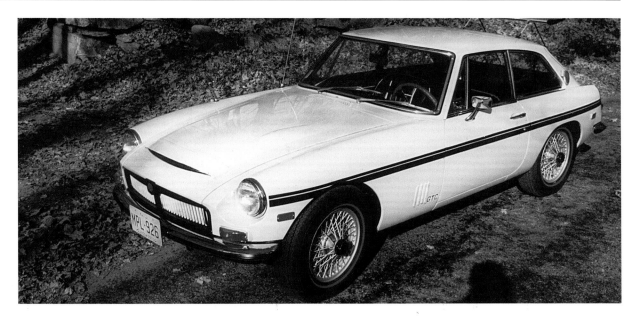

Bruce McWilliams of British Leyland's US subsidiary explored ways of injecting the MGC with more modern appeal. Sadly it was too late to save the car.

The University Motors MGC

urrey and London-based MG dealers
niversity Motors bought a batch of the
st MGC roadsters and GTs and offered
em with a variety of Downton tuning
acks and customised paint and trim. The
andard University Motors GT with wire
heels and seat belts cost £1,370 delivered
vith four months' road tax). Extra cost
ptions included: special paintwork £65,
Veathershields sunroof £43, vinyl roof
overing £30, front grille to match 1970-
odel-year MGB £22, inertia-reel seat belts
17, Koni front dampers (pair) £16,
otolita steering wheel £13, Cosmic 15in

alloy wheels (set of five) £60, Downton
engine conversion £175, stereo eight-track
tape player £58, and push-button radio
£33. However, sales of these customised
MGCs remained a drop in the ocean.

Ian Elliott, later to become a British
Leyland press spokesman, was editor of an
in-house newsletter at the time. 'An
enduring regret for me is that I got
agreement of University Motors to lend me
one to road test for the Apprentices'
magazine *Torque* that I edited — but the
Training boss wouldn't sign off the
insurance required. With the benefit of

hindsight, I can see why he didn't want the
responsibility of a 120mph accident or at
least an M5 speeding scandal!'

However, one of the MGC University
Motors Specials was tested by *Autocar* and
the report appeared in the 17 December
1970 issue. The GT tested was fitted with a
host of extras (including a £175 Downton
engine conversion) and cost £1, 830 on the
road. Top speed was raised to 130mph and
acceleration improved with 0–60mph in
9.8sec and the standing quarter mile
covered in 17.2sec. Overall fuel consump-
tion decreased from 17.5mpg to 19.7mpg.

What the last MGC models cost (October 1969)

	Basic	Purchase tax	Total UK price
Sports	£937 5s	£288 13s 6d	£1,225 18s 6d
GT	£1,057 5s	£325 6s 10d	£1,382 6s 10d
Extras			
Overdrive	£50	£15 5s 7d	£65 5s 7d
Hardtop (Sports)	£60	£18 6s 8d	£78 6s 8d
Wire wheels (painted)	£25	£7 12s 9d	£32 12s 9d
Wire wheels (chromed)	£64 10s	£19 14s 2d	£84 4s 2d
Folding hood (Sports)	£4	£1 4s 5d	£5 4s 5d
Tonneau cover (Sports)	£8	£2 8s 11d	£10 8s 11d
Heated rear window (GT)	£15	£4 11s 8d	£19 11s 8d
Automatic transmission	£80	£24 8s 11d	£104 8s 11d

The University Motors Special MGC has passed into legend — and has undoubtedly been copied by the less scrupulous. This is the special badge seen on some, but not all, such cars.

1970
'Sport the real thing. MGB'

The 1970 model year saw the most dramatic change to affect the MGB range to date and divided MG enthusiasts into two camps — you either loved the 'trendy' new features or loathed them with a passion. The press release of October 1969 trumpeted the news of 'exciting new styling and trim and colour changes, designed to keep the cars ahead of their competitors'. In some ways, the MGB was getting rather better — although this did vary from market to market — and those responsible for the styling changes claimed that these had been demanded by the US importers. The strange thing is that few of the survivors of those days at British Leyland Inc in Leonia, New Jersey, can now remember the person who asked for the alterations. This is therefore either a case of collective amnesia or more likely the simple fact that the people who made the decisions were neither in Leonia nor Abingdon but at Longbridge and Cowley — and that whatever these people said just had to be right. They say a camel is a horse designed by a committee; to many eyes the 1970 MGB was just such an animal.

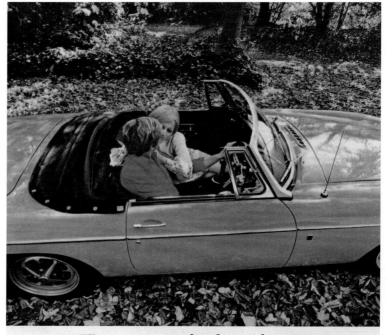

The sports car for the enthusiast.

The MGB is the car for the man who's been around. Tried them all. But won't take less anymore. He knows what he's after. And knows he can get it in an MGB.

He's after performance. Like 0-50 m.p.h. in a cool 9 seconds*. The kind of performance you get from the famous 'B' series engine.

And now we've given him looks to match. The new MGB has a matt black recessed grille with chrome

*Motor.

surround. Black and silver Rostyle rally wheels. And redesigned light clusters.

Inside you will find new rake adjusting seats, covered in black knit-backed expanded vinyl. A feature we're sure will appeal to our enthusiasts.

The MGB comes in four wild new colours. Bronze Yellow, Glacier White, Blue Royale, Flame Red. And of course, you can still get the famous British Racing Green

and Pale Primrose.

Take one out on a Test Drive. Bring a passenger. But be warned – you'll never take less again.

Recommended price £1125 including P.T. Extra is charged for delivery, seat belts, number plates, radio and aerial.

Sport the real thing. MGB.

'Sport the real thing. MGB.' this advertisement in Motor told us.

What the 1970 model MGB cost

	Basic	Purchase tax	Total UK price
Sports	£860	£265 1s 5d	£1,125 1s 5d
GT	£970	£298 13s 7d	£1,268 13s 7d
Extras			
Overdrive	£50	£15 5s 7d	£65 5s 7d
Hardtop (Sports)	£60	£18 6s 8d	£78 6s 8d
Wire wheels (painted)	£25	£7 12s 9d	£32 12s 9d
Wire wheels (chromed)	£64 10s	£19 14s 2d	£84 4s 2d
Folding hood (Sports)	£4	£1 4s 5d	£5 4s 5d
Tonneau cover (Sports)	£8	£2 8s 11d	£10 8s 11d
Radial-ply SP68 tyres	£3 15s	£1 2s 11d	£4 17s 11d
Heated rear window (GT)	£15	£4 11s 8d	£19 11s 8d
Automatic transmission	£80	£24 8s 11d	£104 8s 11d

How the 1970 model MGB performed

Top speed	0–60mph	Standing ¼ mile	Fuel consumption	
107.4mph	12.0sec	18.9sec	24.1–43.9mpg	Roadster, MG's figures
107.4mph	13.4sec	19.5sec	24.1–43.9mpg	GT, MG's figures
107.5mph	11.6sec	18.2sec	27.4mpg	GT, *Motor*, 31 October 1970
104.0mph	13.6sec	19.5sec	25.5mpg	Roadster automatic, *Autocar*, 16 April 1970

ustin-Morris designer b Owen produced this etch of the proposed ritish Leyland face-lift.

British Leyland's MGB

The demise of the MGC preceded even more fundamental changes at Abingdon, for the MGB was about to undergo the most controversial changes of its seven-year life. The BLMC merger had killed off any chance of MG creating its own home-grown replacement for the MGB and the Pininfarina-styled EX234 was concealed surreptitiously in a corner at the factory. We saw earlier some of the first attempts to bring the MGB 'up to date' to meet the new challenges from the US domestic 'pony' cars, the Italians and the Japanese; for 1969, however, there would also be a new mantra being chanted in the corridors of Longbridge: cost-cutting.

In the wake of his arrival at Cowley in late 1967, Roy Haynes had brought a troupe of Ford design people, many of whom moved from Essex to live in Wallingford, a short commute away from Cowley. These designers brought with them some of the bright new ideas that had been fostered at their former employer. One of the performance icons in the Ford empire was the Mustang, a saloon-based two-door coupé, hardtop, and convertible range that had stormed the US market in 1964 and continued to lead its youth-oriented market, a sector known as the 'pony car sector' in honour of the Mustang itself.

oug Adams of the ngbridge xperimental body shop uilt this mock-up of ritish Leyland's MGB ce-lift.

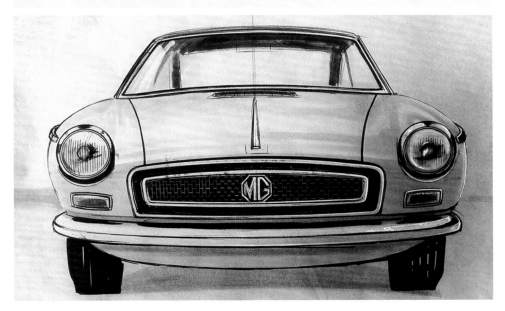

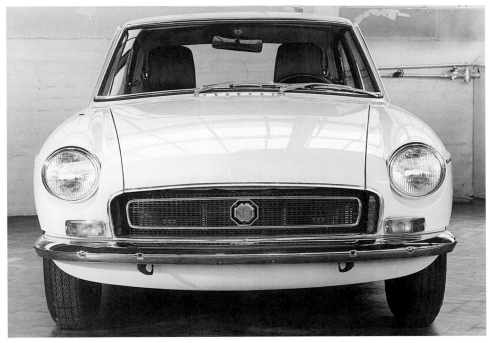

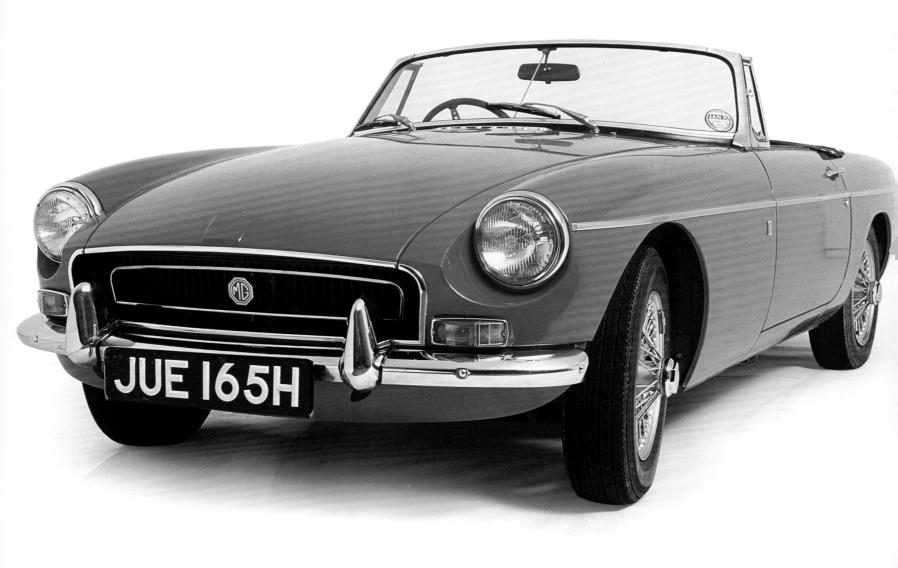

Although Rostyle steel wheels were standard on the 1970 model year MGB, this home-market Flame Red roadster sports the optional wire-wheels — now with safety-inspired octagonal nuts in place of the traditional knock-off spinners.

For the 1967 model Ford had thoroughly overhauled the Mustang and produced the classic shark-nosed look that in January 2003 was the inspiration behind the heritage-themed 2004 Mustang concept. For the 1968 model year — launched just as Haynes and his acolytes were setting up shop in Cowley — Ford US introduced a mildly face-lifted Mustang, which kept the deeply recessed black mesh grille from the previous year but added a neat concentric chrome ring that echoed the outer shape of the grille aperture.

The fact that the 1968 Mustang grille shape was an inspiration for the 1970-model-year MGB of September 1969 is indisputable; the design for the 'MGB for the 1970s' was drawn up by stylist Rob Owen and swiftly turned into a viewing model by Doug Adams of the Longbridge experimental shop. According to Ian Elliott, 'that face-lift grille was a *very* big cost-saving — the main motivation for it! This was saving pounds when the ex-Ford value analysis boys were scratching for fractions of pennies. Austin-Morris at this time was stuffed full of people with 'BTF' degrees (Been To Ford) — most of the styling studio and cost control bods were freshly arrived from Dunton or Dagenham ...'

The new grille was just the tip of the iceberg; the standard disc wheels were ditched in favour of Rostyle wheels, very similar in style to those of the Ford Cortina 1600E, while at the rear the tail lights were made squarer and bolder at Haynes's insistence. On US-bound cars, for this year only, the single rear bumper was superseded by a pair of quarter-bumpers, split to allow the normal US licence plate to fit flush on the rear valance. The launch press pack also suggested that the quarter bumpers were to be fitted to the MGB for all markets but, if that was the original intent, it never transpired.

Perhaps the biggest shock for many traditionalists was inside the car, where the customary Connolly leather seat-facings were discontinued in favour of knit-backed expanded vinyl — apparently instigated by the US importers but more believably one of the many cost-cutting exercises that were being introduced across the whole of British Leyland. The interior trim colour choice was restricted to black, while for the exterior there was the first of a new range of colours that soon included a mixed palette of orangey reds and muddy beiges.

Perhaps unsurprisingly, the management at Abingdon was rather unimpressed by the new changes being foisted upon it but had little choice in the matter; MG was now just a subsidiary of mainstream Austin-Morris, run by George Turnbull, and as such had less of a voice than Triumph, which was part of the more prestigious Specialist Car Division. In July John Thornley was taken ill and soon afterwards retired from the company that he had served faithfully for nearly 40 years; it was the end of an era in more than one sense.

More US safety and pollution legislation

By the end of the 1960s there was national concern in the US that the 1963 Clean Air Act and the legislation that followed was only being adhered to patchily — regulation was delegated to individual states — and so the 1970 Clean Air Act saw federal control of air-pollution control for the first time.

The Environmental Protection Agency (EPA) opened its doors on 2 December 1970 and was tasked with policing the rigorous anti-pollution targets set out in the new Clean Air Act. The Act decreed that there would be significant reductions in hydro–carbon (HC) and carbon monoxide (CO) emissions to 90 per cent of 1970 levels by 1975; similarly oxides of nitrogen (NOx) emissions should be 90 per cent of 1971 values by 1976.

Meanwhile, the Highway Safety Act of 1970 established another government agency, the imaginatively titled National Highways Traffic Safety Administration (NHTSA), which (entirely separately from the EPA) oversaw and policed the self-certification by manufacturers of a growing volume of safety-orientated legislation under the Federal Motor Vehicle Safety Standards (FMVSS).

Left: This Marce Mayhew photograph for the US advertising campaign seeks to emphasise the sporting associations of MG ownership.

Below: From the 1970 model year until the end of production all US-market MGB and 'MGB-GT' models were fitted with side-marker lamps (amber at the front and red at the rear).

1971
'The great British sports car'

1971 model MGB

To the casual eye the 1971 MGB family was a case of more of the same but there were a number of worthwhile improvements — it was perhaps a case of consolidation after the previous year's revolution. For the American MGB customer, however, there was already a noticeable dropping-off in performance as the pollution control equipment began to drag down the potency of the ageing B-series engine. British Leyland was planning a new engine (the O-series) for the longer term — at this stage slated for introduction in the MGB in around 1973–74 — but there were other issues to address: corporate plans for replacement of the whole sports car family (potentially bringing MG- and Triumph-badged cars under a single roof) and impending doubts about the future of the entire US market for open sports cars.

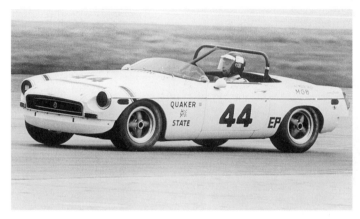

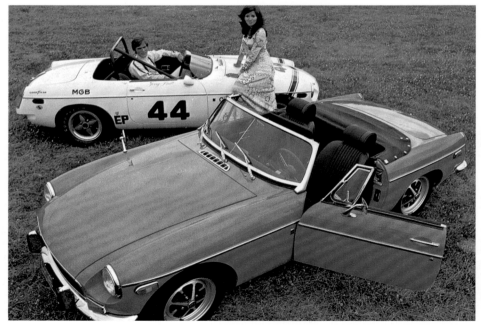

Above left: Even though British Leyland HQ had given up on the MGB as a competition vehicle by 1971, nothing could be further from the truth in the US. Local hero Jerry Truitt (seen here above) raced this MGB with distinction under the guise of the Group 44 race team.

Left: BMC used Jerry Truitt's successful Group 44 race team MGB in its US advertising.

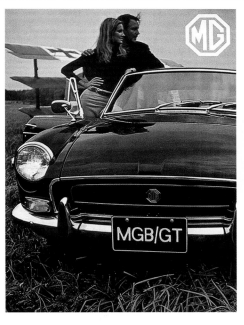

It's the real GT they're after.

Everybody seems to be flashing GT badges these days. It's as simple as this – GT stands for Grand Touring. And that means a touring version of a fast sports car. Like the MGB.

So if you want the real thing – the MGB GT's the one you're after.

You get real GT performance from the famous 'B' series engine. An engine that develops 95 b.h.p. High speed cruising is effortless. Quick getaways are easy.

The MGB GT is as good to look at as it is to drive.

There's a new matt black recessed grille with chrome surround. New light clusters. Plus reversing lights. And black and silver Rostyle rally wheels.

Inside – you'll find real GT comfort. Rake adjusting seats, trimmed in black knit-backed expanded vinyl are standard fitting.

Don't be content with just a GT badge – get a car to match. £1299* buys you in.

Sport the real thing. MGB GT.

A reminder to young lovers everywhere.

Our message is simple. Don't forget to switch off the Hotline heated rear window. If your car isn't fitted with a Triplex Hotline, however your problems start when it's time to go home.

And surely just flicking a switch and waiting for your rear window to clear will impress her far more than scrambling around in the back with a bit of old rag. Triplex XXX

Triplex Hotline. The essential option.

Production of the 1971 MGB and MGB GT started at Abingdon in August 1970, although a visitor to the production line could easily have been forgiven for failing to notice much of a difference. The rubber buffers introduced the previous year for US-bound cars were now fitted to MGBs for other markets (there were slight differences, of interest mainly to concours buffs). At the same time, the short-lived idea of split rear quarter bumpers was quietly dropped on US cars.

If the outside of the 1971 MGB looked pretty much the same as the 1970 version, there were more changes inside. A slight relaxation of the 'black only' trim option came with the availability of Autumn Leaf, a yellowish beige, while black was eventually usurped by navy blue — which arguably worked better in some colour combinations than others. While the open MGB continued with vinyl seat facings, the seats in the MGB GT were differentiated with centre panels of brushed nylon. Both roadster and GT also received a centre storage cubby and armrest (with integral ashtray) that extended back between the seats from a console beneath the dashboard. The door trims on all models were livened up slightly by horizontal chromed plastic strips.

The most significant and very welcome development for MGB roadster enthusiasts was undoubtedly the introduction of a new folding hood, designed by Michelotti. The hood of an MGB might still not have been as easy to erect or take down as the best of the competition (a partial consequence of the shallow height of the windscreen) but the changes marked a welcome improvement that saw the deletion of the previously standard-fitment 'pack-away' hood.

Right: From the outside at least, the 1971 MGB GT looked much like the 1970 model, apart from rubber buffers on the overriders of home-market cars like this specimen. The colour of this car is Bedouin, a short-lived pale beige.

Far right: The lighter interior colour was Autumn Leaf (a very typical orangey beige redolent of the early 1970s), which at least made the MGB's interior less sombre.

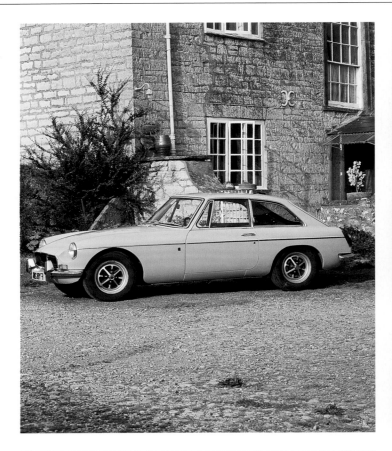

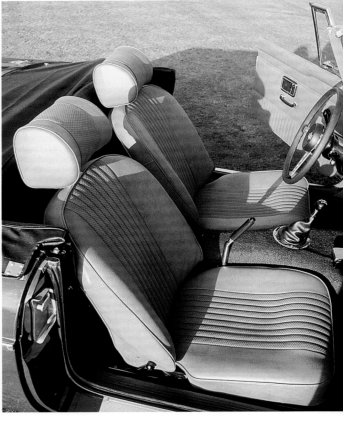

Right: The combination of black vinyl trim and the imposing black impact-absorbing dashboard made the interior of the MGB a fairly gloomy and claustrophobic, if reasonably safe, place to be.

Far right: The 1971-model-year US-market MGB featured the last gasp of the 'Abingdon pillow' type of padded dashboard. The Flame Red car in this shot has a black interior with D-shaped headrestraints as standard as well as sunvisors, the latter not seen on home-market cars until 1977.

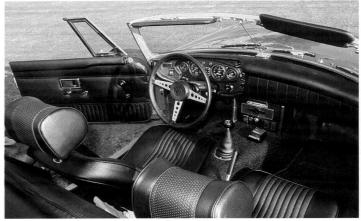

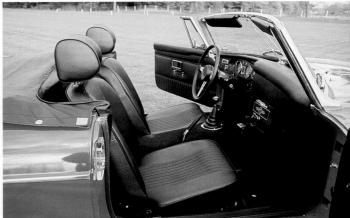

How the 1971 model MGB performed

Top speed	0–60mph	Standing ¼ mile	Fuel consumption	
101.1mph	—	—	21.9mpg	Federal specification MGB, *Motor*, 5 June 1971
102mph	13.0sec	18.5sec	23.7mpg	MGB GT, *Autocar*, 1 July 1971

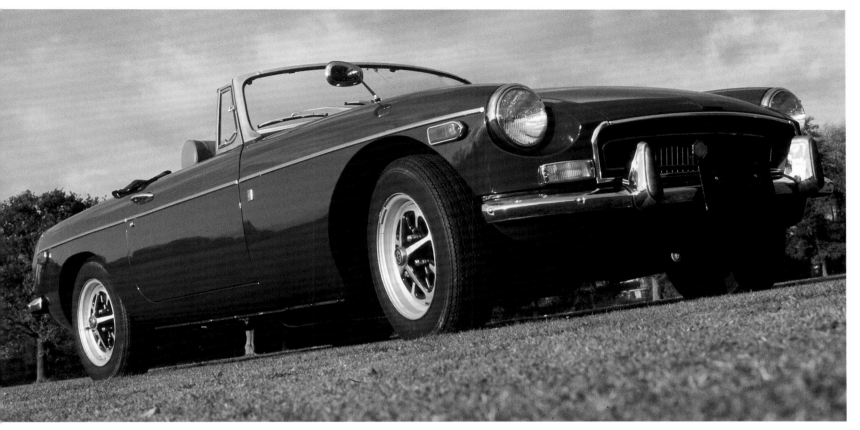

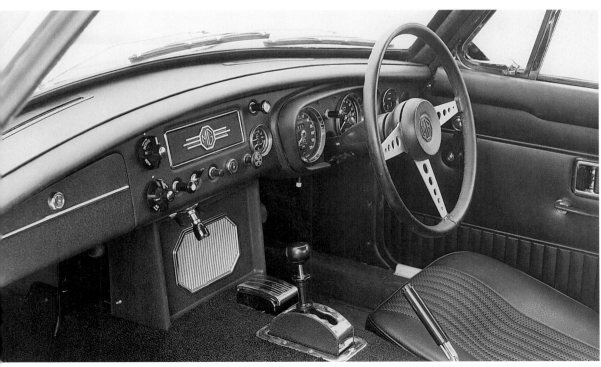

Above: Darker exterior colours, particularly when (as here) the interior trim was Autumn Leaf, suit the recessed-grille MGB well. Note the side-marker lamp, rectangular licence plate mounting, British Leyland badge on the wing ahead of the door, and the passenger-side wing mirror fitted to this 1971 US-market car.

Left: The automatic transmission option for the MGB was available from November 1967 until August 1973 — but only outside North America, where it might surely have had commercial appeal. Note the fascia-mounted lamp used to illuminate the gear selector!

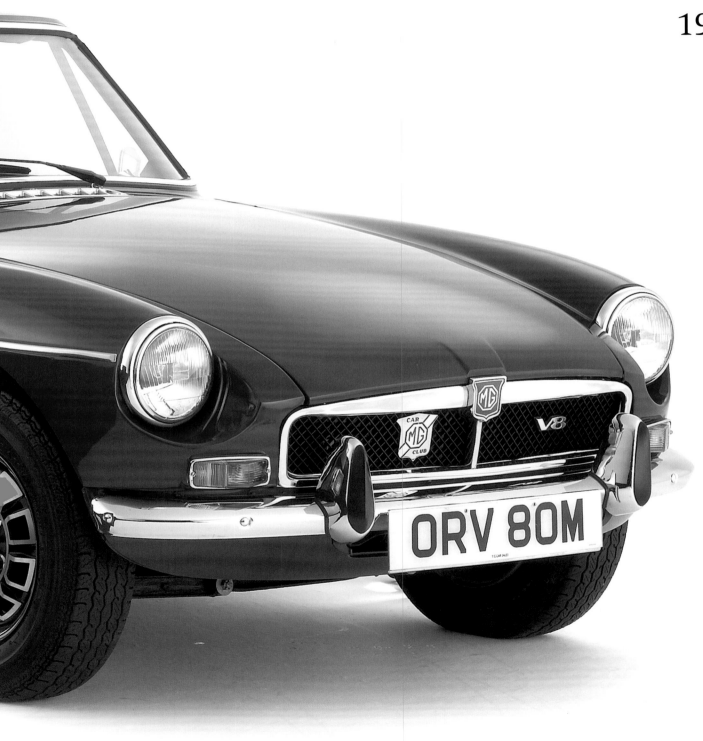

MGB MKIII

1972–1981

1972
'MG. The sports car America loved first'

In late 1971 the 1972 model MGB appeared and for the second year in a row, the average showroom visitor might have been forgiven for failing to notice much in the way of change. However, there were welcome improvements: the new folding hood and modified dashboard arrangements were welcome improvements and seemed to demonstrate a common sense approach. British Leyland decreed, for reasons better known at Longbridge than Abingdon, that this 'new' car should be known as the 'MGB Mark III'. However, behind the scenes at British Leyland problems and far-reaching decisions were beginning to unfold that threatened to impact upon MG affairs in the not too distant future.

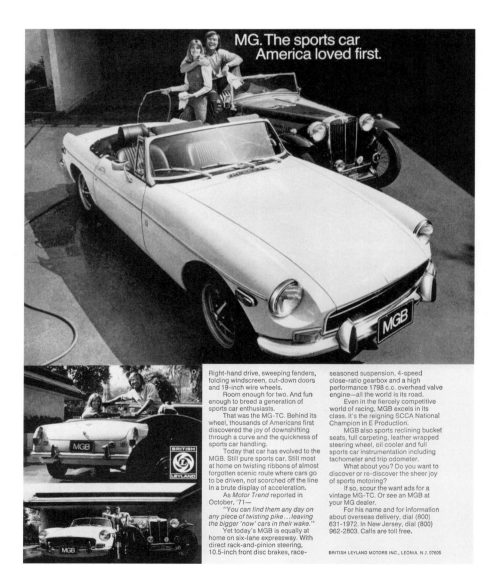

MG. The sports car America loved first.

Right-hand drive, sweeping fenders, folding windscreen, cut-down doors and 19-inch wire wheels.

Room enough for two. And fun enough to breed a generation of sports car enthusiasts.

That was the MG-TC. Behind its wheel, thousands of Americans first discovered the joy of downshifting through a curve and the quickness of sports car handling.

Today that car has evolved to the MGB. Still pure sports car. Still most at home on twisting ribbons of almost forgotten scenic route where cars go to be driven, not scorched off the line in a brute display of acceleration.

As *Motor Trend* reported in October, '71—

"You can find them any day on any piece of twisting pike...leaving the bigger 'now' cars in their wake."

Yet today's MGB is equally at home on six-lane expressway. With direct rack-and-pinion steering, 10.5-inch front disc brakes, race-

seasoned suspension, 4-speed close-ratio gearbox and a high performance 1798 c.c. overhead valve engine—all the world is its road.

Even in the fiercely competitive world of racing, MGB excels in its class. It's the reigning SCCA National Champion in E Production.

MGB also sports reclining bucket seats, full carpeting, leather wrapped steering wheel, oil cooler and full sports car instrumentation including tachometer and trip odometer.

What about you? Do you want to discover or re-discover the sheer joy of sports motoring?

If so, scour the want ads for a vintage MG-TC. Or see an MGB at your MG dealer.

For his name and for information about overseas delivery, dial (800) 631-1972. In New Jersey, dial (800) 962-2803. Calls are toll free.

BRITISH LEYLAND MOTORS INC., LEONIA, N.J. 07605

'The sports car America loved first' — a memorable advertising slogan.

The 1972 MGB MkIII

October 1971 saw the announcement of the 1972-model-year MGB MkIII. The casual onlooker might have been forgiven for wondering what all the fuss of the new designation was about, for the 1972 MGB looked pretty much the same as the 1970 and 1971 models. Yes, there were three new colours on offer (Black Tulip, Harvest Gold, and Green Mallard) and an improved heating and ventilation system (accompanied by new facias for both home and export markets) but the controversial 'black hole' grille remained.

Some of the more welcome changes appeared inside the car: the original 1968 'Abingdon pillow' on US models was consigned to the scrap heap due to a relaxation of some aspects of safety legislation and face-level air vents (fed only by ram-effect intakes rather than being integrated into the heater system) and larger demister slots were introduced. Between the seats there

Below left: The 1972-model-year face-lift brought face-level fresh air vents to the dashboard and changes to the switchgear. The steering wheel continued as before, with a series of small circular holes in the three brushed-chrome steel spokes.

Below: Knit-backed vinyl seat facings were featured on the so-called MGB MkIII of October 1971. All models benefited from a slim armrest with a lid, which lifted to reveal a long narrow cubby-hole — ideal for storing spaghetti but little else.

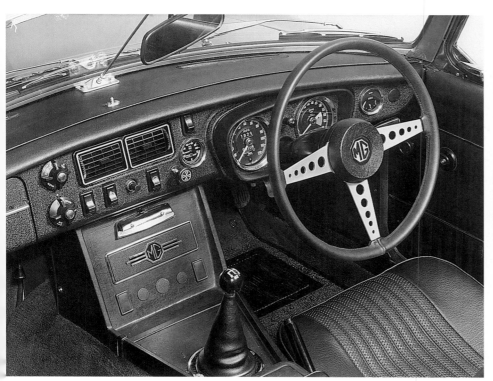

was a console that extended from the centre of the dashboard and included an armrest with a rear-hinged lid that lifted to reveal a long, narrow cubby of limited use. On MGB GT models there were new seat facings with centre panels in brushed-nylon instead of vinyl ('for the first time in the Austin-Morris Group,' gushed the October 1971 press release), while all models received some cheap chromed-ABS trim on the interior door panels.

The steering wheel came in for some minor changes with a new central horn push with an MG badge painted with a red background relief, navy trim replaced black (Autumn Leaf remained available for applicable colour combinations), and the Rostyle wheels were offered with an optional chrome finish in all markets. This was hardly enough to set the world on fire but there would be more welcome changes in store for the next model year.

The so-called MkIII face-lift (a British Leyland concoction rather than an Abingdon one) of the MGB GT featured a much-improved dashboard and the centre panels of the seats were trimmed in brushed nylon.

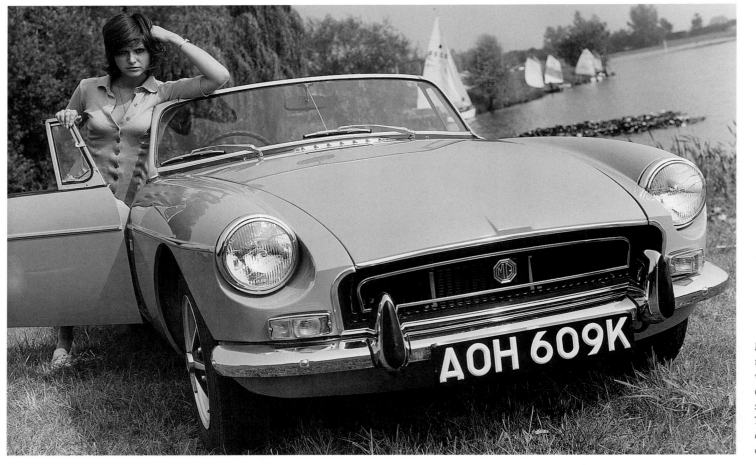

From 1971 the home-market MGB was fitted with the rubber-faced overriders previously seen on US-market cars. The recessed grille continued for this year only.

MG's future is dictated by Triumph

Austin-Morris was continuing to absorb large amounts of money from the company coffers and the launch of the new Ford Cortina MkIII in 1970 had done the Leyland camp no favours. The great white hope of Austin-Morris was the Morris Marina, launched in the UK in 1971 and with big plans for the US following the spring 1972 launch there as the Austin Marina. In his opening address for the 1972-model-year press pack (which previewed the face-lifted ADO16 range as well as the MGB MkIII), Austin-Morris Chairman George Turnbull wrote: 'Since the formation of the British Leyland Motor Corporation ... without doubt the most vulnerable area of the Corporation's business has been the Austin-Morris Group, where we have had to face the fiercest competition and, at the same time, carry out a great deal of company restructuring from Management to the shop floor. Now that we have completed this rebuilding, Austin-Morris will become its greatest strength.' Optimistic words indeed.

Meanwhile, plans for a future corporate sports car were formulated in the summer of 1971, with the real power behind decisions for the US market taken by those in Longbridge kindly disposed to the Triumph camp. A design exercise was undertaken — to which MG at Abingdon had not been invited to contribute — and the two main participants were Triumph engineering at Canley and Austin-Morris styling at Longbridge. Harris Mann of the latter team came up with a wedge shaped sports car which he dubbed the MG Magna and this boldly styled creation was duly picked by management as the sort of forward-looking style wanted for the new decade. Unfortunately for the MG camp, however, the management decided that it would be built in a brand new factory — and first and foremost the key version would be a Triumph.

1971 MG proudly [sh]owed off its heritage [th]rough the MG TC, TD, [a]nd MGA. MG was keen [to] make the point that [n]ewer rivals usually [co]uld not boast such [hi]story.

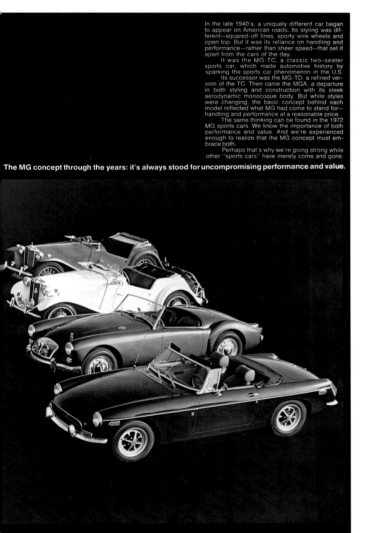

In the late 1940's, a uniquely different car began to appear on American roads. Its styling was different—squared-off lines, sporty wire wheels and open top. But it was its reliance on handling and performance—rather than sheer speed—that set it apart from the cars of the day.

It was the MG-TC, a classic two-seater sports car, which made automotive history by sparking the sports car phenomenon in the U.S.

Its successor was the MG-TD, a refined version of the TC. Then came the MGA, a departure in both styling and construction with its sleek aerodynamic monocoque body. But while styles were changing, the basic concept behind each model reflected what MG had come to stand for—handling and performance at a reasonable price.

The same thinking can be found in the 1972 MG sports cars. We know the importance of both performance and value. And we're experienced enough to realize that the MG concept must embrace both.

Perhaps that's why we're going strong while other "sports cars" have merely come and gone.

The MG concept through the years: it's always stood for uncompromising performance and value.

The SSV era: safety at all costs

The 1960s and 1970s saw a US motoring world in turmoil — not only had there been an onslaught against pollution, which brought forth 'unleaded gasoline' in an effort to reduce lead emissions and crude forms of engine exhaust controls, but there were also growing pressures from inside and outside the Government into making cars safer; somehow the carnage on US highways had fired the popular and political imaginations and so there were concerted efforts to make cars less dangerous for their occupants.

Of course, saner voices argued that one of the better ways to make cars safer was to make them smaller, more nimble, and fuel-efficient into the bargain but understandably there were a few vested interests in the vicinity of Detroit who did not welcome such views. The focus, therefore, was on 'passive' safety — making the car a safe place in which to have an accident, rather than making it easier to avoid the accident in the first place.

Perhaps also fired by the apparent invincibility of technology to solve all its problems — this was a time, after all, when the Apollo space programme was still in full swing — the US Government sponsored a series of safety symposiums. Transpo 72 was an early one, staged at the busy

What the 1972 MGB MkIII cost

	Basic	Purchase tax	Total UK price
Roadster	£1,015	£255.63	£1,270.63
GT	£1,130	£284.38	£1,414.38

How the 1972 MGB MkIII performed

Top speed	0–60mph	Standing ¼ mile	Fuel consumption	
106.2mph	11.5sec	18.5sec	23.5mpg	*Motor, 22 January 1972*

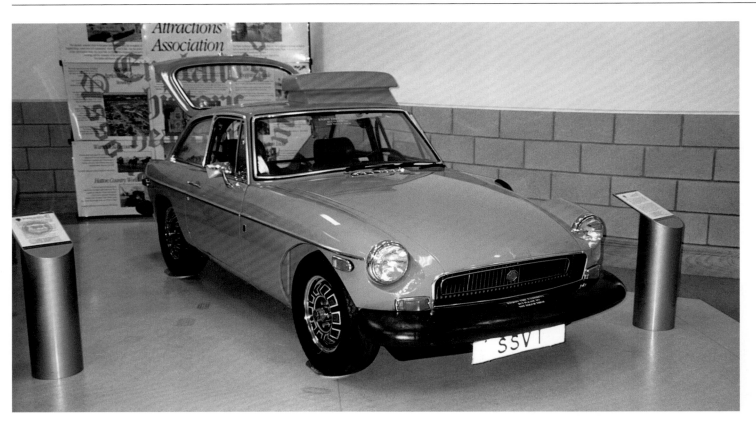

MG's SSV1 prototype (also known internally at MG as EX250) was designed to be a showcase for British Leyland's safety credentials.

MGB GT — or MGB/GT as the Americans knew it.

Finished in Bronze Yellow, SSV1 (developed by Don Hayter under the MG code EX250) featured a prominent but low-mounted 'pedestrian-friendly' impact-absorbing black polyurethane front bumper and a rather inelegant roof-mounted rear visor system that offered a 'panoramic rear view'. It ran on experimental Dunlop 'Total Mobility System' tyres — forerunners of the technically clever but short-lived Dunlop Denovo run-flat system — mounted on specially adapted composite alloy and steel wheels, giving a clue to the wheels that would be fitted to a new MGB GT variant a year hence.

Below the surface there were other changes including a clever Lockheed-developed anti-roll suspension system (part of which was visible through a hole cut in the left front wing). Polyurethane foam was injected into the structural body members to enhance their strength at a reasonable cost in terms of weight, while inside there were passive seatbelts attached

to the door frame that automatically secured the occupant once the door was closed and the engine started. Offering what some probably saw at the time as belt and braces, driver and passenger airbags were also fitted. The piece de resistance, however, was an electronic system designed to prevent the car being used by a drunk driver. This system, developed by Triumph, was dubbed the BLAST — British Leyland Alcohol Simulation Test — and used a system of flashing lights, which the would-be driver had to mimic before being permitted to drive the car.

After the show SSV1 returned to Abingdon, where work was under way to develop production cars to meet new legislation anticipated for the coming years, and eventually the car formed part of the Leyland Heritage Collection. Nowadays it is usually on display at the Heritage Museum at Gaydon, where its fascinating blend of the prescient and the pointless often arouses discussion among onlookers.

transport hub of Dulles Airport in Washington DC, and it is hardly surprising that such a shop window should prove attractive to those who were keen to demonstrate their responsible nature as safety-conscious manufacturers. British Leyland teamed up with the UK Government-sponsored Transport and Road Research Laboratory to mount an exhibition at the Dulles show, with two specially developed vehicles on show dubbed SSV1 and SSV2 (SSV denoting Special Safety Vehicle). SSV2 was a modified Triumph saloon but SSV1 was clearly derived from the

The front suspension of SSV1 was unique and incorporated an experimental anti-roll system. The Dunlop Total Mobility tyres were forerunners of the Denovo run-flat tyre, while the Dunlop wheels would subsequently appear on the MGB GT V8.

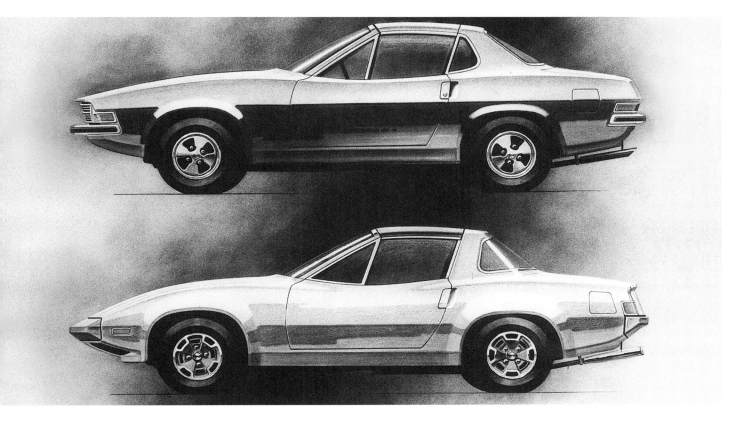

As the debate continued over the future of the open sports car during 1971 — and over the future of the MGB too — MG (in conjunction with Austin-Morris design) played with ideas for a mid-engined coupé under the project code AD021. This is one of many sketches produced by designer Paul Hughes.

Open cars under threat

t the beginning of 1972 the future of the pen sports car looked bleak. The progresve onslaught of safety regulations, oupled with rumours about the roposed next moves by the US egislature, had already contrived to make number of manufacturers either drop heir convertibles or play safe when lanning the major investment required or new models. The fact that the riumph TR7 and Jaguar XJ-S designs were rozen' in 1971 was a clear demonstration f this.

In the summer of 1971 British Leyland ad plumped for the Triumph TR7 as the asis for its proposed new mid-size 'cororate sports car' family — the Jaguar XJ-S rould sit above this family and there reained the possibility of a smaller Midget/ pitfire category car below, although that ras not a high investment priority. With e major investment being directed owards the TR7, and doubts over the

future of any open sports cars, the prospects for the MGB began to look doubtful.

The heart of the problem was Federal Motor Vehicle Safety Standard 208 (FMVSS208), published in draft in January 1972. Under this standard it was proposed that all occupants of the car should remain wholly inside when it was flipped sideways off a platform at 30mph. At the same time there would be the need for passive restraints — in other words, no conscious effort should be required on the part of the occupants to protect themselves. The obvious consequence of this was the air bag, at that time still untried in an open car.

During 1972 legal challenges championed by Ford and Chrysler, and supported by the Automobile Importers of America, addressed — amongst other things — the roll-over requirement of FMVSS208 in the context of open cars.

Eventually some important concessions were won. Firstly, the compulsory fitment of airbags was delayed indefinitely. Next, it was recognised that the Highway Safety Act of 1970 did not give the National Highway Safety Administration the right to decimate whole categories of motor car with its standards.

Open cars were accordingly exempted from the extremes of the roll-over test, although they had to pass a windscreen pillar crush test and to provide a combination of lap belts and adequate internal protection. This was understandably a cause for some relief at Abingdon, where the engineers had some experience of roll-over rig testing and had been able to support the legal challenge. So the MGB roadster won itself a new lease of life and, rather ironically, the car that was supposed to replace it — the TR7 — had been designed and was being tooled as a closed sports coupé.

1973
'MGB — one jump ahead'

Although the so-called 'black hole' grille version of the MGB has its adherents and supporters, it has to be said that they have not been in the majority. For many years MG parts specialists have had a roaring trade selling reproduction chrome grilles to the owners of 1970–72 MGBs, to the extent that an unmolested mint condition MGB of this period is now quite a rarity. Although a black-grille car now looks very redolent of its period — particularly in such 'seventies' colours as Bronze Yellow and Flame Red — it has to be conceded that what was a rather crudely executed face-lift remains even now an acquired taste. Apart from those in the Austin-Morris design office who perpetrated the deed, few in the company liked the 'black hole' grille either; the MG management quietly loathed it, as did key people at the US import offices in Leonia. In the end it was the Leonia staff — in particular Bruce McWilliams — who came up with the basis of a rescue plan that effectively married the traditional MG grille shape with a matt black cross-hatched grille that had echoes of racing MGs from the 1930s. It was a simple master stroke and for some MGB fans the 1973 MGB is a close second in popularity to the earlier all-chrome grille models.

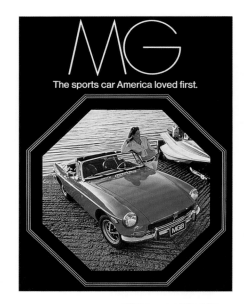

The Bruce McWilliams-instigated face-lift of the MGB for 1973 was an inspired move. This Flame Red roadster, photographed by Marce Mayhew, appeared on the cover of the US sales brochure.

The front end of the Bruce McWilliams proposal neatly married the pre-1969 grille's chrome surround with a black cross-mesh grille (harping back to pre-1936 MGs). Note how the prototype McWilliams has retained the simple red MG badge from the contemporary recessed grille.

The 1973 model MGB

Production of the 1973-model-year MGB began in August 1972, in the time honoured fashion, with the first cars being unveiled in public at the October 1972 Earls Court Motor Show. The most obvious change — a welcome one to many eyes — was the replacement of the controversial 'black hole' grille of 1969–72 with an attractive new one, closely modelled on the original MGB grille that had served so well from 1962 until the 1970 model year. Ian Elliott pointed out that the surround of the 'new' grille was the same as the original: 'I understood that Nanoforte simply dragged out the old tooling and started bashing them out again.'

The grille surround was anodised aluminium alloy (its virtue of light weight countered by its vulnerability to denting) but in place of the former vertical alloy slats there was an attractive matt black cross-mesh grille arrangement, contrived by the use of ABS plastic inserts clipped in either side of the central grille badge plinth. The plinth itself was much as it had been in 1962 — and so better suited the small raised section at the centre of the bonnet — but whereas the old MG plastic shield badge had used a red octagon surrounded by a black shield, this time the whole badge was red and arguably the more effective for it.

Underneath the slim chrome bumper there were now two oblong air-intake holes cut into the front apron, which improved air flow to the radiator, and the exterior badges were revised on the MGB GT to incorporate a neat winged 'BGT' badge on the tailgate.

The optional chrome Rostyle wheels,

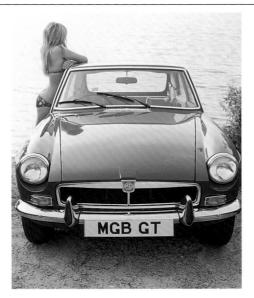

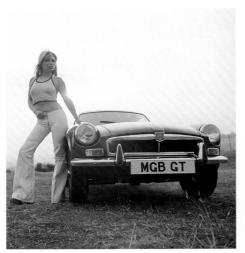

Far left: The MGB GT of 1973 still looked as stylish as the original had done when it had first appeared seven years earlier. Also, 1973 was the year that Classic Cars *magazine was born — the term was already part of the popular lexicon.*

Left: New for the 1973 MGB GT was this neat winged tailgate badge. Note the fitment of the standard non-locking petrol filler cap on this Teal Blue car.

Far left: A 1973 Teal Blue MGB GT alongside a model whose clothes would hardly look out of fashion if she were to travel 30 years into the future ...

Left: Rubery Owen's Rostyle pressed steel wheels were standard fitment on the MGB family from autumn 1969 onwards.

made available as an all-markets option the previous year, were now withdrawn from the US market altogether, made standard in European export markets, and retained as an option for the home market.

Inside the cockpit the greenish-beige Autumn Leaf trim colour was superseded by the more vivid orange-yellow Ochre and the seat facings were changed on both roadster and GT models as part of trim upgrades to comply with US flammability legislation (FMVSS302 — Flammability of Interior Materials) effective from 1 September 1972. Other safety measures exclusive to the US market were the introduction of intrusion beams in the door interiors and special anti-burst door

locks (FMVSS214 — Side Impact Protection — effective 1 January 1973).

Other changes made to US-market cars included minor enhancements of pollution-control measures, such as changes to the carbon canisters and the fitment of an anti-run-on valve; the big changes in this area were yet to take effect.

During 1973 there were the usual series of running changes, including most noticeably a modified steering wheel design where the former slots were merely 'coined' as indentations to obviate completely the possibility of trapped jewellery and consequent litigation. In another effort by the US legislature to harmonise standards in the automotive

industry, all switch labels had to feature word legends in English rather than the ISO symbols that were being introduced in other markets. In July North American Specification (NAS) roadsters and GT models were fitted with a new electronic audible seat belt warning buzzer. In the same month the slightly gaudy Ochre trim was retired and Autumn Leaf brought back on cars painted in Black Tulip, Green Mallard, or Teal Blue. Navy was also phased out in favour of black once again.

The big event in 1973, however, coincided with the 1974 model year and was unquestionably the introduction of a rather special MGB — the MGB GT V8 — which is covered in the 1974-model-year section.

Right: By 1973 the MGB GT featured full-width brushed nylon cord-pattern seat facings, seen here in the 1972/73-only option of Navy Blue.

Far right: The 1973-model-year face-lift for the MGB range, introduced in autumn 1972, brought some interior changes including a steering wheel with elongated slots instead of round holes. Head-restraints remained an optional extra on home-market cars.

Right: By 1973 MG's Austin-Morris parent had long given up racing the MGB. The story in the US was very different, however: British Leyland Inc of New Jersey kept up healthy support for racing in the SCCA arena. Here Brian Fuerstenau's white MGB racer sits on the grid at Road Atlanta in October 1973.

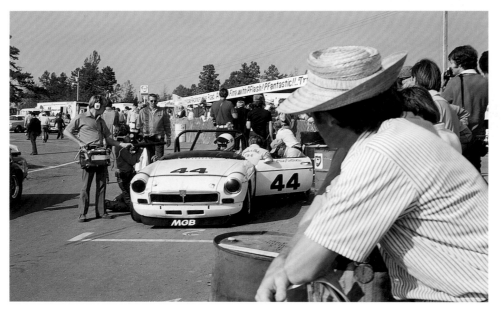

Bigger bumpers to cut repair costs

The various pieces of US automotive safety legislation enacted in 1966 and 1970 had been focused, understandably, on the improvement of vehicle safety but there was another powerful lobbying force — the insurance industry, supported to some extent by the consumer lobby. What insurers were concerned about was the cost of vehicle repair, in particular the damage to bumpers and lighting in minor accidents known colloquially as 'fender benders'. However, the existing legislation did not empower the Government to address these cost issues and so a new law — the Motor Vehicle Information and Cost Savings Act (MVICSA) — was passed on 20 October 1972.

This innocent sounding piece of legislation was anything but; along with requiring manufacturers to disclose data about the crashworthiness and reparability of their products, it also set the tone for the changes in bumper impact requirements that changed the MGB progressively through 1973 and 1974. The National Highway and Transport Safety Administration had already been promoting one of its growing number of Federal Motor Vehicle Safety Standards (FMVSS15), which dealt with bumper safety; the new MVICSA allowed financial considerations to be mixed into the equation.

One jump ahead: the MGB that fell to earth

owadays we tend to take it for granted hat car manufacturers will set aside a onsiderable portion of their annual narketing budget to produce glossy elevision commercials to publicise their roducts but 30 years ago this was still a easonably new concept. With the rmation of British Leyland the showman side Sir Donald Stokes meant that it was ot long before the company was quite eavily committed to prime-time television dvertisements in key markets. So when he Austin Marina was launched in North merica on 22 February 1973, the fanfare was supported by TV advertising during the commercial breaks of the Dean Martin show.

For the local import office at Leonia, however, even bigger things were being planned for the MGB. Although sales of the MGB remained strong, there were increasingly successful challenges from other manufacturers — notably the Continental Europeans and Japanese. BL Leonia's Consultant Creative Director, Marce Mayhew, decided that there needed to be a clever advertising twist to remind the public that MG was the 'genuine

original' in a market becoming crowded with interlopers. The solution that the creative team came up with was clever— but fraught with risk if the advertising shoot went wrong: they were going to drop an MGB out of the sky.

Mayhew sold his pitch to the advertisers with a series of sketches and said to them: 'I think I've got a commercial that's gonna make your dealers stand up and applaud.' The response was: 'Great, let us see it.' Mayhew had to explain that this was not easy to achieve: 'the idea: we throw an MG out of an airplane.'

Far left: Canadian Marce Mayhew was the creative force behind much of the classic MG advertising in the US during the 1960s and 1970s.

Left: All goes well as the MGB is launched from the back of the transport plane ...

... but unfortunately the parachute failed to open properly.

The sad result of the first 'take' back in the local aircraft hangar.

The MGB landed safely on the second 'take' and is shown here with the parachute rigging still attached.

Marce Mayhew arranged this shot, which shows the substantial volume of the specially made parachute, after the successful second 'take'.

The theory was simple and looked great on the storyboard: an MGB would drop out of a cargo plane, a parachute would open, and the car would glide to the ground ahead of a distant pack of rival sports cars which were speeding towards the landing spot. Meanwhile a man in a jumpsuit and wearing an MG crash hat jumps out after the MGB. The MGB and driver both having landed safely, the driver would calmly climb into the car, start the engine, and drive it off before the others arrived. The strap-line of the commercial was 'MGB — One Jump Ahead'.

The preparations and planning had to be meticulous; a remote location (El Mirage) had to be chosen in case of accidents and there were careful calculations to ensure that the parachute and rigging were both strong enough to take the load of an MGB pushed backward out of a plane. The film shoot would need both ground and Cessna-mounted camera and their crews plus a second Cessna with a back-up parachutist in case the one in the plane could not drop with the car; to get the best lighting, everything would have to take place around dawn.

Unfortunately the first 'take' was a disaster: the main parachute failed to open properly and the red MGB plummeted nearly 9,000ft to the desert floor, ending up as flat as a pancake. The only consolation was that nobody had been hurt. Marce Mayhew wryly observed that the flattened MGB would have made an interesting coffee table. However, it was literally crunch time as Mayhew realised: 'We had wrecked chute, a client who was not very happy, only one MGB left and no assurance it would work the second try — we might even end up with matching coffee tables.'

It was an understandably rather concerned Mike Dale back at base who took the call from his colleague Bob Burden explaining that one of the MGBs had crashed to oblivion but Dale gave the go-ahead for a second attempt with the surviving car. This time the car dropped out of the plane properly and the parachute opened but it was soon apparent that the trajectory was not quite the one anticipated, which meant an unholy scramble across the desert floor for the

film crew in their chase truck. 'It was two and half miles away. We really had the pedal to the metal screaming across the desert,' Mayhew recalled.

The film crew got to the right place just in time but was alarmed to note that, because the MGB had veered off course, the spot where it was going to land was not as flat as planned. 'There's cactus all over. It's bumpy ground too — no longer flat. We can only hope it lands right. If it lands on top of cactus, there goes our second MGB!', Mayhew thought. Fortunately, the car landed upright, even though the shock of landing drove one of the parachute harness bolts through the MGB's sump, which meant that as the car was driven off the platform, it dribbled a trail of oil — subsequently eradicated by careful editing — over the desert soil.

While the end-game of this drama played out, Mike Dale was still anxiously awaiting a progress report from California: 'The following day I was having lunch in the executive dining room with our company President, Graham Whitehead, and I had told Bob that as soon as it was successful he absolutely had got to call me because I wanted to have the good news before Graham had asked me what had happened to the MG. The drop took place very early in the morning, because of the light, and as it was out west, it was possible for Bob to get to a phone at about 6.15 a.m. which was 12.15 in NY. Graham had just sat down with a drink, and he remembered that we had dropped the MG the day before. He just asked the question as to how it went, when the phone rang and saved my life — it was Bob on the other end and he just said "it worked" — and so I was able to put the phone down, give a big smile and say "it just worked fine — it took us a couple of goes — but it worked fine …"'

The US television advertising was a great success (winning a prize) and the theme of 'MG — one jump ahead' was used successfully in advertising and promotion.

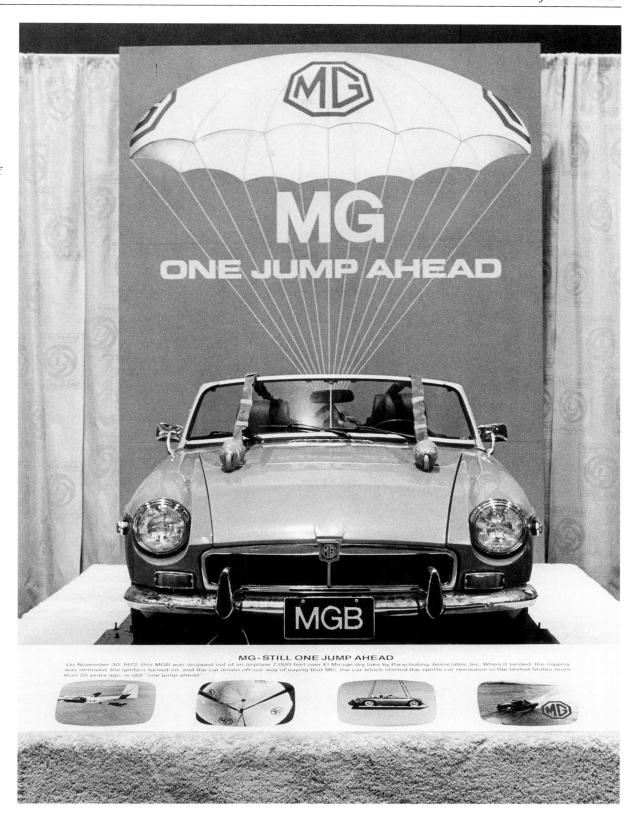

MG-STILL ONE JUMP AHEAD

On November 30, 1972, this MGB was dropped out of an airplane 7,000 feet over El Mirage dry lake by Parachuting Associates, Inc. When it landed, the rigging was removed, the ignition turned on, and the car driven off-our way of saying that MG, the car which started the sports car revolution in the United States more than 25 years ago, is still "one jump ahead."

1974
'You can do it in an MG'

The 1974 model year started off promisingly enough; the 1973 face-lift that had brought back the traditional MGB grille — albeit in a slightly more modern guise — had been a popular move and sales of the MGB were still buoyant. Parent company British Leyland had launched the second of its crucial new Austin-Morris cars — the Austin Allegro — and Sir Donald Stokes spoke confidently about the future. MG, too, had reason to be cheerful; the MGB GT V8 was launched in August 1973 and MG's first production V8 promised a 125mph top speed and 0–60mph acceleration of around 8sec. Unfortunately, conflict in the Middle East led to petrol-rationing scares and a new perspective on V8-engined sports cars, political unrest in the UK led to the three-day working week and crippling knock-on effects upon business, while the onward march of US safety and emissions legislation threatened to blunt the MGB's appeal as it moved into its second decade.

Eight cylinders for the Octagon: the MGB GT V8

The saga of the MGC was an object lesson in how a promising concept could go badly wrong; lesser men than those at MG might have given up on the idea of a bigger-engined MGB after the MGC had been quietly dropped. However, there were a number of factors that contributed to the decision to revisit the big-engined MGB. Firstly, as soon as the disastrous side-effects of the heavy cast-iron six-cylinder engine were known, and the Jaguar group (including Daimler) had come into the fold, some of the MG engineers began tinkering with alternative engines.

As well as the diminutive but powerful Coventry Climax V8, they looked at the Daimler 2.5-litre V8 (they even considered the Daimler 4.5 litre but it was too wide). With the British Leyland merger the all-aluminium Rover V8 had been added to the corporate store cupboard too but, as Rover was part of the Specialist Car Division, the new engine at first remained outside MG's grasp.

Then the enterprising Ken Costello discovered that the Rover V8 engine fitted neatly and fairly simply into the MGB engine bay and began offering his own conversions. Costello's

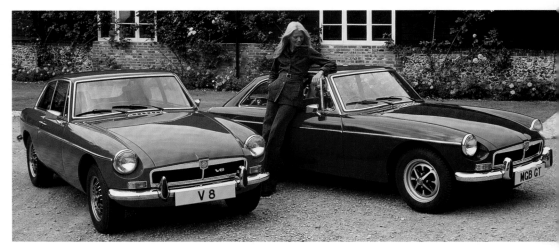

New for 1974 was the MGB GT V8. The Damask Red example here is alongside a Teal Blue MGB GT. The elegant model is Saskia (Pat Parkes

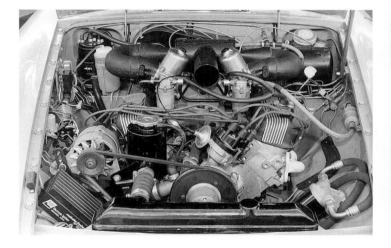

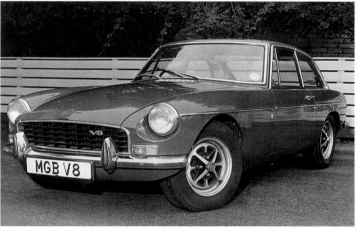

...ght: Former Mini ...cer and tuner Ken ...stello built the first ...ccessful engine ...nsplant into an MGB ...ing the ex-Buick alloy ...8. Costello retained ...e original Rover ...rburettor set-up (seen ...re) on his early cars, ...cessitating a bonnet ...lge.

...r right: Costello's ...GB V8 featured a ...stinctive egg-crate ...ille that was unique ... his cars.

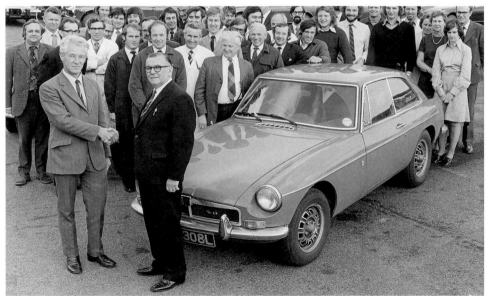

...ec Hounslow (in dark ...it), one of MG's ...minaries, retired in ...74. He had been ...sponsible for design-...g the novel intake ...anifold arrangements ...r the new MGB GT V8, ...e first pre-production ...ototype of which is ...hind him in this ...oto. Don Hayter is ...nveying the best ...shes of his ...gineering colleagues.

transformation of the MGB (with the V8 producing 150bhp at 5,000rpm) was so remarkable that it soon came to the attention of British Leyland's management. Donald Stokes arranged for Costello to bring one of his cars to British Leyland HQ in London's Berkeley Square and was sufficiently impressed that Costello received a request to build a new car and submit it to Abingdon for study. Within a short space of time MG's Chief Chassis Engineer, Terry Mitchell, was starting work on Abingdon's own MGB V8 and by the end of 1971 the first prototype had been built.

A period of development followed, during which the distinctive MGB GT V8 transverse SU carburettor arrangement was designed by MG's Alec Hounslow and work proceeded on adapting the car for

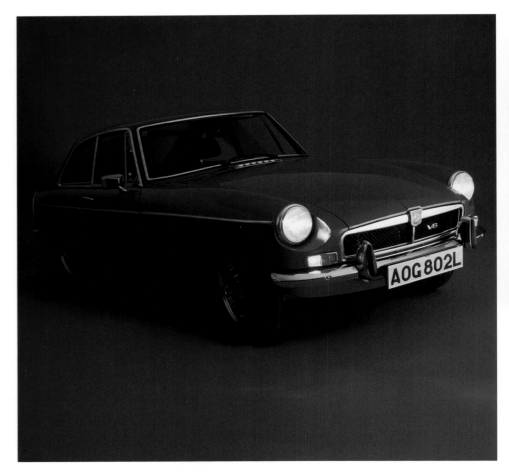

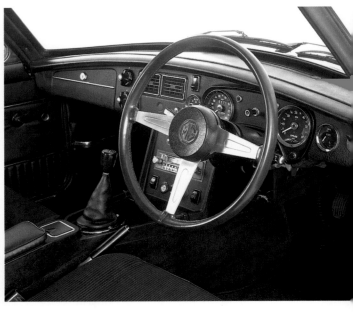

What the MGB GT V8 cost

Basic	Car tax	VAT	Total UK price
£1,925	£160.42	£208.54	£2,293.96
Extras			
Static seat belts			£9.77
Inertia-reel seat belts			£15.85

Above: This particular Damask Red MGB GT V8 was the first production right-hand-drive car and was used extensively in studio and outdoor publicity photography.

Above right: The dashboard of the 1974 MGB GT V8 looked broadly similar to the contemporary MGB, although minor differences included smaller instruments, needed to accommodate a collapsible steering column.

possible sale in the home and export markets, including the US. Seven pre-production prototypes were built with engines aimed at the US market, complete with the obligatory air-pumps, and one of these cars was shown at a dealer convention in Hollywood along with the new Austin Marina and Jaguar XJ12. By now it was the spring of 1973 and there was talk of showing the MGB GT V8 at the imminent New York Motor Show.

However, plans for the US-certification of the V8 were dropped and efforts were focused instead on the European market. There were probably a number of reasons why this happened — some sensible commercial ones and others doubtless tinged by internal rivalries. Rover and Triumph had come under the same directorship within British Leyland during 1972 and, with thoughts turning to a

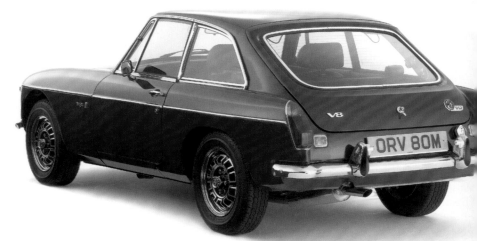

The 3.5-litre MGB GT V8, and the 1.8-litre MGB GT version that continued in production, benefited from a higher roofline *than the low-browed MGB roadster and an opening tailgate (the term 'hatchback' had yet to be invented).*

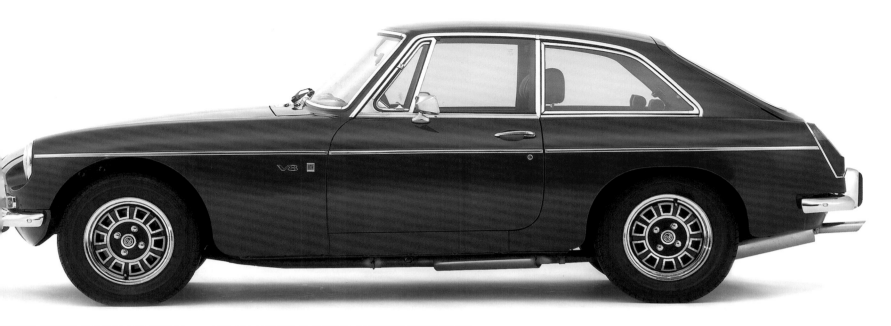

How the MGB GT V8 performed

Top speed	0–60 mph	Standing ¼ mile	Fuel consumption	
128mph	7.8sec	15.8sec	18.8mpg	Costello conversion, *Autocar*, 25 May 1972
124mph	8.0sec	15.9sec	22.6mpg	Costello conversion, *Motor*, 2 June 1973
124mph	8.6sec	16.4sec	23.4mpg	*Autocar*, 16 August 1973
125mph	7.7sec	15.8sec	19.8mpg	*Motor*, 25 August 1973
121.8mph	8.25sec	16.45sec	20.0mph	MG factory figures

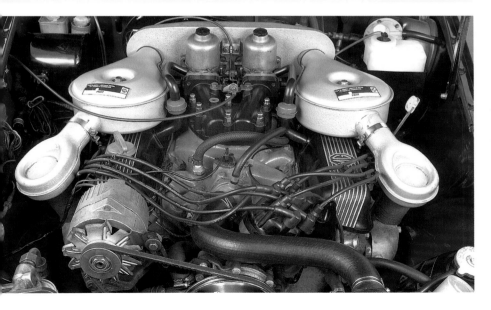

Triumph-badged corporate sports car and the need to keep Rover engines in house, support for the necessary US certification quietly evaporated. At the time US dealerships for Triumph-Rover and Austin-MG franchises were entirely separate too, which hardly helped the case, although before long this anomaly was eradicated.

By the end of 1972 production of the MGB GT V8 was slowly under way, aiming for a launch in the summer of the following year. Eventually the V8 was launched on 15 August, just ahead of the formal 1974 model year. A consequence of this is that some early MGB GT V8s have 1973-model-year rather than 1974 trim — a typical clue being the presence on these early cars of navy instead of black trim. Very early cars also have overdrive on both third and fourth gears; problems in service with stripped gearboxes caused by over-enthusiastic gear changes soon led to overdrive third being blocked off and most production MGB GT V8s only have overdrive on top gear. Ian Elliott, who wrote the press pack for the GT V8, recalled: 'I was told by engineering that the provision of O/D on third was a mistake, it was never intended to happen, but some early cars were built without the necessary inhibitor switch.'

The neat crisp rooflines of the GT were a clever marriage with the curvaceous lower body of the MGB — a hallmark of Pininfarina's genius.

The engine bay of the MGB GT V8 was tightly packed with the ex-Rover V8 engine. Unique intake manifold arrangements placed the twin SU carburettors transversely across the rear of the engine, while the substantial air-cleaners (popularly known as 'lobster claws' by enthusiasts) were fed by design award-winning bimetallic air intake devices later seen on other British Leyland vehicles.

Top row, left: The radiator grille of the early MGB GT V8 variants (prior to the introduction of the black bumpers in late 1974) was superficially similar to that of the original MGB, although in place of vertical chrome-plated bars there was a black plastic cross-mesh. A V8 badge was positioned discreetly on a small plinth within the grille mesh.

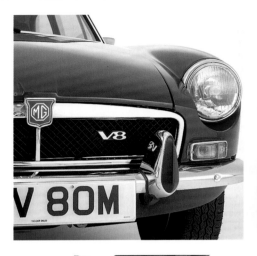

Top row, centre: The grille badge on the MGB GT V8 (and all contemporary MGB variants) was similar in shape to that of the original 1962 MGB but featured an all-red background in place of the black 'shield' of the original car.

Top row, right: The subtle chrome-plated V8 badge ('borrowed' from contemporary Rover saloons) featured in just three places on the early MGB GT V8: here on the tailgate, on the nearside front wing, and on the radiator grille. With the introduction of the black bumpers later in 1974, the number fell to two with the omission of the radiator grille badge.

Goodbye automatic

The start of the 1974 model year saw the deletion of an option that had seemed so essential for the US; the Borg-Warner 35 three-speed automatic gearbox was dropped from the options list. Ironically the BW35 had never been offered in the US market on the MGB — the MGC had been sold there in automatic form but, of course, in very small numbers. There had been plans to offer an MGB automatic in the US; it proved moderately successful in other markets and was offered in Australia on the CKD cars built there. However, although proto-types were built, the federal MGB automatic never reached production. In truth it would have been an unwelcome extra distraction from the key task of certifying and selling the mainstream MGB in the US and projected volumes were never very high; with the loss of the MGC, the case for an MGB automatic

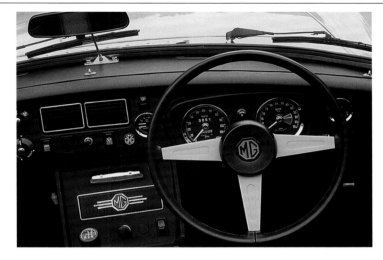

For the 1974 model year the MGB's steering wheel spokes were modified so that the formerly open slots were now merely 'coined'. Note the neat radio blanking plate, complete with stylised MG badge, rarely seen nowadays.

became even slimmer. Had the MGB GT V8 ever been sold in the US, there is little doubt that an automatic version would have been essential; indeed there were tentative plans to shoehorn the

bigger and more modern Borg-Warner 65 gearbox behind the Rover V8 in that case. However, when plans for a US version of the MGB GT V8 died, so did the automatic MGB.

The MGB GT V8 and its rivals

Make and model	Top speed	0–60mph	Standing ¼ mile	Fuel consumption	Price inc tax
Datsun 240Z	125mph	8.0sec	15.8sec	21.4mpg	£2,690
MGB GT V8	124mph	8.6sec	16.4sec	25.0mpg	£2,294
Morgan Plus 8	124mph	6.7sec	15.1sec	18.3mpg	£2,163
Ford Capri 3000GT	122mph	8.3sec	16.6sec	20.7mpg	£1,763
Lotus Elan +2S 130/5	121mph	7.5sec	16.0sec	25.6mpg	£2,789
Reliant Scimitar GTE o/d	119mph	9.3sec	16.9se	20.8mpg	£2,480
Triumph Stag	116mph	9.3sec	18.3sec	20.6mpg	£2,744

Sabrina

As the new decade of the 1970s got into its stride there was a new voice abroad — that of the consumer — and what the consumer seemed to want was better automotive safety. The various pieces of the Federal Motor Vehicle Safety Standards jigsaw were still being slotted into place but, while aspects of interior safety and fuel system integrity had been tackled, the issue of crash-resistance was still to be addressed. In parallel with the safety lobby there was

pressure from the American insurance industry, which was keen to minimise its losses through claims due to low-speed impact damage. The Federal Standards did not provide any legal mandate for this but all that changed with the Motor Vehicle and Cost Saving Act of 1972, which allowed the inclusion of a 'no damage' amendment to existing legislation.

The idea was to ensure that certain safety-orientated equipment — in

particular the lights — would not be damaged in low-speed shunt-type collisions and this meant that some type of damage-resistant impact-absorbing bumper device would be required. This would need to be quite substantial to cope with the weight of a typical US domestic vehicle but also there was a potential problem with the varying bumper heights on different cars, not to mention the porpoising soft suspension prevalent on many big

Right: Citron Yellow was a typical bright colour of the kind popular in the early 1970s. This home-market MGB roadster features the standard painted Rostyle steel wheels.

Far right: The massive impact-absorbing bumper overriders for the US market, fitted for that market alone during 1974, were known at the factory as 'Sabrina' bumpers. This photo was taken in Pope Valley, California, by Marce Mayhew — with some slight irony as, by this stage, the MGB/GT in the background was no longer on sale in that state.

The MG marque was cleverly aligned with the concept of an active outdoors lifestyle by Bob Burden, Marce Mayhew, and their advertising colleagues. The advertising slogan that accompanied this Mayhew shot of an MGB/GT proclaimed 'parachuting ... matches the fun of sportscar motoring'.

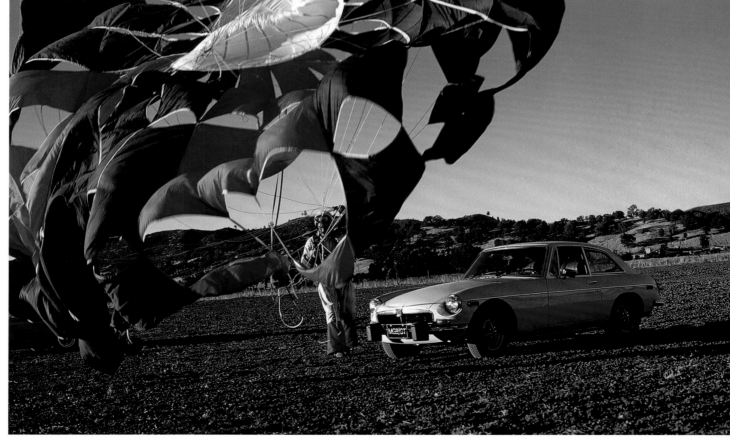

domestic American saloons. In an attempt to deal with all these variables, the NHTSA came up with a pendulum test; the business end of the pendulum had two protuberances — the lower one being the actual 'nose' intended to strike the bumper being tested and the upper one protruding further but not being permitted to hit any part of the car. The pendulum was set at 16–20 inches above the ground, effectively requiring a bumper 4in deep from top to bottom.

The result as far as MG was concerned was the so-called 'Sabrina' overriders (named after a well-endowed British entertainer) fitted to US-bound cars for the 1974 model year only. These overrider units were manufactured from rubber moulded over substantial metal castings, which in turn were bolted through the otherwise conventional bumpers on to sprung steel bars that were designed to transfer impact loads back to the main body structure.

Specifications: MGB GT V8

ENGINE

Description
V8 with aluminium alloy block and cylinder head. Roller chain-driven central camshaft. Overhead valves with pushrods and hydraulic tappets. Five-bearing crankshaft

Capacity
3,528cc (215.3cu in)

Bore and stroke
88.9mm x 71.12mm (2.80in x 3.50in)

Compression ratio
8.25:1

Maximum power
137bhp (DIN) @ 5,000rpm

Maximum torque
193lb ft (261Nm) @ 2,500rpm

Carburettors
Twin 1¾in SU HIF6

TRANSMISSION

Gearbox
Four speed all synchromesh. Laycock-de Normanville overdrive on top gear

Ratios
1st	3.138:1
2nd	1.974:1
3rd	1.259:1
Top	1.000:1
O/d top	0.820:1
Reverse	2.819:1

Clutch
Borg and Beck, 9.5in single dry plate

Propshaft
Hardy Spicer, needle roller bearings

Rear axle
Hypoid bevel, ratio 3.071:1

BRAKES

Front
Lockheed disc, 10.75in

Rear
Lockheed drum, 10in x 1¾in

Operation
Lockheed hydraulic, servo

Handbrake
Lever with cable to rear drums

SUSPENSION

Front
Independent. Coil springs, wishbones with integral Armstrong lever-arm dampers

Rear
Live rear axle, semi-elliptic springs, Armstrong lever-arm dampers

STEERING

System type
Cam Gears rack and pinion

Number of turns lock to lock
2.9

Turning circle
32ft (9.75m)

Steering wheel
Steel three-spoke, 16.5in diameter

WHEELS AND TYRES
5J x 14in Dunlop composite alloy and steel wheels

Tyres
175HR-14 radial-ply

PERFORMANCE
Autocar road test, 16 August 1973

Top speed
123.9mph (199kph)

Acceleration
0–50mph (80kph)	6.4sec
0–60mph (96kph)	8.6sec
0–70mph (112kph)	11.8sec
0–80mph (128kph)	15.1sec
0–90mph (144kph)	19.0sec
Standing quarter mile (402m)	16.4sec

Overall fuel consumption
25.0mpg (11.3l/100km)

DIMENSIONS

Length
12ft 10.0in (3.91m)
Nov 1974 on 13ft 2.25in (4.02m)

Width
5ft 0in (1.52m)

Height
4ft 2.0in (1.27m)
Nov 1974 on 4ft 2.9in (1.29m)

Wheelbase
7ft 7in (2.31m)

Track
Front: 4ft 1in (1.24m)
Rear: 4ft 1.25in (1.25m)

Ground clearance
5.25in (133mm)

Weight
2,387lb (1,082kg)

1975 'The golden age of sports cars'

The 1974½ model year

September 1974 saw the biggest and most dramatic change that the MGB had seen in over 12 years of production and created far more controversy than the 'black hole' grille face-lift five years previously. The substantial polyurethane bumpers front and rear, combined with raised suspension, came as quite a shock to MG enthusiasts. They had just got used to the return of the traditional grille and were clinging forlornly to the hope that somewhere within the bowels of British Leyland — if not at Abingdon itself — an all-new MG sports car was being readied to take up the mantle. However, the truth was that British Leyland could barely afford to keep the MGB afloat and had already decided that the future for its sports car family lay — for the short term at least — with Triumph and Jaguar.

There were other changes for the annual MGB update of September 1974 but few people really noticed any but the obvious ones of new bumpers and raised suspension, both linked to the need to meet fresh US legislation.

The first stage of this process had seen the introduction of simple straight-ahead tests — for which the 'Sabrina' bumpers had been adequate — but when diagonal corner impact tests were introduced, quite deep full-width bumpers were needed. With the decision to style these into the shallow-profile nose of the MGB, it also became necessary to raise the ride height of the car, which hardly aided the handling. Several attempts were made to come up with an acceptable compromise that would work equally well in all the climatic conditions that prevailed in the US market; an impact

The change to the so-called 'rubber bumpers' (in fact they were polyurethane) was a controversial move — particularly when the MGB/GT would soon be withdrawn from North America.

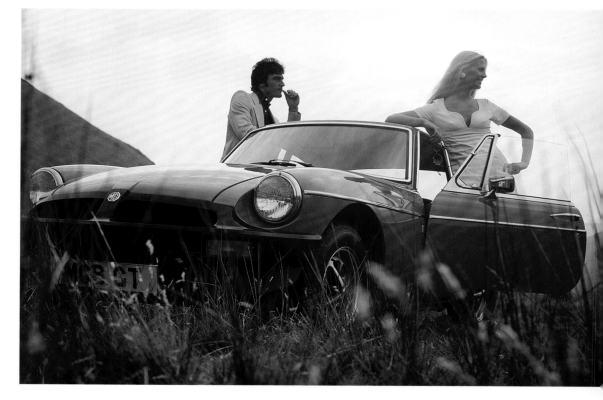

bumper had to work just as well in an Alaskan winter as in an Arizona heatwave. This latter requirement ultimately ruled out the rigid bumper with oil-filled dampers that had been favoured initially; in the end the design chosen was a blended shape full-face bumper — incorporating two grille recesses and styled by Harris Mann of Austin-Morris Styling. The material used was Bayer's Bayflex 90 polyurethane, moulded for the

MGB by Marley Foam in special chrome-plated moulds to give a neat semi-gloss finish — but it was only offered in black.

There were experiments with coloured finishes — either coloured polyurethane or flexible paints could have been used in production — but costs were considered too high and the painting technology associated with matching flexible bumpers to metal bodywork was still in its infancy.

Trouble at the top: British Leyland's woes

The state of much of British industry in 1974 was dreadful; reeling from the fuel crisis that had been precipitated by the Arab-Israeli conflict the previous October, a protracted miners' strike and a determined British Conservative Government led to three-day working and power crises. At the same time a 50mph speed limit was imposed in Britain, in an effort to conserve fuel. A general election in February 1974 — seen by Prime Minister Ted Heath as a test of confidence — resulted in no overall majority. Heath resigned in early March when he failed to persuade the Liberal party to form a coalition and so former Labour Prime Minister Harold Wilson found himself back at 10 Downing Street. This also meant that Anthony Wedgwood Benn — proponent of industrial nationalisation and promoter of the BMC/Leyland merger six years earlier — was back in a position of power at the Department of Trade and Industry.

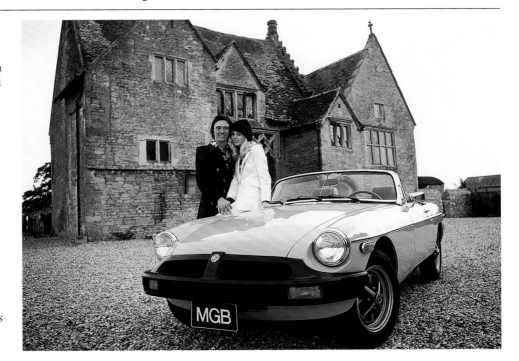

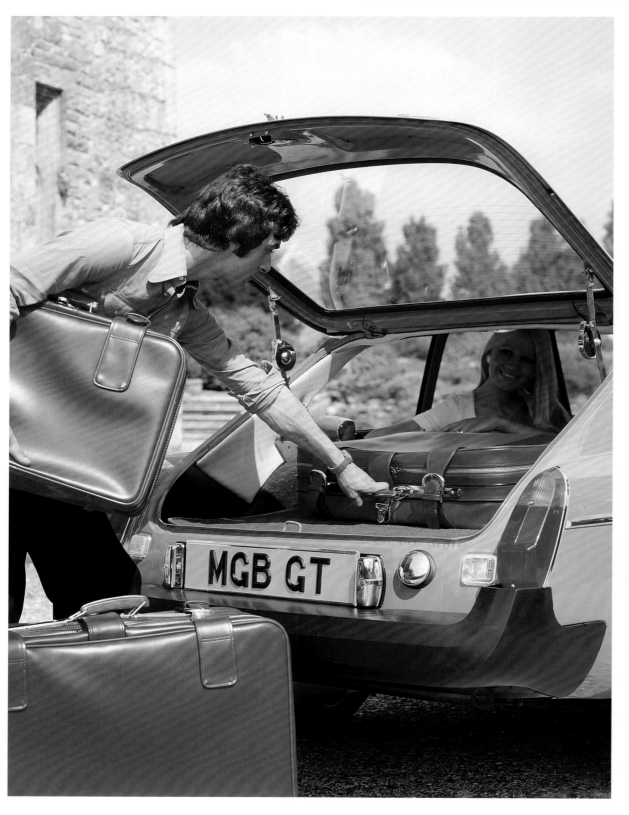

If all this turmoil was bad for strong stable companies with few industrial problems and a good history of inward investment, it was disastrous for weaker ones like British Leyland and by the summer of 1974 the cracks were showing. It became fairly common knowledge in July that the company was talking earnestly to major banks about credit and by November — with the 1974½ MGB barely on sale — the financial situation was becoming desperate.

In December Wedgwood Benn informed the UK Parliament that the Government would guarantee British Leyland's capital, which was tantamount to saying that the Government would bail the company out if private finance efforts failed — in other words, nationalisation by stealth. Rampant UK inflation — soaring away at 18.3 per cent per annum — was matched by record-breaking wage increases of 29 per cent while production output fell by three per cent. Before long Sir Don Ryder (the Labour Government's Industrial Advisor) was appointed to carry out a thorough review of British Leyland, his report arriving in the spring of 1975. As so often in the past, Abingdon seemed like a sea of comparative sanity on a stormy ocean of chaos.

Left: By 1975 the MGB GT was being built in much smaller numbers following the withdrawal of the model from the US market and the launch there of the Triumph TR7. The opening tailgate — or hatchback as the Americans called it — made the MGB GT a reasonably practical shopping car.

Above: This Sandglow home-market MGB GT features Autumn Leaf trim with brushed nylon cord-pattern seat facings. The substantial D-shaped headrestraints were optional on the home-market MGB and GT but standard on the MGB GT V8.

The end of the 'MGB/GT'

If MG fans were rather shocked at the news in September 1974, those of them in North America would have even more reason for dismay the following January — when the 'true' 1975-model-year MGB arrived. Just as safety and insurance issues were shaping the physical appearance of the MGB — as of course they were with all other cars on sale in the US — the separate onslaught of emissions legislation was dealing a second blow to the ageing B-series engine. We saw earlier how the O-series engine was planned to take over from the B-series but the financial traumas of the early 1970s led to several programme slippages for the vitally important new unit. By late 1974, however, it was apparent that the new O-series unit — yet to undergo a serious road-testing endurance programme — would not be available in mass production for at least another two to three years and yet the MGB was a critical part of Austin-Morris exports. The new emissions legislation had several aspects which posed fundamental problems for the classic MGB twin SU carburettor set-up; from 1975 new cars had to be not only low in emissions — and be able to use lead-free petrol — but they had to stay that way for extended periods without variation. The only solution available was to junk the twin SUs on American models in favour of a single Zenith-Stromberg 175CD5T carburettor, complete with automatic choke and a new inlet manifold and air cleaner.

Whilst this solution — coupled with a specially cast cylinder head tolerant of lead-free petrol — was vital in allowing the MGB to stay on sale in its most important market, there was an unfortunate price to pay. Performance fell quite alarmingly,

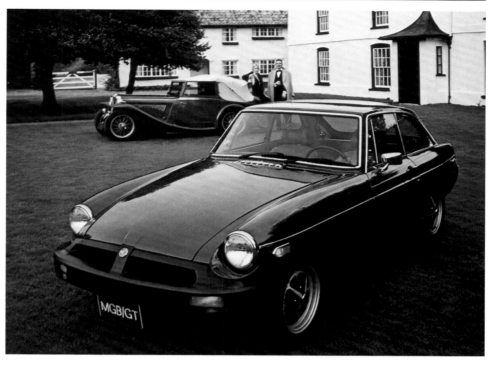

A very rare animal, the so-called '1974½' MGB/GT, in this case finished in Tundra (an olive green colour). The MGB/GT was dropped from the US market for the 1975 model year.

making the 1975 US MGB a shadow of its former self, but for the MGB/GT there was even more of a problem. Each car had to be assessed for emissions in relation to a class system devised by the Americans on the basis of weight. The MGB just managed to scrape within a class — and even then only by stripping out such items as the front anti-roll bar — but the MGB/GT weighed more and so ended up in the next class up, where standards were tougher. Sales of the MGB/GT in the US had never been particularly strong — arrival of the Datsun 240Z had hardly helped — so, with the new Triumph TR7 coupé

on the way, it was decided to drop the GT.

The polyurethane bumpers were heavy units based around steel armatures and in early 1975 they were modified to cut out some of the weight (from February 1975 on US-market cars and from May on home-market ones). The first catalytic converter-equipped MGB (with the special 18V-801/802-AE-L unleaded specification engine) appeared in June 1975 — initially for the Californian market only (from car 382,135) — although by September 1975 this specification was adopted across the whole of the US as part of the 1976 round of model-year changes.

MG's golden jubilee and the MGB GT Jubilee

Even if there were major problems at the top of the company, and developments with the MGB in 1974 had been controversial to say the least, sales of the car in the US continued to hold up extremely well. There is little doubt that this was partly a consequence of the

then favourable dollar/sterling exchange rate (some US politicians accused the British of 'dumping' cheap cars in their market!) but also there were other factors. The MGB had become, almost by default, one of the few genuine open sports cars still on sale; as a

result of the stillborn legislation that had threatened to outlaw open cars, the new TR7 and Jaguar XJ-S models for 1975 were both closed coupés and many other manufacturers had just abandoned the convertible market altogether.

Elegant lines; steady road-holding; a top speed of 107.6 mph; 0–60 in 11.6 seconds;* and the sort of luggage space you need when you just want to get up and go – that's the MGB GT.

A worthy stable companion to cars like the Midget, MGB and MGB GT V8.

Look out, too, for the 'limited edition' of 750 specially equipped MGB GTs, built to commemorate MG's fiftieth year.

When you're behind the wheel of an MG, you're driving a true thoroughbred. *Source: Motor

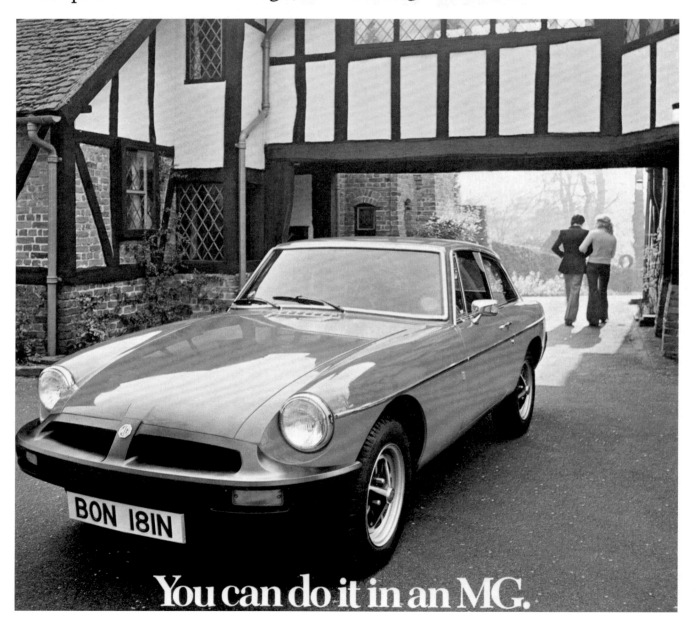

You can do it in an MG.

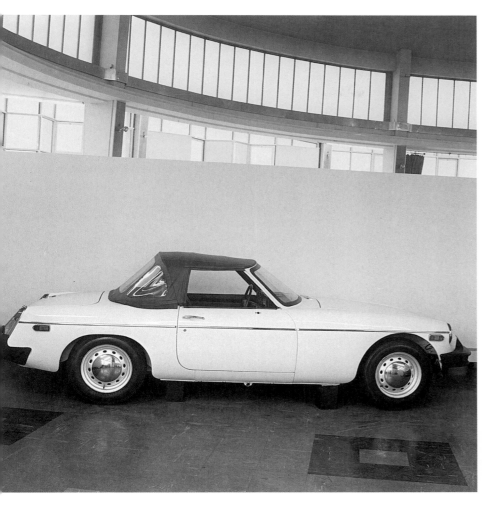

badges on the nearside wing remained stubbornly chrome.

Inside the car the MG logo in the centre of the steering wheel received a slightly unconvincing pale yellow background in place of the previous year's red finish.

Without doubt the *pièce de résistance* of the MG golden jubilee was the limited edition MGB GT made available for the home market in a unique colour scheme of Racing Green with gold side stripes and gold-painted Dunlop wheels, of the pattern normally seen on the MGB GT V8. The MGB GT Jubilee model was quite well equipped: overdrive was fitted (still an option on contemporary standard cars), while inside there was full carpeting (including, for the first time, sill carpets), and the wheel spokes were painted matt black.

A total of 750 MGB GT Jubilees was planned. In fact one more was destroyed during filming for a television commercial (the car crashed through a giant banner but unfortunately buckled irreparably upon landing) and yet another — not strictly in the same production category — was a Jubilee-finished MGB GT V8 that was bought by the British School of Motoring, which registered it as BSM1 and used it to promote its new high-speed driving course. That rather special car survived and has since been restored and re-registered.

Left: During 1975 and 1976 Austin-Morris looked at a cheaper version of the MGB under the project code ADO76. Note the reversion to disc wheels, the new windscreen frame and hood. Below the surface there were proposals to use more Morris Marina parts — fortunately the idea foundered amidst British Leyland's financial woes.

Above: One of the many sketches produced by Rob Owen and his colleagues to explore ways of updating the MGB as part of the ADO76 programme.

Another more easily overlooked factor, however, was the power of clever marketing and advertising — talents that were particularly abundant in the US arm of British Leyland, which effectively exploited MG's pedigree and remaining charms to the full. British Leyland decided that the creation of MG — as with so many stories, a date not exactly set rigidly in stone — should be regarded as 1925; this meant that 1975 would mark the 50th anniversary — the golden jubilee — of the marque, with all the associated razzmatazz that could be mustered to celebrate the occasion.

British Leyland approached the golden jubilee on broadly two fronts: the home-market one, which saw the production of a limited edition version of the MGB GT, and the North American approach, which

saw little more exciting than the fitment of special plaques on the passenger side of the dashboard. One thing common to both markets, however, was the substitution — for the 1975 calendar year only — of gold-finished badges with black backgrounds for the former silver and black items. This meant that externally all the badges, including the badge on the nose, V8 badges where fitted on that model, the MG boot badge on the roadster (now in metal and without the small separate MGB script badge that had formerly sat above it) and the B GT tailgate badge on the MGB GT, were all finished in gold in lieu of chrome. In the case of the B GT badge, the former blue lettering in the B GT 'wing' of the badge was now rendered in black. Even if all other badges were now gold, the square BL

California dreaming: the first catalyst MGB

Whilst June 1975 marked the introduction on home market cars of standard overdrive, this useful — some would say vital — feature remained an option on US cars to the end of production. Part of the problem in the US was the need to keep weight and cost down but overdrive adds considerably to the pleasure of driving an MGB at even moderately high speeds and its omission from the standard specification of export cars was a pity.

Of more significance in the North American market, however, was the introduction for California of the first MGB to feature a modified B-series engine that could tolerate the lead-free petrol that was now compulsory for new cars sold in that State, together with another MG first — a catalytic converter. In 1975 both 'unleaded gas' and catalytic converters — or catalysts as they became known — were still something of a novelty. As the catalyst's

During 1975 the first MGB to be fitted with catalytic converter wer on sale in California (other states would follow the next year). The filler neck carried this handy reminder t the owner to use only unleaded fuel.

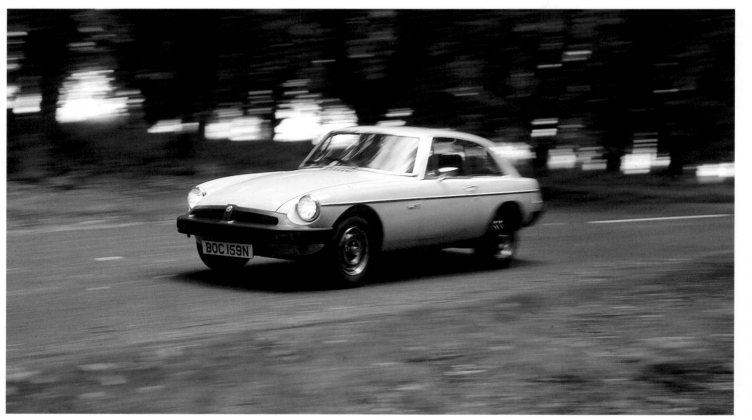

The MGB GT V8 shared the large impact-absorbing bumpers of the rest of the MGB range. This particular Glacier White specimen is a 1974½-model-year car, built before the end of 1974, with a red and silver MG badge on the nose.

platinum-coated matrix could be irredeemably contaminated by normal petrol containing tetra-ethyl lead, the fuel filler was specially adapted to allow it to only accept the narrower nozzles fitted to 'gas station' pumps that dispensed the new unleaded petrol.

One problem with the catalytic converter was heat; the device — fitted beneath the car and installed in-line within the exhaust system — could become extremely hot and not only could this heat travel into the cockpit, there were also incidents of fires caused by cars with

extremely hot converters parked in fields of dry grass. This was not a problem unique to the MGB but with its lower sports car stance it certainly became a risk and high engine bay temperatures also led to other improvements to the fuel supply system.

Specifications: MGB MkIII (1975)

ENGINE

Description
In-line overhead valve pushrod four-cylinder with cast iron block and wet liners, cast iron cylinder head. Roller chain-driven side camshaft. Solid skirt four-ring aluminium alloy pistons, steel connecting rods, and copper-lead shell bearings. Five-bearing crankshaft

Capacity
1,798cc (109.7cu in)

Bore and stroke
80.26mm x 88.9mm (3.16in x 3.50in)

Compression ratio
9.0:1 (US 8.0:1)

Maximum power
84bhp (DIN) @ 5,250rpm
(US 65bhp (DIN) @ 5, 250rpm)

Maximum torque
104lb ft (131Nm) @ 2,500rpm
(US 92lb ft [124Nm] @ 2,500rpm)

Carburettors
Twin 1½in SU HIF4
(US single Zenith-Stromberg 175CD/5T)

TRANSMISSION

Gearbox
Four speed all synchromesh. Optional Laycock-de Normanville overdrive on top and 3rd gear

Ratios
1st	3.036:1
2nd	2.167:1
3rd	1.382:1
(O/d 3rd	1.133:1)
Top	1.000:1
(O/d top	0.820:1)
Reverse	3.095:1

Clutch
Borg and Beck, 8in single dry plate

Propshaft
Hardy Spicer, needle roller bearings

Rear axle
Hypoid bevel, ratio 3.909:1 (US 3.89:1)

BRAKES

Front
Lockheed disc, 10.75in

Rear
Lockheed drum, 10in x 1¾in

Operation
Lockheed hydraulic, servo

Handbrake
Lever with cable to rear drums

SUSPENSION

Front
Independent. Coil springs, wishbones with integral Armstrong lever-arm dampers

Rear
Live rear axle, semi-elliptic springs, Armstrong lever-arm dampers

STEERING

System type
Cam Gears rack and pinion

Number of turns lock to lock
2.9

Turning circle
32ft (9.75m)

Steering wheel
Steel three-spoke, 16.5in diameter

WHEELS AND TYRES
5J x 14in Rostyle steel disc wheels. Optional 4½J x 14in 60-spoke wire wheels

Tyres
165SR-14 radial-ply

PERFORMANCE
Autocar road test, 5 April 1975

Top speed
105mph (169kph)

Acceleration
0–50mph (80kph)	8.2sec
0–60mph (96kph)	12.1sec
0–70mph (112kph)	16.5sec
0–80mph (128kph)	22.7sec
0–90mph (144kph)	34.5sec
Standing quarter mile (402m)	18.3sec

Overall fuel consumption
26.1mpg (10.8l/100km)

DIMENSIONS

Length
13ft 2.25in (4.02m)

Width
4ft 11.7in (1.52m)

Height
4ft 2.9in (1.29m)

Wheelbase
7ft 7in (2.31m)

Track
Front: 4ft 1in (1.24m)
Rear: 4ft 1.25in (1.25m)

Ground clearance
5in (127mm)

Weight
Roadster 2,253lb (1,021kg)
Roadster (US) 2,275lb (1,032kg)
GT 2,260lb (1,025kg)

1976
'MG. The wide open sports car'

After all the upheaval of the previous 12 months, the changes for the 1976 model year seemed extremely mundane; the keen car-spotter might have noticed the satin black finish sprayed on to the front valance to reduce the visual impact of the big black bumper but there was little else to see on the exterior. The lack of change with the MGB belied major problems with the parent company and reflected those of the British economy — the UK's annual rate of inflation peaked at just under 27 per cent in August 1975, just as the Government finally completed its takeover of British Leyland. In the wake of the TR7 launch in the US, interest began to turn to the UK launch in May of the following year and the promised TR7 family — including a 2+2 'Lynx' coupé, a faster 'TR7 Sprint', and a V8 'TR8' version, all expected to follow before long. At the same time development of the new O-series engine continued, with testing across Europe in the autumn of 1975 using a variety of vehicles including an MGB. A bright spot came with the production in October of the millionth MG — a left-hand-drive MGB specially finished in Brooklands Green but set off with the gold Jubilee side stripes.

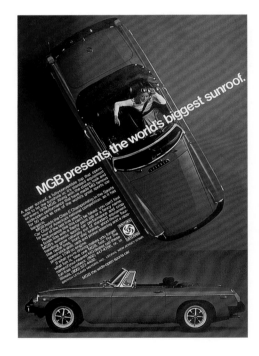

Another classic from Creative Director Marce Mayhew — 'MGB presents the world's biggest sunroof' — was designed to appeal to a marketplace starved of new convertibles of any description.

Changes for the 1976 model year

To the casual onlooker the 1976-model-year MGB looked practically unchanged but there were important changes under the skin — mainly for the all-important US market. A small exterior clue to the different model year was the finishing of the front under-bumper apron in satin black in place of the former body colour. This was an attempt to better-integrate the polyurethane bumpers —still only offered in black — but the effect was achieved simply by masking and overspraying the apron with black on top of the main body colour.

The catalytic converters and lead-free petrol engine introduced in the summer of 1975 for the Californian market had been just a prelude; in emissions legislation terms it was still a case of where California led, the rest of America followed, and so it was for the new model year. MGB roadsters for all US states consequently received the 18V-801/802 unleaded-fuel-tolerant engines, catalytic converter, and the various fuel system and filler neck modifications. Canadian market cars, however, did not receive the catalytic converters — the engines for that market were of the type 18V-797/798. Under the bonnet a small change to US cars was the changeover of the bonnet strut from the left-hand to the right-hand side to ensure that it could not foul the new brake servo set-up.

Mid-way through the 1976 model year — in March 1976 — there were a few more minor changes. Throughout British industry various health-threatening practices were being phased out through a combination of new legislation, good practices, and economics; one area where

all three conspired to work together was the reduction in the use of lead-loading of steel body panels. In the case of the MGB GT, there was a joint between the roof and both rear quarter panels that had always

been smoothed over with lead; from March 1976 this practice was discontinued. So the panel joint was concealed by a neat handed GT badge that had been schemed by a young British Leyland designer,

Gordon Sked, who 15 years later would be the head of Rover Group design. At around the same time, another small change was the substitution of stainless steel door mirrors for chrome-plated items.

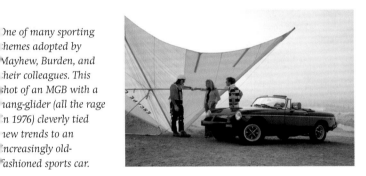

One of many sporting themes adopted by Mayhew, Burden, and their colleagues. This shot of an MGB with a hang-glider (all the rage in 1976) cleverly tied new trends to an increasingly old-fashioned sports car.

The MGB and its rivals in the US

Make and model	Top speed	0–60mph	Fuel consumption	Price inc tax
Triumph TR7	105mph	11.5sec	22.5 US mpg	$5,649
Fiat 124 Spider	100mph	14.8sec	22.0 US mpg	$5,845
Triumph Spitfire	94mph	15.3sec	25.0 US mpg	$4,295
MGB	90mph	18.3sec	19.5 US mpg	$4,795
Fiat X1/9	90mph	16.3sec	26.0 US mpg	$4,947
MG Midget	83mph	15.5sec	29.0 US mpg	$3,949

Goodbye MGB GT V8

After the 'golden badges' intermission of 1975 (used by MG to celebrate 50 years since the supposed creation of the first MG), it was back to a silver finish for 1976. Before 1975 this MGB GT would have had a blue flash to its tailgate badge; for 1975 (and afterwards) this became black.

The summer of 1976 saw two strands of the MGB story draw to a close. First and foremost, the last remaining left-hand-drive versions of the MGB GT were withdrawn from sale, along with the European specification LHD MGB roadster. The official reason was to rationalise sales

but it was no coincidence, of course, that just beforehand — in May 1976 — the Triumph TR7 was launched in Britain and Europe. Despite the scepticism of many MG enthusiasts, insiders like Ian Elliott insist that the main reasons were economic: 'Does anyone really think that BL, particularly in this post-Stokes phase, would have deliberately turned down sales for 'political' reasons?', he asked. Another important new British Leyland model, the Rover 3500 (SD1), also made its world debut in June 1976, complete with a much-modified version of the ex-Buick alloy V8. The need for production capacity for this new engine, coupled with dwindling sales,

jointly conspired to allow British Leyland to quietly pull the life-support on the MGB GT V8. Understandably this was not without some anguish at Abingdon and some local lobbying took place to allow limited production of the MG flagship to continue. However, the future sports car application for the engine was seen corporately as within the Triumph TR7 programme — Rover and Triumph were in the same corporate group — while MG was stuck within Austin-Morris, so MG's pleas fell largely on deaf ears. The MGB GT V8 — arguably Abingdon's best postwar sports car — quietly slipped into oblivion after just 2,591 production cars had been built.

1977
'Where it matters most — it takes a lot to beat an MGB'

By the summer of 1976, nearly two years on from the introduction of the 'rubber' bumpers, there was an opportunity to address some of the problems that face-lift had introduced and also to give the MGB something of a new lease of life in the interim until the hoped-for new engine could be introduced. Legislation that had threatened to outlaw the open sports car had fizzled out and, with no open version of the TR7 available, it clearly made good sense to lavish a little attention on what remained the company's best-selling export to North America, even if only to tide things over until a new open Triumph (and, perhaps, a cheaper MG sister car) could be made ready for the market.

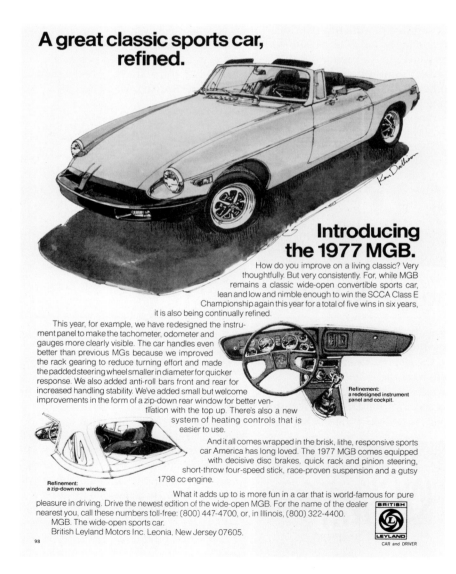

Ken Dallison's artwork accompanied this advertisement for the 1977 MGB in Car and Driver *in March of that year.*

The 1977 model year

The long-term future for British Leyland's sports car programme was supposedly tied to the proposed family of cars based on the new Triumph TR7 of 1975 but, by the time that this model had arrived as a closed coupé, the open MGB was undergoing something of a new lease of life in the US. While the Jubilee MGB limited edition was being mocked-up in the Austin-Morris design studio at Longbridge, plans were also under way to give the whole MGB a fillip aimed not only at addressing market and legislative needs but also to accompany the planned switch to the new O-series engine, proposed for 1977–78.

British Leyland was intensely preoccupied with a programme to replace the heart of its Austin-Morris range — new models being worked on ranged from an all-new Mini (ADO74) to a new Marina (ADO77) and Project Diablo — the large wedge-shaped ADO71, which took over from the Austin-Morris ADO17 'landcrab' in 1975. Add to this the work on overhauling the whole engine range and it is clear that the financial collapse in late 1974 had been a bitter blow. In the case of the MGB, whose face-lift was code-named ADO76, much of the groundwork was already done by the time that cost-cutting and restructuring swept through the company, so it was decided that most of the improvements should still be implemented even if the most important one — the new engine — had to be deferred.

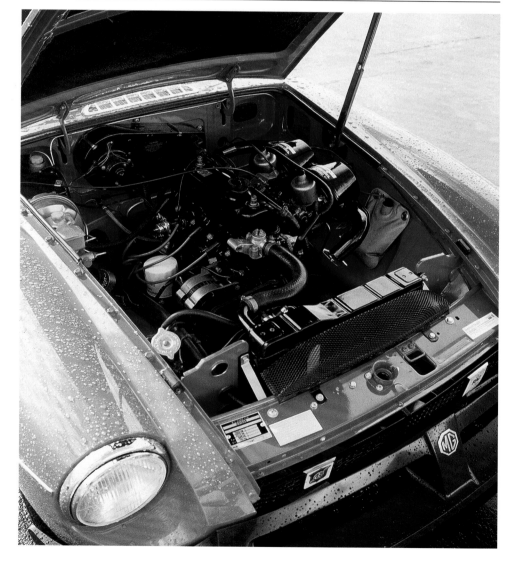

The home-market MGB maintained the twin-SU tradition from start to finish. From 1977, cars were fitted with dual-circuit brakes.

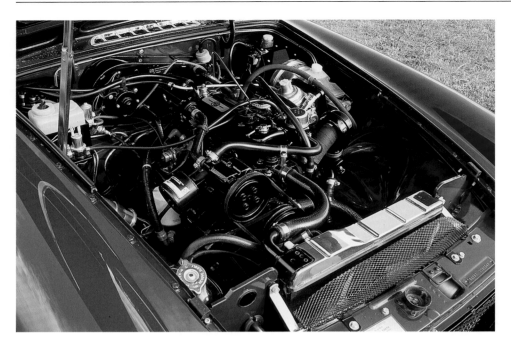

The 1977-model-year face-lift consequently sought to redress some of the worst aspects of the 1974½ changes, some of them in response to feedback from the US. The engine bay came in for some attention with the radiator being set further forward (in a position communised with the MGB V8 — ironically discontinued at the same time), while the engine-driven cooling fan was pensioned off in favour of an electric thermostatically controlled fan mounted in front of the radiator (twin fans, à la V8, were fitted for the US models). UK-market models featured halogen headlamps (to meet local laws US-bound cars still had to make do with feeble tungsten sealed-beam units). The wayward handling that had come as a consequence of the raised ride height was partially addressed by the standard fitment of new anti-roll bars for both the roadster and GT — 15.8mm diameter at the front and 17.4mm at the rear — together with a lower-geared steering rack, with 3.5 instead of 2.9 turns from lock to lock.

The real changes, however, came inside the cockpit. Both left- and right-hand-drive models were treated to an all-new facia and steering wheel, there were new instruments and modified seats (still expanded vinyl in the US, lurid 'deck-chair' nylon fabric in the UK), while the over-drive control (where fitted) was now sensibly inserted Triumph-fashion into the top of the gear knob. The dashboard changes were more extensive on the US models, which featured complete new panels, while the UK equivalents had a comparatively simple injection-moulded plastic overlay to take the instruments and switches. The original plan had been for the US and UK dashboards to have been mirror images of one another; in the event limited funds meant that the bigger market got the more extensively changed dashboard.

Ironically, the 'deck-chair' fabric seats had also been planned with the US in mind. Allegedly, the office at Leonia was wholly unimpressed, so the practical Ambla seats remained standard-fit in that

Danny Waters is a UK-based enthusiast who owns a concours-condition 1977-model-year US-specification MGB in Brooklands Green with an Autumn Leaf interior. Note the side-marker lamps on the front and rear wings, similar to those fitted to other contemporary US-market BL vehicles.

The chrome Rostyle wheels on Danny Waters's MGB are an attractive addition but are not strictly original for the year. They were withdrawn from sale in the US in 1972 but remained standard fitment on export cars for other markets until June 1976.

Note the compact rear licence plate lamps (chrome on this 1977-model-year car but changed to a black finish for the following year) and the rear lamp lens arrangement, which is different on the North American cars from contemporary home-market models.

Above: By 1977 US emissions legislation had reduced the horsepower of American-market MGB's by about a third. Note the single Zenith-Stromberg carburettor (home market cars still had twin SUs). The bulky black belt-driven device at the front left of the engine is the air pump, which feeds unburnt exhaust gases back into the engine for recombustion.

The 1977 Model Year MGB saw the introduction of halogen headlamps (for markets outside North America) and a number of other specification improvements.

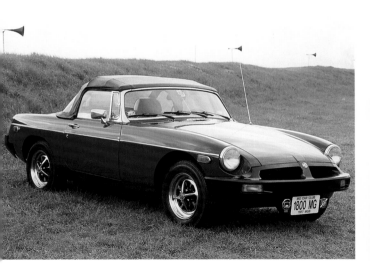

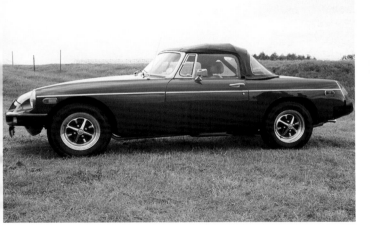

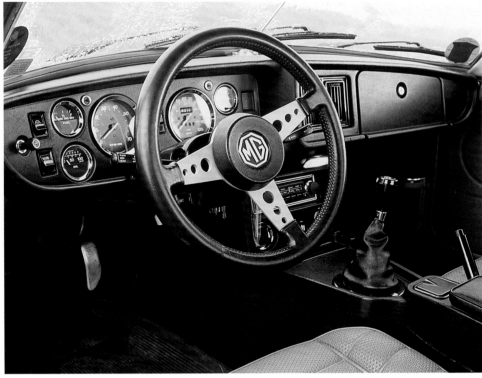

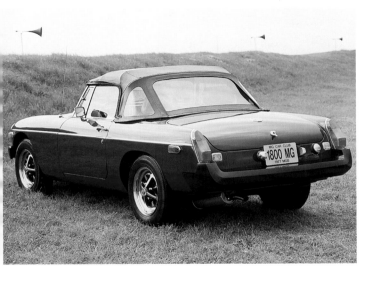

market through to the end of production, although carpets now replaced the rubber coverings of the sills and front footwells. Head restraints were now standard for all markets and were of a slimmer style common to other Austin-Morris models. Fourteen years after the motoring press had first complained of the difficulty of heel-and-toe gear changing in the MGB, the accelerator pedal was at last modified. For the open MGB, another welcome improvement was a zip-out rear window in the hood.

New for the 1977 model year were an all-new dashboard moulding for LHD cars. MG wanted to have similar handed facias for both RHD and LHD cars but budget limitations meant that the UK-market cars had less extensive alterations.

The MGB GT and its rivals

Make and model	Top speed	0–60mph	Standing ¼ mile	Fuel consumption	Price inc tax
Triumph TR7	109mph	9.1sec	17.0sec	26.4mpg	£3,371
Ford Capri 2000S	106mph	10.4sec	17.9sec	24.0mpg	£3,522
Colt Celeste 2000GT	104mph	11.2sec	19.1sec	24.9mpg	£3,349
Toyota Liftback ST	102mph	12.7sec	18.8sec	27.6mpg	£3,413
MGB GT	99mph	14.0sec	19.1sec	25.7mpg	£3,576
Fiat X1/9	99mph	12.7sec	18.8sec	30.7mpg	£3,298

1978
'A great classic sports car refined'

This was another one of those limbo years; most of the important changes had been made in 1977 and for Abingdon it was a case of biding time until the important new O-series engine could be readied. Its introduction in the MGB seemed almost a foregone conclusion, even if only to allow the MGB to soldier on long enough to allow an MG to be spun off the TR7 or another platform. If all was relatively unexciting on the MGB front, things were very different at the head of the company. In November 1977 British Leyland had received yet another in a growing line of Chairmen with the arrival of Michael Edwardes, the diminutive South African powerhouse who had headed the Chloride Group. Few commentators saw much likelihood that Edwardes's tenure would be any longer or more distinguished than his forebears but they would soon be proved wrong.

A new era for British Leyland

On the day that new Chairman Michael Edwardes arrived, the toolmakers at the strife-torn Triumph factory in Speke, home of the TR7, went on strike: it was almost as if they had chosen to mark the occasion in the way they knew best. Edwardes, though, proved to be a much more vigorous defender of management's right to control the company and rather less conciliatory than his predecessors; he was also backed in his resolve by a government frankly exasperated with the 'Leyland problem'.

The new management did not wait long before making its mark: February 1978 saw the announcement of the first of the new management team's corporate plans, which called for a reduction of some 12,000 jobs — some made up from the closure of the Speke factory. Arguably, Edwardes had called the toolmakers' bluff. It was the first step in a new era for British Leyland.

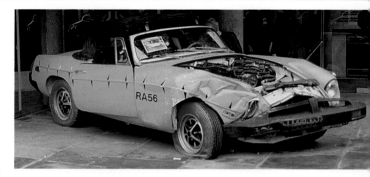

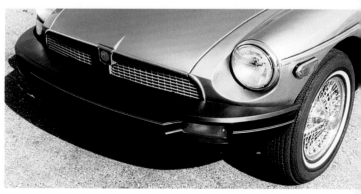

The 1978 model year

Once again it takes the sharper-eyed observer to spot the changes that mark out a 1978-model-year MGB from a 1977 one. The new model year got under way in September 1977, a date which saw the production of a Japanese-specification MGB using most of the parts of a Californian car — including the left-hand drive — but with metric speedometer, ISO symbol-labelled switchgear and UK-type rear lamps. Inside the car the flat H-pattern steering wheel introduced the previous year continued but the previously all-black MG badge in the plastic centre cap was now finished with hot-foiled

ft: MG was
stifiably proud of
e strength of its
rs. A crash-test car
here on display
tside the Abingdon
ol, then a
mmunity centre.

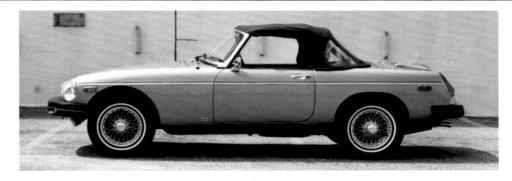

Left: The 'Leonia MGB'
schemed out by Bruce
McWilliams featured
less pronounced
bumpers and a taller
windscreen — two
ideas that would later
resurface in the Aston
Martin MGB.

ft: By 1978 Bruce
cWilliams was
oking again at ways
freshen the appeal of
e MGB. This proto-
pe shows a cut-down
nt bumper to allow a
ore traditional grille
le.

ght: The so-called
eckchair' style of seat
bric in this home-
arket MGB GT is the
ss strident grey and
ack variety. Note the
ver highlights on the
ering wheel badge.
e dashboard differs
om the more compre-
nsively face-lifted
version seen on
ge 135.

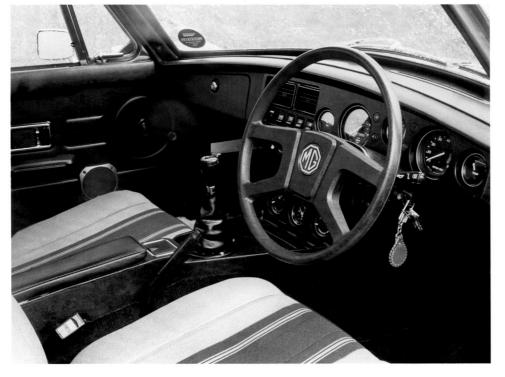

silver to highlight the MG octagon
and lettering. In front of the windscreen,
the washer nozzles were now twin
plastic units with single jets for both
roadster and GT models. In a case of
British Leyland penny-pinching, UK
market cars now came with only the
driver's door mirror fitted as standard,
the two holes for the now-optional
passenger mirror filled by a nasty oblong
grey plastic plug.

Soon after the start of the 1978 model
year there were some minor trim changes
for the US market cars, with Autumn Leaf
trim (and its corresponding carpet colour)
being superseded by Beige trim and
Chestnut carpets. This change did not have
much significance for home-market cars,
which continued with the various 'deck-
chair' fabric seat facings accompanied by
black vinyl trim and carpets. From
December the final British Leyland badge
was deleted from the nearside wing, a sign
of the arrival of Michael Edwardes the
previous month.

1979
'Unlimited fun'

By the time that the 1979 model year hove into view, the new management regime under Michael Edwardes was already making significant inroads. Many of the old guard left and those who remained found themselves pushed into new and often much more challenging and demanding roles. Layers of management evaporated and suddenly nervous middle managers found themselves directly accountable in a way that had been lost through years of muddled bureaucracy and lack of direction. MG was not at the focus of Edwardes's attention — understandably there were more pressing issues to tackle at the heart of the business — but as MG was still part of the big-volume Austin-Morris Division, for the time being the affairs of the two seemed inextricably linked.

British Leyland goes: MG joins JRT

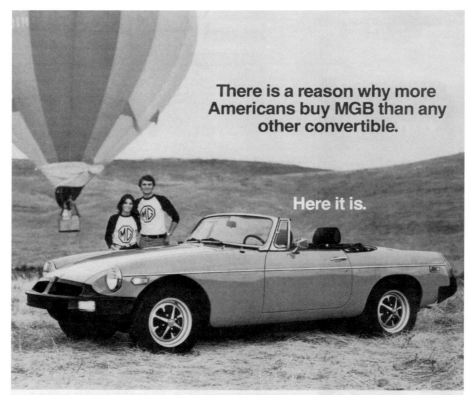

There is a reason why more Americans buy MGB than any other convertible.

Here it is.

The 1979 MGB is the latest edition of a great best-selling classic. The MG-TC was the first imported sports car to win the hearts of America, and the fact MG today outsells any other convertible is an eloquent testimonial to the qualities that make a classic endure. But no testimonial can duplicate the sheer excitement of driving a top-down, wide-open MGB.

Here is a pure sports car: lean, honest and quick. The MGB has the athletic reflexes of rack and pinion steering, short-throw, four-speed stick, track-bred suspension, 1798cc engine and front disc brakes. Driving the MGB is a very individual pleasure—an act of defiance against an increasingly homogenized world. If you've forgotten the feeling of wind in your hair, sun on your face and the sheer exhiliration of driving a car that is all thrust and response, come drive the 1979 MGB today. For the name of the dealer nearest you, call these numbers toll-free: (800) 447-4700, or, in Illinois, (800) 322-4400. British Leyland Motors Inc., Leonia, New Jersey 07605

FOR THE MG SHIRT SHOWN, SEND $6.25 TO: MG SHIRT OFFER, BRITISH LEYLAND MOTORS INC., LEONIA, N.J. 07605. SPECIFY S,M,L OR XL. ALLOW 6-8 WEEKS.

*The hot-air balloon w[...]
a common theme in U[...]
advertising for the 19[...]
MGB.*

July 1978 Michael Edwardes confined
the British Leyland name to history. By
that stage the name had become the butt
of comedians' jokes — the question 'How
many people work at British Leyland?'
brought the answer 'About half of them'.
The new name of BL Ltd removed the
stigma of the Leyland name and allowed a
return to the focus on individual marques.
 At the same time the Jaguar-Rover-

Triumph grouping was reflected in the
North American side of BL being renamed
JRT Inc. In September 1978 MG was moved
from Austin-Morris to join the more
exclusive JRT franchise — a move made
logical by the focus on these marques in
North America — although it was
significant that still the MG name did not
feature within the corporate title of the
division in which it sat. In November 1978

Edwardes accompanied JRT's Managing
Director, William Pratt Thompson, on a
morale-boosting visit to Leonia. Meanwhile,
back home Edwardes's tougher negotiating
style brought agreement of the workforce
to his new pay deal; workforce,
management, and the Government alike
had learned to respect the new Chairman
— whether that respect was enthusiastic,
grudging, or resentful.

The 1979-model-year MGB

The unusually early start to the 1979 model
year came in May 1978. At first the changes
were once more relatively minor; all
thoughts were on the expected and much
anticipated changes that were due to
accompany the introduction of the new
much-heralded O-series engine. The changes
— such as they were — proved of little con-
sequence: home market cars saw the
standard fitment of a radio aerial and door
speakers with the associated wiring, there
were some electrical equipment rationalis-
ations, and the oil hose gave way to a pipe on
export models. Hardly the stuff of dreams.
Later in the year there were some minor
revisions to the instrument faces inside the
cockpit, with rationalisation of the speed-
ometer markings. At the tail end of the
model year five-spoke alloy wheels, similar to
those specified for the US MGB Limited
Edition (see separate section), were made an
optional extra for the home market,
complete with wider 185/70SR-14 tyres.

*A colour borrowed from
the Triumph palette
was Inca Yellow, here
seen on an MGB GT.*

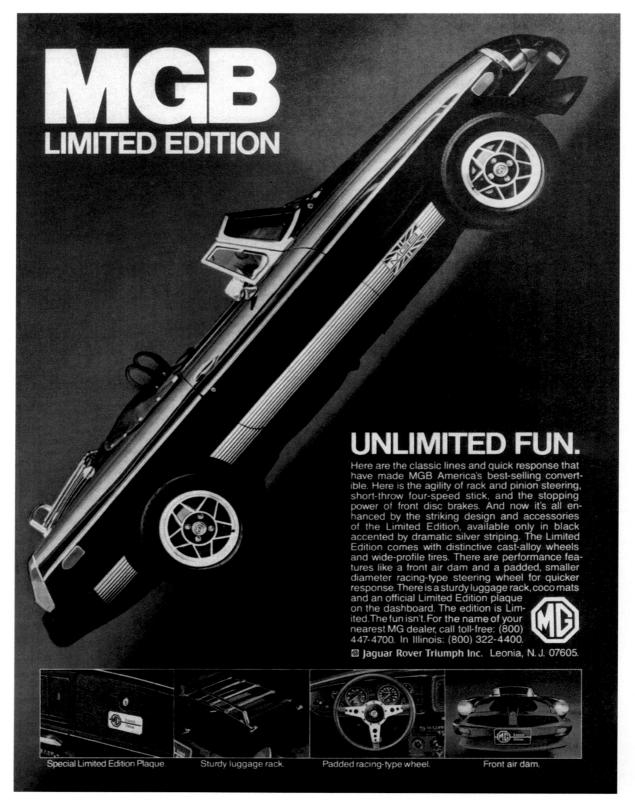

MGB
LIMITED EDITION

UNLIMITED FUN.

Here are the classic lines and quick response that have made MGB America's best-selling convertible. Here is the agility of rack and pinion steering, short-throw four-speed stick, and the stopping power of front disc brakes. And now it's all enhanced by the striking design and accessories of the Limited Edition, available only in black accented by dramatic silver striping. The Limited Edition comes with distinctive cast-alloy wheels and wide-profile tires. There are performance features like a front air dam and a padded, smaller diameter racing-type steering wheel for quicker response. There is a sturdy luggage rack, coco mats and an official Limited Edition plaque on the dashboard. The edition is Limited. The fun isn't. For the name of your nearest MG dealer, call toll-free: (800) 447-4700. In Illinois: (800) 322-4400.

ⓂG

Ⓜ Jaguar Rover Triumph Inc. Leonia, N.J. 07605.

Special Limited Edition Plaque. Sturdy luggage rack. Padded racing-type wheel. Front air dam.

The 1979 Limited Edition MGB for the U and Canadian market was finished in black with silver side stripes and standard-fit alloy wheels.

Midnight B — the US Limited Edition

Despite the fact that motoring magazines were becoming increasingly frustrated at the relative stagnation of the MGB, customers — particularly in North America — confounded the critics by continuing to buy the cars in healthy numbers. By the time that the 1979 model year came round resistance to the controversial but practical 'rubber' bumpers was waning and the paucity of significant open sports car opposition helped buoy MGB sales in a market starved of choice.

By way of celebration JRT Inc decided on another of its successful marketing exercises with another limited edition — a black-finished MGB with a variety of standard-fit extras including GKN alloy wheels, sports steering wheel, front air

dam, and a trunk (boot) mounted luggage rack. The MGB Limited Edition also boasted special longitudinally striped silver side decals, which incorporated a stylised Union flag, and the car was launched as the principal MG interest at the New York Motor Show in April 1979. Price was $8,550, a premium of $600 over the standard MGB, but even so the 'limited edition' went on to sell some 6,682 cars.

When tested by *Road & Track* an LE model accelerated from 0–60mph in 13.6sec, covered the standing quarter mile in19.6sec and went on to a 94mph maximum speed. Fuel consumption was 18.5 US mpg and the power output of the catalyst-equipped engine was stated to be 67bhp at 4,900rpm.

Interestingly the Limited Edition was

not a uniquely American phenomenon, for the model also appeared on sale in Canada — for that market it was fitted with a metric speedometer and ISO-symbol-labelled switches and was without the catalytic converter of US-bound cars.

The MGB was, at this time, JRT's best-selling car in the US, easily exceeding Triumph TR7 sales by a large margin despite discounting offers with the latter. However, the launch of the open version of the TR7 at the Los Angeles International Auto Show in May 1979 was certainly a shot across the bow for MG; even though JRT could argue that the MGB and closed TR7 appealed to different customers, the gap between the Abingdon car and the new, open TR7 was certainly narrower.

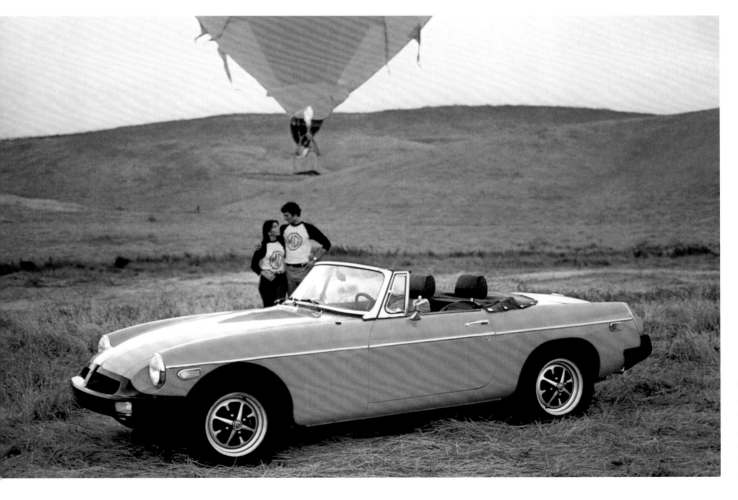

The hot-air balloon theme was skilfully linked by Marce Mayhew and his colleagues to contemporary US-market advertising.

The MGB hot-air balloon

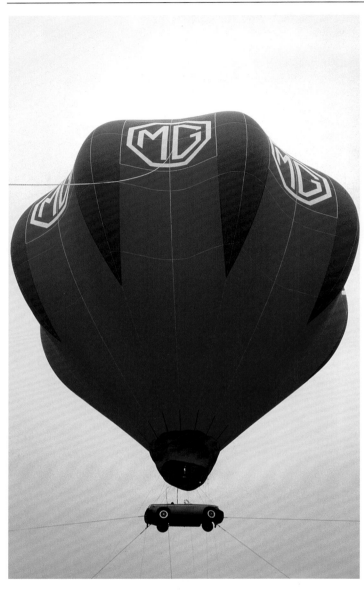

An MGB was turned into hot-air balloon for another Marce Mayhew concept, with 'flights' of the 'experimental aircraft' tied into advertising and promotional activities.

EXPERIMENTAL AIRCRAFT

\- PASSENGER WARNING -
THIS BALLOON IS EXPERIMENTAL
AND HAS NOT BEEN PROVEN TO COMPLY
WITH FEDERAL AVIATION REGULATIONS
FOR STANDARD AIRCRAFT

The cockpit of the MGB hot-air balloon was fitted with this special plaque commemorati its status as an 'experimental aircraft

The MGB had been converted to a gondola, with steel bars welded to the front and rear of the body, to which were fixed four steel cables. A propane gas cylinder was installed in the boot, while the 'burn' controls were in the car interior. JRT had to register the MGB air balloon with the Federal Aviation Authority as an 'experimental aircraft' and it was flown to 6,500ft as part of another bold 30-second television advertisement, breaking the record for the heaviest lift by a hot-air balloon in the process. During the course of the following year this would be used on promotional tours; no less successful than the earlier 'one jump ahead' commercial but thankfully this time there was no falling to earth.

By late 1978, with the 1979-model-year MGB on sale, the advertising slogan then used in the US was 'the wide open sports car' — making great play of the fact that the MGB went one better than a simple sunroof in a market starved of genuine convertibles. For 1979 JRT Inc arranged for an MGB to be cannibalised to produce a giant red hot-air balloon — at 350,000cu ft the second largest such balloon in the world.

The MGB that never was: the O-serie:

The engine at the heart of the MGB — the venerable B-series — was also one of the principal building blocks of the whole Austin-Morris range. By the late 1970s this engine was nearing 30 years in production and work on a replacement had been proceeding at a somewhat stop-start pace since the beginning of that decade. Over the ensuing period a few MGB prototypes had been built with early examples of this engine, which became known as the O-series. By the time that the British Leyland financial crisis came in 1974 there were plans for a major face-lift of the MGB (under the code-name ADO76), which it was planned would accompany a range of trim and dynamic improvements along with the introduction of the new engine.

The financial woes that beset the company put most plans back in the melting pot — ADO76 among them — but work on the new engine, also needed for the Marina and Princess ranges, continued. Six MGB development cars were equipped with federalised O-series engines and were sent to the United State for high-speed circuit testing near Charleston, for work on emissions, temperatures and so on as necessary in order to pass the federal tests, and on to New Orleans for cooling tests.

Test figures disclosed in a confidential report showed how promising the new engine was in performance terms:

MGB performance compared: B-series v O-series

	North America B-series fuel injection	United Kingdom O-series with 2 SU carbs	B-series	O-series with
Top speed	93mph	106mph	104mph	107mph
0–60mph	17sec	12sec	13.3sec	11.1sec
City fuel consumption	16 US mpg	23 US mpg	—	—

Many changes were considered as part of the development programme for the new engine and one or two actually made it was far as production, owing to the need to retool for some parts and the obvious logic of going for the newer specification to save subsequent costs. For example, the front cross-member tooling was modified to cater for clearance with the new engine; late MGBs (from chassis number 512,240, starting in January 1980) have the O-series style of cross-member fitted to them. According to Don Hayter, MG's last head of engineering: 'At least 11 cars ran with O-series in them and more were "space" models. None were ever sold or released by MG Development in complete form as every engine was removed and sent to Longbridge, or Triumph, for installation in the TR7. With very sad hearts, as this was it, as far as the MG Design and Development programme was concerned'

Hayter did manage one fairly clandestine exercise: 'Alongside the official programme I built one turbocharged O-series GT for future development and that developed 160bhp — it was a very quick motor car!'. Like the other units, this engine was also returned to Longbridge, which was experimenting at the same time; a turbocharged version of the O-series engine was briefly considered within other MG-TR7 programmes and a production version appeared in the MG Montego Turbo of 1985.

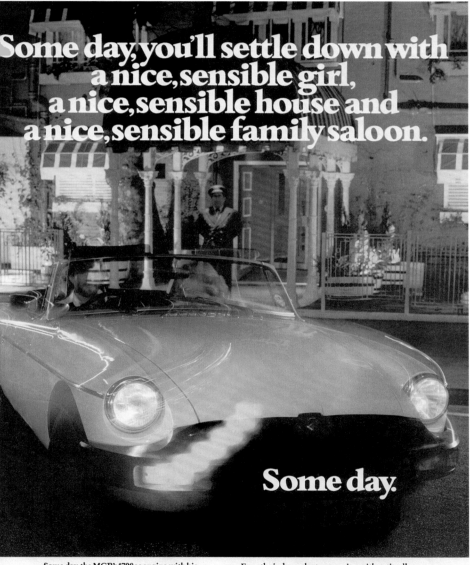

Some day, you'll settle down with a nice, sensible girl, a nice, sensible house and a nice, sensible family saloon.

Some day.

Some day, the MGB's 1798cc engine with big twin SU HIFA carbs might not interest you anymore. Nor the 0–60mph in 11.6 seconds, torque of 104lbs/ft at 2500rpm, 97bhp at 5000rpm, Rostyle wheels with 165SR-14 radial tyres and servo-assisted 10.75 inch front discs.

Even the independent suspension with anti-roll bars, 4-speed gearbox with overdrive, rack and pinion steering, full sports car instrumentation and interior equipment may leave you unmoved. Some day, perhaps. But surely, not yet.

 B SPORTS With Supercover

In June 1978, as this advertisement appeared, BL was launching the first O-series engines in Austin-Morris cars.

A Russet-painted US-specification MGB on the line at Abingdon in 1979.

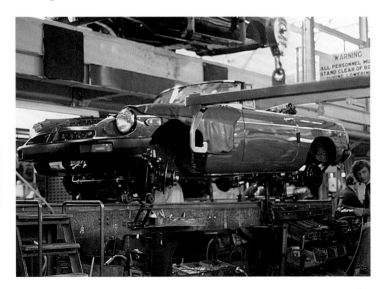

1980–1981 'MGB. The classic breed'

The 1980 model year: 'changes are on their way ...'

In the run up to the 1980 model year, MG enthusiasts felt a sense of renewed optimism; in an article in *Motor* in May 1979, an unnamed Jaguar-Rover-Triumph spokesman was quoted with the immortal words: 'MG? We'd be crazy to ditch it — next to Jaguar it's the most valuable name JRT possess.' The article made it clear that the MGB 'forms part of the product plan for the next five years' and there was a recognition that the typical TR7 and MGB customers were subtly different. Unfortunately, two other events would undermine the MG euphoria. Firstly, the Triumph TR7 finally appeared at the New York Motor Show as a convertible — with its attractive modern lines and convenient folding top, it was clear that Triumph would once more be stepping firmly on what had become almost exclusively MG turf. Of even greater significance was the British general election, which ended five years of Labour government and began Margaret Thatcher's long period in office. The financial and business institutions welcomed the change of direction and the currency markets responded accordingly; the pound sterling started to soar, particularly against the dollar. Suddenly the exchange-rate cushion that had so protected BL exports to the US was being undermined. It would not be long before the tough BL management made its response.

With the new optimism in MG's future — and in particular that of the MGB — few commentators seemed to shed many tears at the passing of the MG Midget. Sales of the similarly venerable Triumph Spitfire were stronger and US dealers were promised continuing sales of the Triumph for the time being, pending new derivatives of the TR7. To compensate for the loss of the Midget, it was announced that MGB production would be increased and the Vanden Plas 1500 would be moved from the old Vanden Plas factory at Kingsbury to be built at a rate of 20 a week on a dedicated line at Abingdon.

Buoyed by the good-news story that it had been able to publish in May, *Motor* was back on the subject of MG affairs in August 1979 in an interview with JRT's William Pratt Thompson, who was bullish about the MGB: 'There continue to be a very strong demand for it,' he said, 'if we could, we would increase the production of MGB's, but we're really restricted by the supply of engines. I intend that the MGB keeps on going. I want to improve it; I think it wants a bit more performance, but we have plans in that direction.'

The performance changes were undoubtedly aligned to adoption of the new O-series engine, for the 1980-model year MGB remained as gutless as its immediate predecessor. Meanwhile the production cars for the 1980 model year were built from June 1979; US-bound

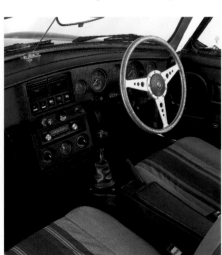
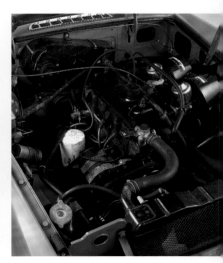

Far left: The dashboard of this home-market car (in common with all similar models from the summer of 1976 onwards) was much modified from the original. Into the plastic overlay on the driver's side was mounted a phalanx of new smaller instruments and internally illuminated switches. Like many others, the owner of this car has replaced the rather unsporting standard black plastic H-pattern steering wheel with an aftermarket one more in the traditional vein.

Left: At least the home-market MGB never suffered the dubious distinction of the single carburettor that afflicted the North American export model. Note the electric fan (a single unit for the UK but two, as on the MGB GT V8, for the US). The black box mounted on the bulkhead at the rear of the engine is the heater unit.

cars had speedometers labelled only up to 85mph (a consequence of legislation rather than the MGB's lacklustre performance) and six-digit odometers. For home-market cars, UK legislation saw the standard fitment of separate rear fog lamps, suspended below the rear bumper, where they tended to get blasted by debris or, in the case of the right-hand unit, soaked and made brittle over time by petrol spilt during careless refuelling. More changes in legislation also saw the introduction of the new industry-standard Vehicle Identification Numbers (VIN), which meant that while the chassis number sequence remained unbroken from before, the GHN5 prefix gave way to the GVADJ- sequence.

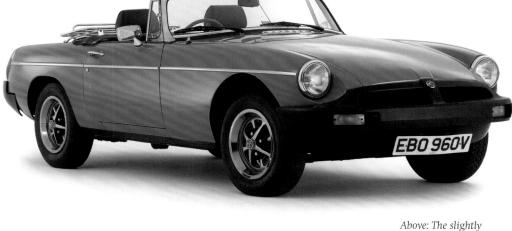

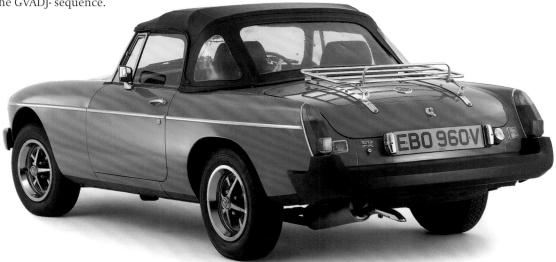

Above: The slightly higher stance of the later MGB is more apparent in this view. The larger wheelarch gap over the front tyre and the higher impact area of the bumpers conspire to make the car look less lithe than the chrome-bumper originals.

Left: An ever-popular aftermarket accessory for the MGB was a luggage rack to add to the car's boot capacity for touring.

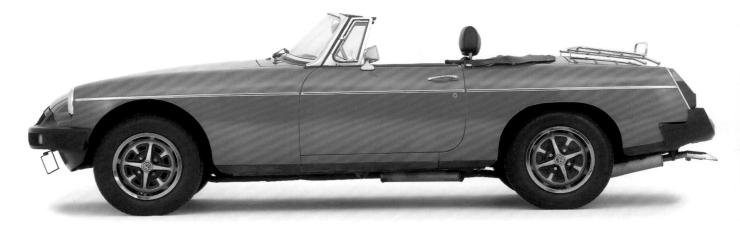

Right The black-bumper MGB rode about an inch higher than the original but even so the overall ride height and driver's eye-level were still much higher than most contemporary cars by 1980. The black paint on the sill is not original.

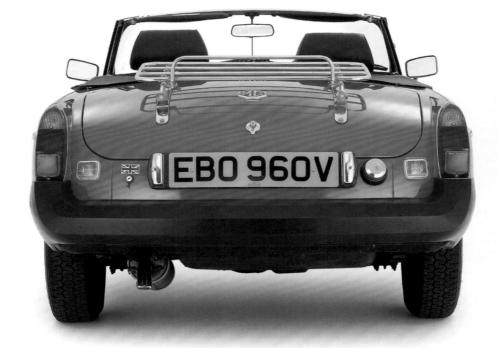

Right: The rear impact-absorbing bumpers swept neatly up to meet the tail lamps — a feature that not every-one liked at the time but which arguably has grown in acceptance. The owner has chosen to substitute pre-1976 chrome-plated metal rear number-plate lamps for the nastier black plastic ones originally fitted to this car.

Far right, centre: By 1980 the poor MGB's door trim was perhaps looking the cheapest it had ever done. The heat-welded vinyl would hardly have looked out of place in a base-model Austin Allegro.

Far right, bottom: Compare these smaller and flatter head-restraints (similar to those used in other con-temporary Austin-Morris cars) with those in the MGB GT V8 seen earlier.

Celebrations again

The US arm of BL — now trading under the name of JRT Inc — knew how successful its well-orchestrated marketing and promotional campaigns had been in shifting the focus from the less attractive features of the MGB, which by the end of 1979 was the only MG on sale — the Midget having been laid to rest that autumn. The 250,000th MGB raffle, Golden Jubilee campaign, the Millionth MG Giveaway, and most recently the MGB Limited Edition had all proved great successes in the important task of raising the levels of showroom traffic. MG advertising in the United States often made much of the Abingdon MG factory's 'magic' — so it was no great surprise when it was decided that the 50th anniversary of MG production at Abingdon would be a good excuse for another party.

As part of the celebrations JRT Inc hit upon the idea of chaperoning a substantial visit by US MG dealers and their families to visit Abingdon and join the week-long festivities, which were being organised locally. How better to cement even more strongly the relationship between the

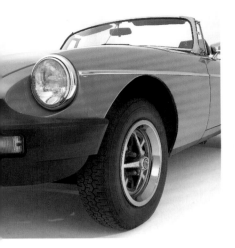

Far left: From 1977 onwards home-market cars were fitted with H4 halogen headlamps, identifiable by the flatter lenses. The decision to overspray the front and rear valances in satin black from the 1976 model year was an attempt to lessen the visual impact of those massive bumpers.

Above centre: The substantial impact-absorbing bumpers were something of a shock to enthusiasts when they first appeared and they still polarise opinion. The polyurethane skin conceals a hollow egg-crate interior and a sub-stantial steel armature: these bumpers are more than capable of surviving minor shunts, unlike the chrome originals.

Above right: Made by Rubery Owen, the 14-in diameter Rostyle pressed steel wheel was fitted to the MGB as standard from the 1970 model year onwards. The chrome-plated rim embellishers seen on this car were a popular dealer- or owner-fitted accessory, particularly in the US.

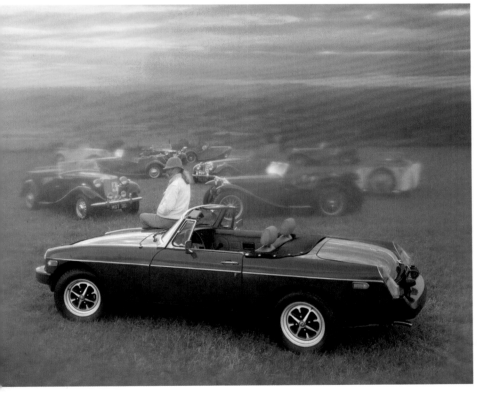

and were driven away to a house which in many cases had been repainted and cleaned up for the occasion.'

The event comprised a week of festivities which were scheduled to end on Sunday 9 September with a finale to mark what was hoped would be the start of the next 50-year chapter of the association of MG and Abingdon. Sadly, however, the party was not to have a happy ending; the rapid strengthening of sterling was hitting exports badly, exposing the inefficiencies of the MG operation and adding to the woes being experienced by the parent company as the new management wrestled with the many obstacles to profitability and strife-free production. Alarm bells rang when newspapers reported that the AEC commercial vehicle factory in London was to be closed and rumours rapidly circulated that other plants would be next.

On Monday 19 September MG fans, factory employees, and even industry commentators were stunned when the formal announcement broke that further cuts at BL would see car production at Abingdon cease altogether. BL did not want to close the plant; the company recognised the relatively strike-free record it could boast — almost unrivalled throughout BL — but henceforth the factory would become a satellite of Cowley. It was a bitter blow, made all the harder for the employees to swallow when the first that many knew of the decision was when they were greeted by reporters at the factory gates.

eople who made the cars and the people ho sold them in the most important arket? Graham Whitehead, the head of e US sales operation, went along for the rip, which he recalled was 'a great ccasion — because the factory opened its rms to us, and people opened their omes — visitors would go round and had a in the private homes of MG employees; he dealers thoroughly enjoyed that.'

Whitehead was accompanied by his colleague Mike Dale, who recalled that as there was no hotel large enough to take the party of 300, the idea came to ask MG employees if they would accommodate an MG dealer and his wife in their homes. 'The result was quite astonishing; there was a row of cars waiting for the dealers when they got off the buses and as each dealer couple got off, they got into a car

Left: Marce Mayhew was at it again — but there was a poignancy to this US advertisement with the older MG's appearing ghost-like in the misty background.

All hands to the pumps: preparing to save MG

If Michael Edwardes and his colleagues at BL thought that the MGB would go quietly, they were very much mistaken; defensive moves were soon being planned on at least two fronts that — for a while — frustrated attempts to end MG production at Abingdon. The first person to leap into action was MG's former General Manager John Thornley. He enlisted the help of loyal MG supporters to lobby every MG dealer in the US, sending all 445 of them a signed letter exhorting them to protest to BL in the strongest terms at the imminent loss of business that the demise of the MGB threatened to bring. At the same time Abingdon's Member of Parliament, Tom Benyon, and his colleague Robert Adley began to stir up political support and eventually managed to force a debate on the BL decision.

Before long a core of the US dealers had mobilised and organised a trip to meet BL management to lobby directly for action. The US Jaguar-Rover-Triumph Dealer Council, led by David Brinkley, offered to provide an order for $200 million worth of MGBs, failing which they suggested they might sue BL if it discontinued the MGB without an effective replacement. 'A lot of dealers will go out of business,' warned Brinkley. The dealers met in London and began to discuss the idea of forming a consortium to buy out the MG interests but soon retrenched when they understood how interwoven the MGB was within the wider fabric of BL. A BL spokesman told *Motor*: '... although it is not yet clear what the US dealer consortium will come up with, it is unlikely that they will be able to affect the proposals for Abingdon'. What the US dealers did manage to secure, however, was a commitment from BL that MGB production would be sustained to maintain good supplies into 1981 while a 'new' MG sports car could be made ready.

Meanwhile the enthusiast clubs too played their part in whipping up popular support for Abingdon and the MG sports car — both the MG Car Club and the media-friendly MG Owners' Club found themselves pushing at the open doors of national newspapers keen to carry the story of plucky MG fans seeking the moral high ground against the draconian monolith that was BL.

As a result of all this activity BL was stung into publicly defending its actions and swiftly proclaimed that it was 'losing £900 on every MGB sold'. Of course, as the saying goes, there are lies, damned lies, and statistics. While there is little doubt that production and sales of the MGB were neither highly efficient nor economic — such factors as the shift in exchange rates, lack of development funds, and increasing obsolescence of the parts and equipment associated with the MGB certainly did not help — it was also clear that if the MGB was uneconomic, other models in the BL family must have been in a similar position.

Aston Martin Lagonda's rescue bid

In the closing months of 1979 many people discussed the virtues of MG, the Abingdon plant, and the MGB but few of them had anything to offer beyond passion and debate. One man who thought he could do more than just talk about MG seemed an unlikely saviour — he was Alan Curtis, the Chairman of Aston Martin Lagonda — purveyors of exclusive sporting cars to the well-heeled and best known for film legend James Bond's Aston Martin DB5.

Curtis had been looking at ways of extending Aston Martin Lagonda's business beyond the exclusive and vulnerable arena of thirsty and supremely expensive supercars. He saw an intriguing similarity between Aston Martin's Newport Pagnell home and the MG factory at Abingdon; both sites had become legendary amongst enthusiasts for the respective marques and boasted loyal workforces who built cars in a slightly quaint and relatively unmechanised manner. Curtis was not alone in thinking this, as he told me: 'I was particularly enthused by the US dealers I went to see who told me that they could see a synergy between Aston Martin and MG.' Curtis could clearly see ways of future economies, perhaps extending MG slightly upmarket to meet a lower-priced Aston Martin model.

Soon Curtis had managed to enthuse various business associates and in mid October 1979 the fledgling Aston Martin Lagonda Consortium first met at London's Grosvenor House Hotel, where Curtis maintained a suite of rooms for business use. Within 48 hours, having secured various assurances of financial and business support, the Consortium had established the basis of an offer for MG — and headlines splashed across the front page of the *Daily Mail* proclaimed the '£30 million plan to rescue MG'. BL responded by saying that while it might be willing to license rights to the MGB, the actual MG name was non-negotiable; it had its own plans for the MG badge — at that stage planned to front a badge-engineered Triumph TR7 to meet the commitment given to the US dealers.

Curtis garnered both some political support and the enthusiastic backing of the MG clubs; the Government, however, remained staunchly neutral — a fact confirmed by a letter from the Department of Trade and Industry to BL Cars' Chairman,

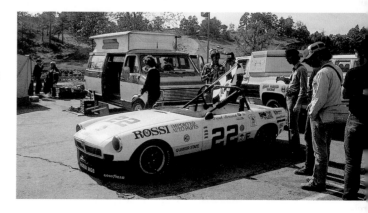

Even when BL appeared to have given up on the MGB, the car refused to lie down in the US, winning races there in the hands of people like Paul Brand, seen here at Road Atlanta in October 1980.

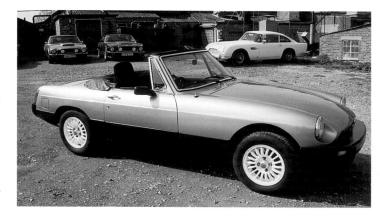

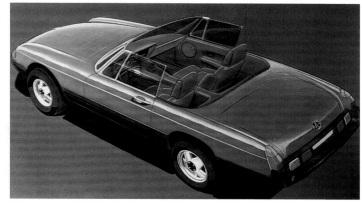

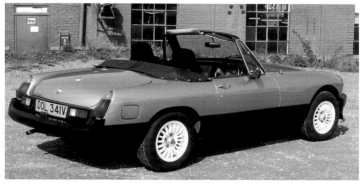

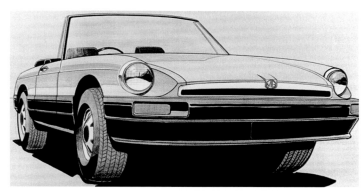

*ght: The one-and-only
ton Martin MGB
rvives in the ownership
enthusiast Cedric
ullis.*

*r right: William Towns
anned an all-new
terior for his Aston
artin face-lift, seen in
s sketch. There just
isn't time to build it
to the one-off prototype.*

*ght: The one-off Aston
artin MGB prototype
ck at Aston Martin's
wport Pagnell factory
ring a special reunion
ganised by the author
1998.*

*r right: This sketch by
signer William Towns
ows his attempt to
odernise the MGB
ape within a limited
dget by using a taller
ndscreen and slimmer
mper with cut-down
rome grille — echoes of
e Bruce McWilliams
onia MGB' (pictured in
e 1978 section).*

*low right: This clay
odel by William Towns
ows what the Aston
artin Lagonda
nsortium had planned
r the near future.*

*r right: In the longer
rm (at least by 1983)
an Curtis and his
lleagues at the Aston
artin Lagonda
nsortium planned to
skin the MGB, as these
illiam Towns sketches
ow, and fit new
robably Toyota) engines.*

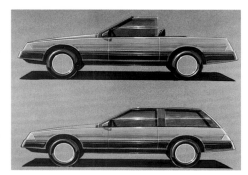

Ray Horrocks, stating that the Government was not opposed in principle to a 'commercially based' plan for MG's future.

With the beginnings of a possible agreement tabled, there then followed what became an increasingly drawn-out process as Curtis's consortium found it increasingly hard to guarantee the necessary funds, while BL found its restructuring plans partially in limbo. By early December, with no sign of a conclusion to the talks, BL announced its own plans for the Abingdon factory, which it said would become a facility to crate-up kits of BL vehicle parts for export and local assembly overseas. It was far less glamorous than building MGBs at 'The Home of MG Sports Cars' but for the loyal workforce and the people of Abingdon it would at least have guaranteed some employment.

Meanwhile, the talking continued and in January 1980 — just as the half-millionth MGB was being produced — the press carried further reports that a £35 million deal to save MG was imminent. BL responded by saying that 'MGBs will be produced until late 1980 and will be available into 1981. The MG name will be retained and there are plans to build a successor to the MGB when production ends at Abingdon.' However, within less than a month plans for this 'MG TR7' were being reviewed — along with the entire Triumph TR7 programme — and so by the beginning of March, BL seems to have been in a more favourable mood to accommodate the Aston Martin Lagonda deal.

On the last day of March, following an intense three-hour meeting, the following joint statement was issued: 'After close and cordial discussion between BL and the Consortium headed by Aston Martin Lagonda Ltd. the two groups today reached agreement in principle for the sale to the consortium of the MG plant at Abingdon together with a world-wide exclusive license for the use of the MG marque. The discussions were based on an offer made by BL on 7 March. The two groups agreed to co-operate fully in implementing this agreement. In the light of this both parties look forward to completing the agreement and thereby providing for continuity of production and employment at Abingdon.'

From triumph to disaster

The announcement that BL had reached the basis of an agreement with the Aston Martin Lagonda Consortium was generally received with enormous relief throughout all corners of the motoring world; clubs and commentators alike were fulsome in the their praise of Alan Curtis and his team and the MG Owners' Club made Curtis its Enthusiast of the Year. Of course, the agreement was just the starting point for a great deal of activity on several fronts; Curtis had to raise the necessary finance, broker new dealers with the distribution chain, and secure the commitment and employment of the MG workforce. Above

MG range
Triumph rang[e]

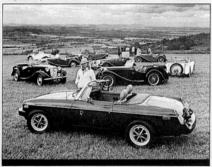

This is the last MGB ad you'll ever see.

Its legend will live on. All of the fun and all of the thunder will endure in the hearts of people who love sports motoring. When the present very limited supply of 1980* model MGB convertibles is gone, it's gone forever. Which means that a classic investment opportunity will vanish too. For, over the years, early models of this great sports car marque—the MG TC and TD—have proven to increase substantially in value. But whether you see investment opportunity, or the chance to own a rare and highly entertaining convertible, hurry. It's your last chance to own an MG, the sports car America loved first. See the Yellow Pages for your nearest MG dealer.

*Only 1979 models available in California.

all this, however, he had one further hurdle to leap — that of keeping the MGB certified for sale in the US, the expenditure on which had been one of the many factors influencing the decision to kill it under the BL plan

The MG name itself was not part of the deal but BL had conceded that an MGB without an MG badge would have been a nonsense and so agreed to license the badge to the Consortium for £1m 'with review procedures to protect quality and quantity aspects ... in order to protect the reversion of the marque to BL should the new company fail'. On the MGB itself, discussions began with MG's Don Hayter and plans were set out for an engine testing and certification programme to be sub-contracted to Olsons of the US, the objective being to allow the new engine to be introduced for the 1982 model year.

For a few brief weeks Abingdon and the MGB seemed to be immersed in an optimistic spring but away from the focus of media attention all was not well. Compounding the rise in sterling was a collapse in the US market that also affected sales of the Aston Martin V8 models. BL complained that, while its was doing its best to boost production and sales of its TR7 range in a depressed US market, it was also haemorrhaging £400,000 per week on propping up the MGB. There seemed to be no positive signs of the Consortium concluding its deliberations

by May 1980 and that month BL tersely, but hardly unreasonably, said that it needed a decision within weeks or it wou[ld] begin to wind down the whole plant by late September.

Then, on the first day of July 1980, Curtis broke the news that no MG enthusiast wanted to hear; nearly half the £30 million needed had been withdrawn — and the financial backers had retreated domino fashion. While BL offered a last-chance opportunity if finances could be found within days, Curtis dashed off to search for new backers. He hoped they would be found i[n] Japan and, perceptively, he hoped also to persuade Toyota that Aston Martin and MGB could provide the Japanese giant with a foothold in Europe. However, the Japanese are not usually rushed; they are measured and decisive when they do act but they rely upon careful analysis — tim[e] was one thing Curtis and his team did n[ot] have. 'In our view,' Curtis stated in his prospectus, 'it is imperative that an agreement is reached by not later than th[e] end of August to facilitate continuity of employee and supplier support — this requires AML to re-open negotiations wit[h] adequate financial backing by August 15t[h] at the very latest.' It was all in vain, however; Curtis returned home frustrate[d] and conceded defeat. BL's announcement on the closure of Abingdon was promulgated on 9 July.

The 'MG Car Company' and the MGB Limited Editions

With the decision made, BL set in motion the plans to transfer staff or make them redundant in the three-month statutory period, so that the main activities of the factory would come to an end in October. This period was still busy, however, for production of MGB models was maintained to ensure adequate stocks for the coming year. By this stage the previous plans for an MG-badged version of the TR7 had been put on ice; for a while the idea was revisited with different variants but before long the whole future of the Triumph sports car programme was in as much jeopardy as the MG one had been.

MGB exports were sent to markets that had placed special orders for the last models while they could still be bought; substantial shipments went to Japan and South Africa as well as the US and Canada. Meanwhile BL Cars picked up a trick from its US offshoot and prepared a final Limited Edition — for the home market only — with the message that the final cars would be saved for the BL Heritage Collection, stressing the 'collectability' of the final series. With no apparent sense of corporate irony, these Limited Edition cars were even marketed (three months after the production lines fell silent) under the aegis of the 'MG Car Company Limited' — final recognition, perhaps, of the enormous heritage that the marque still retained despite all that had been thrown at it. One thousand of these LE models were built — split between 420 roadsters and 580 GTs, priced at £6,108 and £6,756 respectively.

The roadsters all came in Bronze metallic (with gold side stripes), while the GT coupés were Pewter metallic (with silver stripes). On 208 of the open cars there were painted wire wheels, the remainder being fitted with the same GKN alloy wheels and 185/70SR-14 tyres used on the GT version and similar to those offered since 1978 as an optional extra on the standard production MGB. Contrary to popular belief, although the two 'end of line' LE models — an MGB LE roadster followed by a GT as the

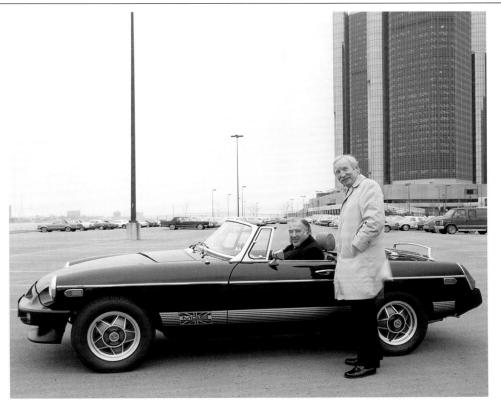

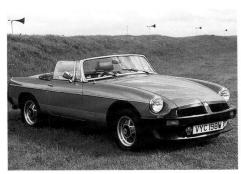

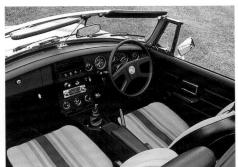

'last' car — were photographed on the end of the production line and bore the final chassis numbers, neither was the last car actually built. That distinction was accorded to a LHD US-specification Porcelain White car (destined for Japan), which finally came down the line in October 1980. Then that was the end; the production lines fell eerily silent for the last time and 51 years of MG assembly came to an end.

On Monday 9 February 1981 Henry Ford II (sitting in car) took delivery in Detroit of the last officially imported US-specification MGB from JRT President Graham Whitehead (standing alongside). Ford's father, Edsel, had once owned the first MG Midget to be imported and drove it for three years before donating it to the Ford museum.

Below far left: The MGB LE roadster was a home-market-only concoction, built at Abingdon after the closure announcement, and featured a metallic bronze paint finish borrowed from the contemporary Austin-Morris saloon range.

Left: The interior of the MGB LE was largely the same as ordinary home-market cars and dominated by the 'deck-chair' fabric, here in orange and brown. One small identifying feature, seen here, was the unique red finish applied to the background of the steering wheel badge.

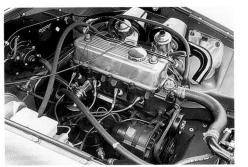

The owner of this MGB LE has fitted a polished alloy rocker cover, a popular period accessory, but otherwise this engine bay is close to how it would have left Abingdon in 1981.

The Heritage MGB and the RV8

1988–1995
'The marque has returned'

MGB Heritage bodyshells

When most cars cease to be manufactured, the chance of them re-entering production at all is usually extremely slim; the number of cars that are resuscitated several years after their demise is consequently even smaller. With the end of the MGB, there was a period when bodies and panels would be built on an occasional basis to meet service demands but the long term prognosis for the tooling was mothballing followed by eventual scrapping. However, thanks largely to one man — David Nicholas of Pressed Steel — the tools survived and were placed in storage at Swindon. Thanks chiefly to another man — former Cowley Materials Control Manager David Bishop — those tools would later be rescued, reconditioned, and brought to a small site at Faringdon as part of bold project to bring the MGB bodyshells back to life.

According to David Nicholas of Pressed Steel: 'When it was realised that the MGB was in decline, from an assembly point of view, it was obvious that the spares side would continue and, because of the relatively small quantities involved, a lot of it was sub-contracted out. We had a terrific production over-load at Swindon, with different models, and obviously we needed to sub-contract a lot of stuff in order to cope.' In due course the MG parts scene grew as the cars maintained their Classic status and various suppliers began to bring in parts that were 'reverse-engineered' copies of parts — often sourced in the Far East. This included body parts, which helped make the decision to consider producing new bodies and panels a logical one for the people who held the original tooling.

Eventually, Nicholas says, it was decided that production runs would be less regular: 'We would do a big batch every now and again with a sub-contractor — on a one-off basis per batch. Because of that, we withdrew all the tooling back to Swindon — something which I personally organised — and it was all stored on the

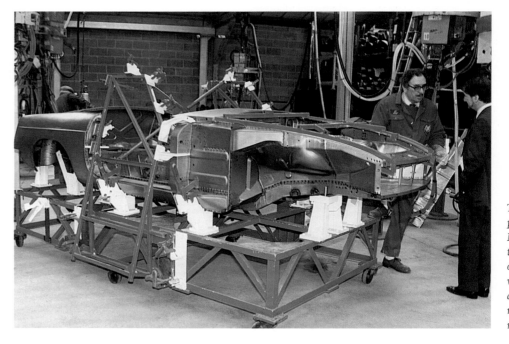

The MGB bodyshel[l] produced by Britis[h] Motor Heritage us[ed] these refurbished original jigs, whic[h] were specially adapted to suit th[e] methods and volu[me] required.

south side of 'C' Building.' Having had a talk with some industry contacts about trends and possibilities, Nicholas concluded that the tooling should not be scrapped immediately but stored to allow for the possibility that future demand would recover.

Meanwhile David Bishop had joined the British Motor Industry Heritage Trust and by June 1984 had become Assistant Managing Director, reporting to Peter Mitchell. British Motor Heritage had evolved from BL Heritage, itself a development from Leyland Historic Vehicles, and its brief was to preserve representative vehicles and archives from the diverse history of the constituent parts of the British Leyland empire. British Motor Heritage Ltd supported the manufacture of genuine service replacement parts for some of the more popular classic marques and models and also covenanted 75 per cent of its profits to support the British Motor Industry Heritage Trust, which owned the collection of historic former British Leyland vehicles.

Bishop saw an order to scrap much of the Triumph TR7 bodyshell tooling pass across his desk and he was determined to try to avoid this fate for the MGB. 'We looked at the time and cost involved in the renovation of an old MGB bodyshell and we realised that we could reduce this by up to a half if a new one was available.' In late 1986 Bishop began the task of hunting down the tooling, jigs, and fixtures — not all of which were stored at Swindon — and during the Christmas break Bishop studied the 250-page file that contained

information on all the panel and sub-assemblies for the MGB. This detective work provided the clues needed to identify all the tooling dies. With about 240 individual pressings to each MGB bodyshell, 3,000 spot welds, and over a hundred inches of gas welding needed in each one, this was not going to be a simple project.

'There were nearly 800 press tools in all, weighing over 1,000 tonnes, which translated into fifty lorry loads to move everything,' according to Bishop. Permission to remove all the tooling was given by Rover Group and a base was set up at Faringdon, roughly halfway between Oxford and Swindon. This strategic location — also not far from Abingdon — was beneficial as it facilitated the recruitment by Bishop of a number of former Pressed Steel men, who in many cases had retired locally. Remarkably, just four of the 800 tools were found to be missing; if just one of the major dies had been missing, the whole project could have been scuppered at the outset.

Bishop used his inside connections and address book to the full in coaxing staff — many with the specialist skills that can only be built up over a lifetime of experience — to come out of retirement to work for him; among them was Jack Bellinger, who had recently retired from the body facility at Cowley. The Faringdon plant started operations in April 1987 and the first complete bodyshell was ready the following February in time for the press launch in central London in April 1988, the month after Rover Group was acquired by British Aerospace. At the time of the

launch, Bishop told me that he would have been reasonably happy if he sold 250 of the MGB bodyshells at some £1,295 plus VAT each; of course, many more than this would be sold and in due course the Heritage body panel business would expand considerably.

It was decided to maximise launch publicity by building up a complete MGB in front of the visiting public at the National Classic Motor Show held at Birmingham's National Exhibition Centre over the Bank Holiday weekend at the end of April 1988. Several specialists got in on the act, stripping down a rusty MGB and transferring its identity (with a few new parts in the process!) into a ready-painted Tartan Red Heritage bodyshell. Registered TAX 192G, this MGB inevitably soon became known as 'Taxi' and, after being used for promotional purposes, joined the Heritage Collection. The idea of a weekend rebuild was a novelty in 1988 but has since been a popular spectacle at subsequent Classic car shows.

At first the Heritage bodyshells were supplied without doors, bonnet, boot lid, or front wings fitted — the normal service body supply pattern — but improved methods and materials (including zinc-coated steels) ensured that a re-shelled MGB would last much better the second time around. However, the large number of amateur customers found to be rebuilding their own cars, rather than entrusting everything to experts, led to a review of how the bodies were supplied and later MGB shells were supplied with all crucial body panels ready fitted.

Towards a new MGB: the Heritage MGB V8 project

You did not need to be a rocket scientist in 1988 to see that the potential next step from bodyshell manufacture was limited production of complete cars, although obviously that would be a bold step for a company like Heritage to take. Nevertheless the attraction was obvious and Bishop soon homed in on the concept of offering the best 'MGB that never was' — a chrome-bumper MGB V8 roadster. One of

the early customers for a Heritage shell was policeman Roger Parker, who had built his own MGB V8 roadster. Parker was often involved in liaison with manufacturers over the development of police-specification vehicles and so his contacts and relevant expertise within the industry were both impeccable.

In July 1989 David Bishop was asked to bring along a couple of MGBs to an

MG programme review meeting chaired by Rover Group Chairman John Towers; Bishop cannily invited Parker to bring his British Racing Green MGB V8 along. After their meeting the management team — including one of the then design directors, Richard Hamblin, a keen supporter of the idea of a new MG sports car to respond to the new Mazda Miata/MX-5 — showed interest in Parker's

Classic car with its green paint and chrome wire wheels. The casual interest sharpened somewhat when Parker explained that a fuel-injected Rover V8 was under the bonnet and he was asked if he would mind starting the car up. 'When the engine started, all conversation stopped,' Parker said; craftily the seed of an idea had been sowed.

David Bishop arranged for his own prototype MGB V8 to be built the following spring at Heritage's Snitterfield storage facility by engineer Mark Gamble and this car — DEV1— was a test mule with new running gear and suspension to allow proper evaluation of the performance and handling. Test runs took place at the Gaydon test track and demonstrated the great potential but Bishop could not get corporate support for a production MGB V8 as a £17,000 retro-rival to the contemporary Morgan Plus 8.

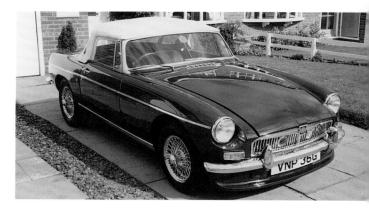

Project Phoenix

The Phoenix name has been used so often in recent years that is has become almost a talisman for the revitalised MG company but its first significant usage was in association with a project hatched at the start of the 1990s to revive the concept of a proper MG sports car. The MG programme meeting in 1989 (referred to earlier) was just prior to the start of the formal programme, which was set up the following spring under the aegis of the new Rover Special Products (RSP) subsidiary.

Roger Parker's MGB V8 roadster had been a useful catalyst, particularly with regard to thoughts about a new V8-powered MG sports car, but at the same time Richard Hamblin had produced studies of how the MGB styling could have evolved, had it been treated in the way that Porsche had dealt with the 911. In 1990 it was recognised that an all-new MG sports car could not really be made ready much before 1994 (in the event, it would be 1995...) but Hamblin saw that there was an interesting opportunity to capitalise on the Heritage MGB bodyshell project and produce an interim limited-production sports car. Consequently, just as Bishop had been working on DEV1, Richard Hamblin at the newly formed Rover Special Products had taken the idea a step further, subtly restyling the MGB bodyshell as the basis of a 'retrospective MG'.

Within RSP this concept — described by its advocates as 'celebratory' rather than 'retro' — took shape under the name Project Adder, the name being a reference to the only poisonous snake indigenous to the British Isles and, of course, hinting at the Cobra name.

RSP designer Jerry Newman produced a sketch showing a modernised MGB with laid-back headlamps, integrated bumpers, and flared wheelarches. Before long this initial sketch was being refined and used as the basis of a full-size model study followed by studio work building up clay directly on to the body of a Carmine Red MGB roadster (LFC 436S). This car was ready for management viewing in July 1990 but for a while the project was deferred. Then a few months later — around ten years after the closure of Abingdon — the project was revived and another styling model (using a bodyshell furnished by David Bishop) was used to take the proposals further.

The style of the car evolved, with particular emphasis being placed on getting the shapes of the wings right (while retaining the MGB doorskin), while at the rear various abortive experiments with proprietary tail-lamp units led to the decision to commission special one-off Adder tail-lamps — a wise move, in hindsight. Soon approval was given to produce a glass-reinforced plastic (GRP) model, which would allow a much more realistic impression to be formed of the final result. Moulds were taken off the finished clay model (unfortunately destroying that model

in the process) and the GRP panels produced were fitted to the ex-Heritage DEV1 prototype before painting in metallic British Racing Green, a popular Rover colour at the time.

A clinic viewing took place in June 1991 and the green prototype was well received by viewers, who immediately guessed its MG provenance. Approval for the project to move towards production came in July but then the following month came the shock news that Rover would be abandoning the US market, with the exception of the successful Land Rover/Range Rover models. This meant that plans for sending an MG sports car to the US were also suspended indefinitely; for a brief moment it seemed that projects such as Adder and the remainder of the Phoenix programme might be under threat too.

MG Enthusiast Roger Parker built his own MGB V8 roadster, which would prove to be a key influencing factor in kick-starting the programme that would eventually lead to the MG RV8.

A fully finished styling drawing shows Project Adder in nearly its definitive form.

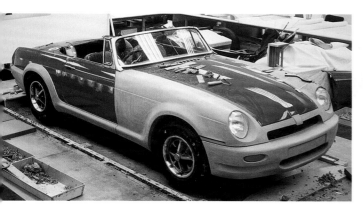

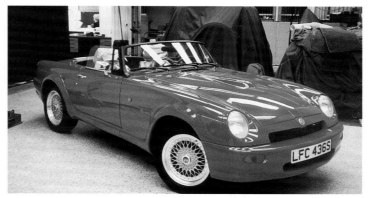

The Rover Special Products team developed these original iterations of the new generation MGB by the simple expedient of applying modelling clay to an MGB bodyshell.

Fortunately the main thrust of the Phoenix programme — the PR3 mid-engined sports car that would emerge in 1995 as the MGF — had been so well received, and was seen as saleable in non-US markets, that the sports car programme survived, albeit with North American sales unfortunately no longer part of the plans. Adder continued, with work starting on producing the definitive master tool patterns. (A process not without its own problems, for the DEV1 base car was found to have been accident-damaged in an earlier life, necessitating some manipulation of the mathematical data scanned from the model!)

By the spring of 1992 Project Adder was moving rapidly towards fruition. Engineering development work had included the bodywork modifications, including all-new front and rear wings, adapting the impressive Land Rover 3.9-litre V8 engine and LT77 five-speed gearbox and upgrading the front and rear suspension to more modern standards and to cope with the significant torque and power of the powertrain. On the production car so many components had been modified or changed that Rover could claim that only five per cent of the new car was to MGB specification. At the same time a production 'home' had been established in a corner of the Cowley Rover plant, while Rover Group's Sales & Marketing Division built up towards the new car's launch by producing and issuing a teaser brochure in June — the legend on the front promising 'The Shape of Things to Come'.

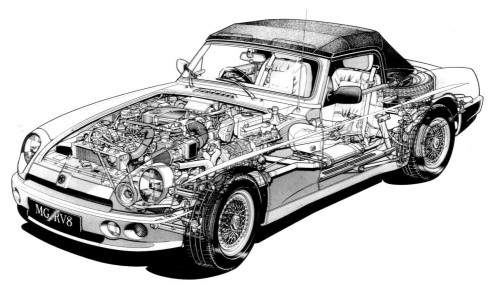

This factory cutaway drawing shows the 3.9-litre Land Rover V8 shoehorned into the RV8's engine bay.

Project Adder becomes the MG RV8

The name given to the production version of Project Adder was the MG RV8 — a sales and marketing concoction that we were told at the time of the launch could mean any one of a number of things; the letter R, we were led to believe, could stand for Rover or Retro — or just for itself in the same way that Cecil Kimber, MG's first chief, said that the letters in the name MG 'just stand for themselves'. The MG RV8 took centre stage at the British Motor Show at Birmingham's NEC in October 1992 and was warmly greeted by a supportive crowd of journalists and enthusiasts. A UK retail price of £26,500 was quoted with deliveries due to start in the spring of 1993. When it finally went on sale the price had dropped

to £25,440 and the only extras listed were a CD player at £590 and special paints at £750.

The RV8 was powered by Rover's all aluminium Ohv 3,946cc V8 engine developing 190PS at 4,750rpm with Lucas multi-point fuel injection. Maximum torque of 234lb ft was at 3,200rpm. Power was fed through a five-speed manual gearbox and stopping was provided by 10.6in diameter front disc brakes, supported by 9in rear drums. Independent suspension at the front was by double wishbones and coil springs while at the rear were leaf springs and a live axle. Dimensions were very similar to the last MGBs with a 7ft 7.7in wheelbase and an

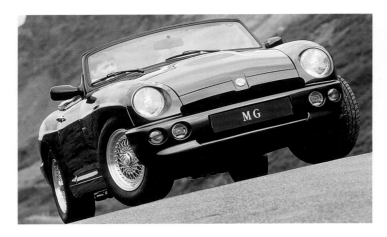

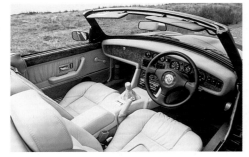

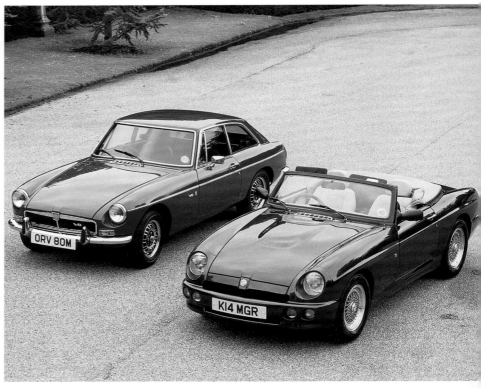

Above and right: The styling of the RV8 was a clever blend of old and new: the nose 'borrowed' headlamps from the contemporary Porsche 911, while the interior owed more to Jaguar than MG tradition.

Far right: One of the official RV8 press cars poses alongside the author's MGB GT V8 at Chiswick House in 1993.

overall length of 13ft 1.9in. The overall width at 5ft 6.7in was 7in greater and the rear track was wider at 4ft 4.4in but the overall height had increased only an inch to 4ft 4in.

Unfortunately, while the *raison d'être* of the MG RV8 had been to point the way forward to the new generation of MG sports cars expected to follow in its wake, the car itself was intended to exploit what had been a burgeoning market in Classic cars. In 1990 and 1991 speculators had driven the price of genuine Classics such as Jaguar E-types and Aston Martins to giddy heights; Rover Group hoped to capitalise on this by offering a new car with the genuine heritage but none of the heart-ache of a Classic. The collapse of the Classic car market and the onset of reces-sion came at an awkward time for the RV8; once again it seemed, MG had mistimed the launch of a V8-powered sports car. During the winter of 1992–93 orders for the RV8 hardly burst the floodgates and there were concerns at Rover Group.

Salvation for the MG RV8 came from a different quarter; the car was launched in

Japan at the Tokyo Motor Show a year after it had first been shown at Birmingham and the retro-styled British sports car went down a storm. Interestingly the single car shown on the Japanese importer's stand was finished in the optional special-order colour of Woodcote Green and Rover Group found that a significant proportion of the cars ordered by Japanese customers were in the same colour — so much so that when one sees a Woodcote Green RV8 today, the first thought is that it is likely to be a reimported Japanese-market car. (Also identifiable by the air-conditioning unit with intake grilles in place of the normal front fog lamps and the add-on 'lip' around the front wheelarches, a response to Japanese regulations on exposure of tyre treads.) The first customer cars left for Japan on the *MV Don Carlos* in January 1994 and they were followed by around 1,300 cars in subsequent months.

The MG RV8 was always intended to be a limited edition and so changes in production were never likely to be particularly significant. However, one welcome improvement that came midway

through production was the substitution of a newer 'R380' gearbox, with a much improved gear change quality, in place of the LT77 unit. By the time that the MG RV8 was nearing its run out, another all-new MG sports car was on sale — the mid-engined MGF, which had grown from the PR3 design that had formed part of the Phoenix programme. The very last MG RV8 — a Woodcote Green car bearing the Vehicle Identification Number SARRAWBMBMG002233 and bound for Japan — went down the production line at Cowley on 22 November 1995.

In production terms, then, the end of the RV8 marked the conclusion of a chapter in MG history that had begun almost 40 years earlier, when the first thoughts about a replacement for the MGA had been hatched. In the wake of the RV8 project, however, the MGB Heritage bodyshell is alive and well and is still being produced — at an impressive BMH facility at Witney. So while the MG factory may now be only a fading memory, fortunately its best-selling product can live on for many years to come.

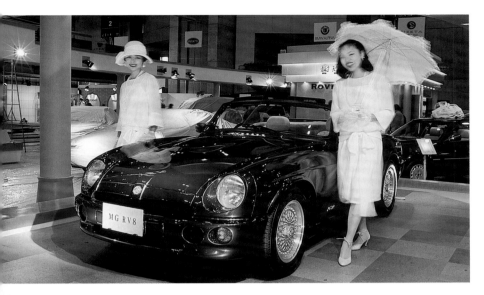

The colour choice

Six standard body colours were offered on the RV8. Solid colours were Flame Red and Black, metallics were White Gold and British Racing Green, and the two pearlescents were Nightfire Red and Caribbean Blue. In addition there were four special colours unique to the RV8 that were available for an extra £750 premium: Le Mans Green Pearlescent, Woodcote Green Pearlescent, Oxford Blue Pearlescent and Old English White. There was no colour choice for the interior, which was finished in two shades of Stone Beige with leather-trimmed seats as standard.

Despite the collapse of the UK Classic car market, which severely dented sales of the MG RV8 in Britain, the new car was greeted very enthusiastically in Japan. Here the 1993 Tokyo Motor Show MG RV8 is upstaged by a pair of elegant Japanese models. The colour of the show car was Woodcote Green, an extra-cost pearlescent paint finish, and by far the largest proportion of cars sold in Japan was ordered in that colour!

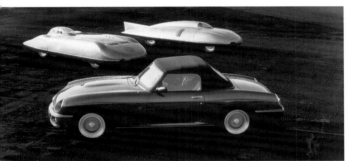

Far left: Rover Group played the heritage card strongly with the MG RV8. Behind this brochure-shoot car are two MG record breakers, X179 and EX181.

The Japanese market proved to be a lifesaver for the RV8 project. Here one of the cars sits on the dock alongside the giant freighter bound for Japan. Note the subtle lip around the front wheelarch and the chrome 'ROVER' script, added at the insistence of the importer.

How the MG RV8 performed

Top speed	0–60 mph	Standing ¼ mile	Fuel consumption	
136mph	6.9sec	15.2sec	20.2mpg	*Autocar & Motor*, 16 June 1993
135mph	5.9sec	—	—	MG Rover figures

MG RV8 Vehicle Identification Numbers

First car: SARRAWBMBMG000251, built 31 March 1993.
Last car: SARRAWBMBMG002233, built 22 November 1995.
The meaning of the various letters in the MG RV8's Vehicle Identification Number (VIN) is explained below:

S	A	R	RA	W	B	M	B	M	G	000251
Geographic area (South)	Country (UK)	Manufacturer (Rover)	Marque Models	Class	Body	Engine	Transmission & Steering	Model Change	Assembly Plant (Cowley)	Serial Number

Index